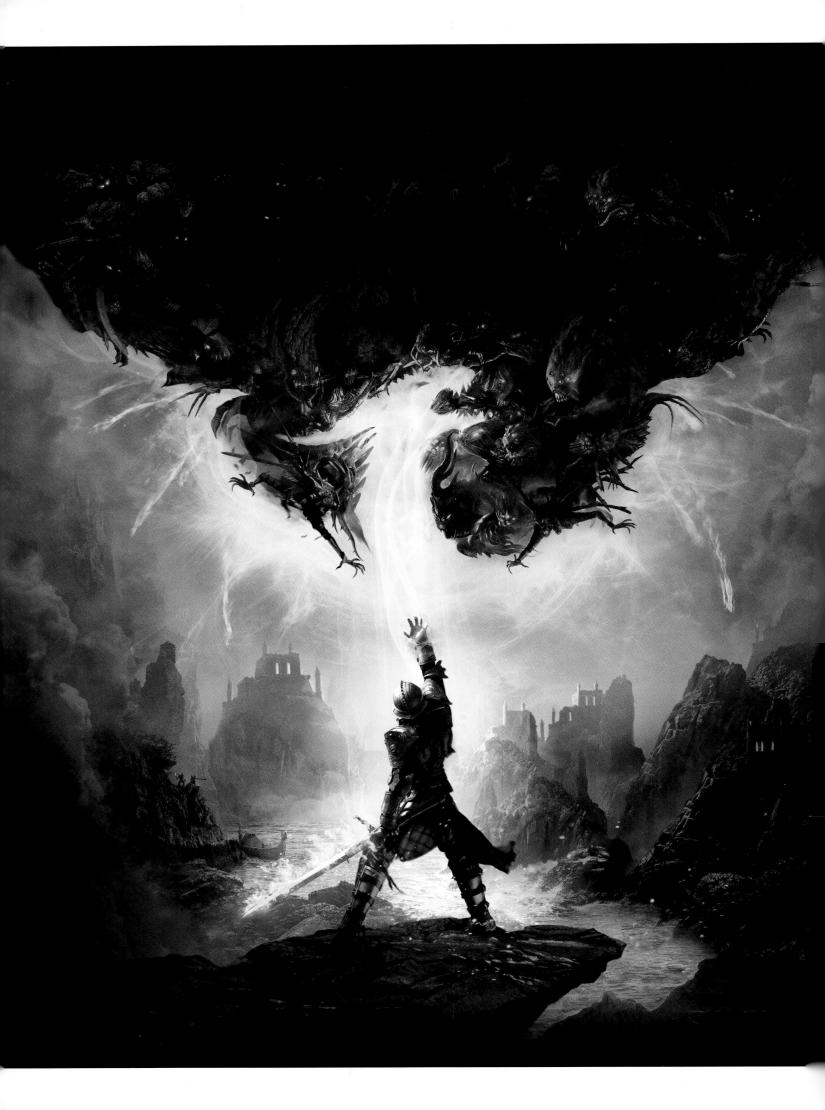

THE ART OF
DRAGON AGE
INQUISITION

BioWare®

Dark Horse Books

BioWare

Project Leads
Nick Thornborrow (art), Ben Gelinas (writing)

Contributing Artists
Marc Holmes, Jae Keum, Ville Kinnunen, Steve Klit,
Casper Konefal, Z Lin, Matt Rhodes, Tom Rhodes,
Ramil Sunga, Nick Thornborrow

Writing
Ben Gelinas, Matt Rhodes, Nick Thornborrow

Editing
Cameron Harris

Cover Illustration
Nick Thornborrow

Dragon Age Leadership
Mark Darrah, Executive Producer
Mike Laidlaw, Creative Director
Matthew Goldman, Art Director
Chris Bain, Business Development Director

Dark Horse

Publisher
Mike Richardson

Designer
Amy Arendts

Digital Production
Chris Horn

Assistant Editor
Roxy Polk

Editor
Dave Marshall

Special Thanks
A legion of artists, animators, and other specialists has contributed to the world of *Dragon Age* as a whole over the past decade, and so we'd like to acknowledge the efforts of the *Dragon Age* team both past and present, and everyone who made this book possible. We'd furthermore like to thank the DICE Frostbite team, the SperaSoft team, the EASH team, and the OF3D team for their contributions to *Dragon Age: Inquisition*.

Published by Dark Horse Books
A division of Dark Horse Comics, Inc.
10956 SE Main Street
Milwaukie, OR 97222

DarkHorse.com
DragonAge.com
BioWare.com
EA.com

Dark Horse International Licensing: (503) 905-2377

First edition: October 2014
ISBN 978-1-61655-186-5 | Limited edition: ISBN 978-1-61655-728-7

10 9 8 7 6 5 4 3 2 1
Printed in China

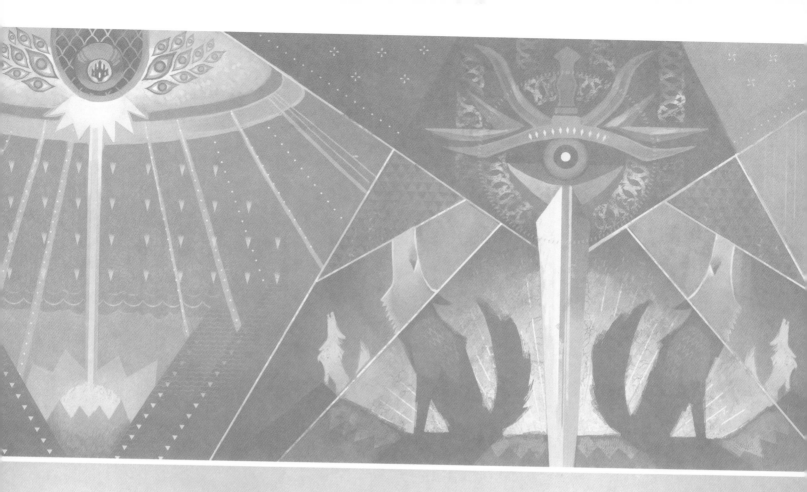

CONTENTS

Forewords by Matthew Goldman and Mike Laidlaw

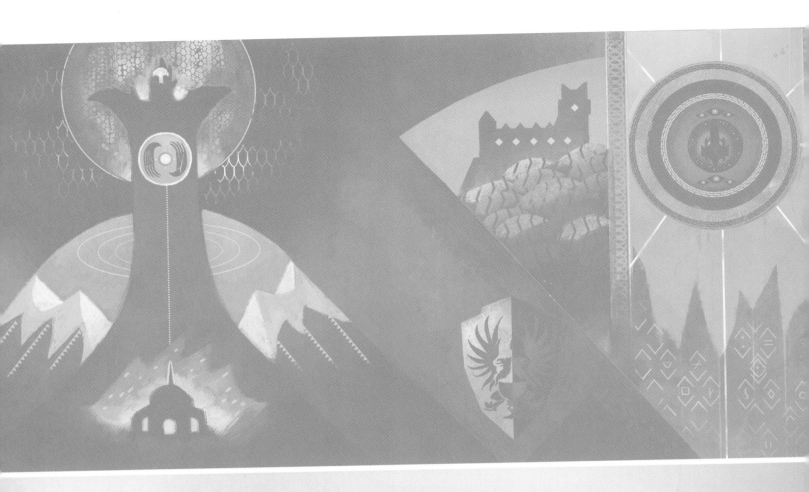

ENTITIES SHALL NOT BE MULTIPLIED UNNECESSARILY

It requires teamwork to defeat demons, dragons, and demagogic demigods. For a work of staggering complexity like *Dragon Age: Inquisition*, no individual, no matter how good, can likewise succeed alone. It is teamwork and collaboration that define success. One person's work is taken by another, then modified, changed, challenged, repurposed, elaborated upon, multiplied, and improved. A figment gains currency and, finally, force. The visual fugue is woven into an experience.

The past five years have been a concerted effort to give *Dragon Age* a strong and consistent visual signature. *Dragon Age* is at its heart a cautionary tale about the weakness of people. Using that idea as a lodestone, we derived artistic principles by looking at the brooding art of the northern Renaissance and the stark simplicity of Japanese prints. The allegorical horrors imagined in these works are physical fact in *Dragon Age*.

Within that overall artistic framework are the myriad of individual nations and organizations vying for control of the world. Each has a distinct mode of dress, design aesthetic, and artistic language by which they represent their concept of the world around them. Greater still is the living landscape, with its soaring mountains, fetid swamps, majestic forests, hidden histories, and ecosystems. What unknown terrors lie beyond the horizon, waiting to be discovered?

Some liken our team to the crew of a carousing pirate ship, rather than the strictly disciplined company of a war galley. I wouldn't have it any other way. The voyage has been eventful. It required tenacity. And it's been a lot of fun so far. It is my pleasure to work with a crew of splendidly talented individuals here at BioWare Edmonton and beyond. Very special thanks to Nick Thornborrow, Ben Gelinas, and our fine partners at Dark Horse for making this handsome tome a reality.

I hope you'll enjoy exploring the world of *Dragon Age* as much as we have.

Onwards!
Matthew Goldman, Art Director

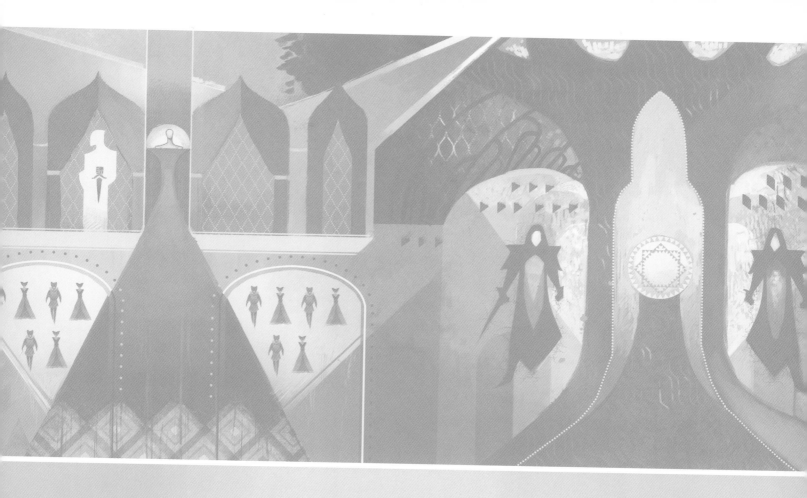

TELLING VISUAL STORIES

Inquisition has come to life in a way like no other *Dragon Age* game before it, and more than anything else, it is because of the combined and diverse talents of the creative team. Over the course of this project, I've watched character descriptions written out in prose turn into evocative concepts and exquisite models, and then come to life on the screen. Conversely, I've seen storyboards and mood images that were so cool and so perfectly evocative that the story was then adapted to allow that particular moment to be brought to life for our players.

In my role, I'm focused on the game play and story more than the visuals, but the *Dragon Age* art team constantly reminds me that visuals can accent and augment every part of the design. There are stories that can be told without a single word written, and game play that only gets stronger when it has a bold visual language to back it up.

Watching the seed of an idea take root and expand in surprising ways is one of the great joys of working so closely with the designers and artists at BioWare. I expect this book will share some of that joy with you as it walks you through the game's evolution.

Mike Laidlaw, Creative Director

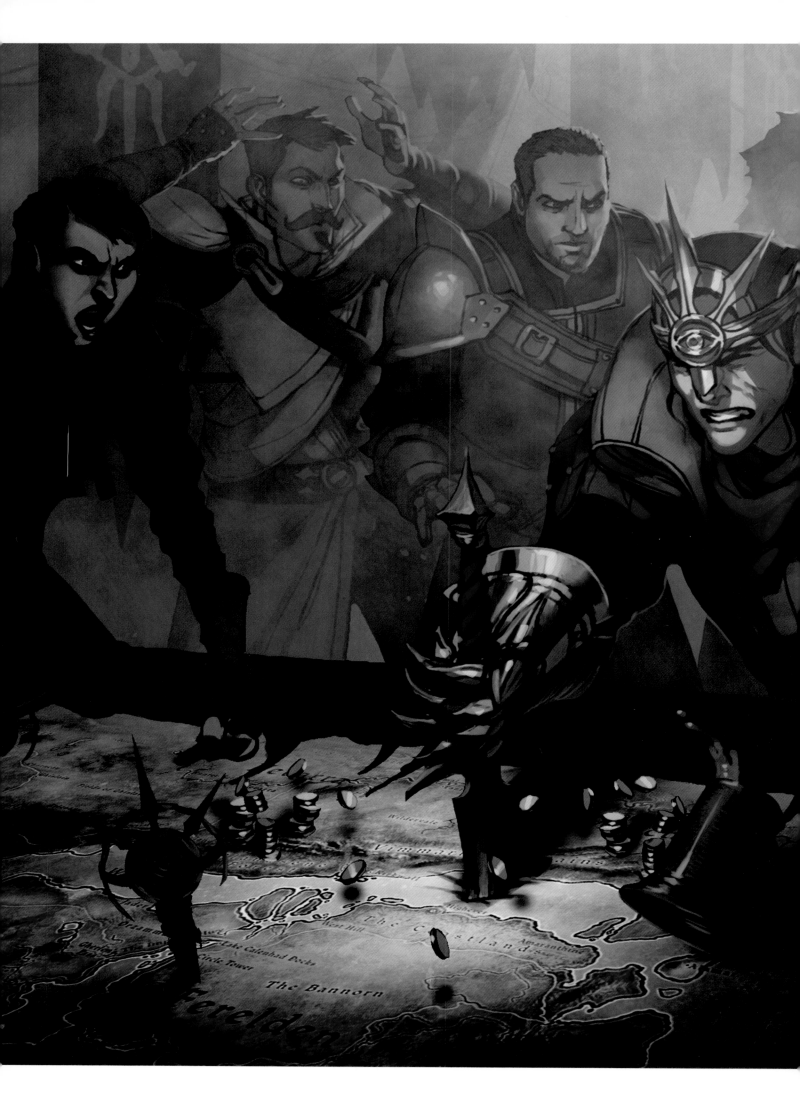

THE INQUISITION

The Chant of Light states, "Blessed are the righteous, the lights in the shadow." When the Inquisition is struck in the height of the Dragon Age, Thedas is all shadow. The templars and mages are at war. The Empress of Orlais is at loggerheads with a usurper to the throne. Amid the unrest, a hole is blown in the sky, tearing apart the Veil that separates the waking world from the mysterious realm of spirits known as the Fade. The Inquisition is tasked with bringing the world back from the brink of destruction.

We wanted to ensure the Inquisition, as a new faction, stood out from the established orders of power in Thedas. Orlais has its fineries, Ferelden its furs. The Wardens are all about the griffon imagery and silver plates. To create the signature look of the Inquisition, we went as far back as Babylon and Mesopotamia for inspiration. We studied many early Islamic armors and the bold and simple pieces worn by traditional Sikh warriors. The colors of the Inquisition are charcoal gray and crimson, evoking the Inquisition's ties to the Seekers, in black, and the templars, in red.

To create the figure at the head of it all, we had to be flexible enough to accommodate a myriad of player customizations while creating a signature look that would really stand out. In *Dragon Age: Origins*, our signature Warden was a warrior. In *Dragon Age II*, our signature Hawke was a mage. This time around, we explored in greater detail what a rogue would look like in a seat of power. A captain's coat with a prominent collar implies authority. The dragon-wing helm is as much about propaganda as it is defense. In Thedas, the dragon is the apex predator, the ultimate symbol of power.

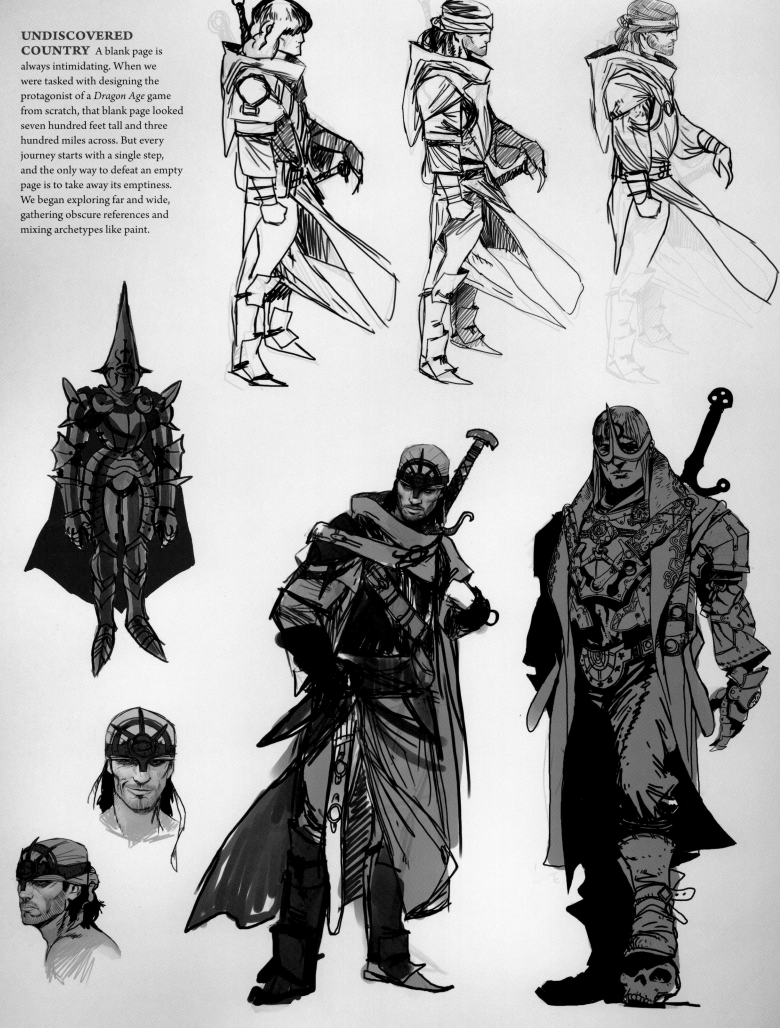

UNDISCOVERED COUNTRY A blank page is always intimidating. When we were tasked with designing the protagonist of a *Dragon Age* game from scratch, that blank page looked seven hundred feet tall and three hundred miles across. But every journey starts with a single step, and the only way to defeat an empty page is to take away its emptiness. We began exploring far and wide, gathering obscure references and mixing archetypes like paint.

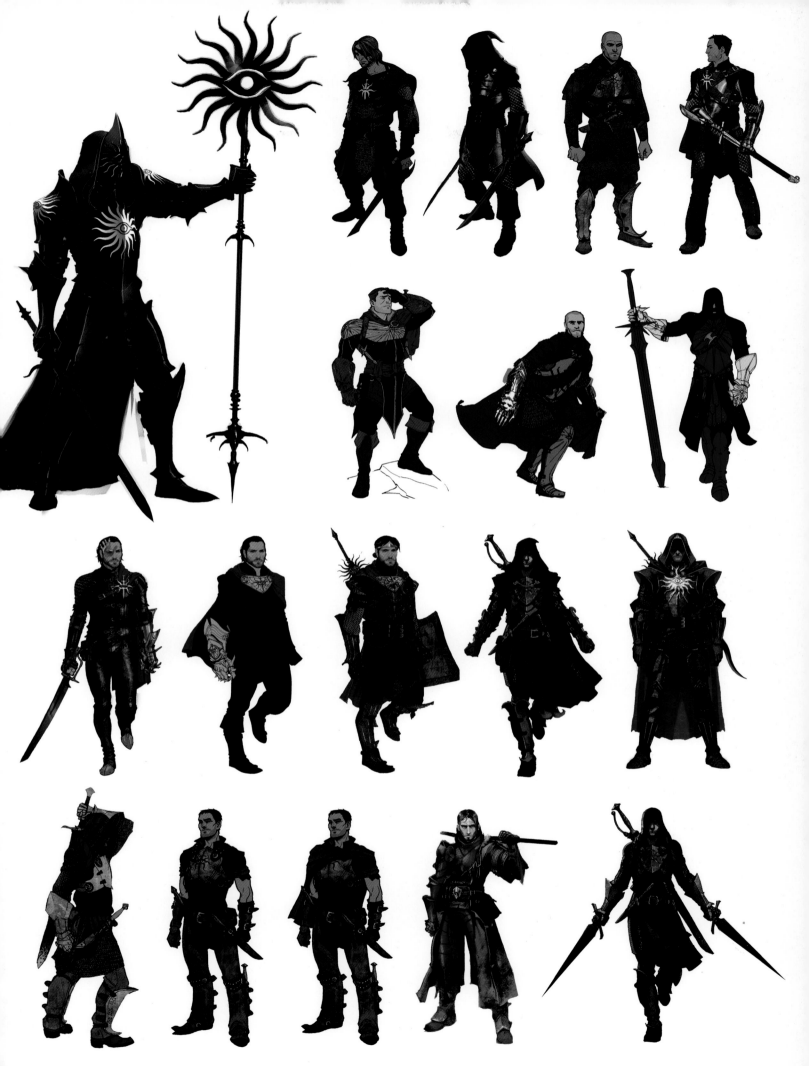

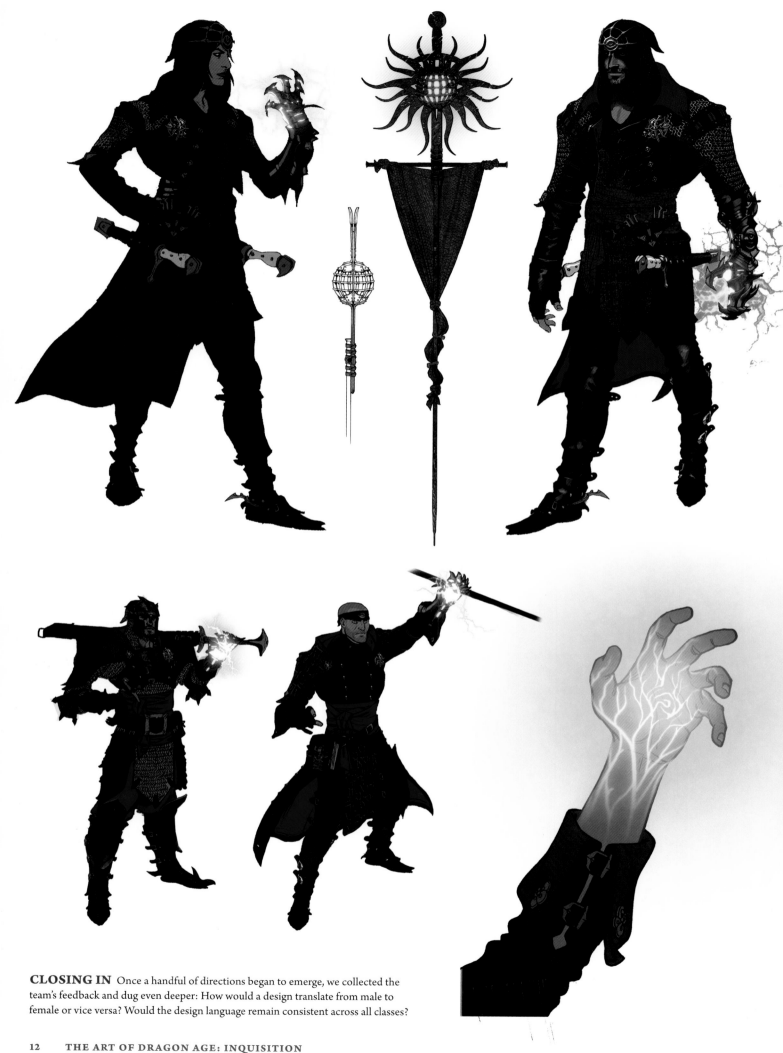

CLOSING IN Once a handful of directions began to emerge, we collected the team's feedback and dug even deeper: How would a design translate from male to female or vice versa? Would the design language remain consistent across all classes?

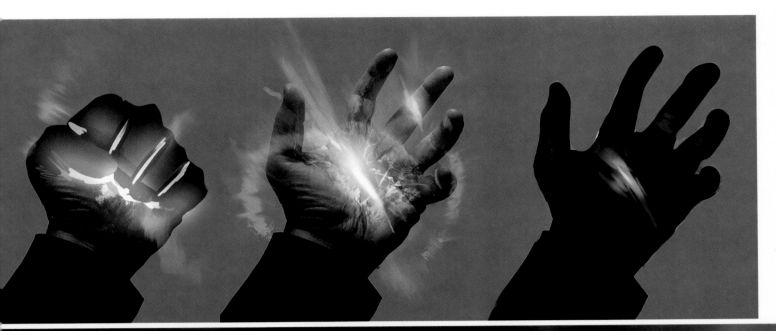

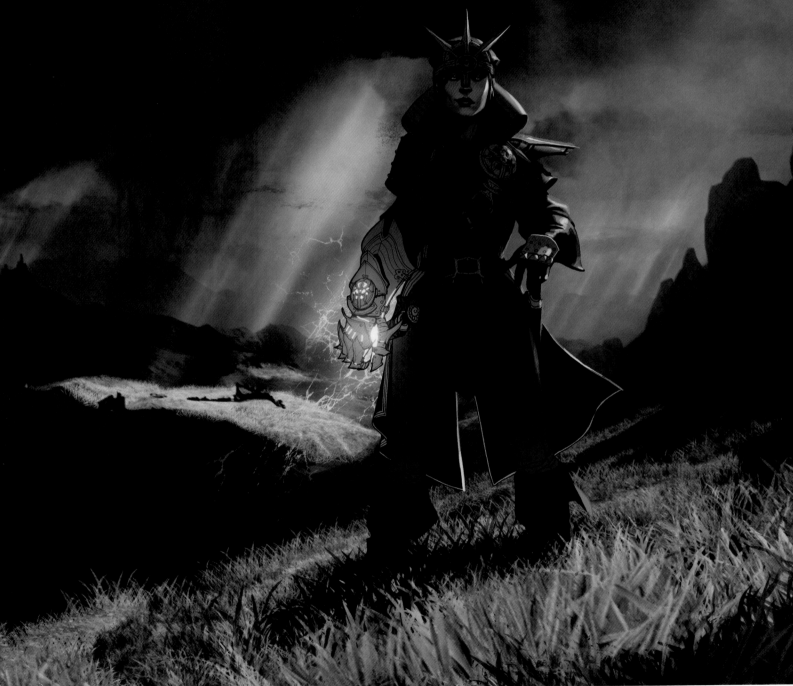

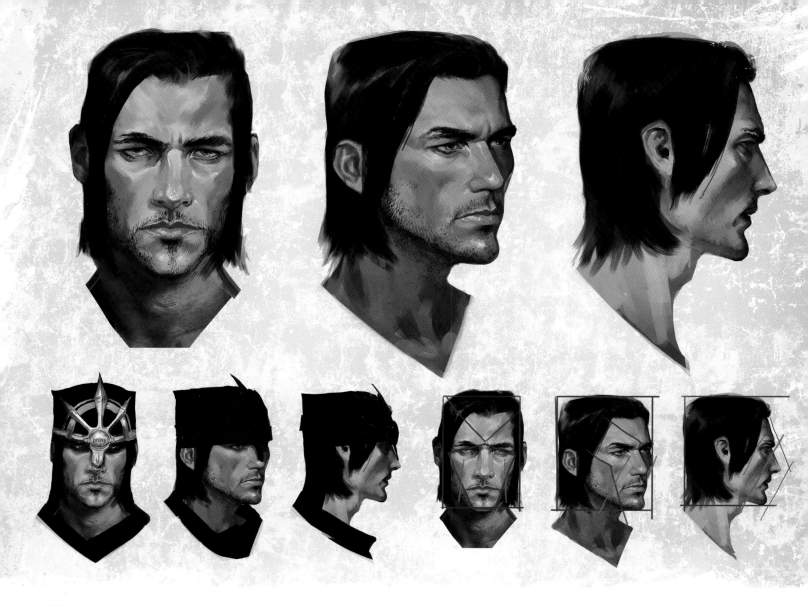

FIRST IMPRESSIONS Nothing takes longer to design or is more intensely debated than our main character, and nothing on the main character receives more iteration than helmets. Helmets are our protagonist's first face. They should create a unique and recognizable identity for the character while also telegraphing densely packed information to the back of the player's brain through familiar symbols and shapes.

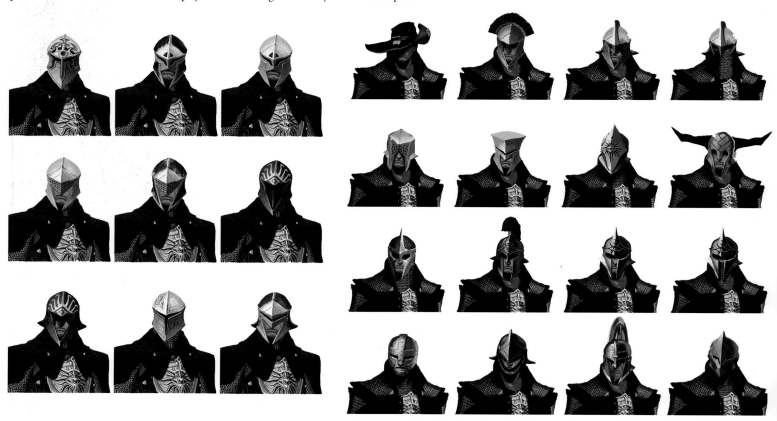

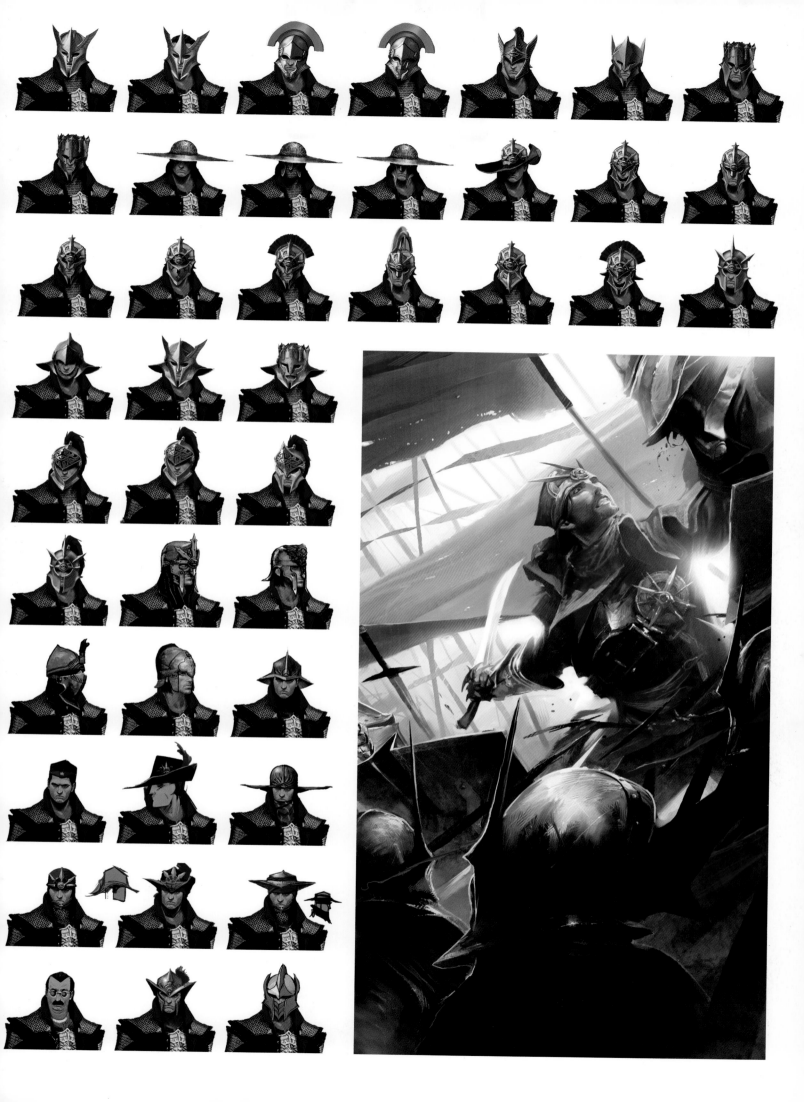

STANDARD ISSUE As we came closer to our Inquisitor, we found it useful to design the Inquisition forces in tandem. Imagining lower-level soldiers, spies, and mages helped us establish a stronger understanding of how Inquisition clothing and armor might be constructed and worn. We then used this knowledge to refine the look of the Inquisitor classes.

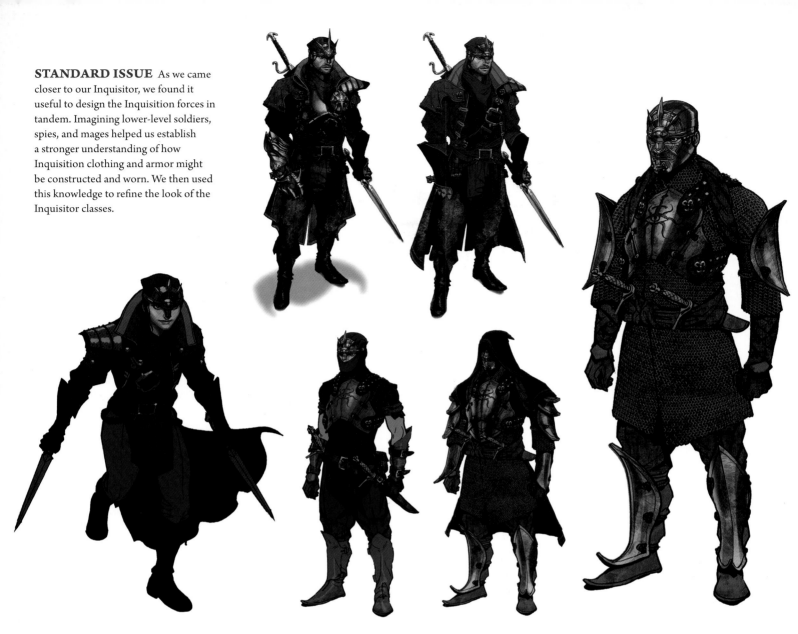

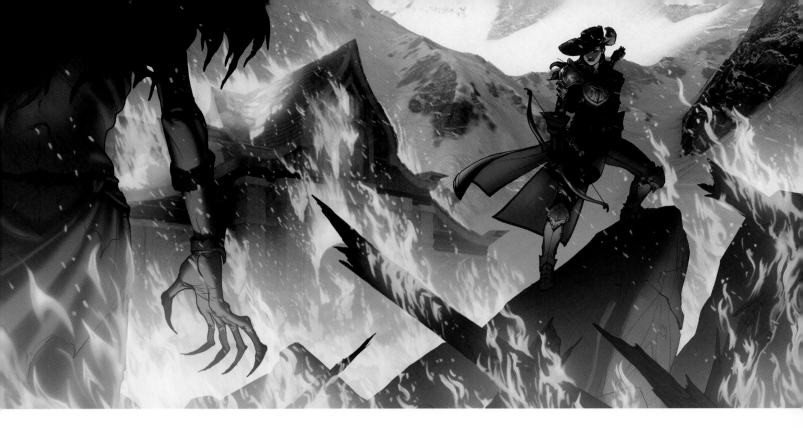

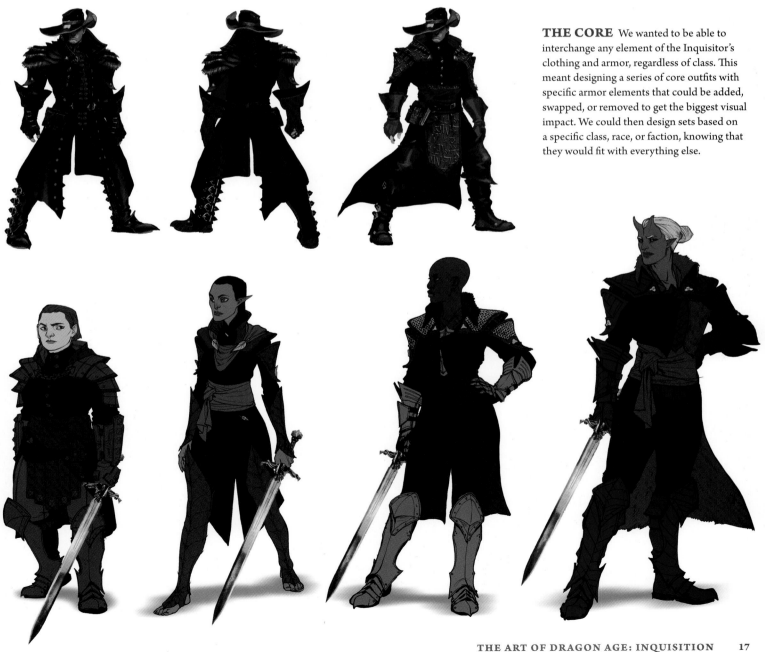

THE CORE We wanted to be able to interchange any element of the Inquisitor's clothing and armor, regardless of class. This meant designing a series of core outfits with specific armor elements that could be added, swapped, or removed to get the biggest visual impact. We could then design sets based on a specific class, race, or faction, knowing that they would fit with everything else.

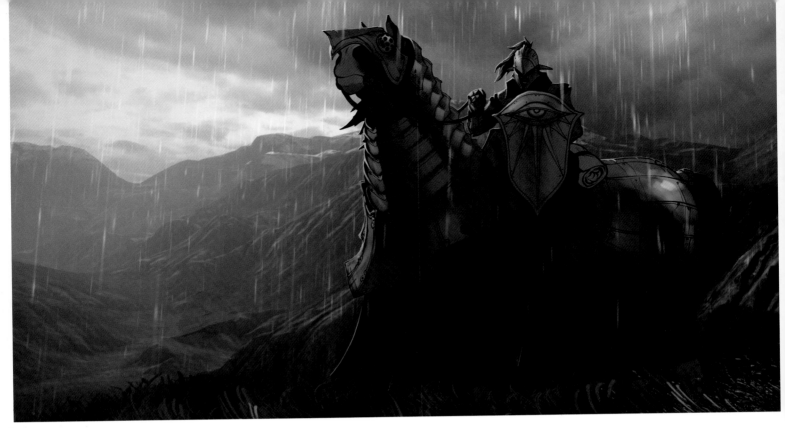

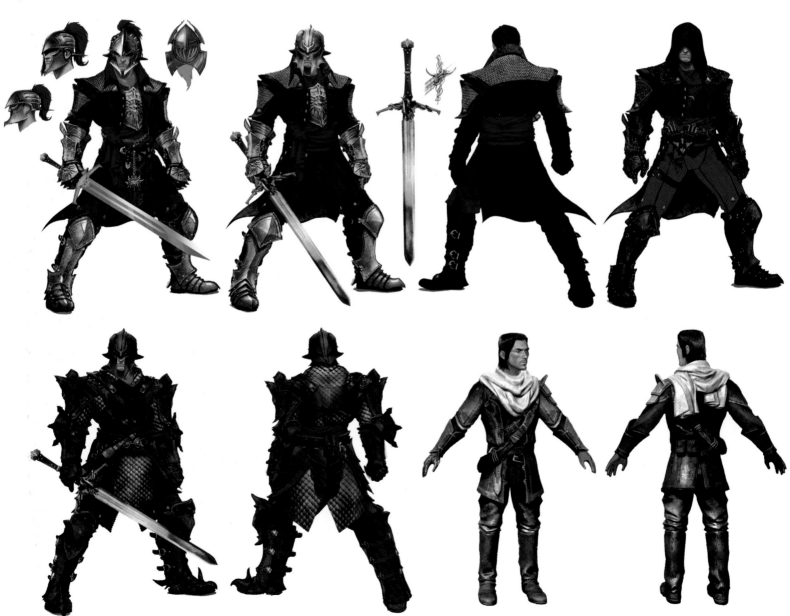

MOTIFS When designing new armor sets, it helps to have a faction, race, or theme in mind. This set of armor evokes the look of a dragon.

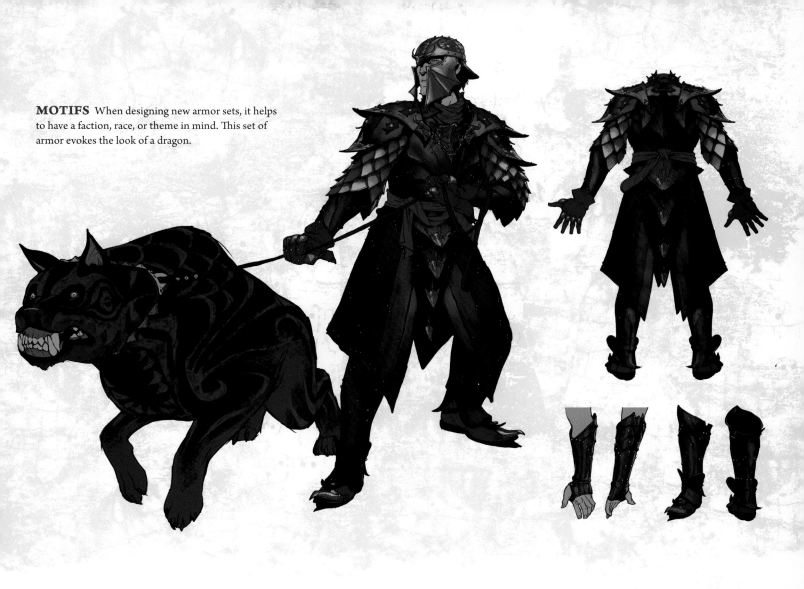

NO STONE LEFT UNTURNED Throughout the game, illustrated tarot cards represent characters, classes, game modes, and enemies. They let us design with unbridled creativity and were a cool opportunity to develop in-world artwork.

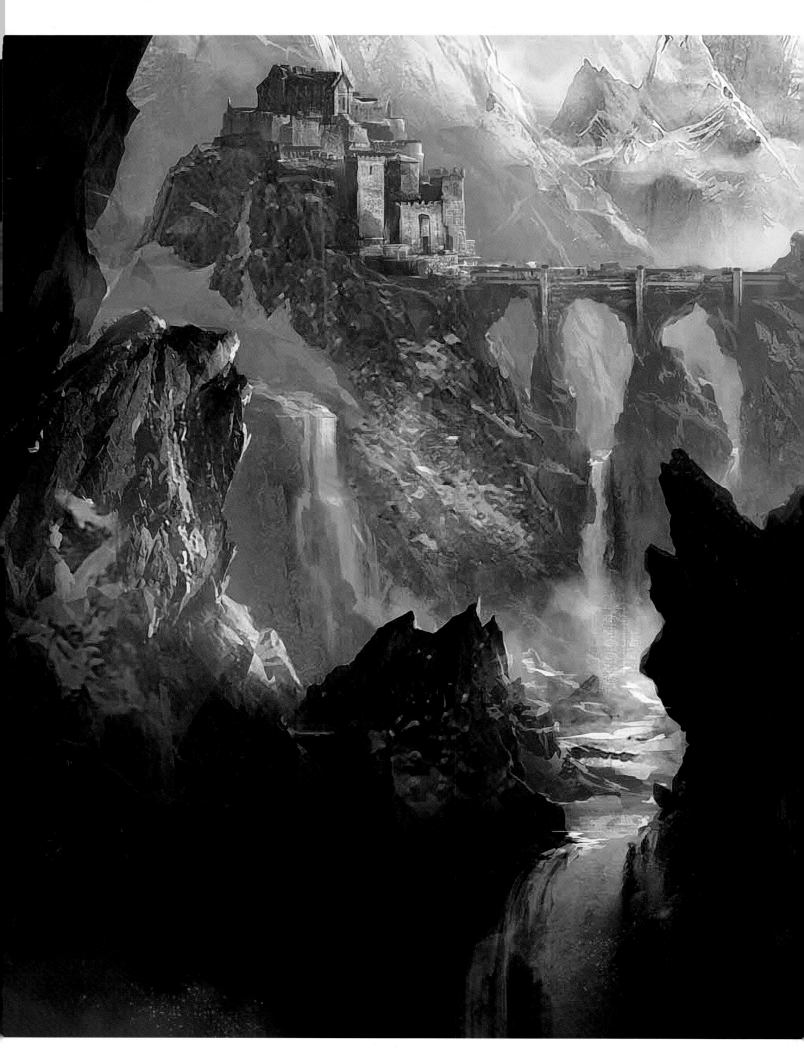

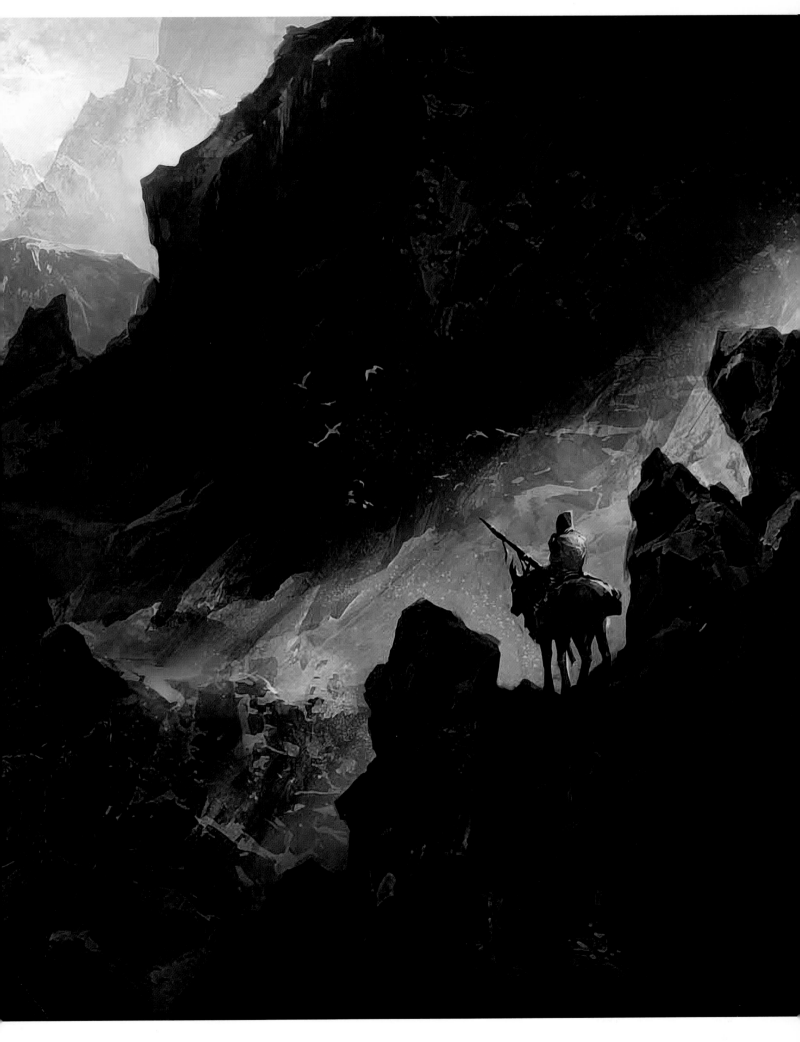

A PLACE TO CALL HOME Throughout
Skyhold's development, the fortress took many forms and
served many functions—but it has always been home.
Early on, we used sketches and a mash-up photo technique
called "photobashing" to try to capture the spirit of the
Inquisition's fortress. Once actual construction began, we
used the development model as a base for more detailed
production paintings.

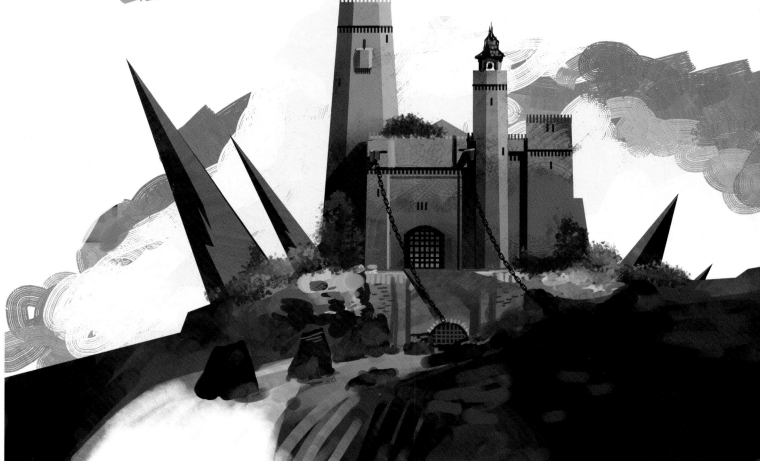

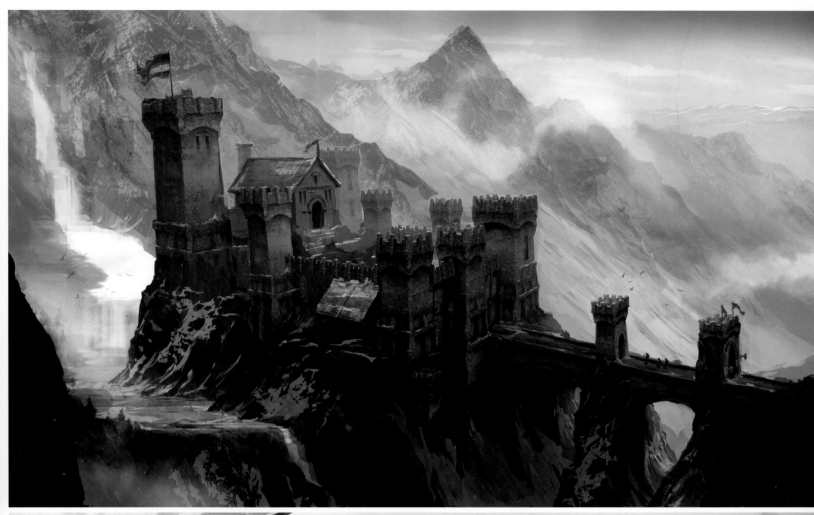
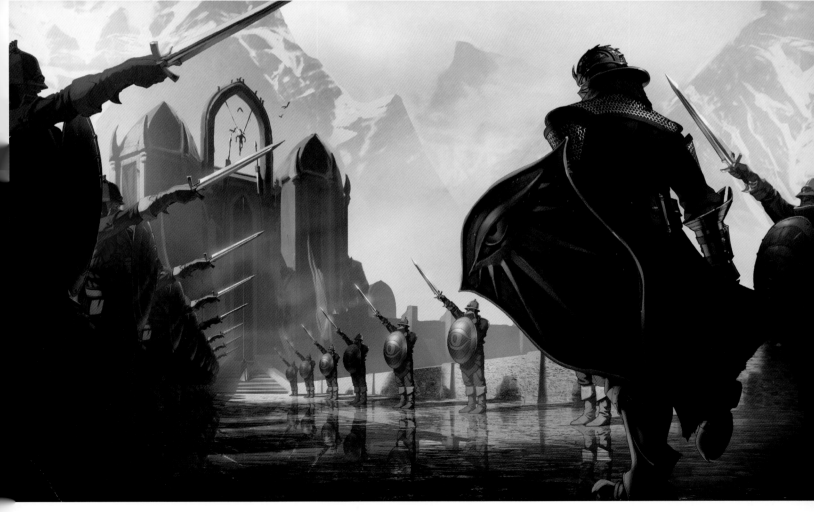

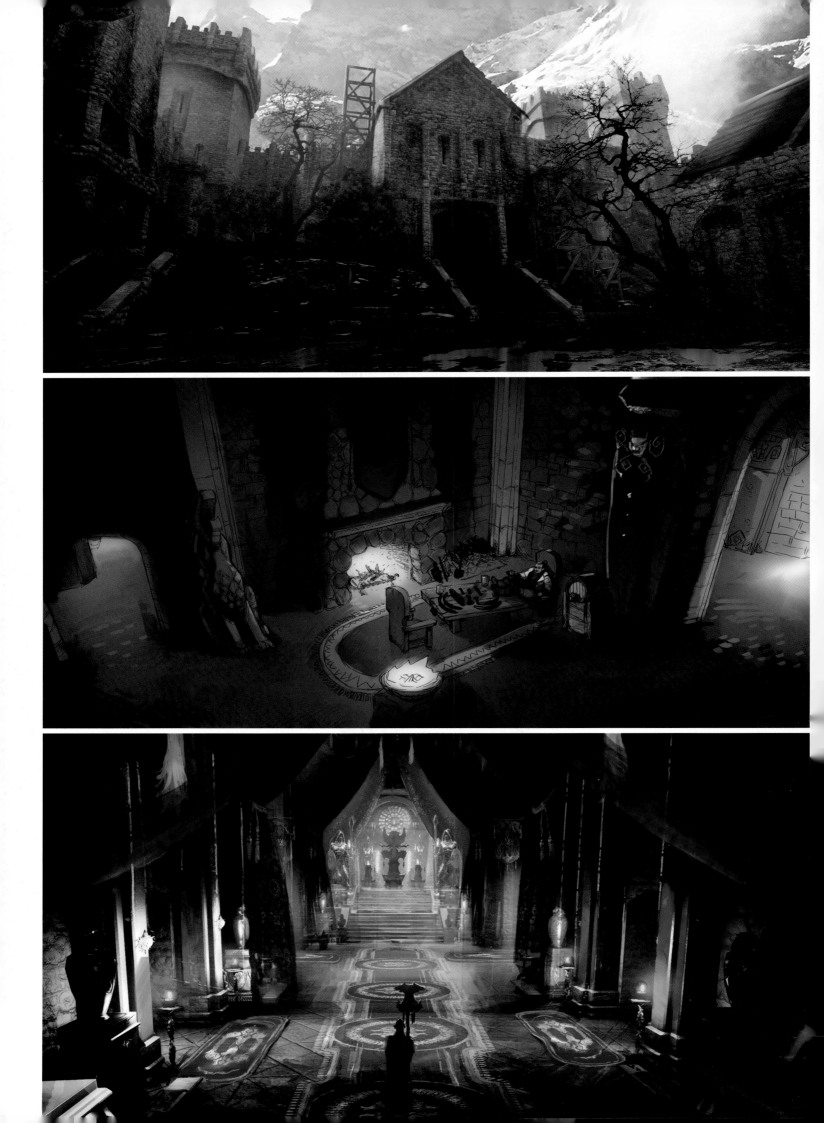

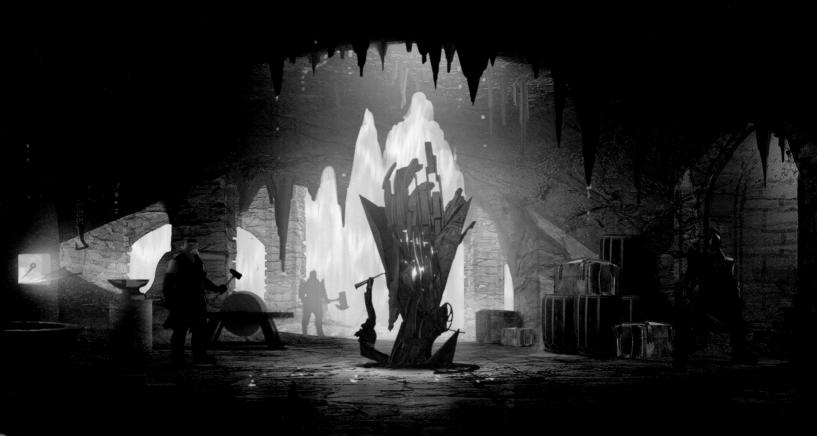

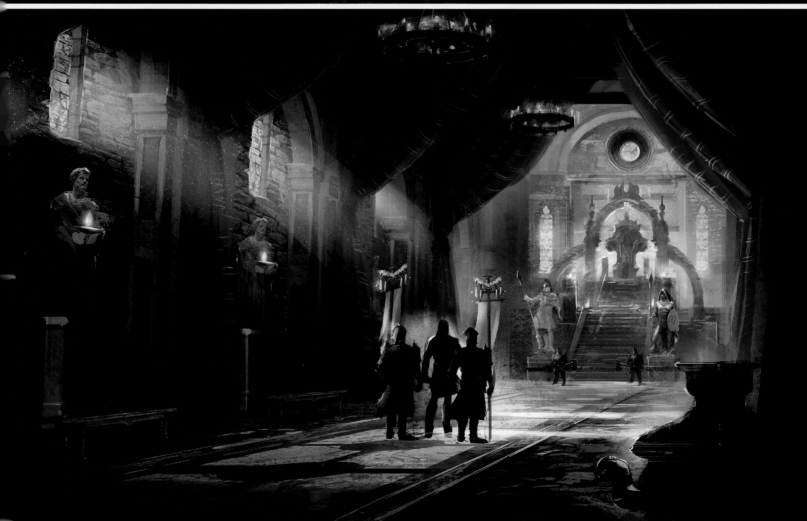

BACK AND FORTH The construction of our environments is a long and involved process. Paint-overs like these help to quickly explore lighting, mood, and prop placement. After some discussion and quick edits, a clearer idea of what a location will look like emerges.

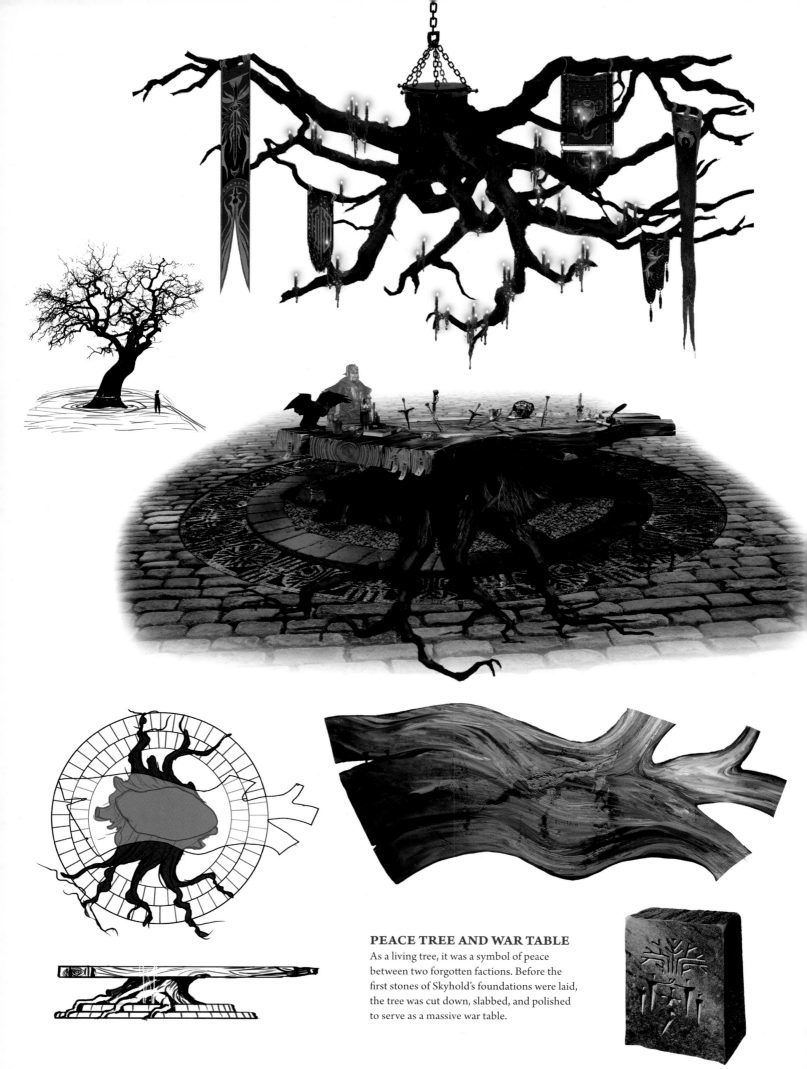

PEACE TREE AND WAR TABLE

As a living tree, it was a symbol of peace between two forgotten factions. Before the first stones of Skyhold's foundations were laid, the tree was cut down, slabbed, and polished to serve as a massive war table.

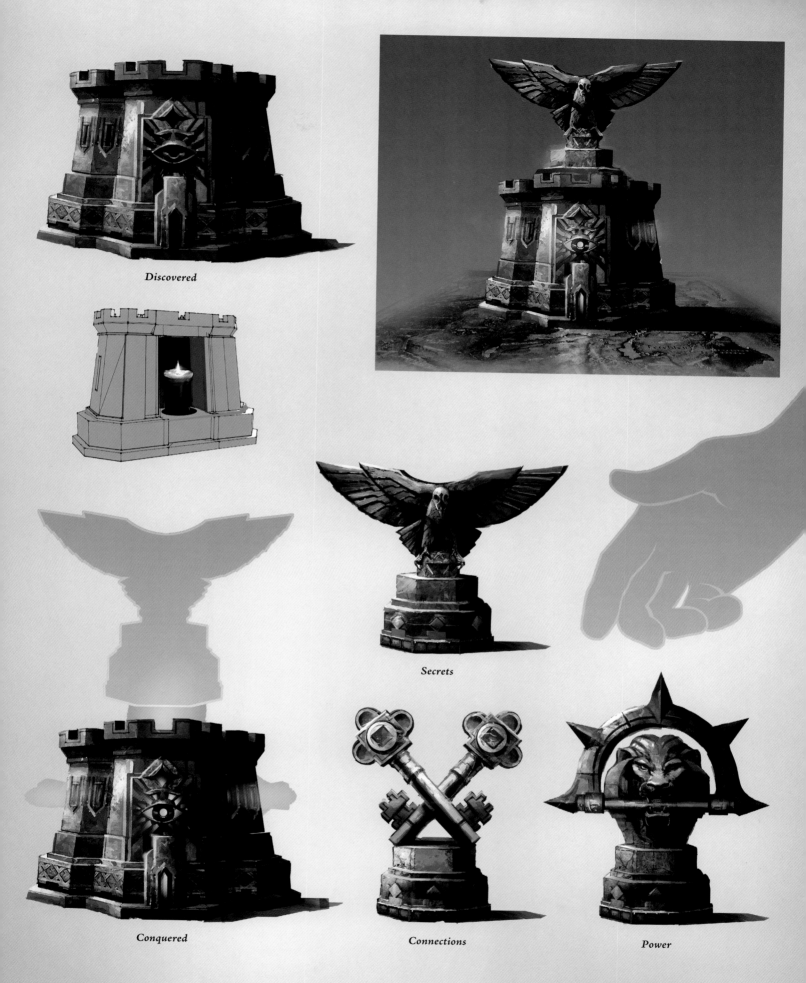

Discovered

Conquered

Secrets

Connections

Power

A DEADLY GAME Running the Inquisition is complicated work. To keep track of the campaign, symbolic markers and various icons represent the states and activities of the many factions and currencies in play.

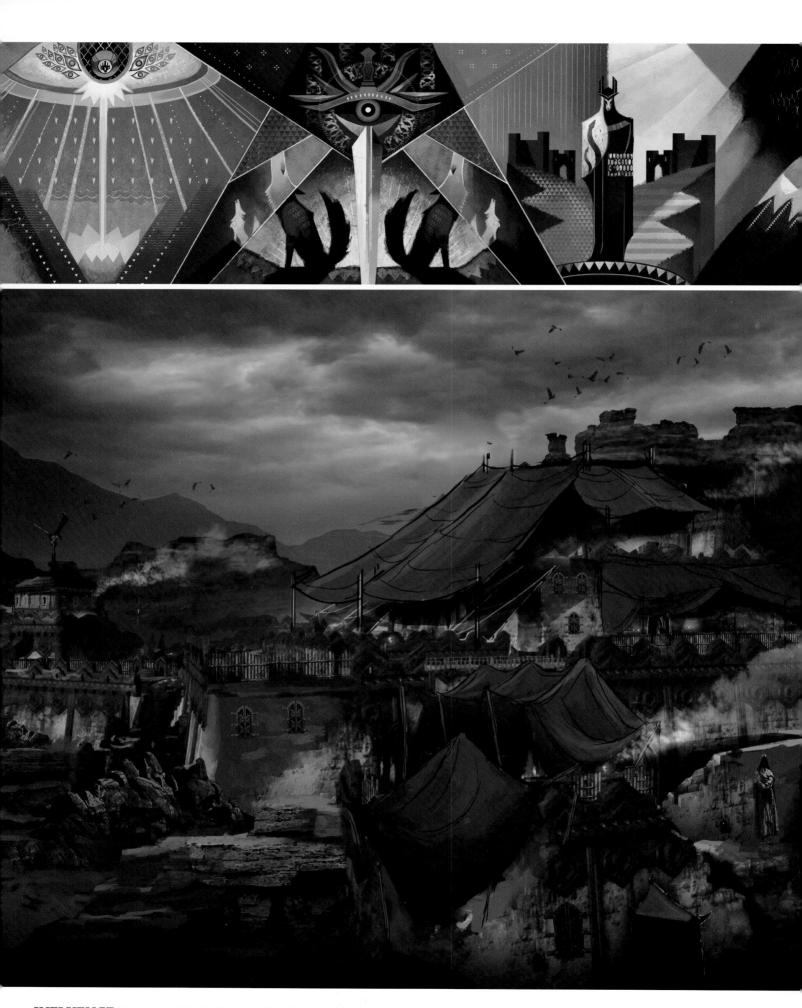

INFLUENCE It was critical that the Inquisition's influence be felt wherever the player goes. That influence can be expressed in many ways. There are political influence and propaganda through artwork and insignia. There is physical influence, as seen through troops, camps, and strongholds. Wherever the Inquisition is needed, its effect on the world must be seen and must be meaningful.

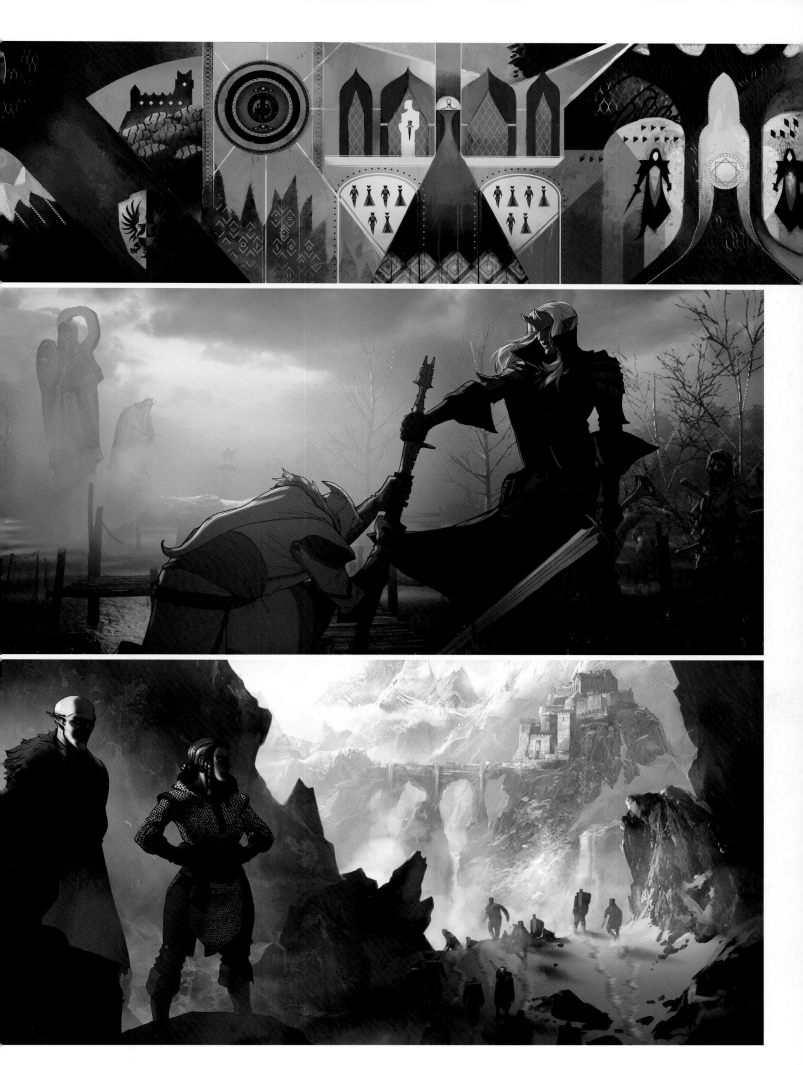

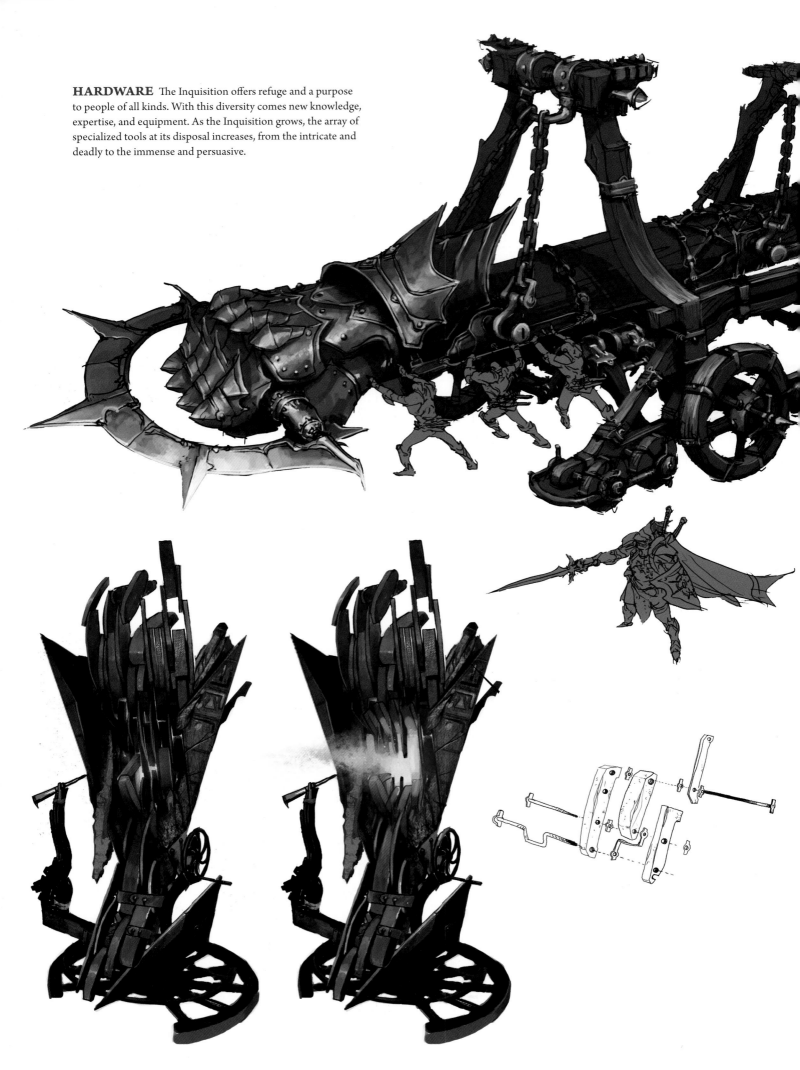

HARDWARE The Inquisition offers refuge and a purpose to people of all kinds. With this diversity comes new knowledge, expertise, and equipment. As the Inquisition grows, the array of specialized tools at its disposal increases, from the intricate and deadly to the immense and persuasive.

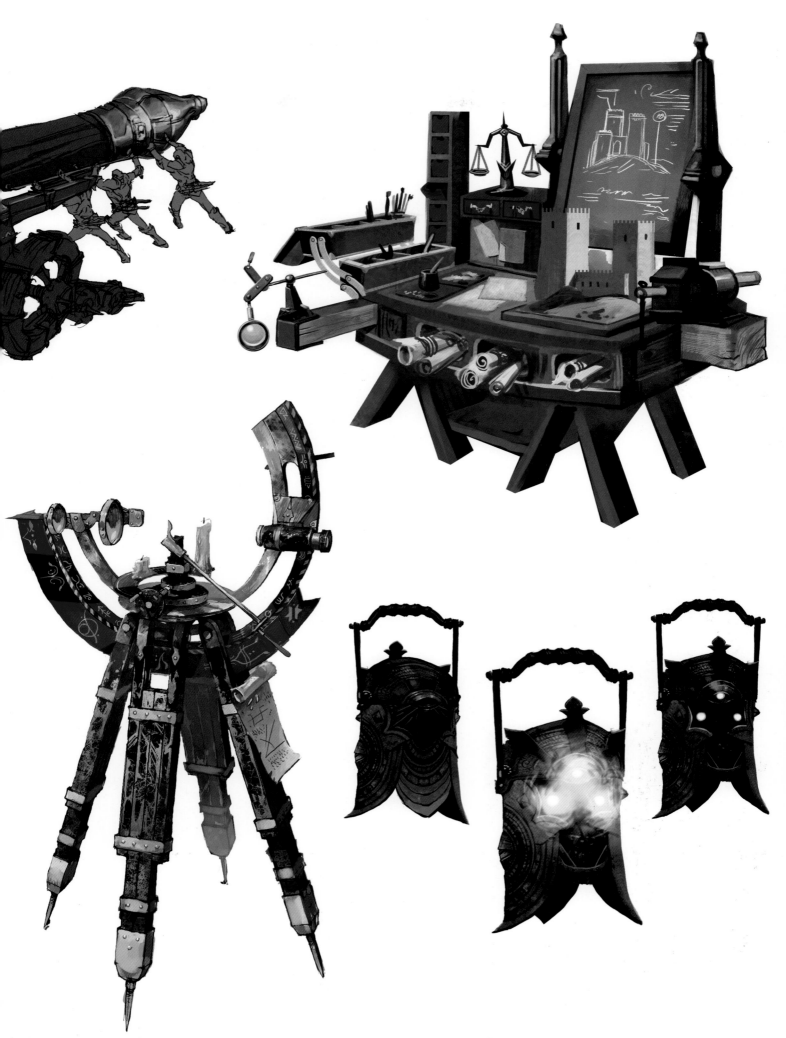

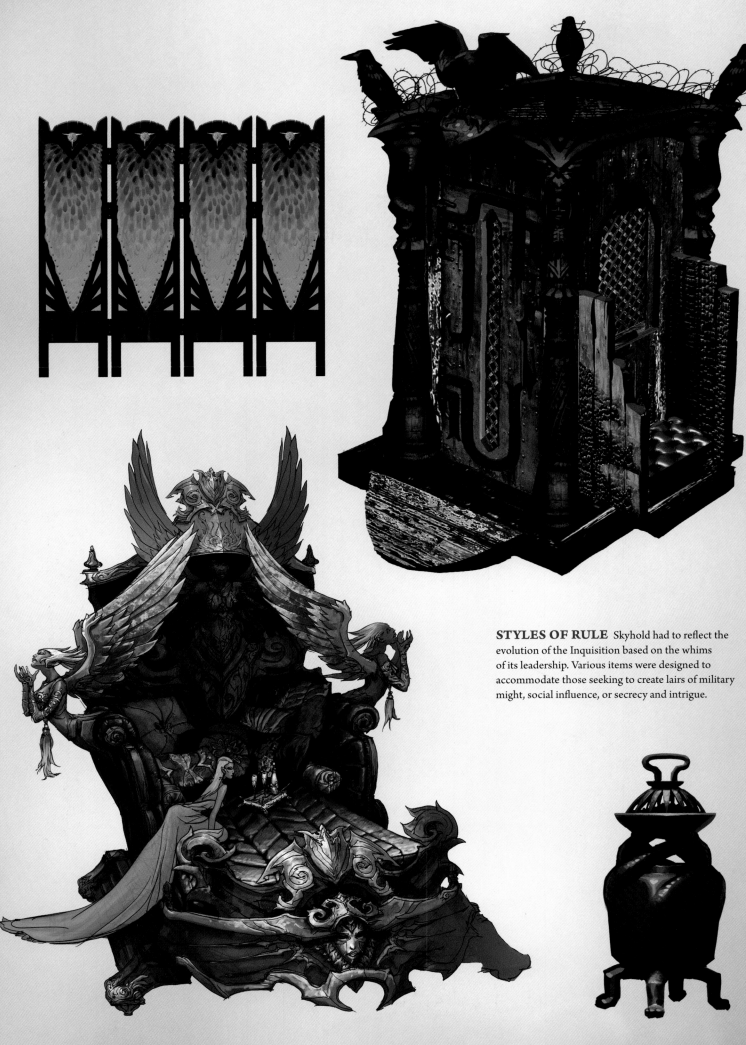

STYLES OF RULE Skyhold had to reflect the evolution of the Inquisition based on the whims of its leadership. Various items were designed to accommodate those seeking to create lairs of military might, social influence, or secrecy and intrigue.

SHADOWY ACCESSORIES Each Inquisition advisor pushes a different approach. We explored what the consequences of following each one to its conclusion would have on Skyhold's appearance. In the case of Leliana, we created props and items that reflected the Inquisition's dependence on spy games and subterfuge.

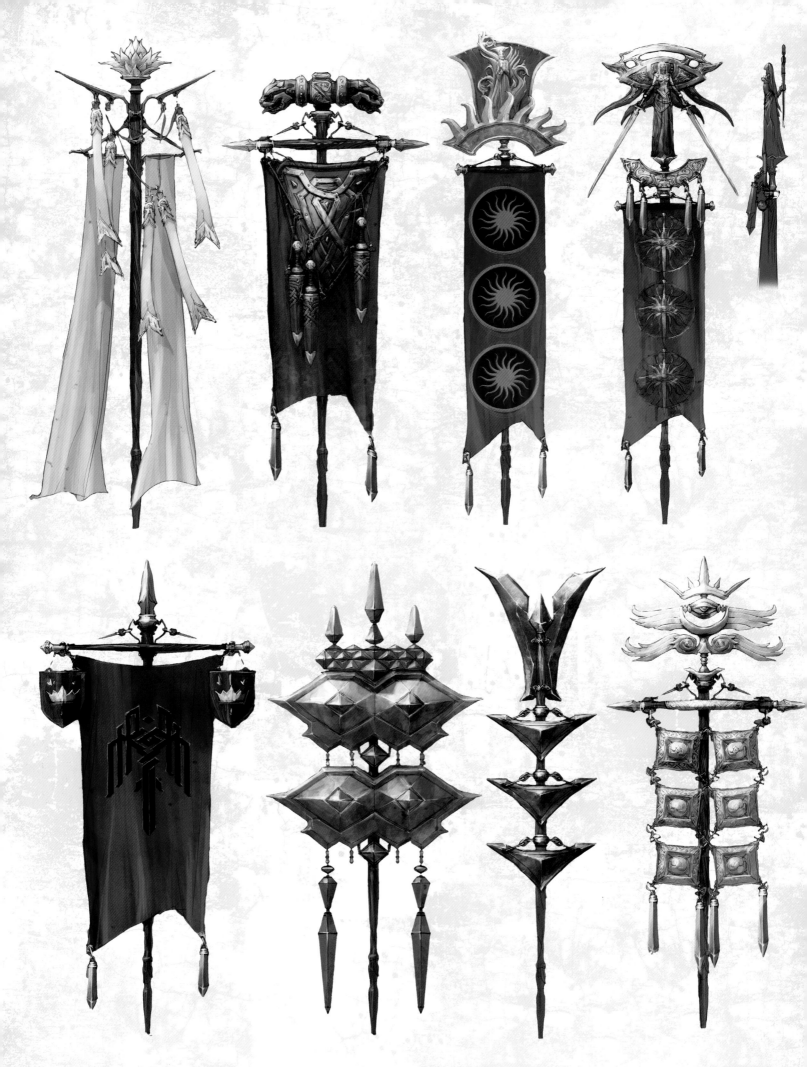

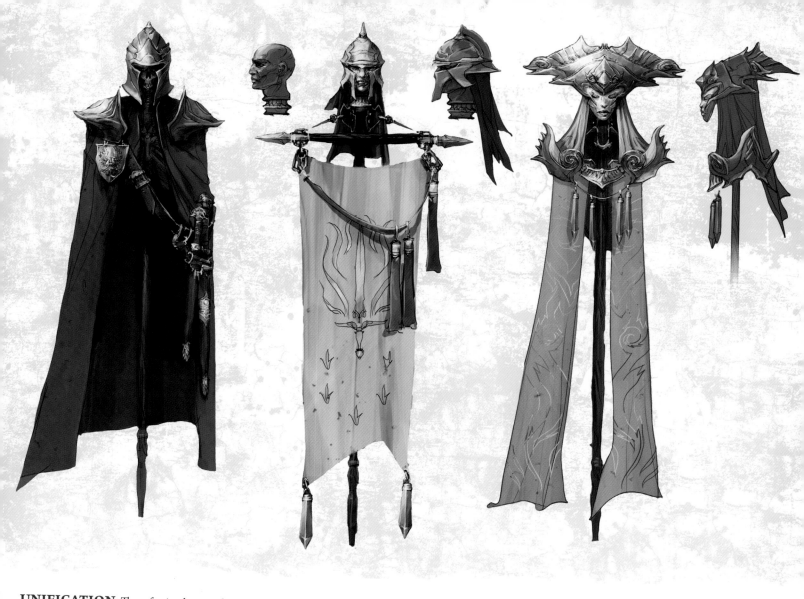

UNIFICATION These faction banners bring a touch of color to Skyhold's halls, but also serve as a reminder of just how much influence the Inquisition has earned in Thedas as it has grown.

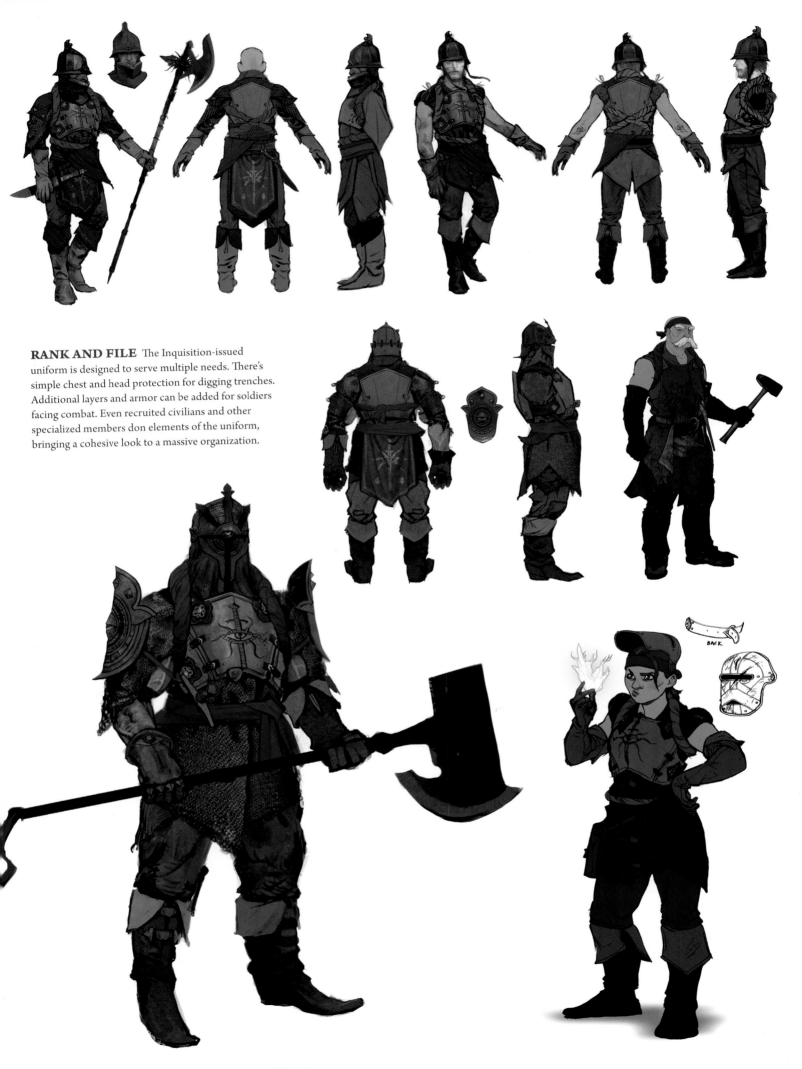

RANK AND FILE The Inquisition-issued uniform is designed to serve multiple needs. There's simple chest and head protection for digging trenches. Additional layers and armor can be added for soldiers facing combat. Even recruited civilians and other specialized members don elements of the uniform, bringing a cohesive look to a massive organization.

BACK

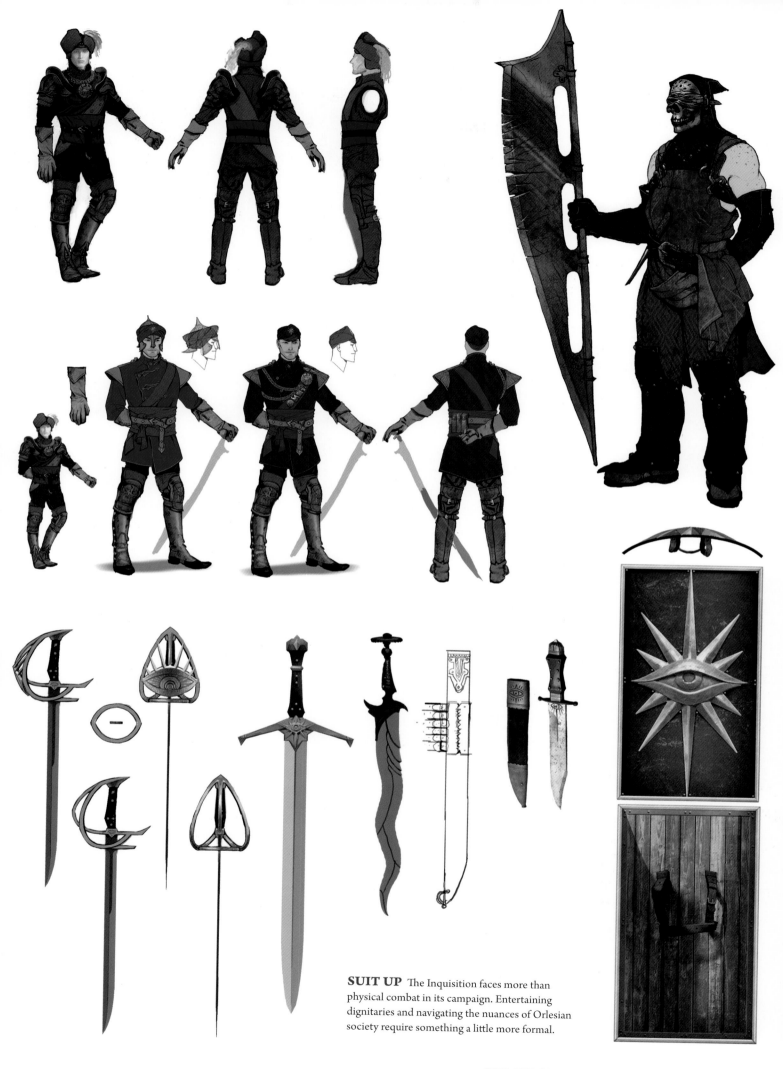

SUIT UP The Inquisition faces more than physical combat in its campaign. Entertaining dignitaries and navigating the nuances of Orlesian society require something a little more formal.

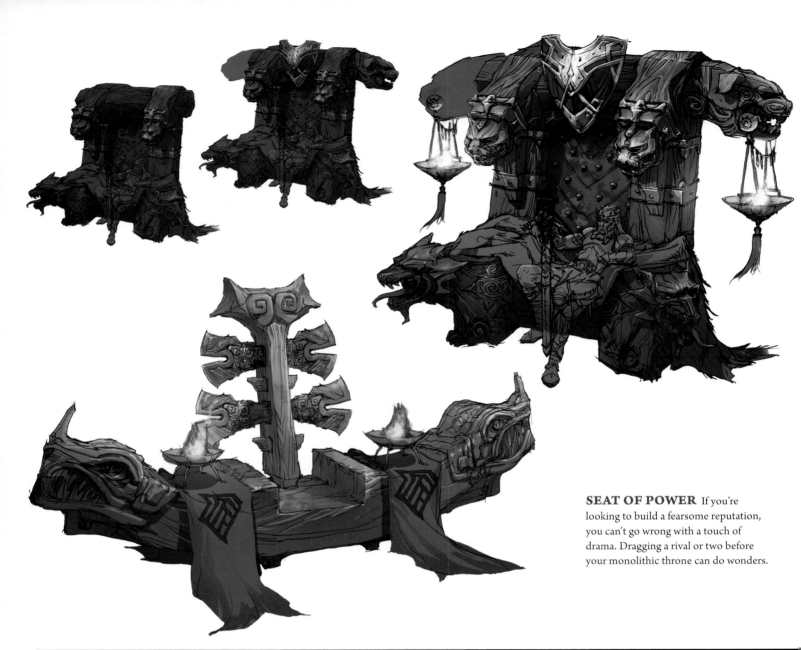

SEAT OF POWER If you're looking to build a fearsome reputation, you can't go wrong with a touch of drama. Dragging a rival or two before your monolithic throne can do wonders.

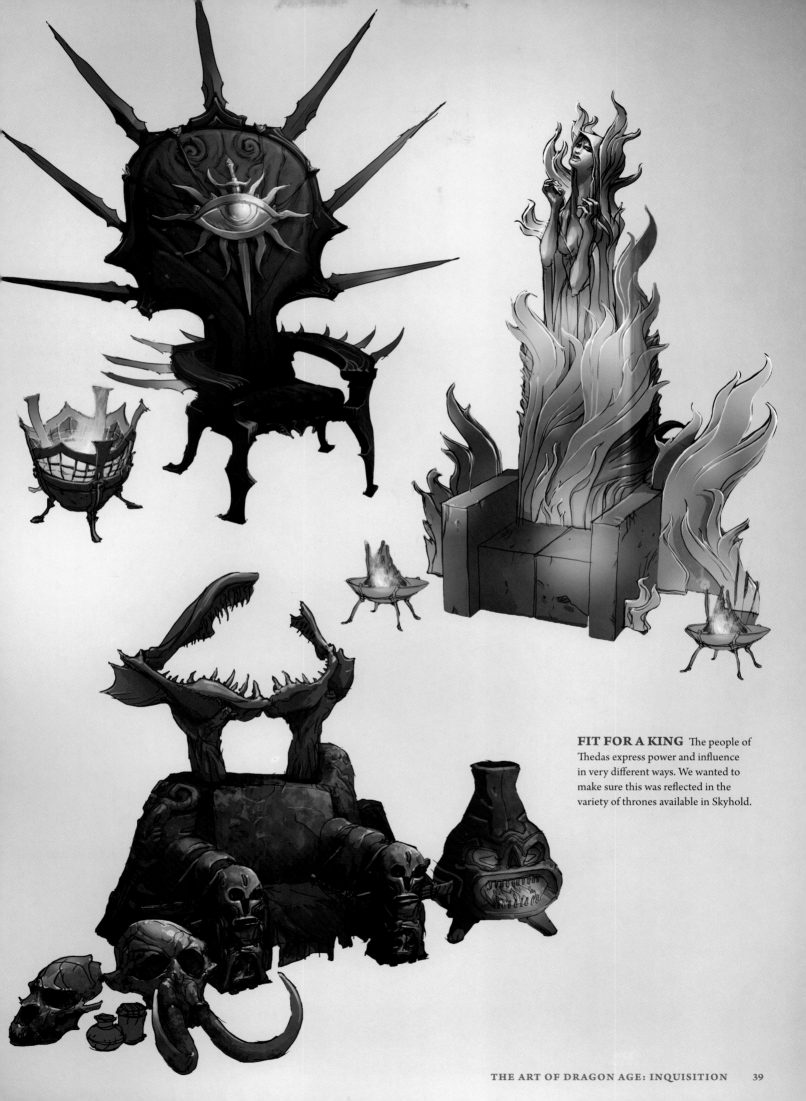

FIT FOR A KING The people of Thedas express power and influence in very different ways. We wanted to make sure this was reflected in the variety of thrones available in Skyhold.

DETAILING We knew Skyhold would be an integral part of the *Inquisition* experience. Players would spend a lot of time wandering its halls. This meant that we could spend more time on the details. Early on, we designed a simple, makeshift war table that could later be upgraded according to your preference of advisor.

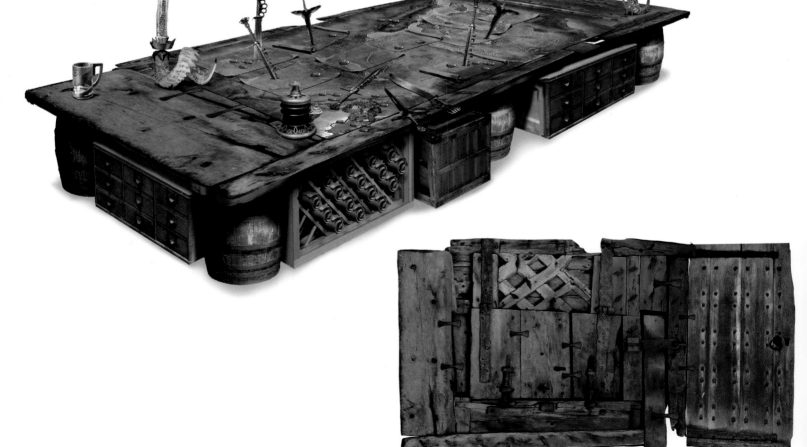

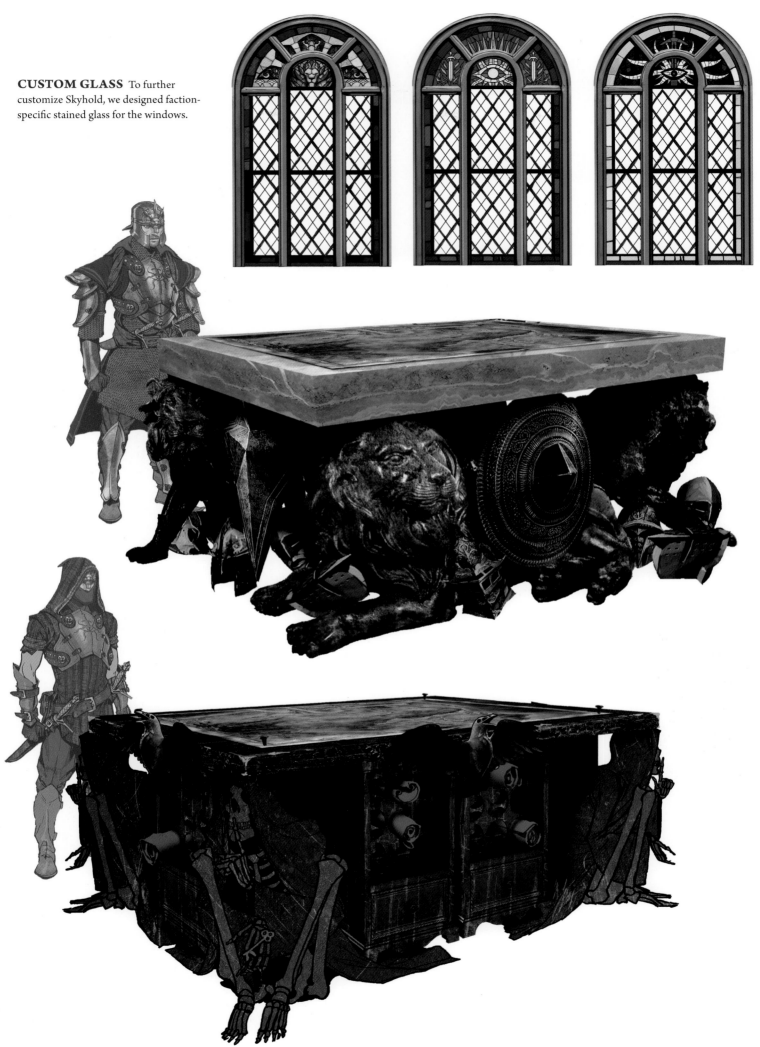

CUSTOM GLASS To further customize Skyhold, we designed faction-specific stained glass for the windows.

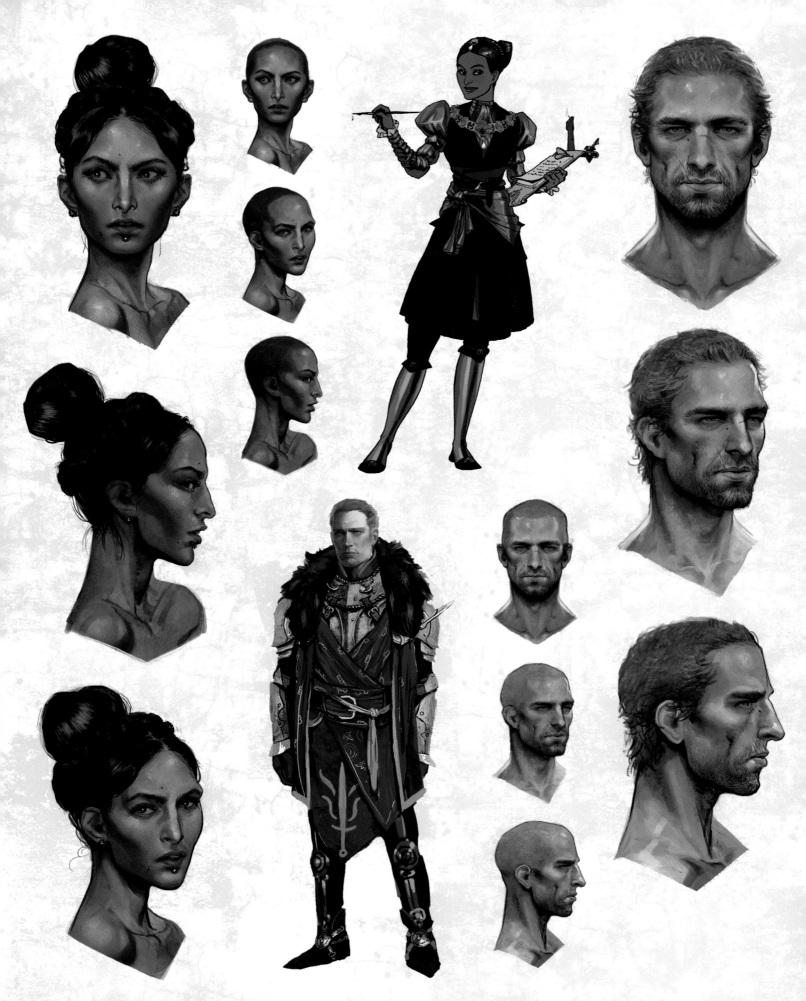

THE DIPLOMAT AND THE GENERAL In their roles as advisors, Josephine and Cullen, along with Leliana (opposite), each represent an aspect of Inquisition strategy. Josephine wears rich materials and constantly looks ready to meet with even the most venerable dignitaries, whereas Cullen is the kind of leader who spends as much time in the dirt with his soldiers as he does in the war room planning their next move.

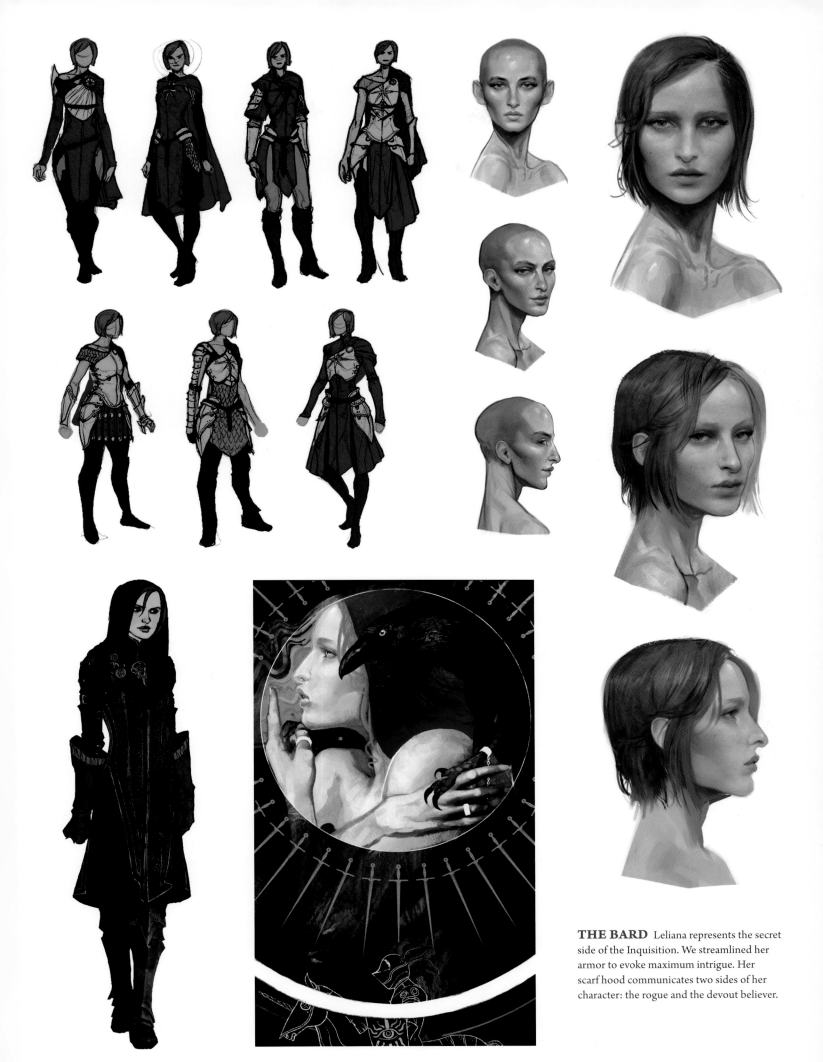

THE BARD Leliana represents the secret side of the Inquisition. We streamlined her armor to evoke maximum intrigue. Her scarf hood communicates two sides of her character: the rogue and the devout believer.

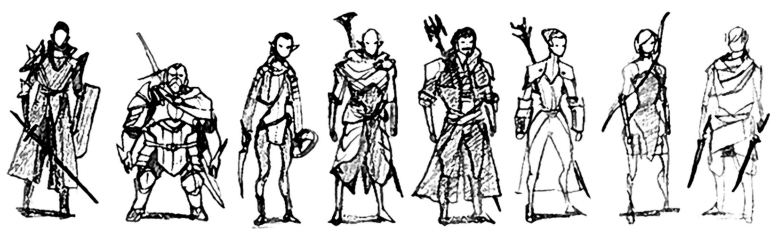

IN THE BEGINNING As artists, we are fortunate to collaborate with an imaginative team of writers, animators, designers, and other developers to bring Thedas to life. This collaboration makes character design one of the most satisfying parts of the job. We brainstorm who these characters are, outlining their goals and what they can show the player about the world. And as we talk, we doodle. At the earliest stages, each scribble and sketch helps to flesh out some aspect of a character. When the dust settles, it's fun to look back at this early work to see how much has changed and what made it into the game.

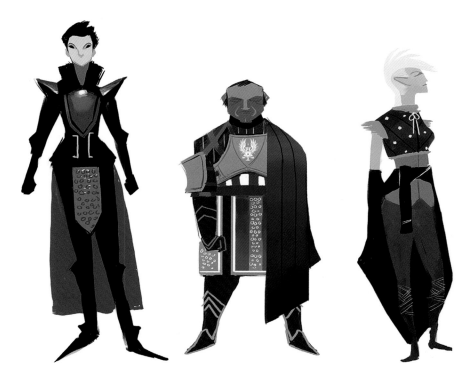

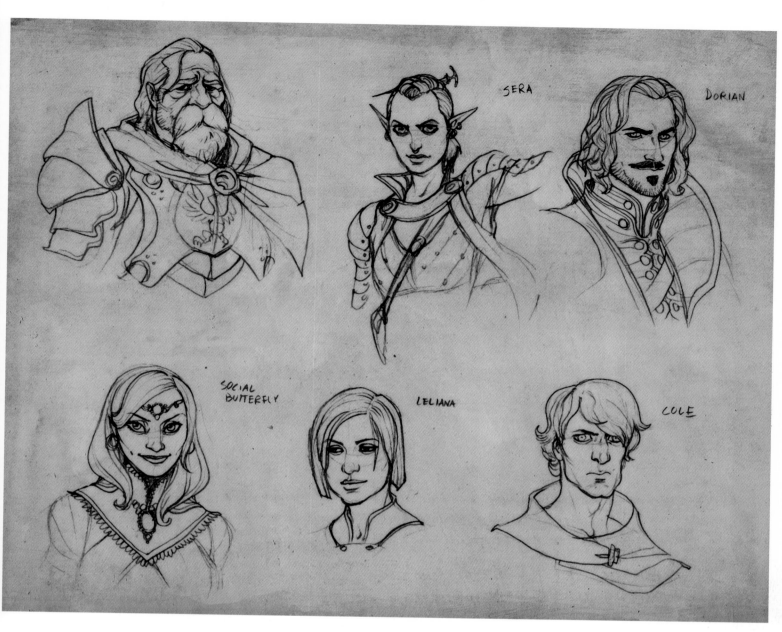

SERA

DORIAN

SOCIAL BUTTERFLY

LELIANA

COLE

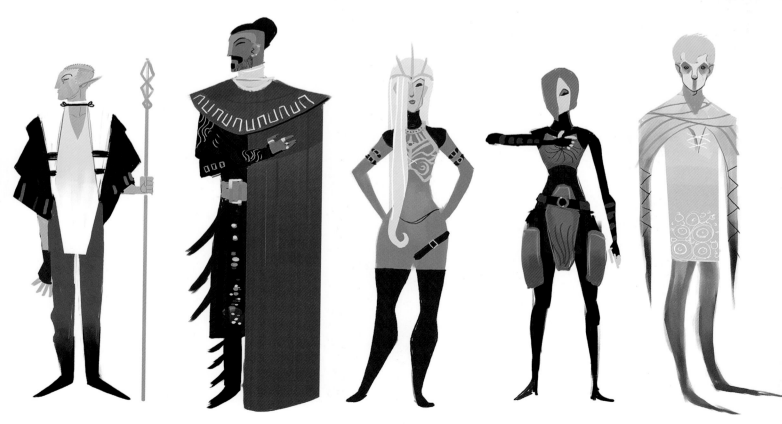

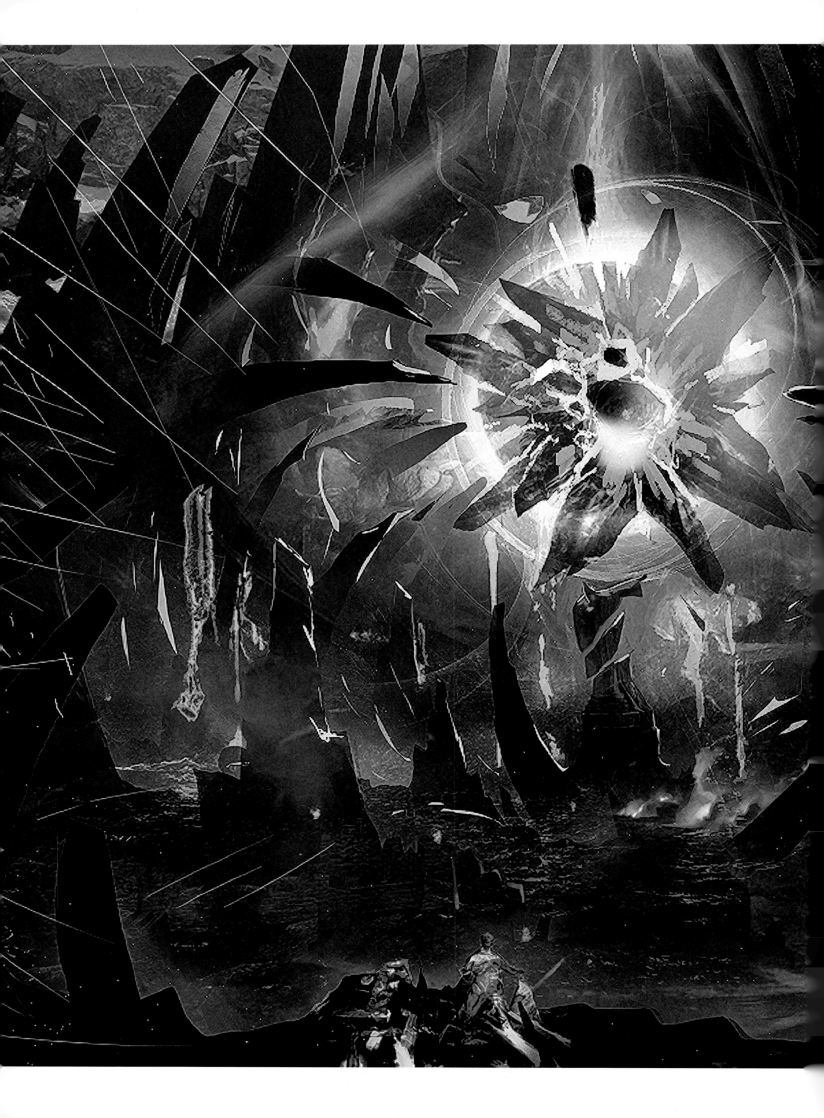

THE WRATH OF HEAVEN

When we first built the massive hole in the sky known as the Breach, it wasn't big enough. That's not to say it wasn't big. It just needed to be at least double the size, something that would overwhelm the sky. It had to be terrifying.

The result is a pulsing, almost breathing wound that can be seen from every ridge in the Frostback Mountains and well beyond. It glows a sickly, alien green—a visual sign of its connection to the otherworldly Fade. What was at first painted into the sky became its own physical entity in the level. The Breach is, at its heart, a series of concentric rings, layered in effects that bring it to life. The closer the player gets to it, the larger the Breach appears, building a sense of menace as the player journeys to the epicenter of the blast.

With the Breach come Fade rifts: smaller tears in the Veil that open throughout southern Thedas. To visually show the relationship between the two, we considered adding tendrils connecting each rift to the Breach. Instead, we found that emphasizing a similar visual language proved more elegant. Rifts share many visual elements with the Breach: the glowing green of the Fade, the ominous sounds of what lurks on the other side. But where the Breach is a hole blown in the sky, the rifts are tears in the air. It's up to the Inquisitor to seal both.

AND INTO THE FIRE

The opening moments of *Inquisition* are colored by chaos, confusion, and an immediate sense of peril. Questions of where you are and how you got there are not immediately answered as monsters chase you through a shifting, nightmarish plane. When you finally escape this space, the real world is clear and resolute, but appears no less dangerous than the one you've escaped.

ELECTRONIC ARTS PRESENTS

A BIOWARE PRODUCTION

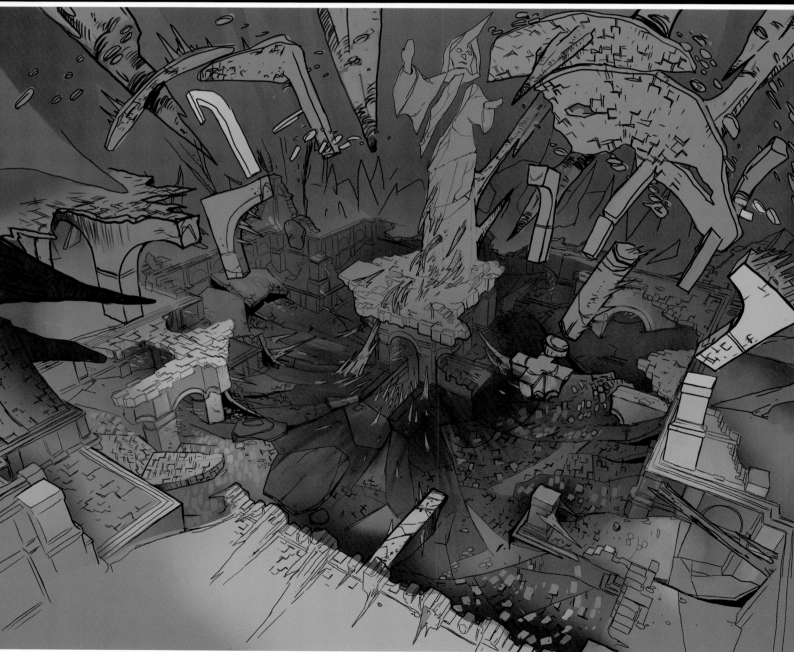

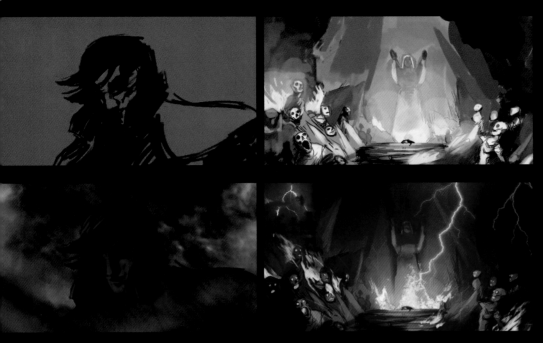

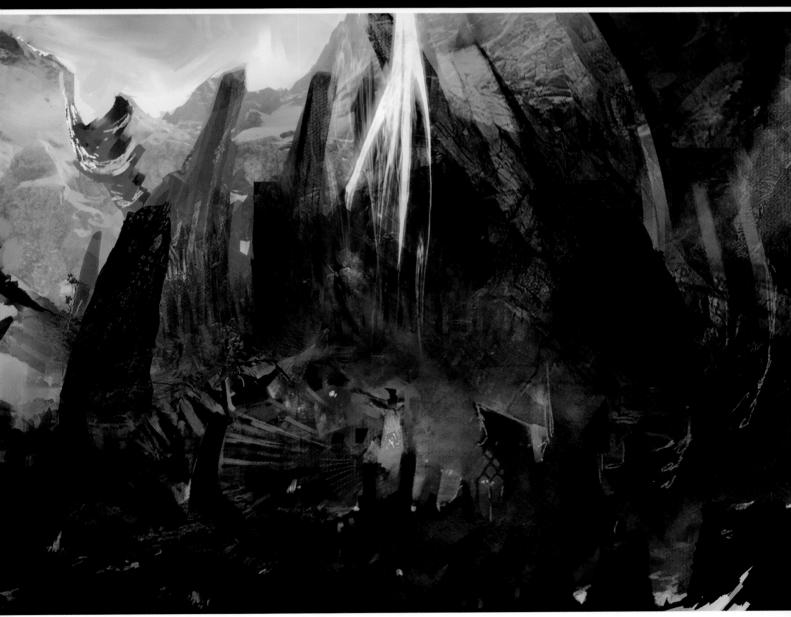

AFTERMATH A crater left by a devastating explosion is one of the first major landmarks you come upon in *Inquisition*. We wanted the geography to suggest that the explosion was magical in nature, so these drawings illustrate dramatic spires that seem drawn toward the blast's epicenter.

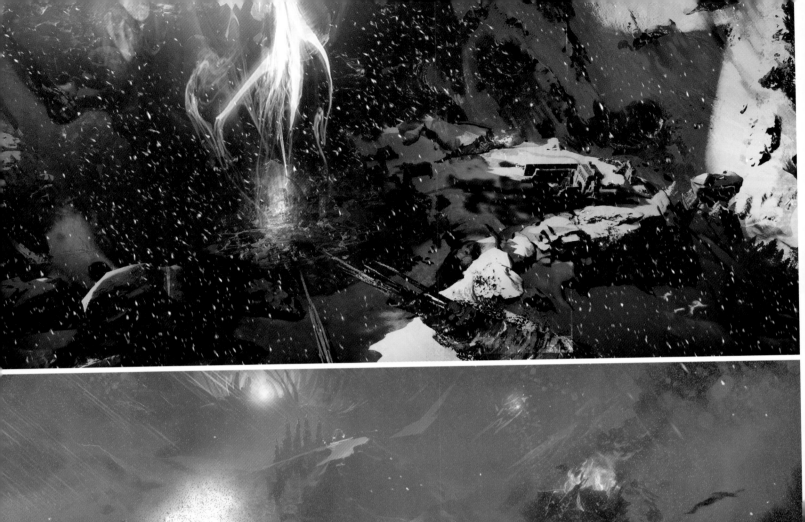
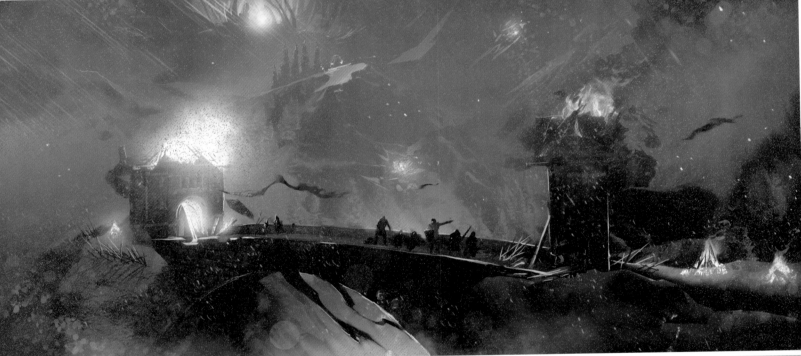
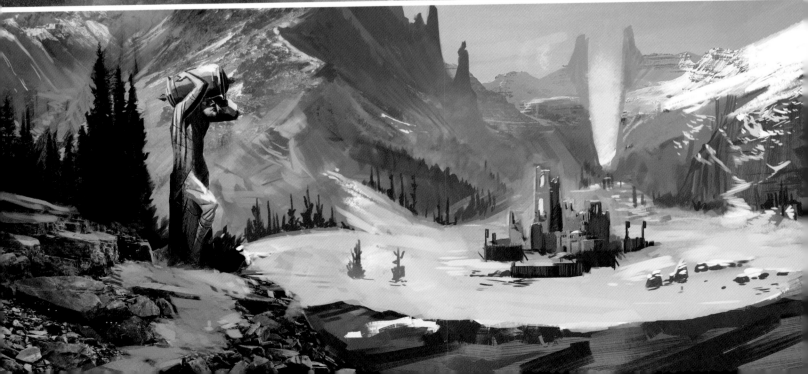

Opposite: In these illustrations, the landscape surrounding the explosion site is explored both before and after the blast.

Left: It was fun to discover for ourselves what kinds of stories and horrors might be uncovered as you came over the next crest. Visual storytelling rewards players who are willing to explore every corner of a setting.

Below: The opening moments of *Inquisition* were storyboarded in full color. A sequence can go through dozens of changes before we're happy with it, so we keep the drawings fast and loose. What's most important is the idea being communicated, not perfect lines or details.

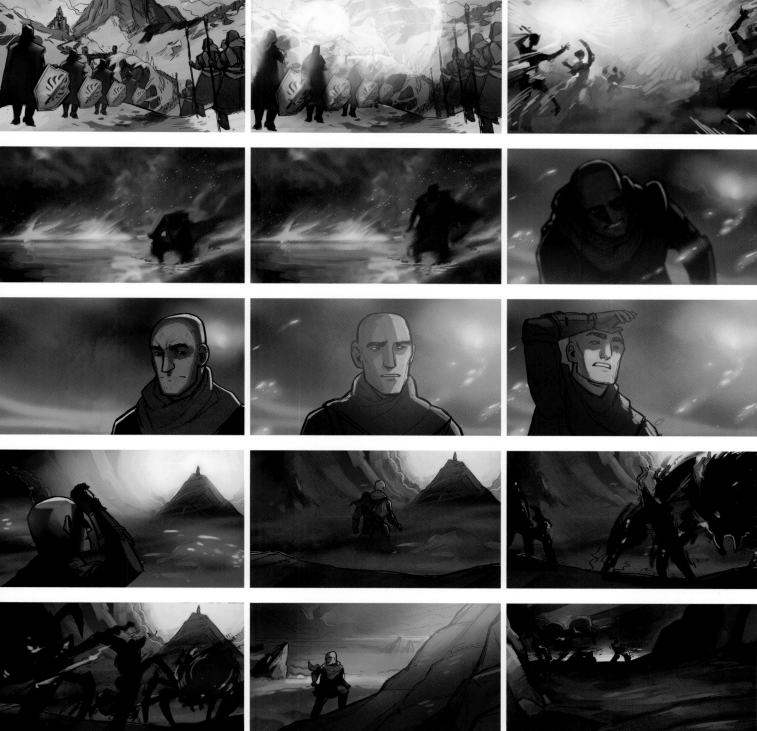

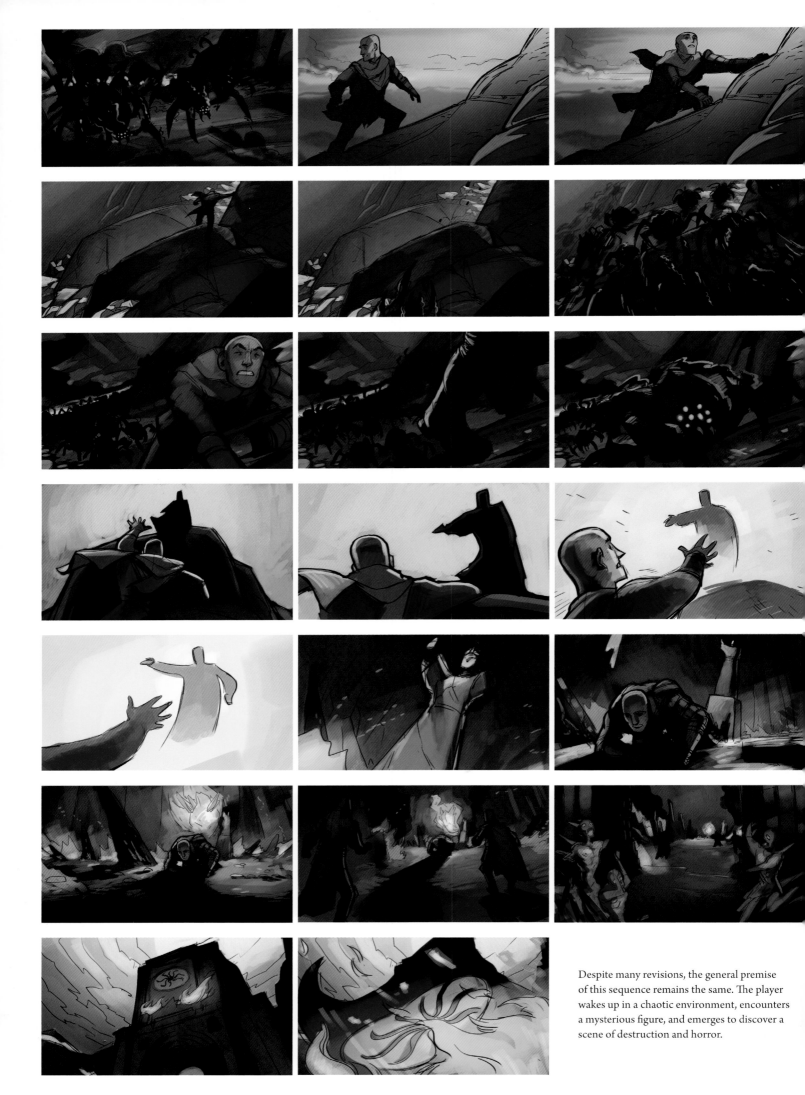

Despite many revisions, the general premise of this sequence remains the same. The player wakes up in a chaotic environment, encounters a mysterious figure, and emerges to discover a scene of destruction and horror.

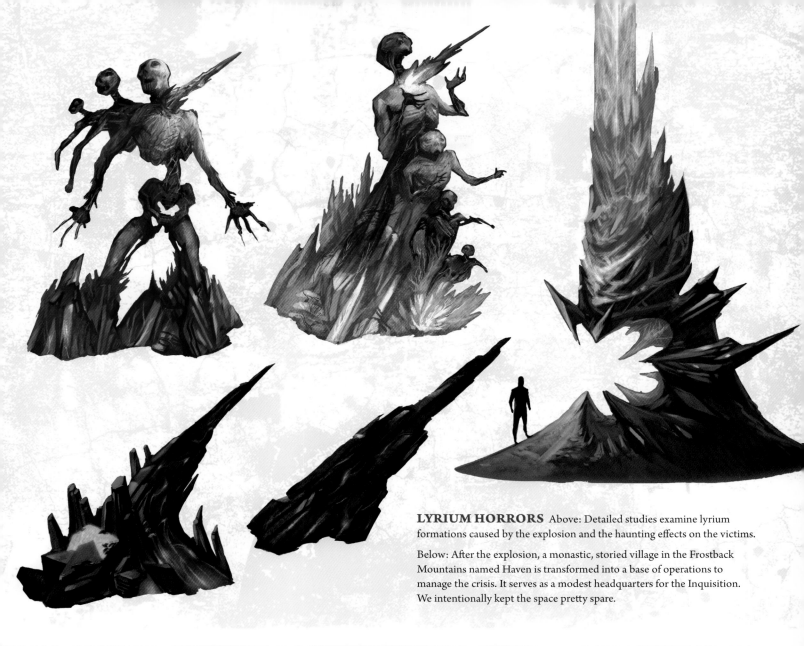

LYRIUM HORRORS Above: Detailed studies examine lyrium formations caused by the explosion and the haunting effects on the victims.

Below: After the explosion, a monastic, storied village in the Frostback Mountains named Haven is transformed into a base of operations to manage the crisis. It serves as a modest headquarters for the Inquisition. We intentionally kept the space pretty spare.

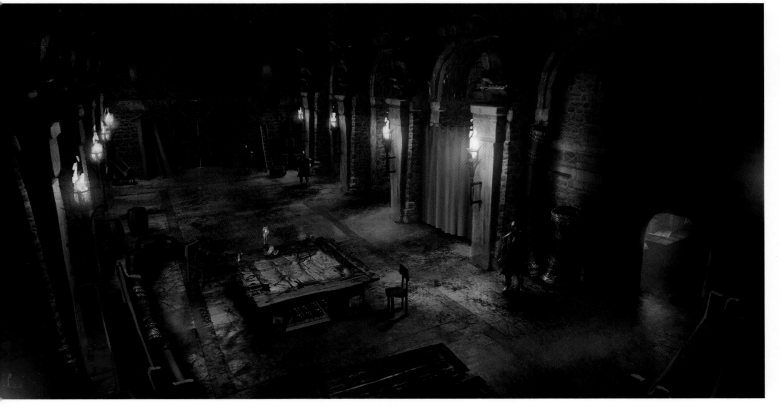

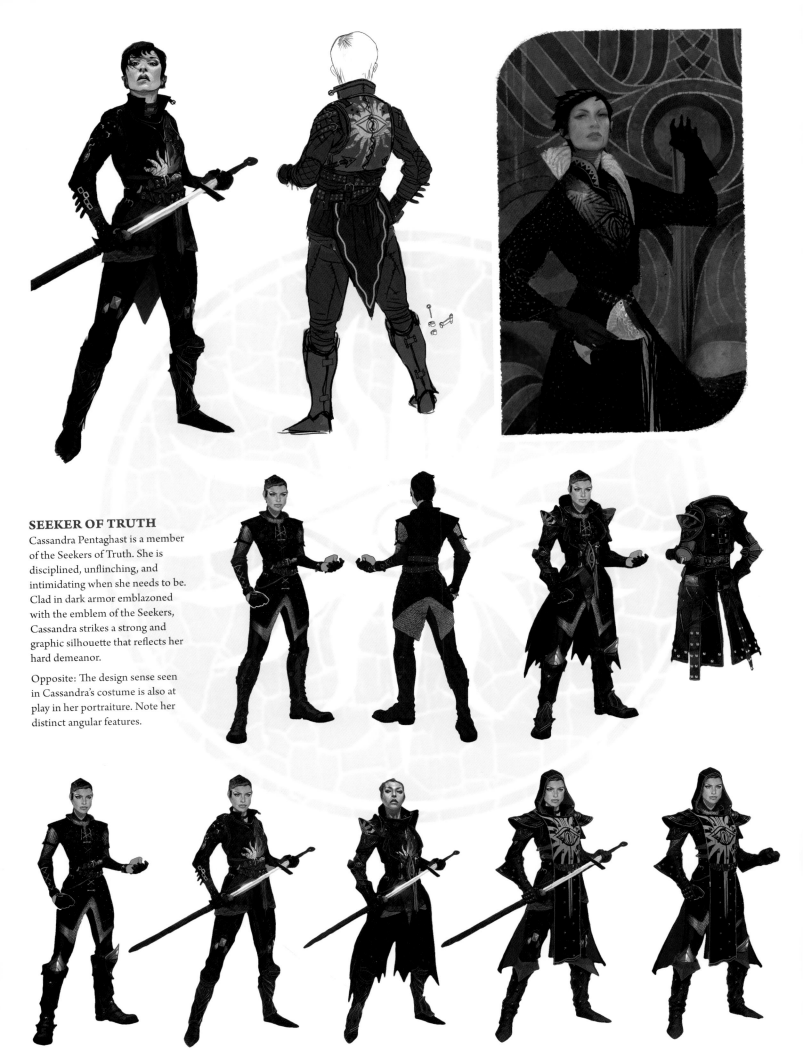

SEEKER OF TRUTH

Cassandra Pentaghast is a member of the Seekers of Truth. She is disciplined, unflinching, and intimidating when she needs to be. Clad in dark armor emblazoned with the emblem of the Seekers, Cassandra strikes a strong and graphic silhouette that reflects her hard demeanor.

Opposite: The design sense seen in Cassandra's costume is also at play in her portraiture. Note her distinct angular features.

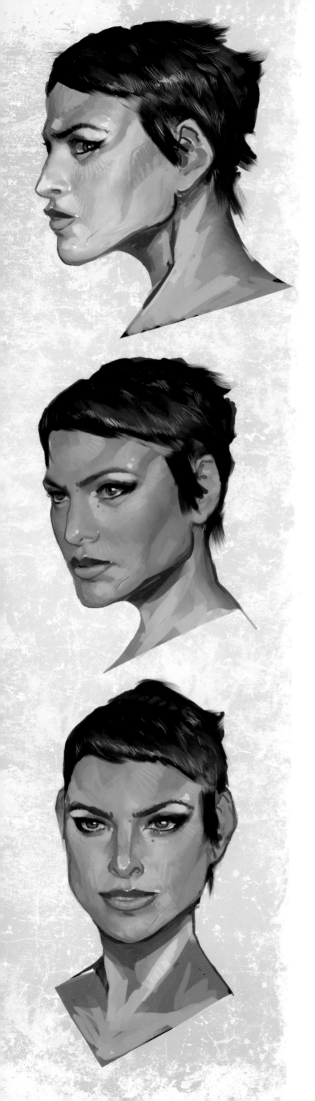

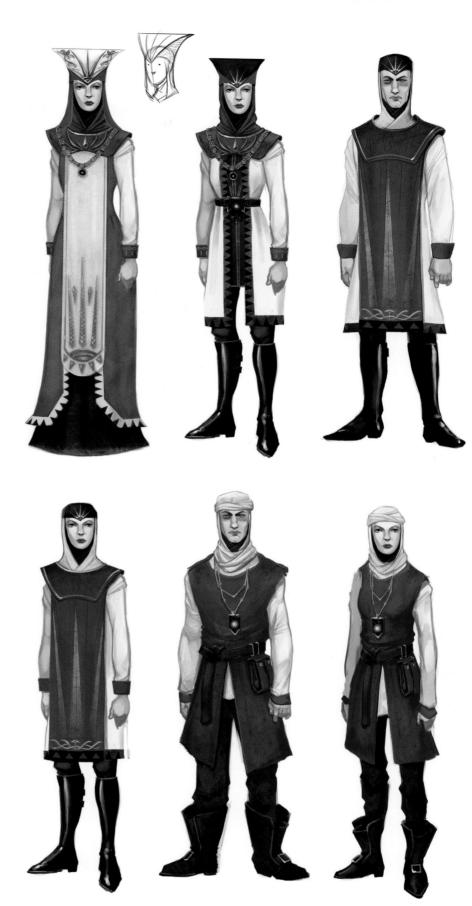

RELIGIOUS ORDER The triangular headdress worn by higher-level Chantry clerics is a smaller version of the one worn by the Divine, the religion's spiritual leader. These uniforms share similarities with aspects of Orlesian fashion, since the Chantry was founded in Orlais, but coarser materials and modest designs temper them and keep them religious. The highest positions in the Chantry are open only to women, which is why male concepts only exist for Chantry brothers and missionaries.

A PUBLIC HUMBLING These story sketches show the Inquisitor's first interactions with the public. Things do not go well. We needed to get across early in the game that your influence as Inquisitor must be earned.

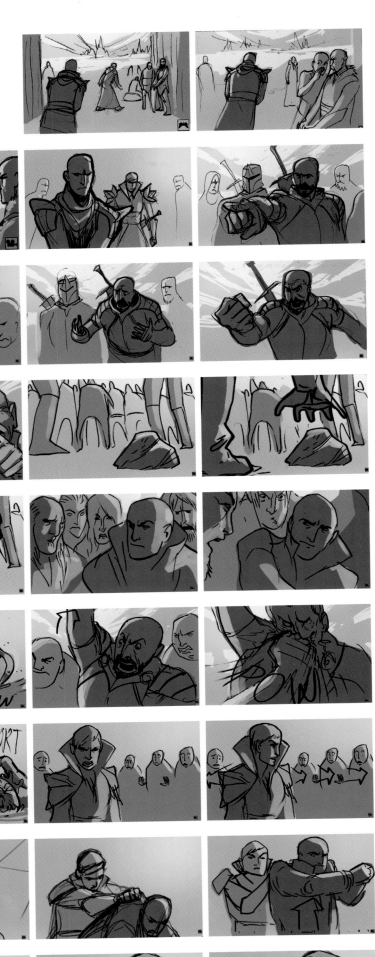

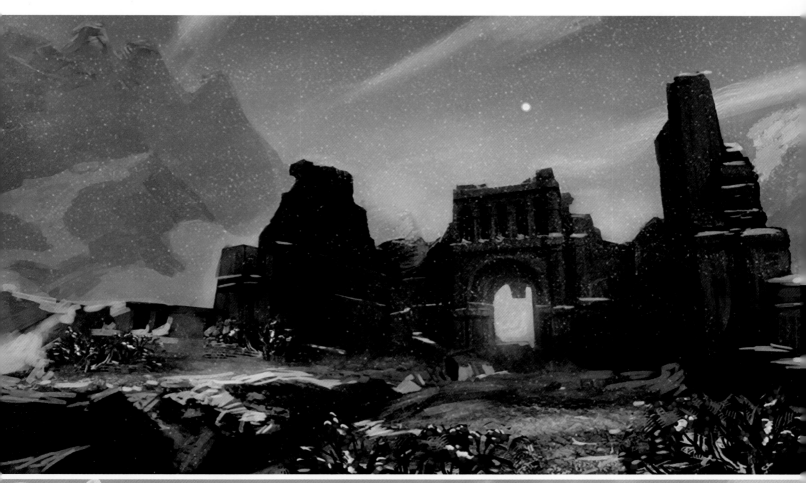

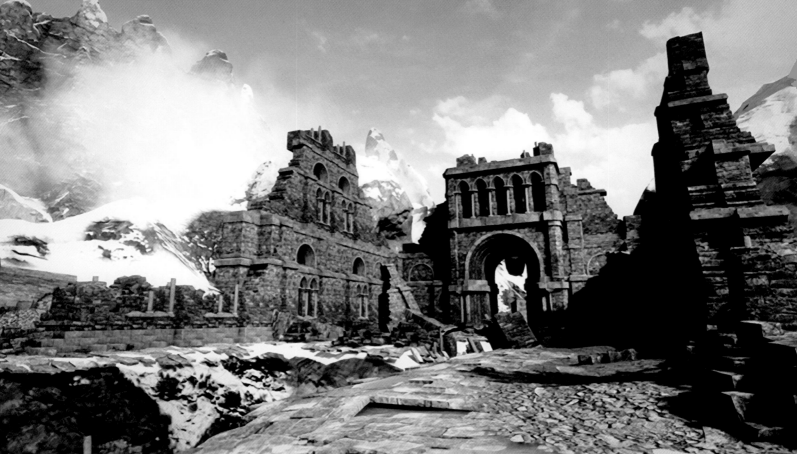

BACK AND FORTH Rough paint-overs of 3-D models let us suggest improvements or offer completely new approaches during iteration. This method is preferable because it's quick: if a change doesn't work in a drawing, it's easier to discard an hour's work than days spent building it in 3-D.

Overleaf: Haven's small chantry exemplifies typical Fereldan architecture. It was meant to serve as a stop along a pilgrim's path to the more elaborate Temple of Sacred Ashes.

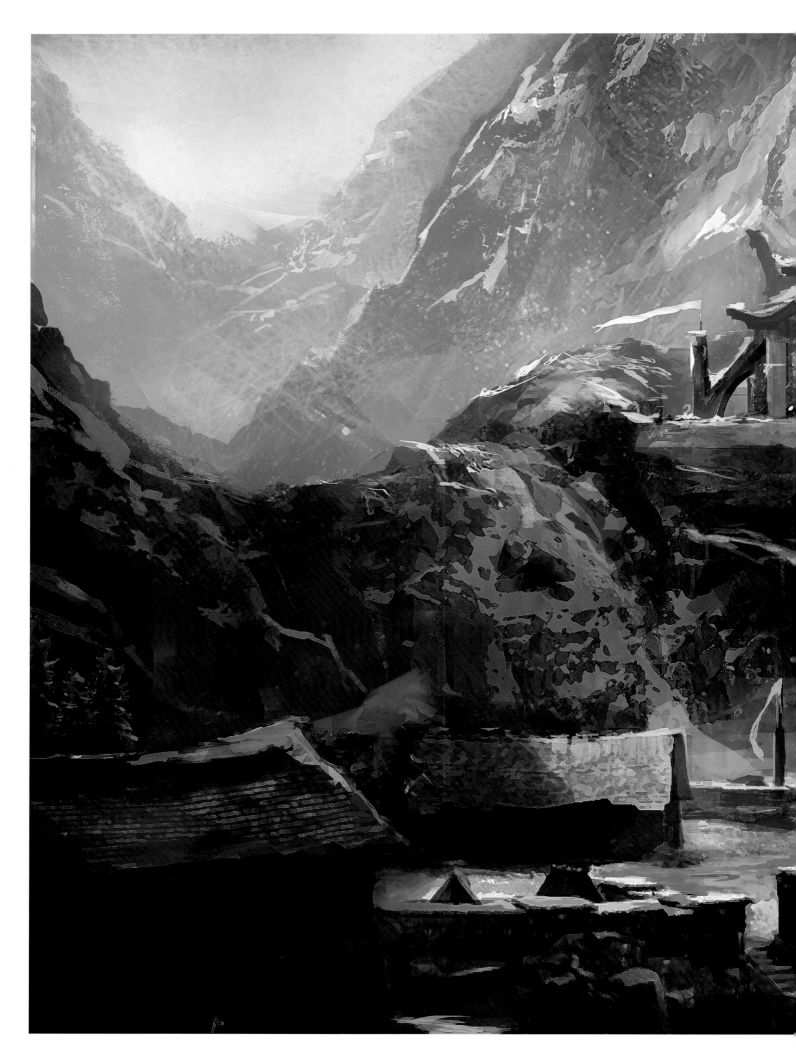

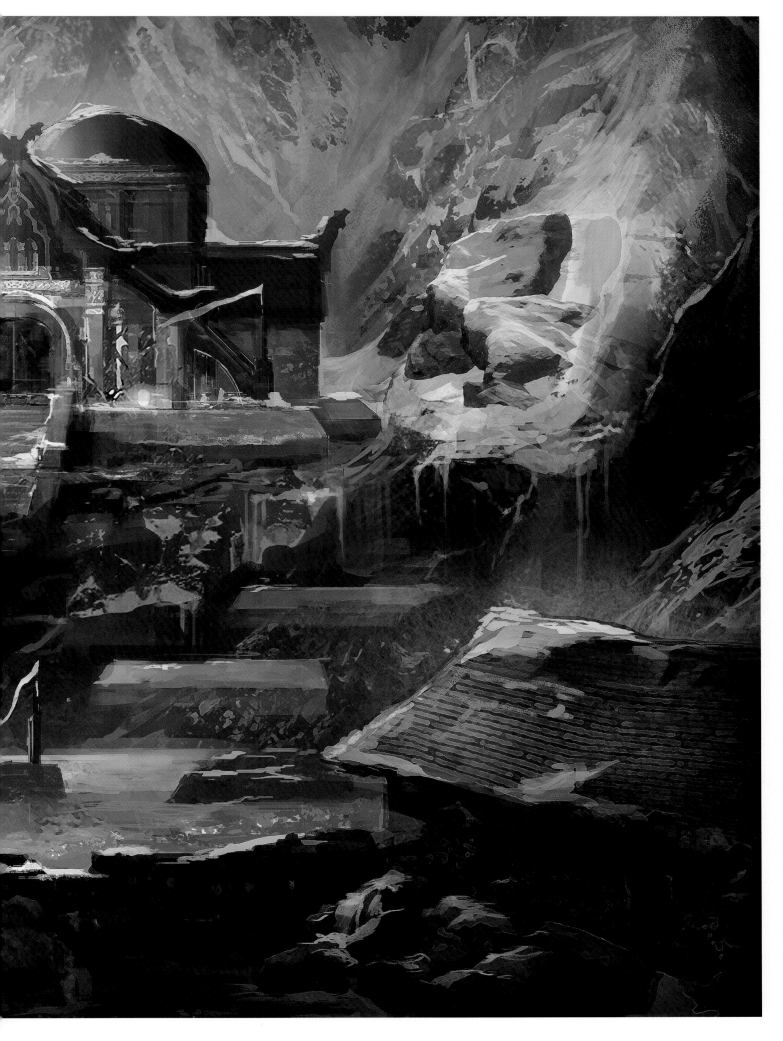

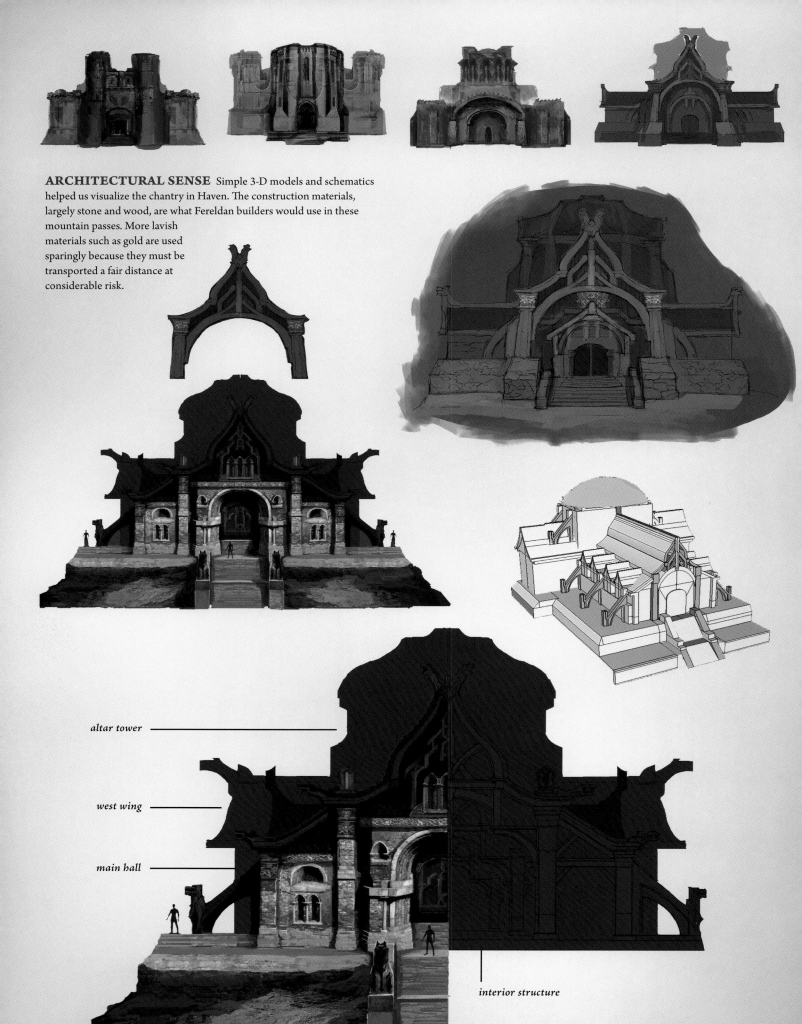

ARCHITECTURAL SENSE Simple 3-D models and schematics helped us visualize the chantry in Haven. The construction materials, largely stone and wood, are what Fereldan builders would use in these mountain passes. More lavish materials such as gold are used sparingly because they must be transported a fair distance at considerable risk.

altar tower

west wing

main hall

interior structure

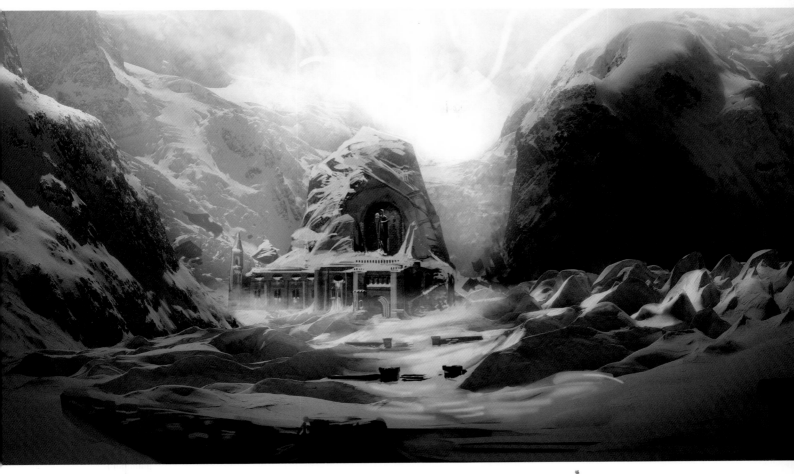

Above: Early concepts pictured the explosion blowing apart the back of the mountain, leaving only a façade of the temple still intact.

Below: Sturdy, rough-hewn stone structures would be built to withstand the harsh mountain climate.

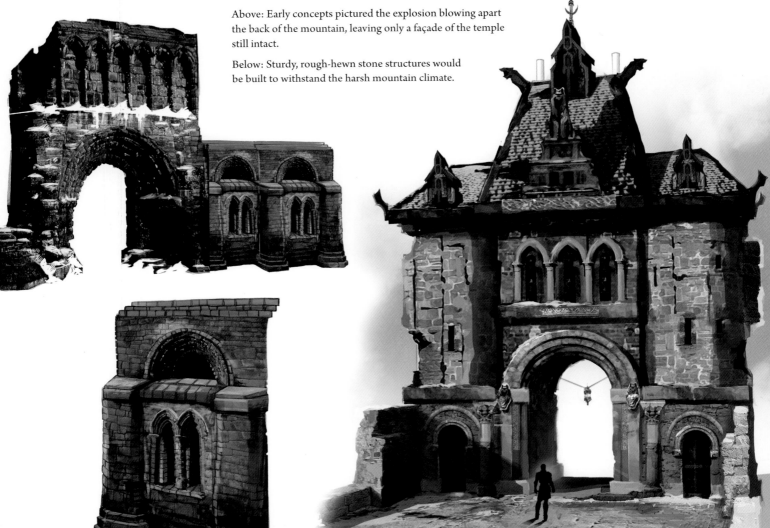

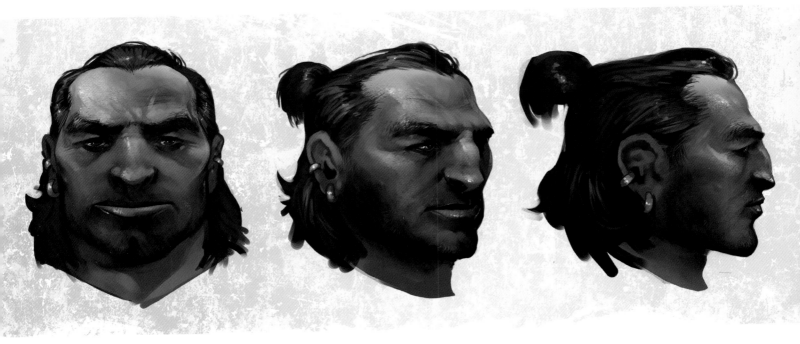

A FAMILIAR FACE Varric Tethras returns in *Inquisition*. The world has fallen into chaos since the events of *Dragon Age II*. It only made sense for the storytelling dwarf from Kirkwall to don sturdier gear this time around. The well-worn armor under his distinctive duster jacket adds a layer of pragmatism to his appearance.

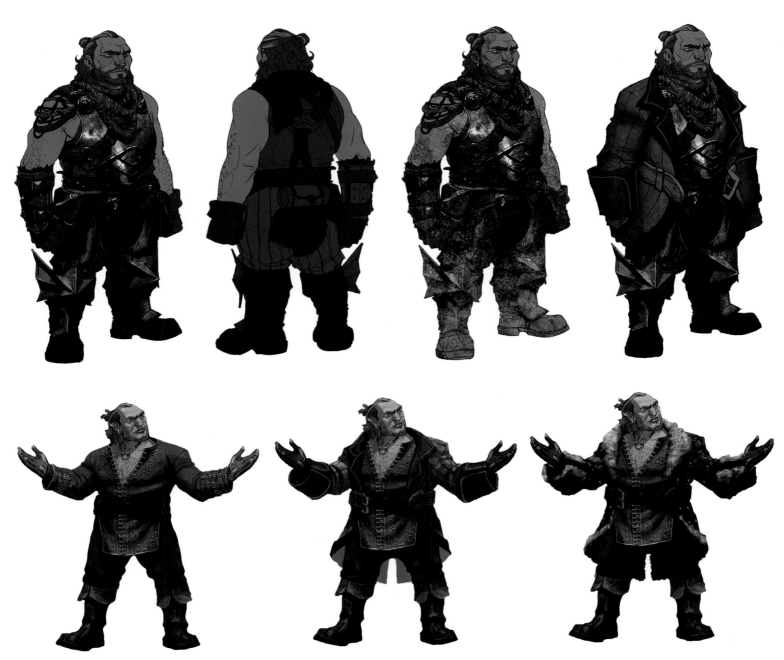

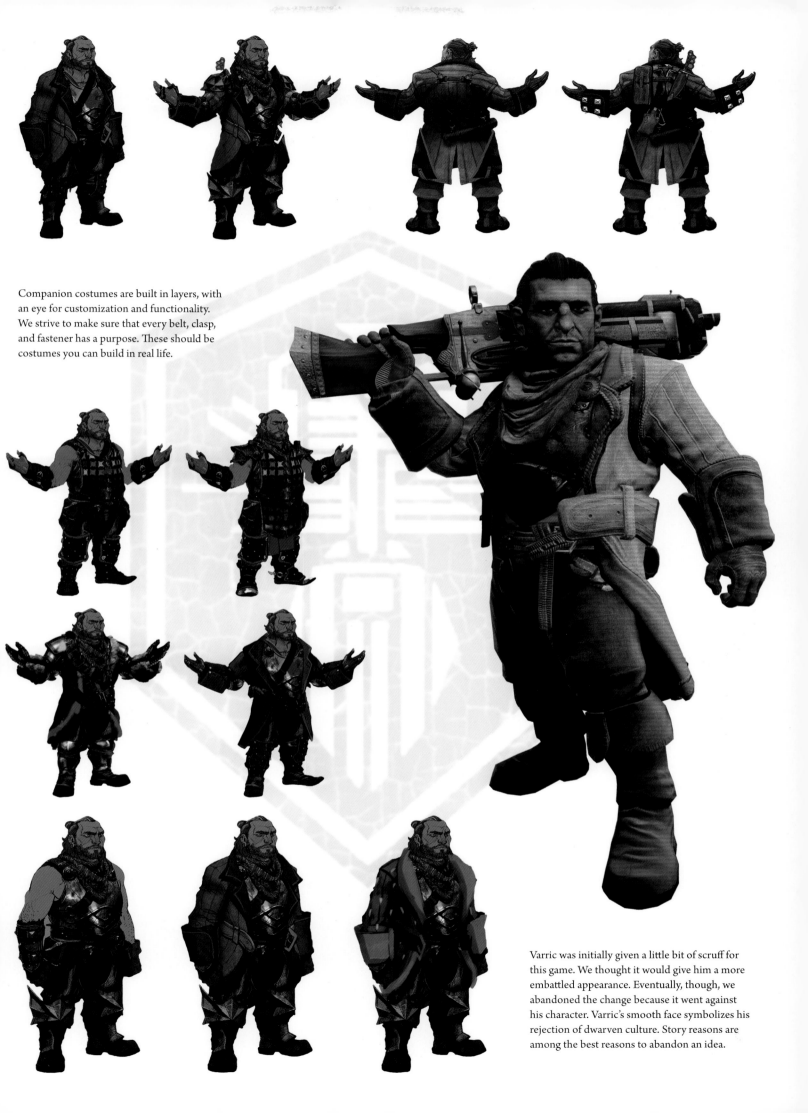

Companion costumes are built in layers, with an eye for customization and functionality. We strive to make sure that every belt, clasp, and fastener has a purpose. These should be costumes you can build in real life.

Varric was initially given a little bit of scruff for this game. We thought it would give him a more embattled appearance. Eventually, though, we abandoned the change because it went against his character. Varric's smooth face symbolizes his rejection of dwarven culture. Story reasons are among the best reasons to abandon an idea.

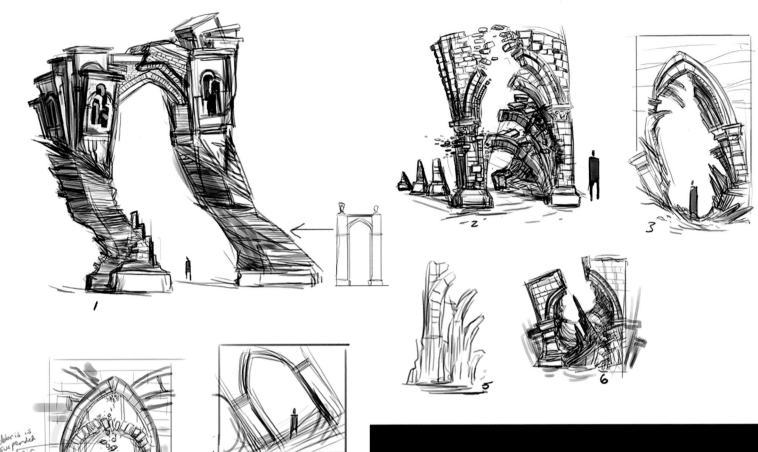

DESECRATING THE TEMPLE We wanted to reinforce that the explosion at the Temple of Sacred Ashes was magical in origin, so we gave its effects a surreal quality. These sketches show how the blast might have duplicated and distorted the architecture, instead of simply reducing it to slag.

Opposite: If you imagine the explosion as an expanding sphere, it would cut a bowl formation into the mountain. Enormous shards of lyrium would be drawn from their veins in the ground toward the origin of the blast and freeze in place.

Opposite bottom: The stripped bones of the structure show the potential extent of the destruction.

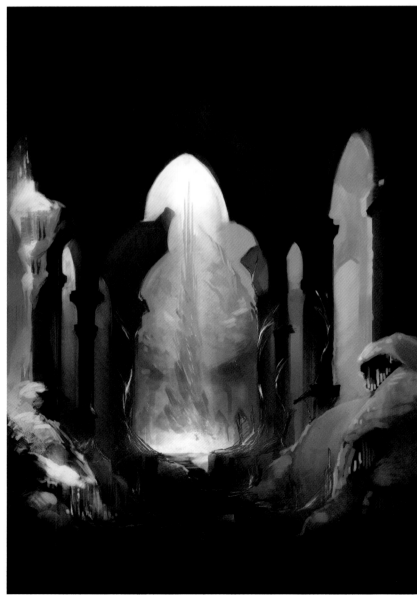

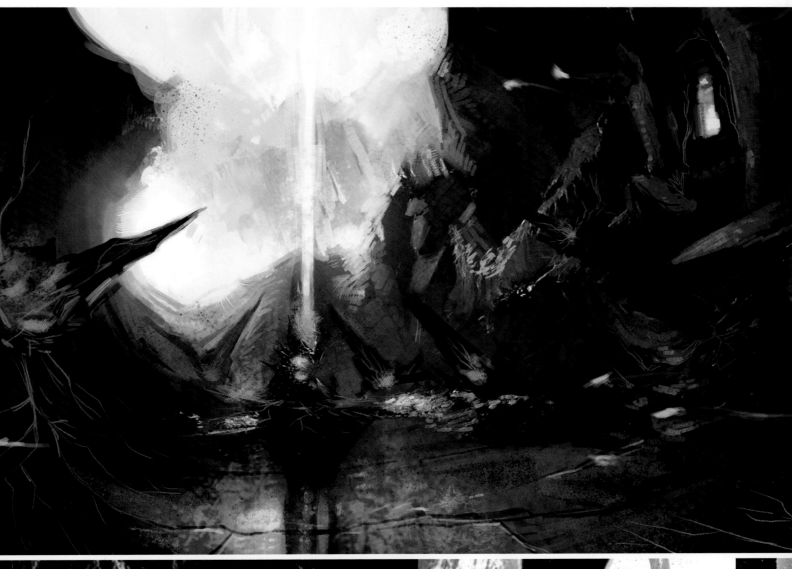

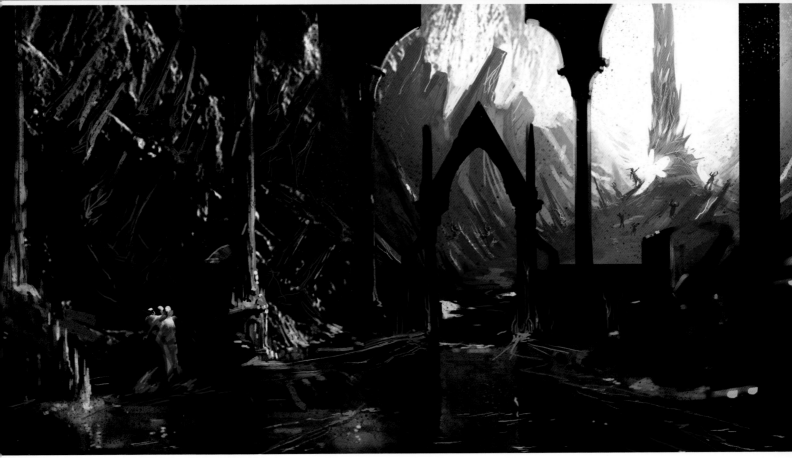

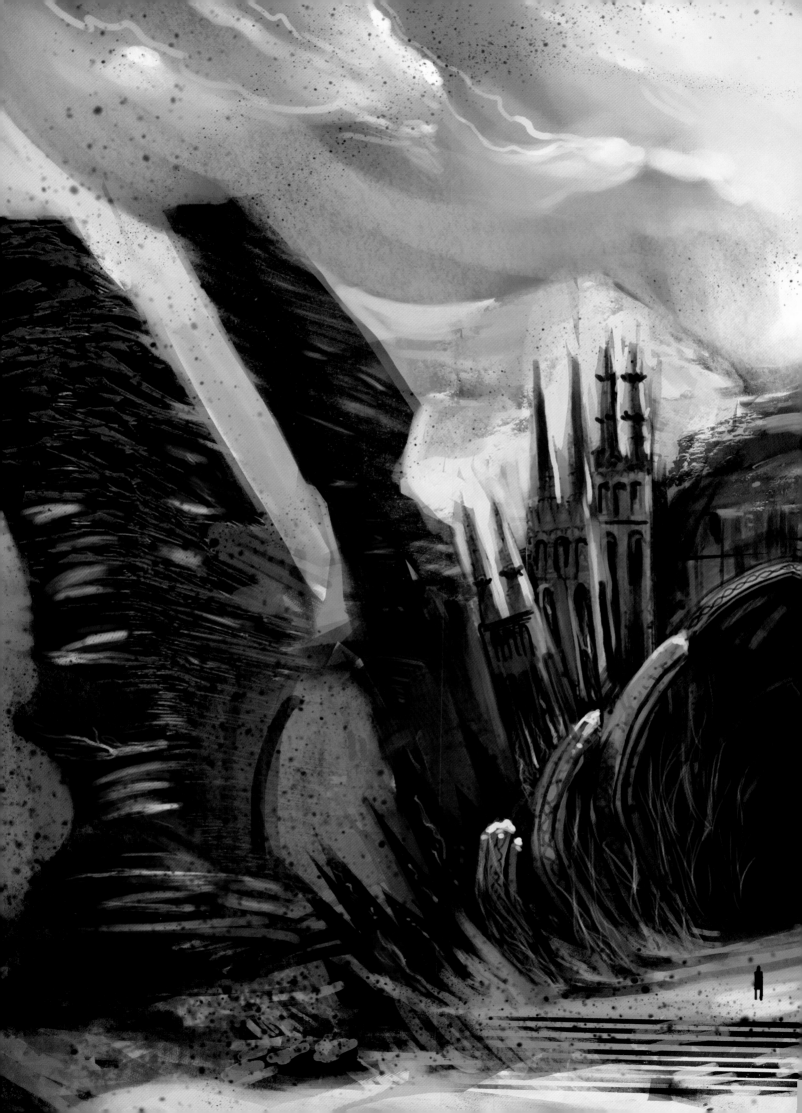

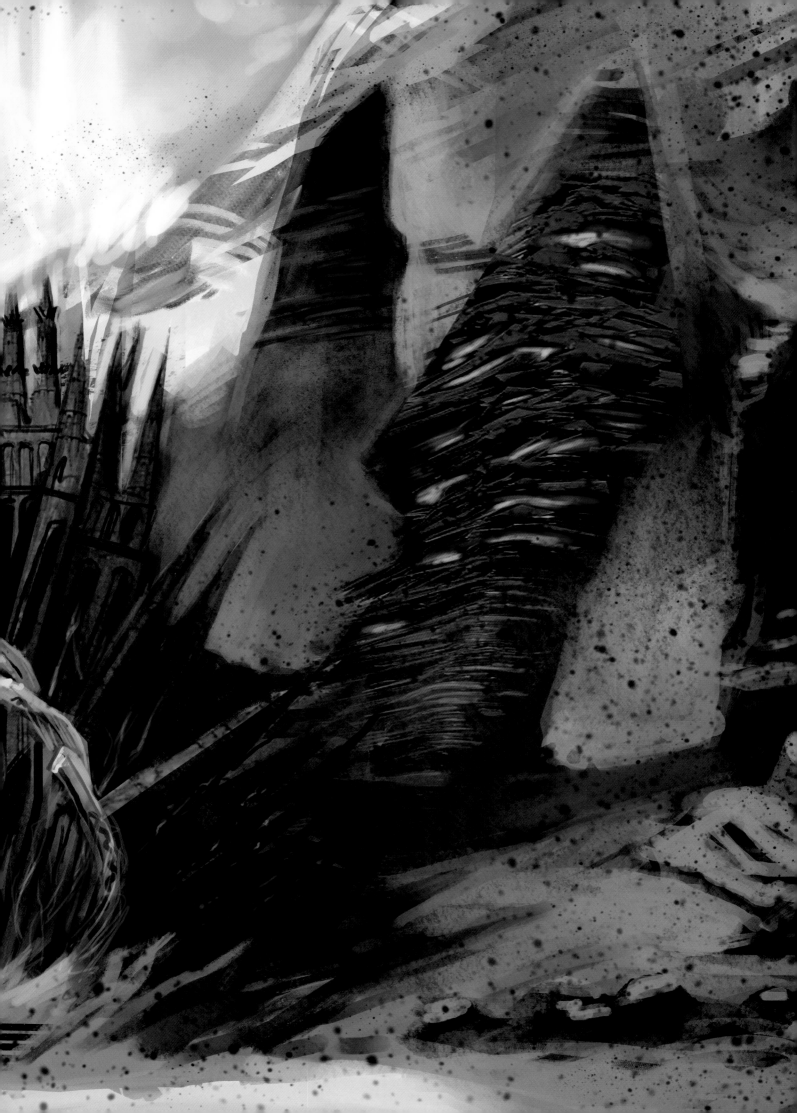

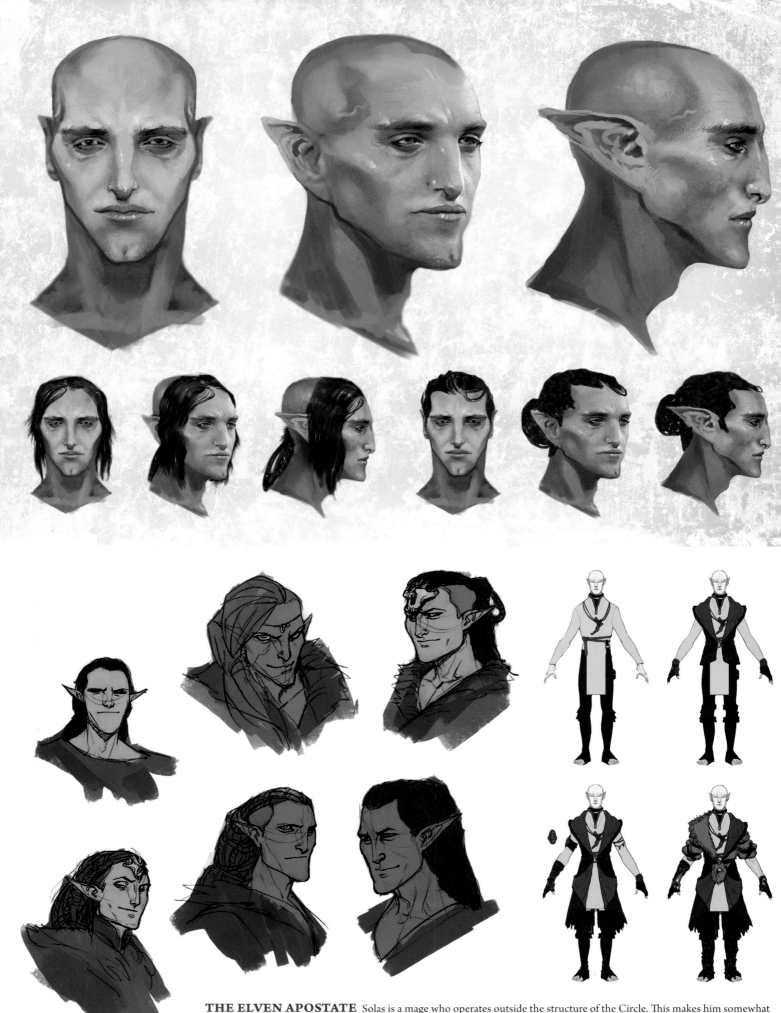

THE ELVEN APOSTATE Solas is a mage who operates outside the structure of the Circle. This makes him somewhat of an outlaw, at least in the eyes of more conservative Thedosians. His appearances reflect the lifestyle of a wanderer. We wanted them to look like homemade improvisations born from necessity, as though he's wearing all that he owns.

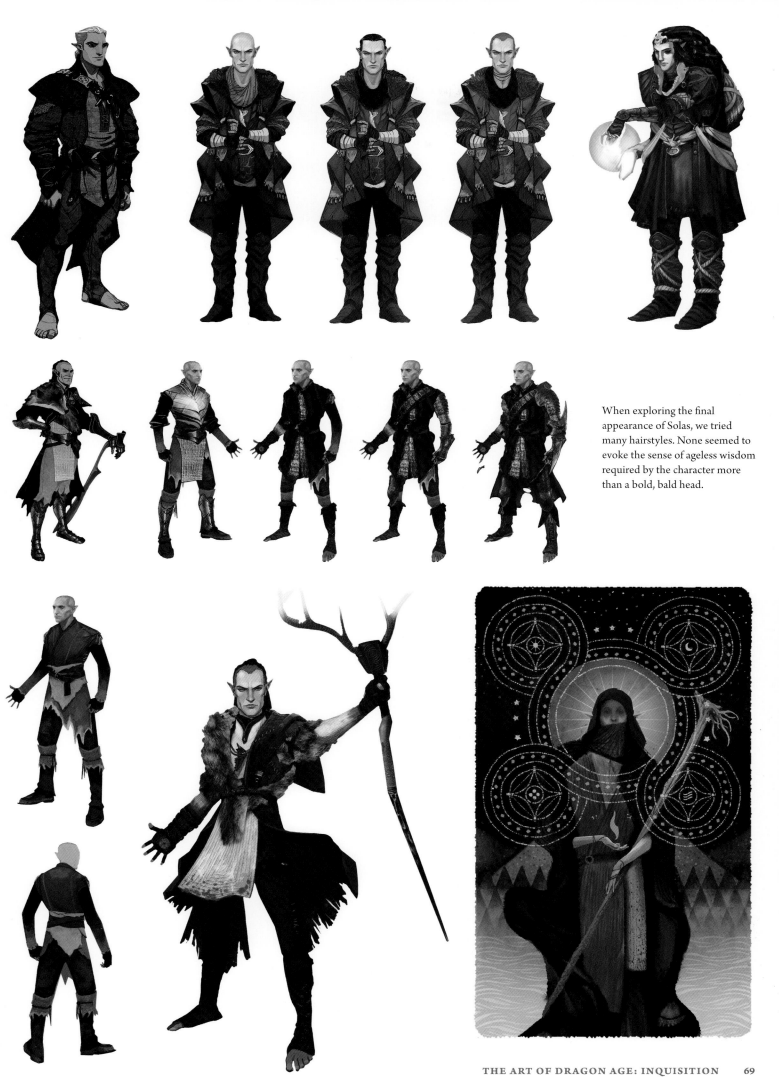

When exploring the final appearance of Solas, we tried many hairstyles. None seemed to evoke the sense of ageless wisdom required by the character more than a bold, bald head.

THE BREACH The Veil that separates the waking world and the Fade is ruptured. The resulting Breach in the sky is expanding, and demons are escaping into the world of the living like an unchecked oil spill. These illustrations of the Breach explore an apocalyptic vibe, with gaslight greens and a blotted-out sun.

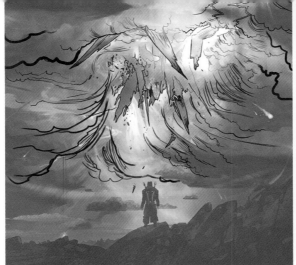
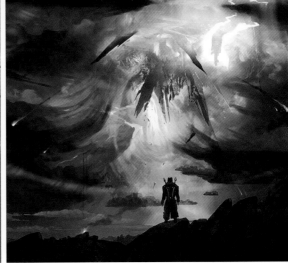
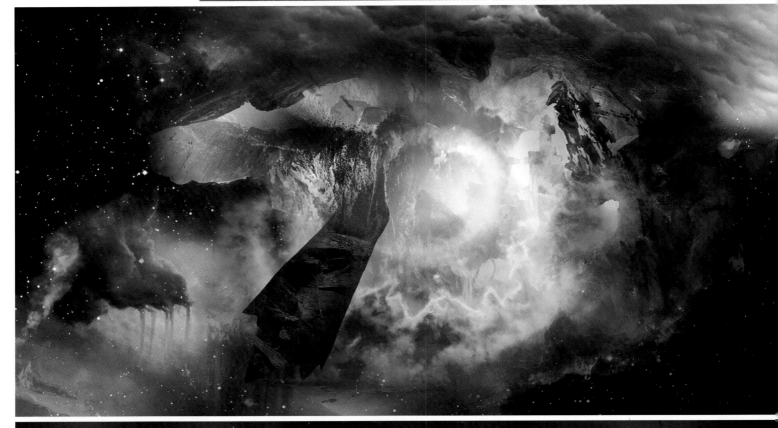
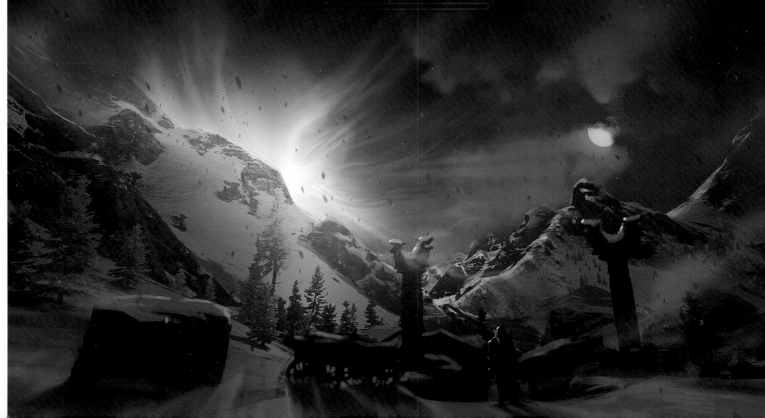

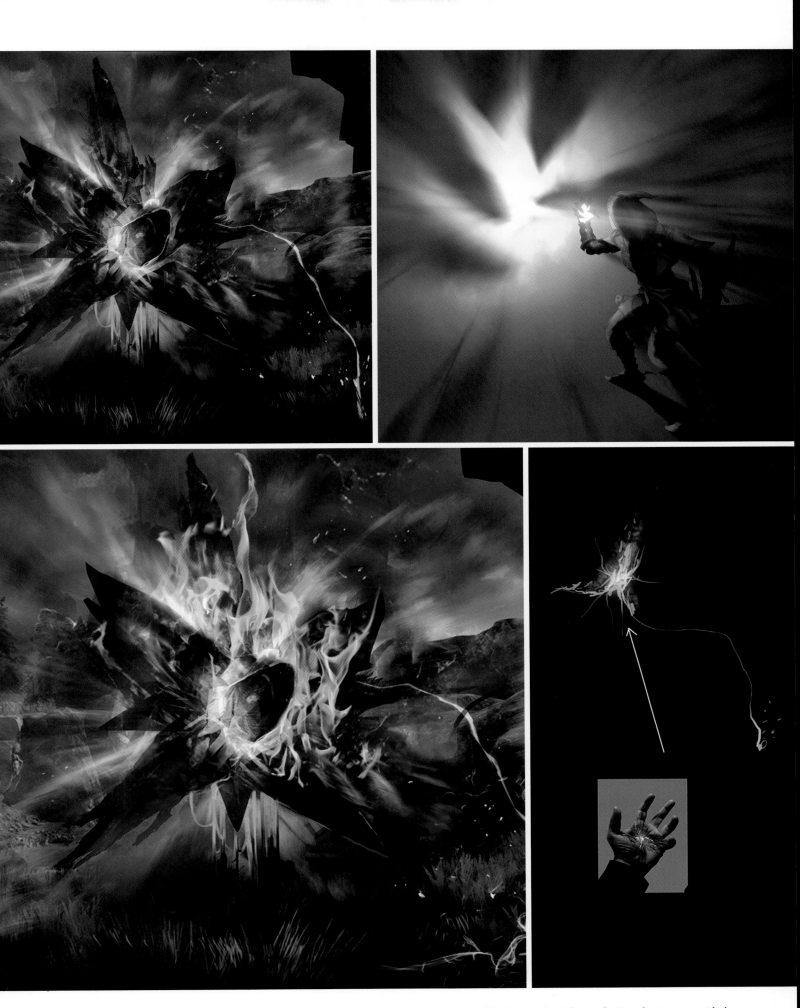

TEARS IN THE VEIL Fade rifts are smaller versions of the Breach that appear throughout the world wherever the Veil is weak. How they interact with the mark on the player's hand is a key aspect of game play in *Inquisition*, and underlines the player's unique and incredible power in the face of such dangerous anomalies.

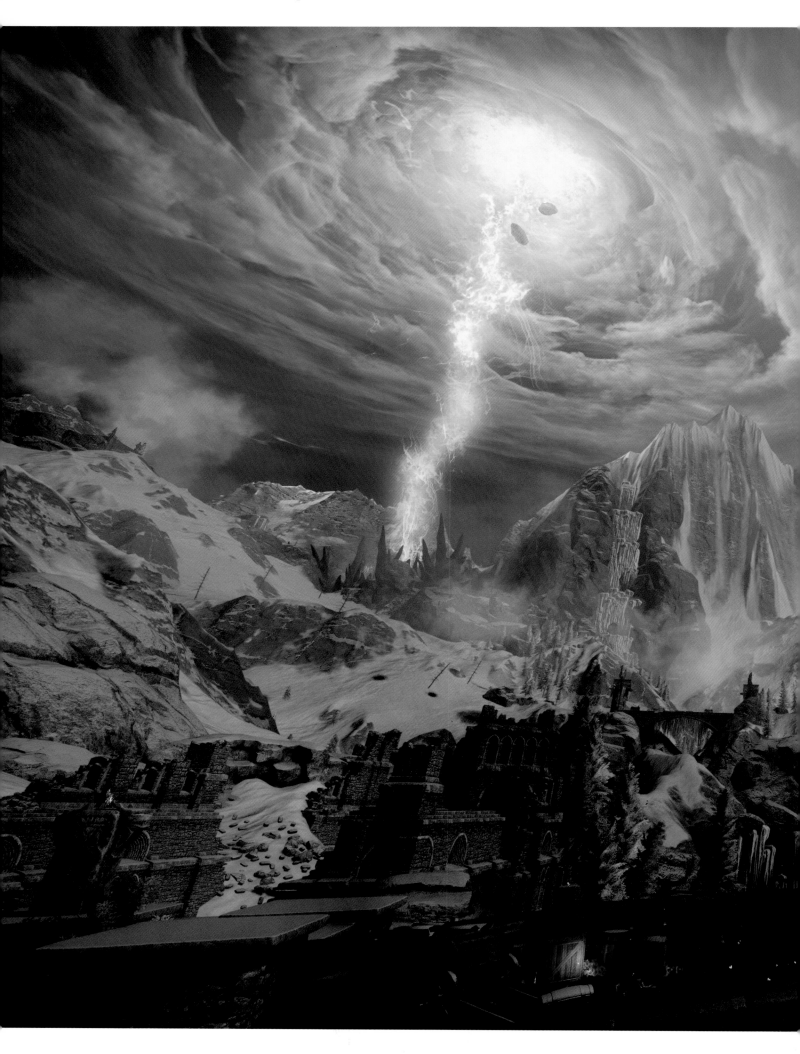

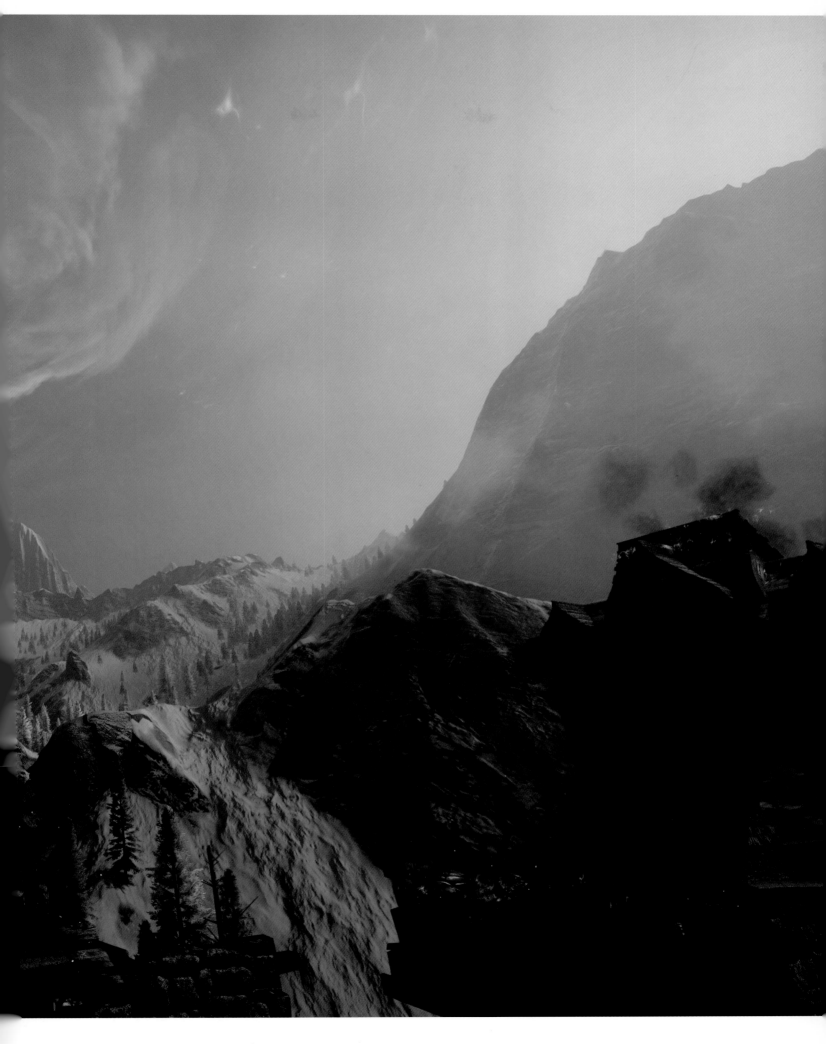

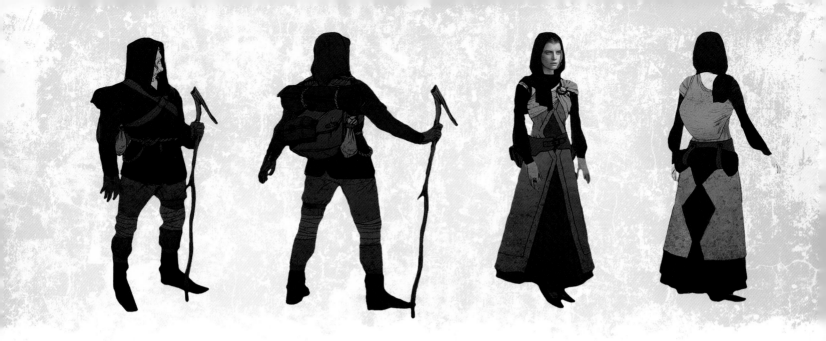

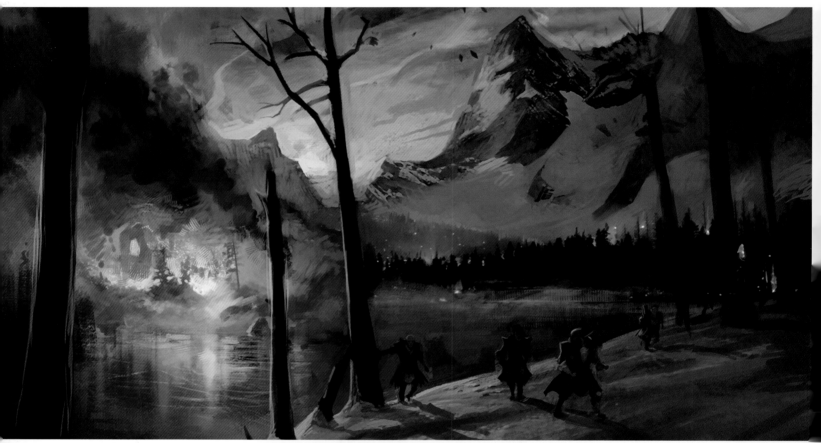

SCENES OF DESTRUCTION

Above: The Inquisitor leads the party away from a major crisis, with the glow of the Breach lighting the way.

Right: This is one of our earliest depictions of the hero, emerging as the only survivor of the blast that tore open the Breach.

Opposite: This illustration, showing the consequences of the Breach if left unchecked, became the inspiration for a major showdown.

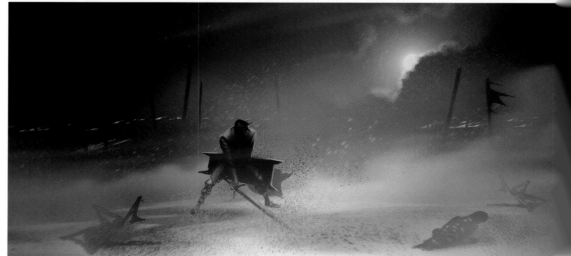

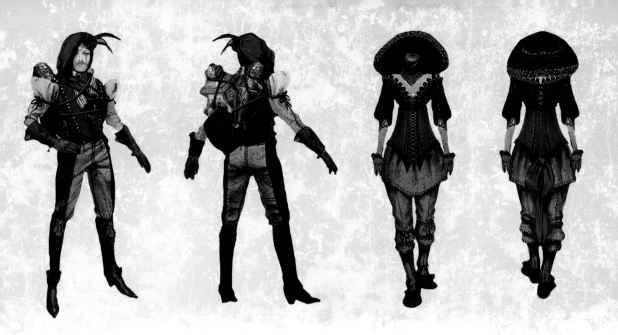

DISPLACED PILGRIMS We designed Fereldan and Orlesian refugees who arrived in Haven on a pilgrimage and were unable to leave following the disaster. Through the evolution of the game's early moments, we opted instead to focus on the military response to the blast.

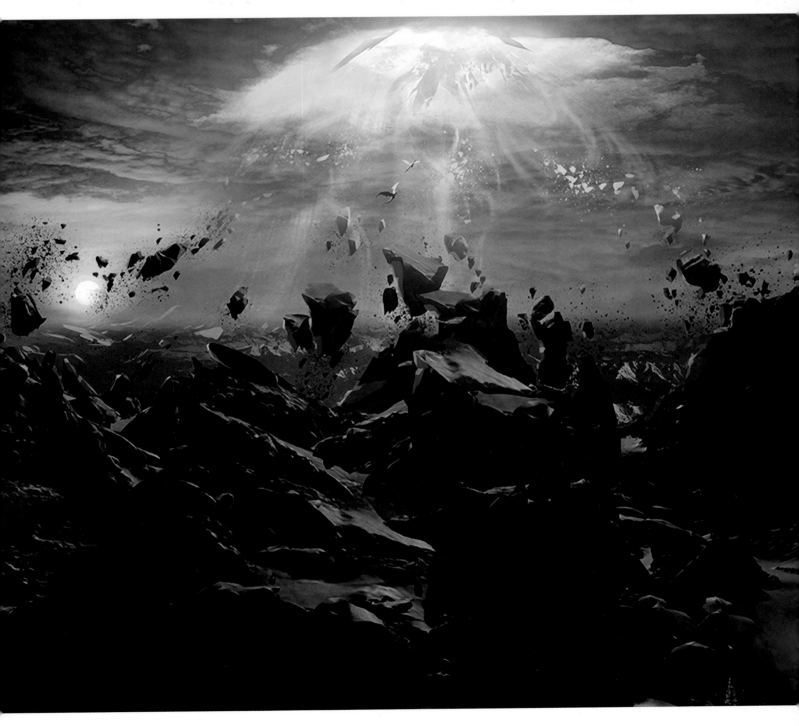

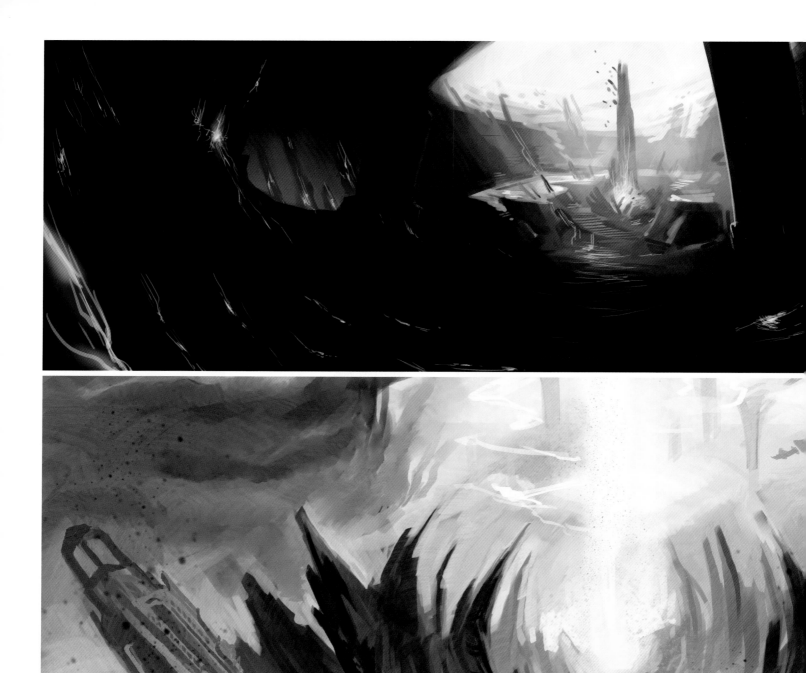

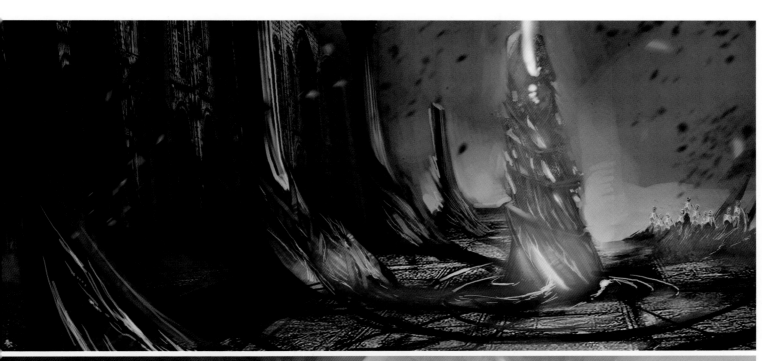

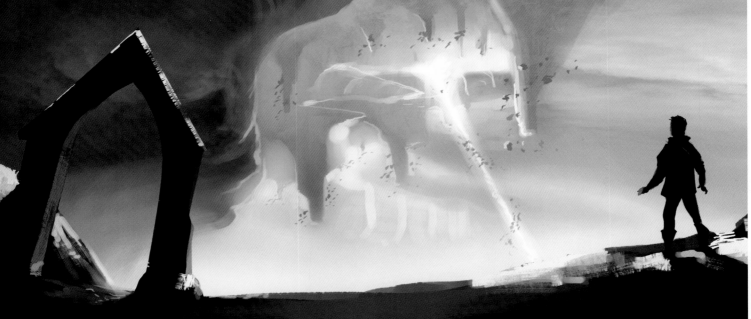

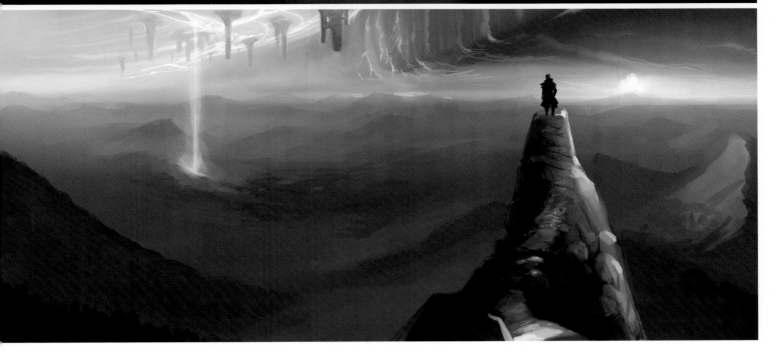

APOCALYPTIC PALETTES

Early renderings of the Breach focus on colors to evoke different moods, from an oil spill's sickly rainbow hues to something more hellish: ash-choked air, accented with orange embers.

Opposite top: These two images show different approaches to the concept of a sole survivor.

Opposite center: It's important to maintain a healthy back-and-forth between concept artists and writers. Production illustrations inspire story ideas and story ideas inspire visuals, as seen in this image of a major setback in the Inquisition's plans.

Opposite bottom: Some of the first enemies faced in *Inquisition* have appeared in previous *Dragon Age* titles. This gave us the opportunity to refine visual concepts of existing creatures, such as rage demons. Drawing creatures and characters in action helps us to better understand behavior and add a level of personality absent in static portraits.

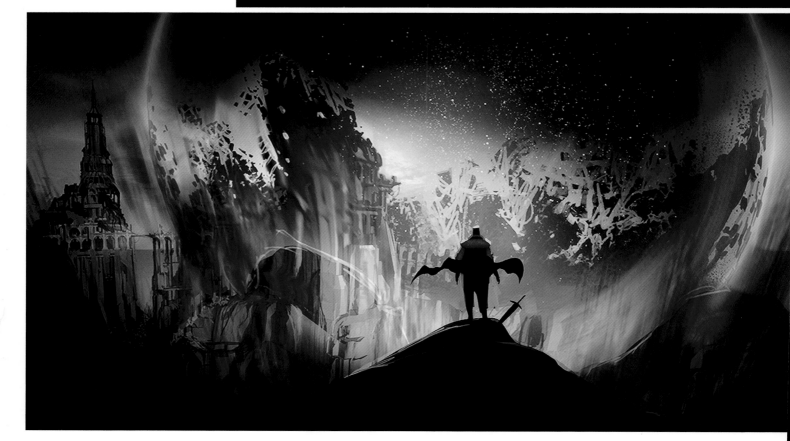

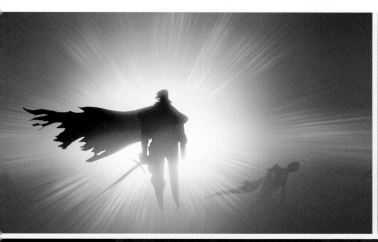
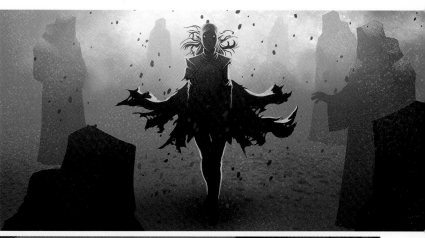
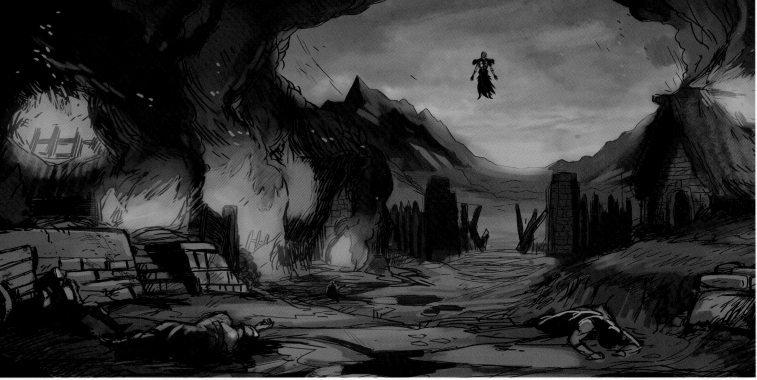
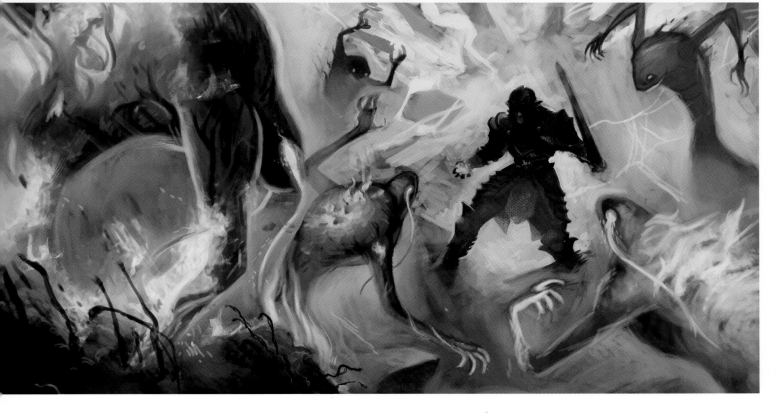

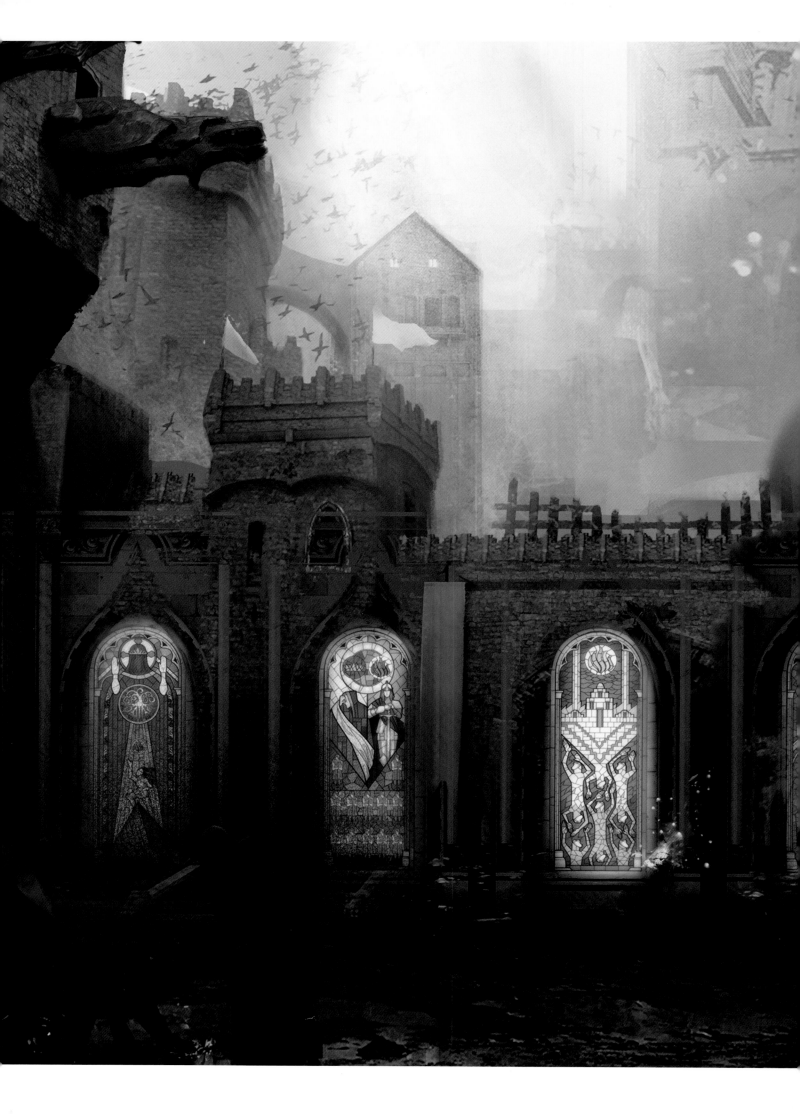

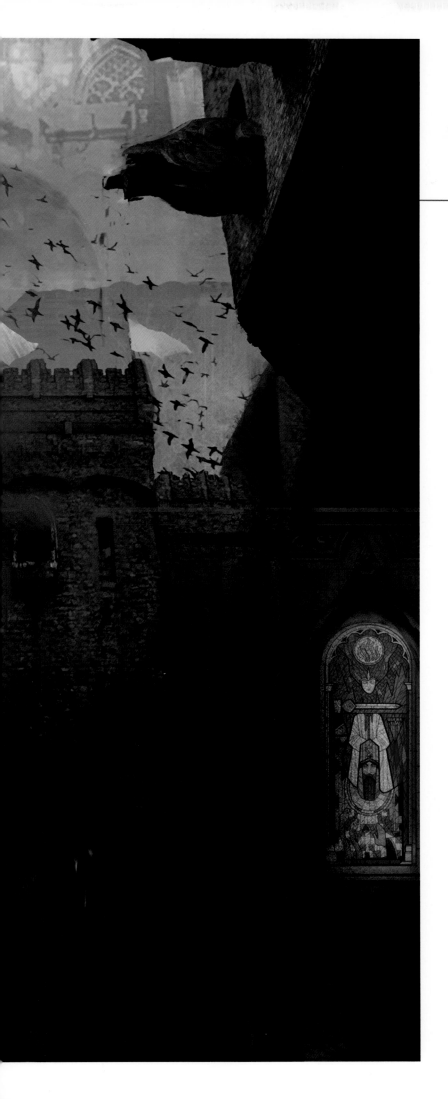

IN HUSHED WHISPERS

The sweat on a warrior's brow. Scars and freckles. A face flush from battle. It is this level of detail that truly brings the characters of *Inquisition* to life.

With character art, we set out to create living, breathing people with their own visual personalities. The way they looked needed to reflect the characters as they were written. Consider Dorian and Cole, two potential followers who come from very different places. One is a prim mage of some standing in Tevinter who is very much used to the finer things life affords. The other is a confused mess of a young man awkwardly trying to find his place in the world. Dorian drapes himself in luxurious cloth. His facial hair, much like the rest of him, is deliberate and painstakingly groomed. Cole, in contrast, dresses in dark rags. He's pale, with mussed hair and bags under eyes so big they're childlike, implying an innocence central to his character. Still, if either gets in a dustup or runs through mud while bound for Redcliffe or Therinfal Redoubt, they're going to get a little dirty.

Details like this make Thedas more than just a fantasy world. They make it feel real.

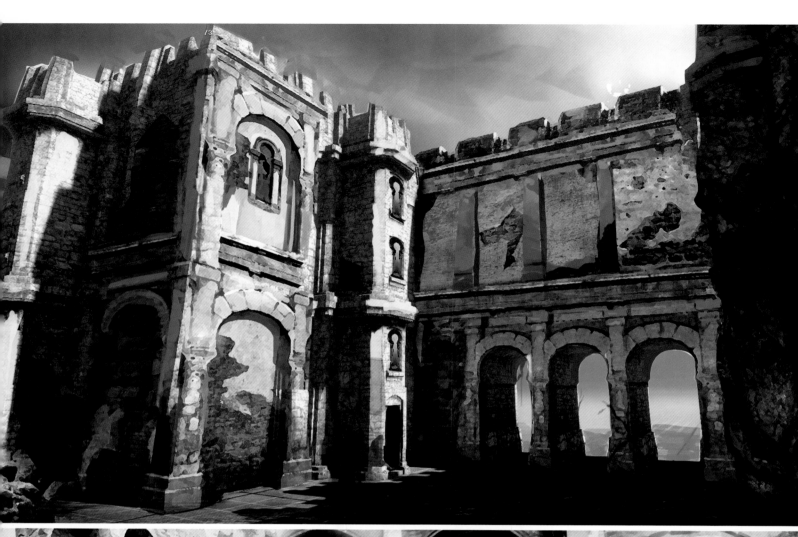

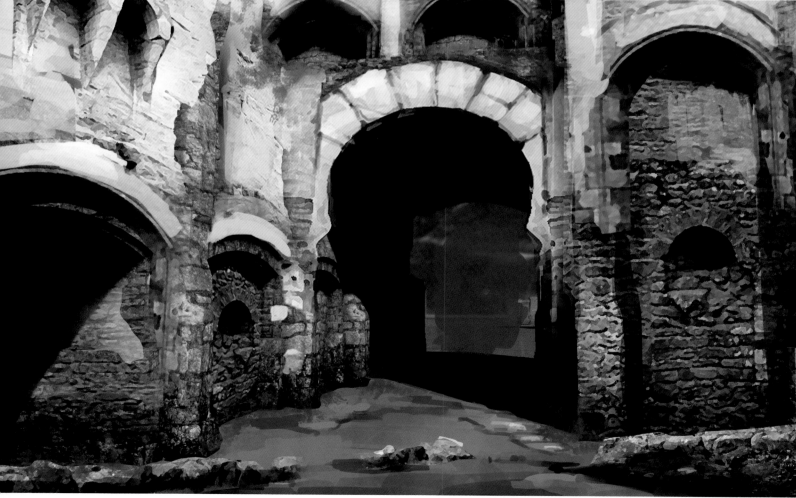

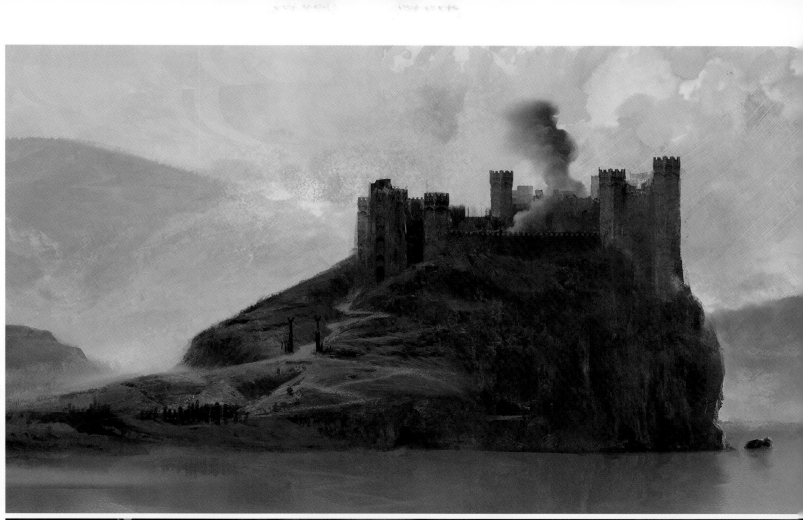

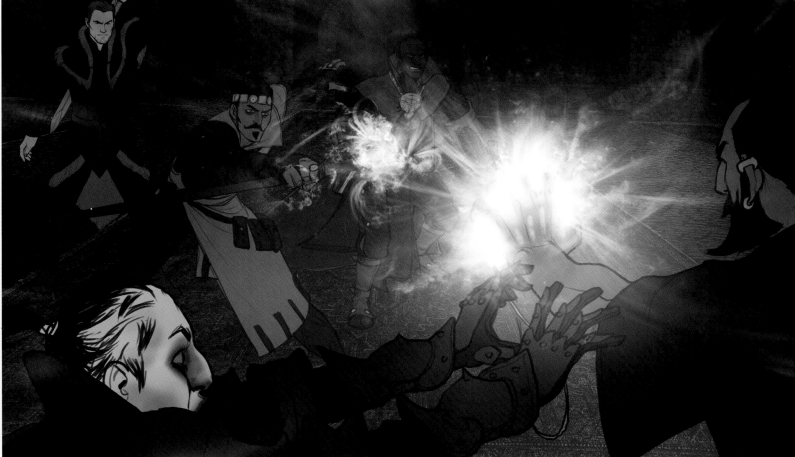

A SECOND VISIT The move to a new engine meant that we could revisit classic locations, open the doors, and explore the surrounding landscape.

Bottom: Even in the earliest stages of development, it can be useful to explore key scenes through storyboards and paintings.

Opposite: For the sake of color, we embraced the "red" in "Redcliffe," contrasting it with pale plaster. Sometimes the literal solution is also the most elegant.

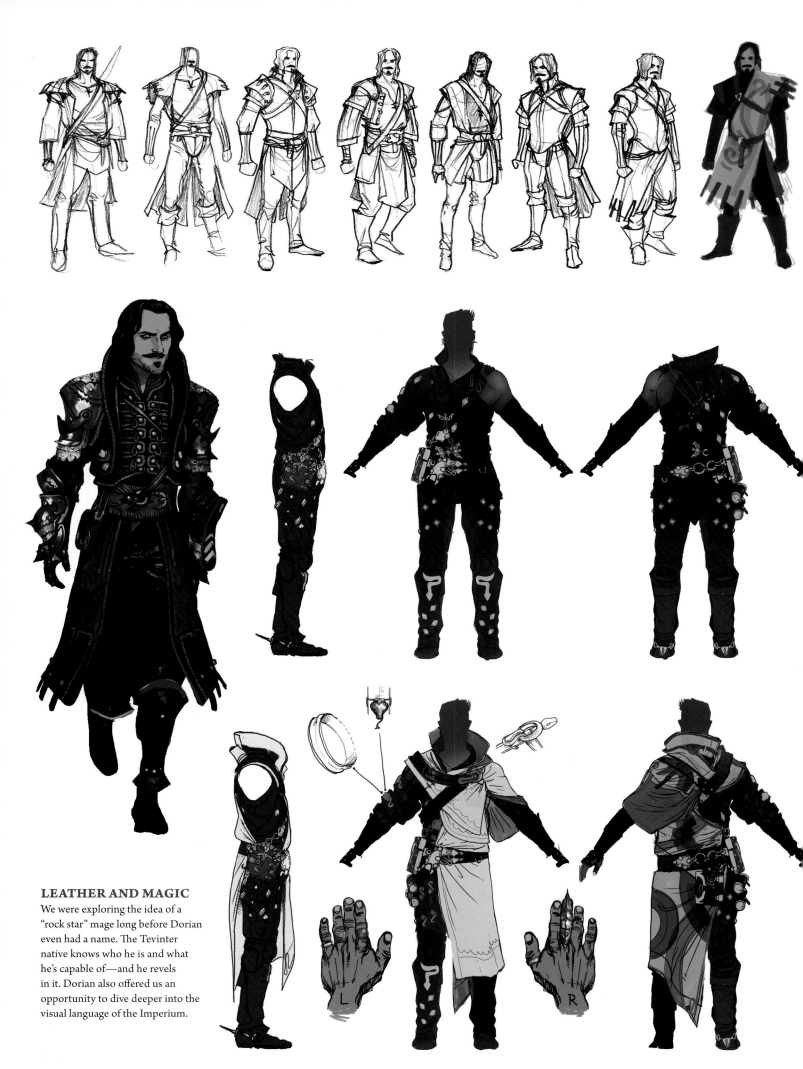

LEATHER AND MAGIC

We were exploring the idea of a "rock star" mage long before Dorian even had a name. The Tevinter native knows who he is and what he's capable of—and he revels in it. Dorian also offered us an opportunity to dive deeper into the visual language of the Imperium.

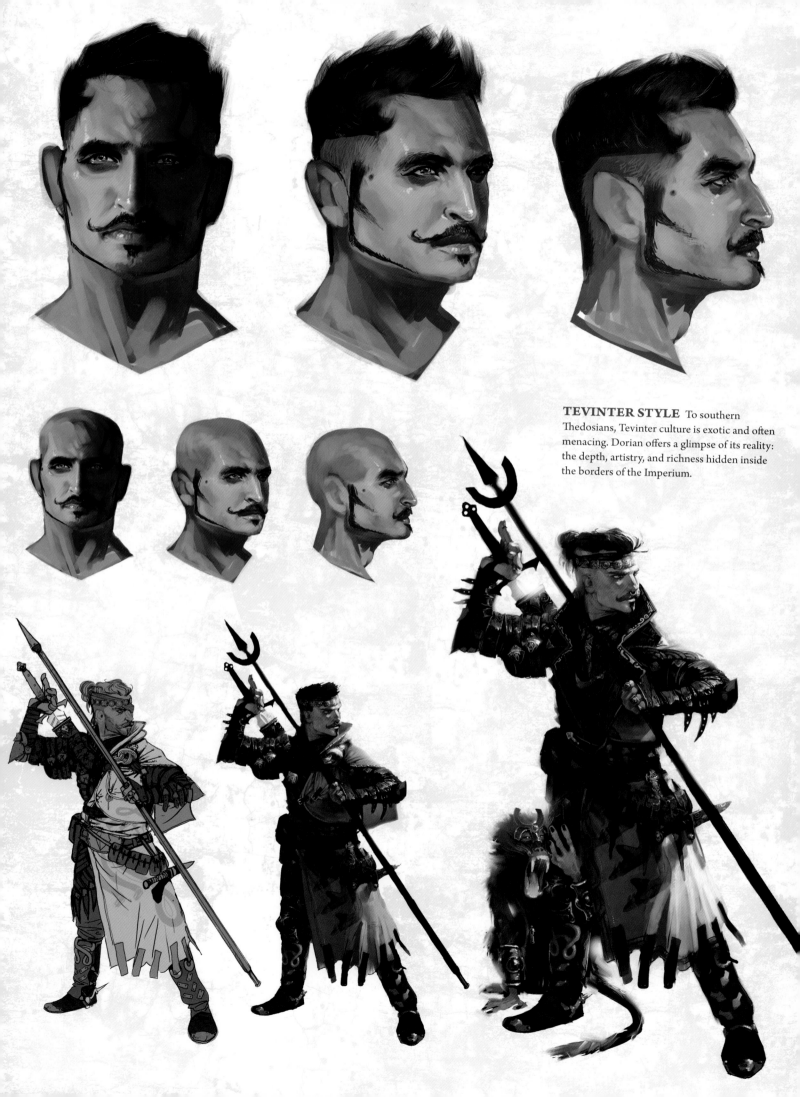

TEVINTER STYLE To southern Thedosians, Tevinter culture is exotic and often menacing. Dorian offers a glimpse of its reality: the depth, artistry, and richness hidden inside the borders of the Imperium.

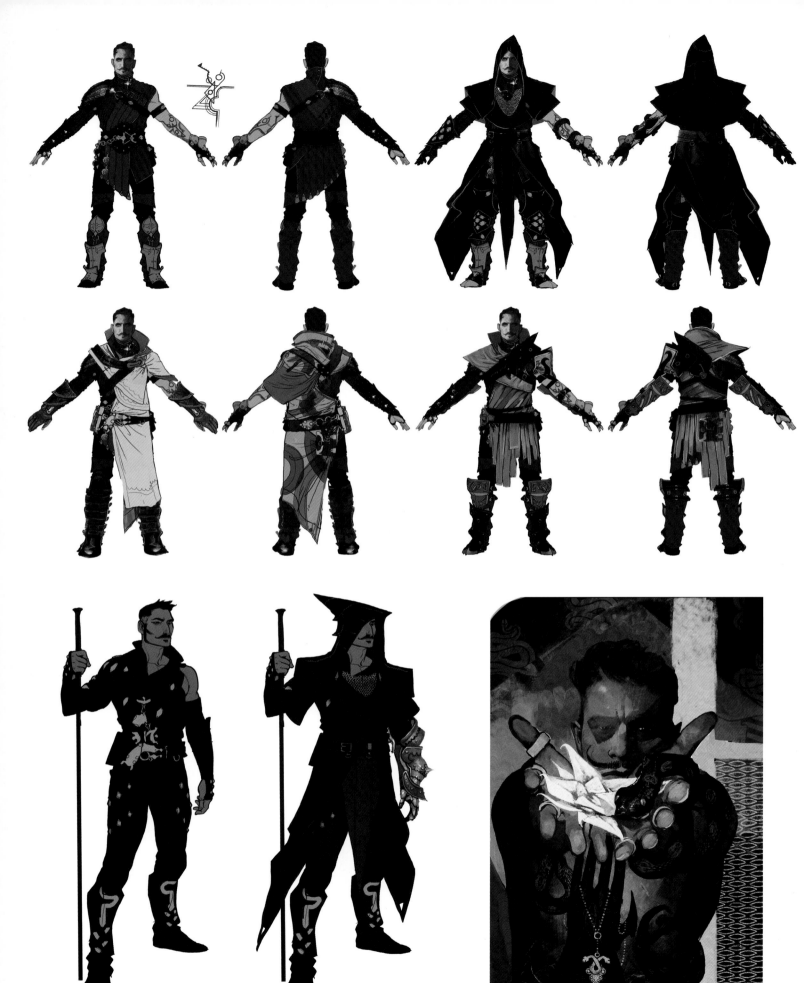

SARTORIAL SORCERY Dorian wears the mage robes of the Imperium, but like a good black sheep, he makes them his own.

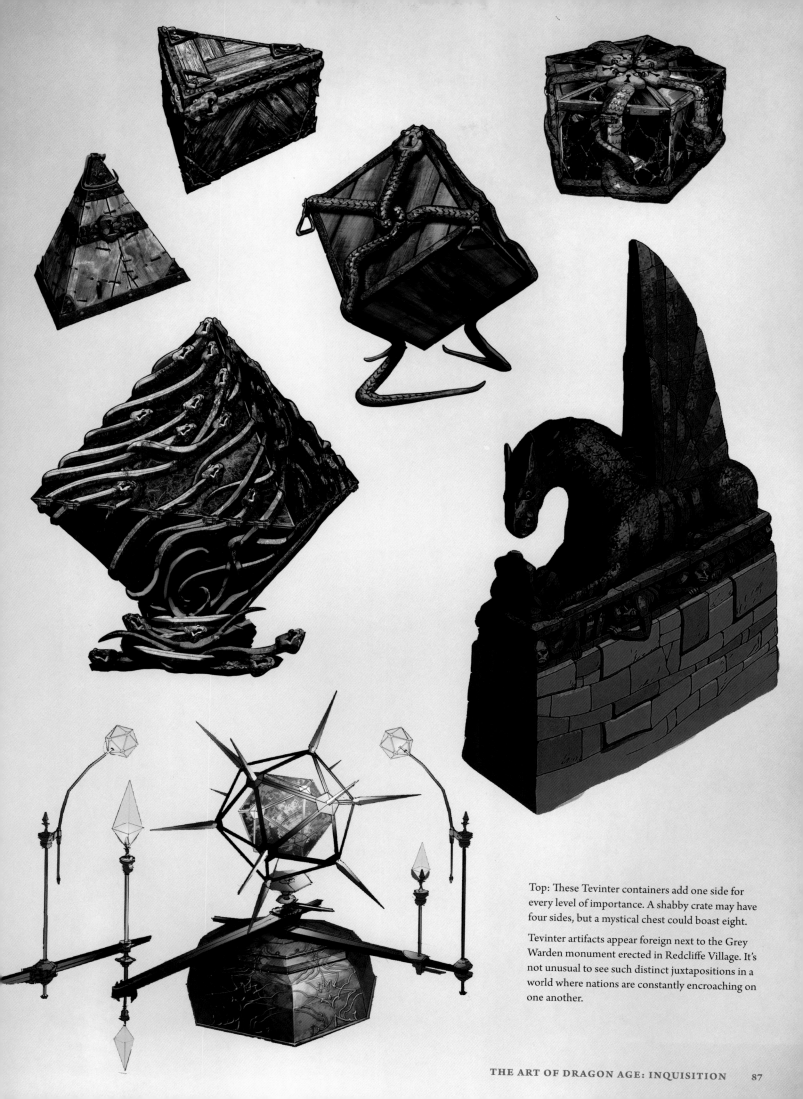

Top: These Tevinter containers add one side for every level of importance. A shabby crate may have four sides, but a mystical chest could boast eight.

Tevinter artifacts appear foreign next to the Grey Warden monument erected in Redcliffe Village. It's not unusual to see such distinct juxtapositions in a world where nations are constantly encroaching on one another.

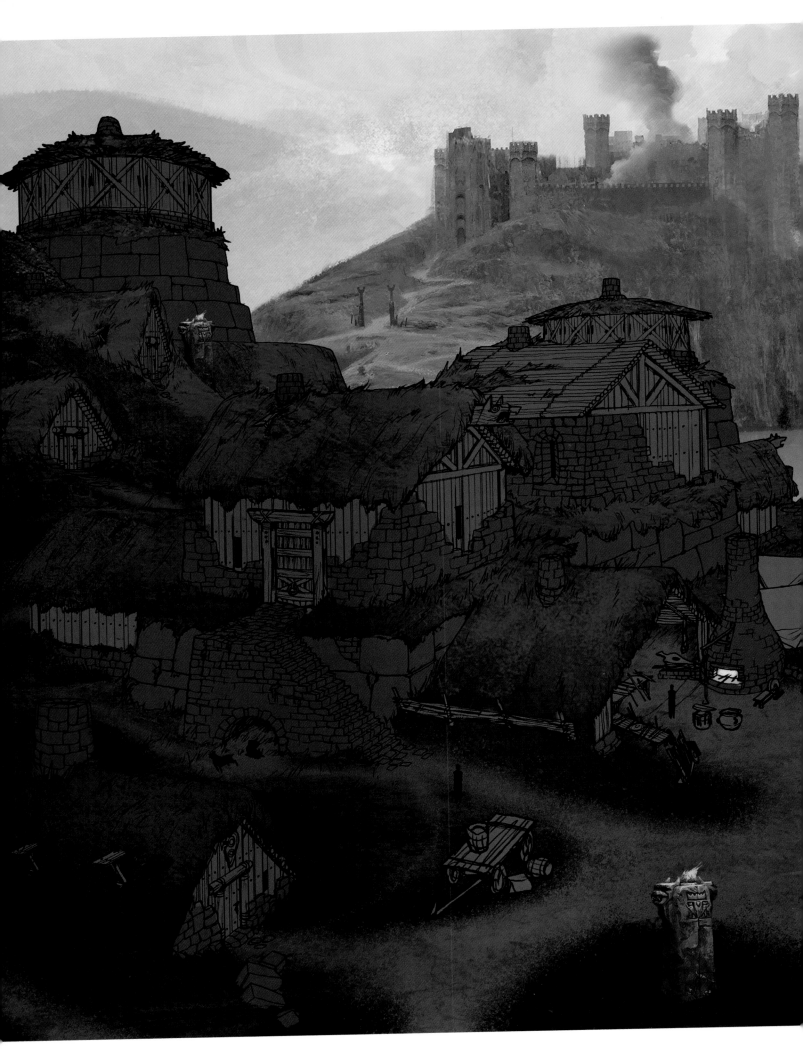

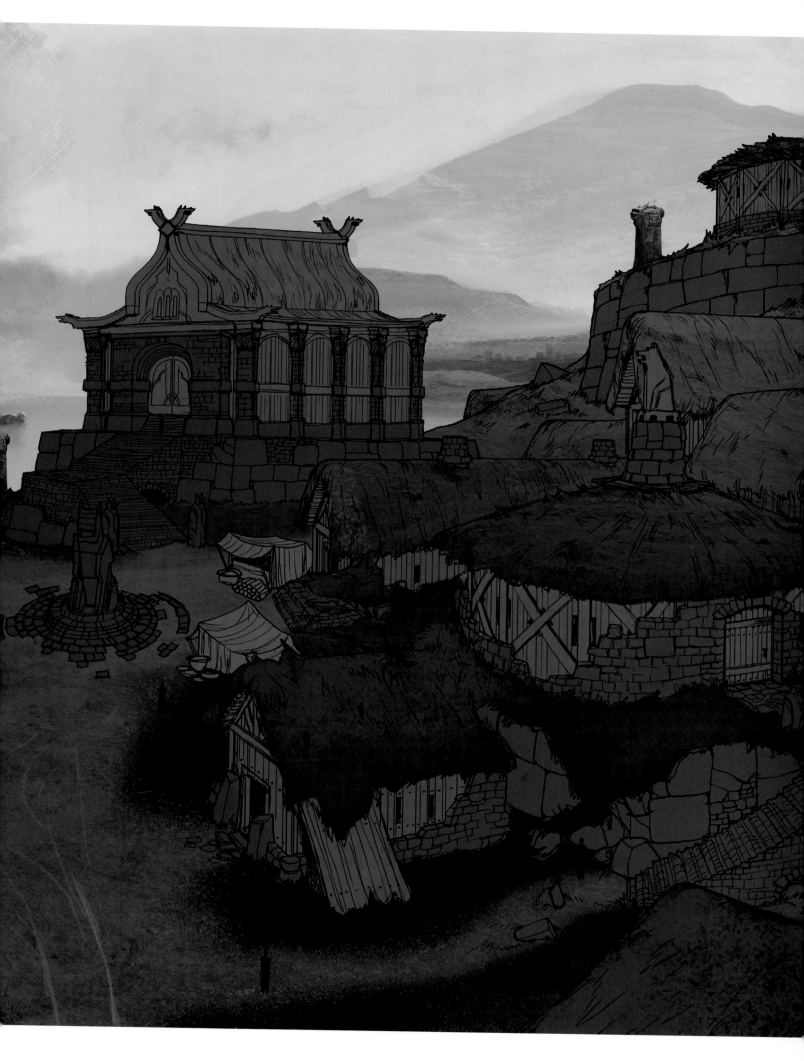

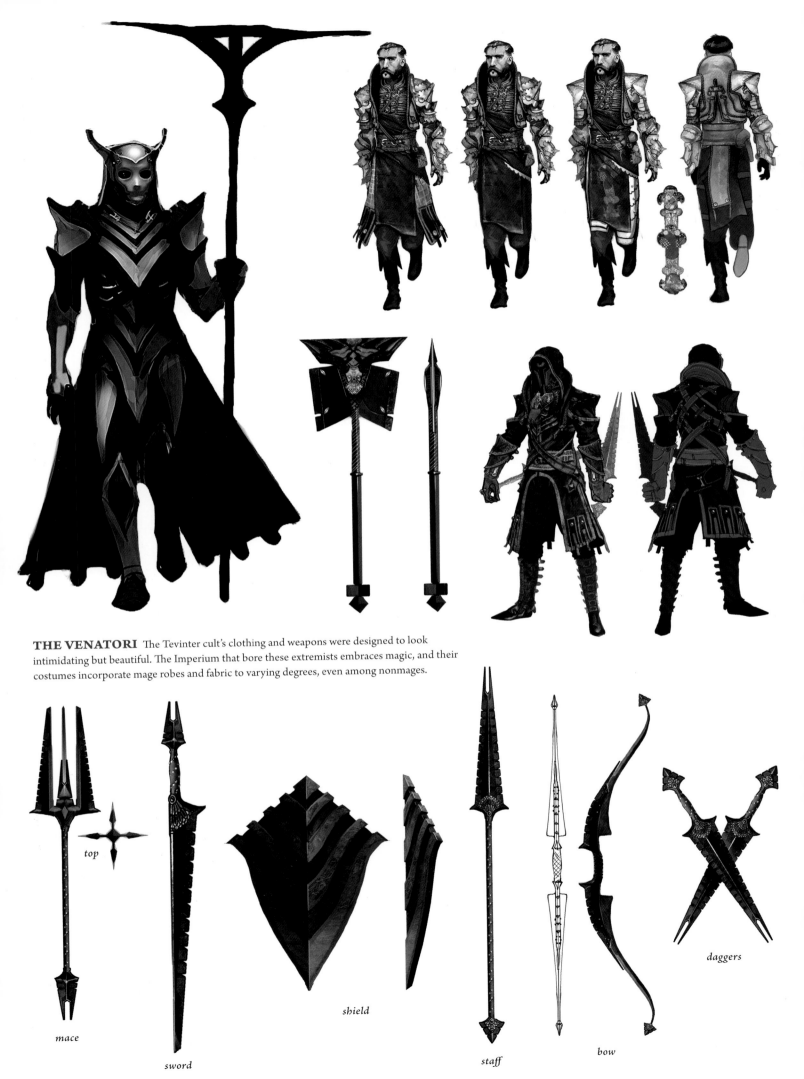

THE VENATORI The Tevinter cult's clothing and weapons were designed to look intimidating but beautiful. The Imperium that bore these extremists embraces magic, and their costumes incorporate mage robes and fabric to varying degrees, even among nonmages.

top

mace

sword

shield

staff

bow

daggers

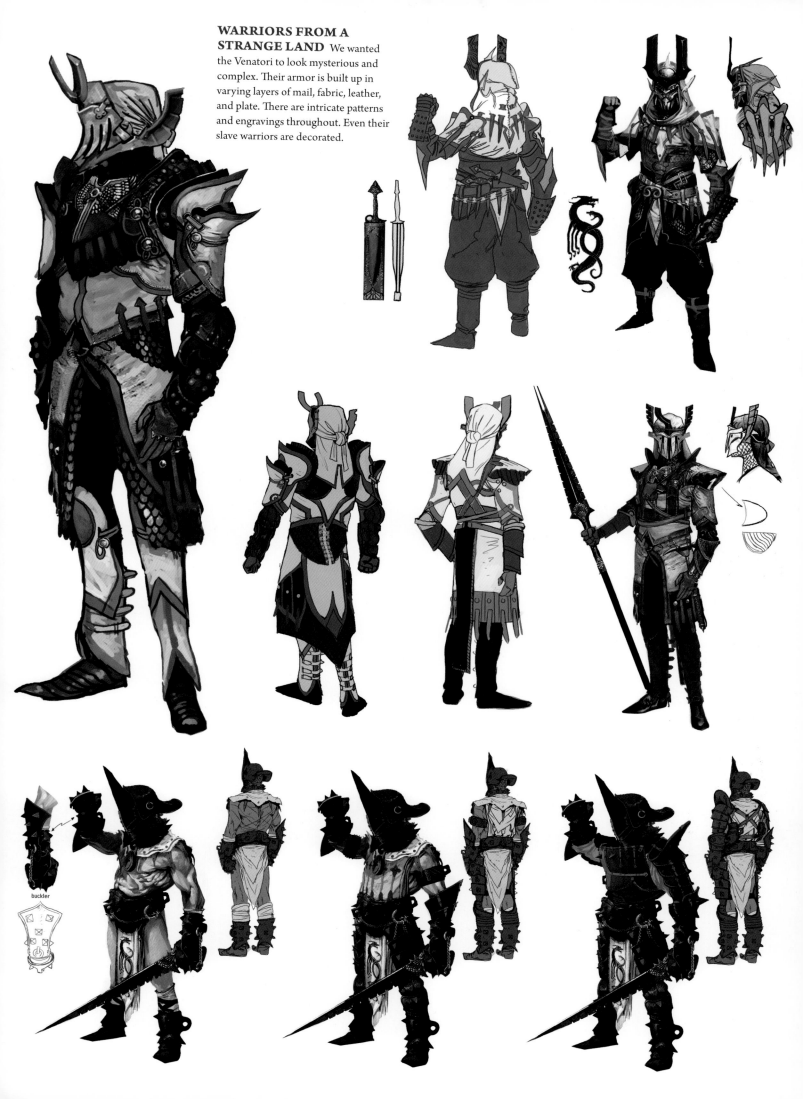

WARRIORS FROM A STRANGE LAND We wanted the Venatori to look mysterious and complex. Their armor is built up in varying layers of mail, fabric, leather, and plate. There are intricate patterns and engravings throughout. Even their slave warriors are decorated.

buckler

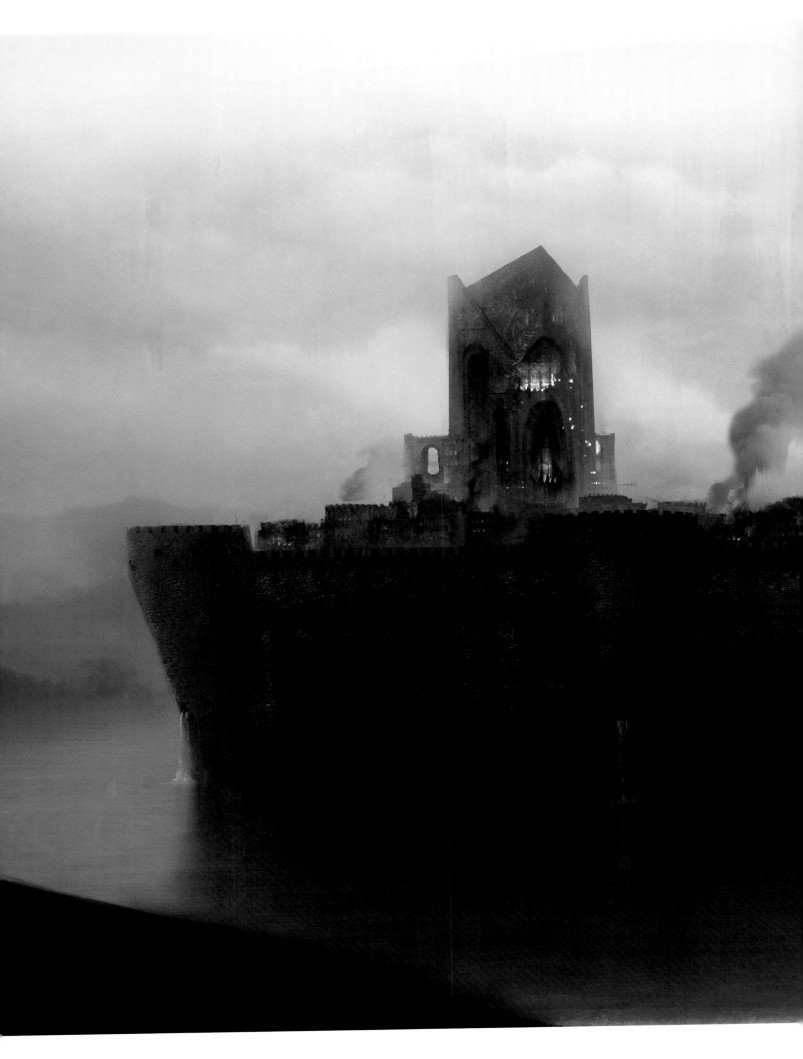

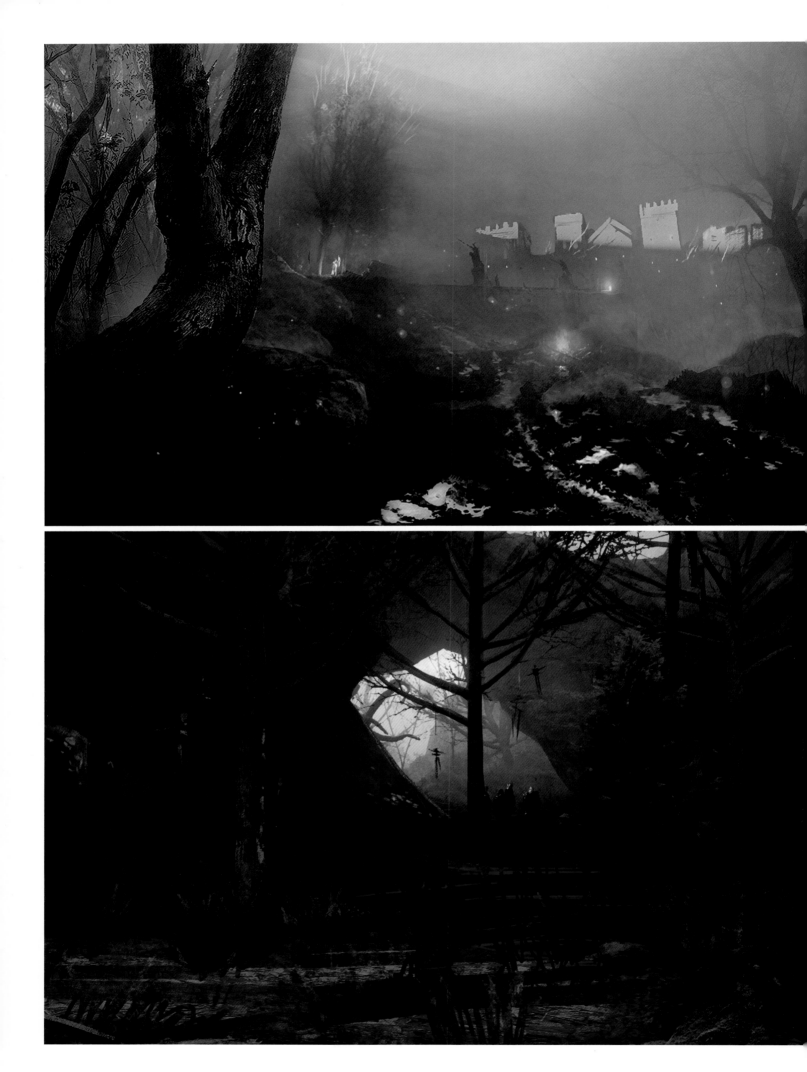

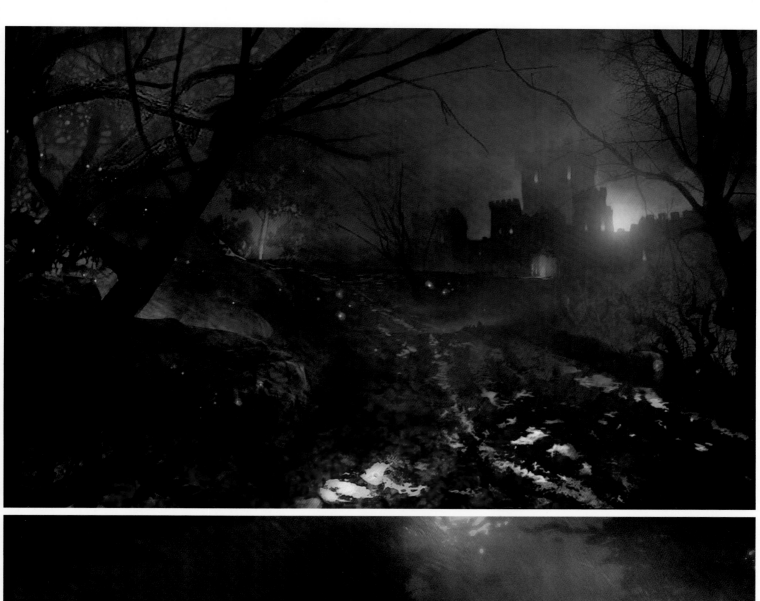

CROSSING THE THRESHOLD Therinfal Redoubt straddles two worlds. We explored lighting and color schemes to telegraph the surreal nature of what lies within.

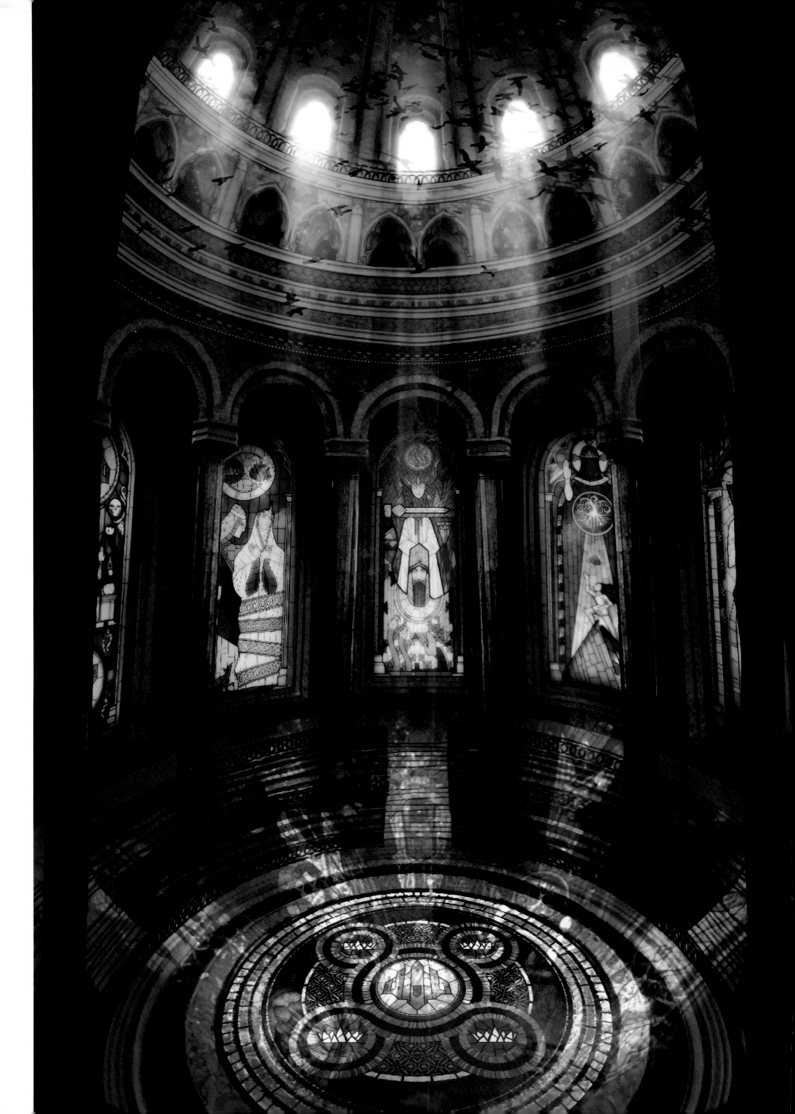

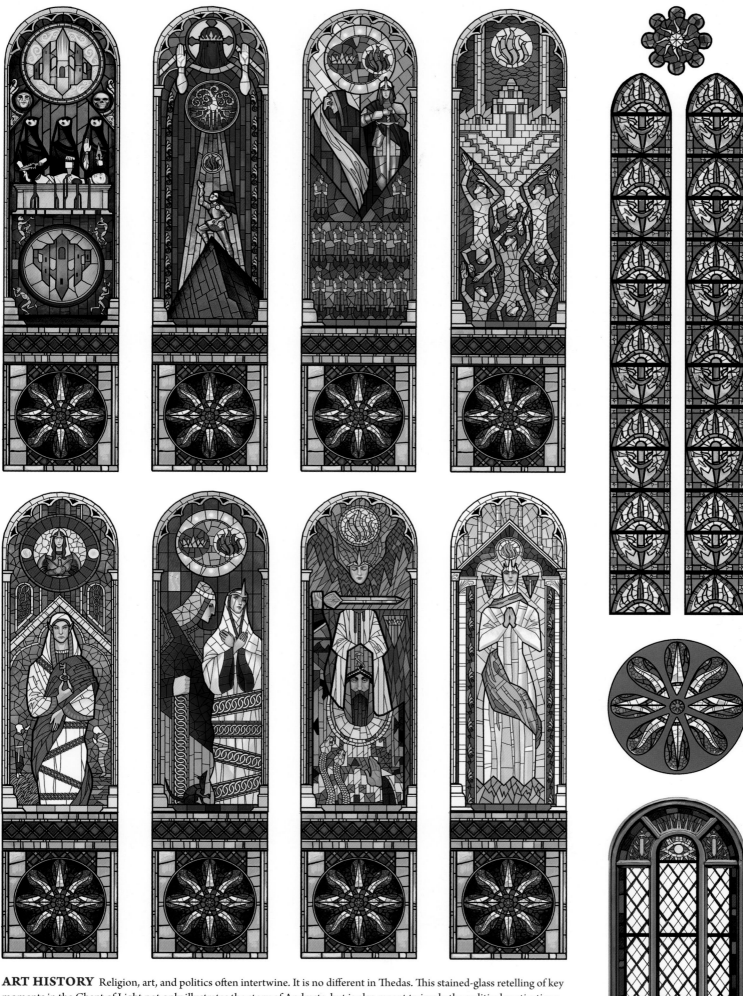

ART HISTORY Religion, art, and politics often intertwine. It is no different in Thedas. This stained-glass retelling of key moments in the Chant of Light not only illustrates the story of Andraste, but is also meant to imply the political motivations of its creators.

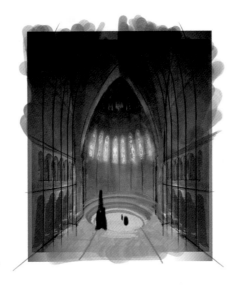

CHOICE SPOT FOR A BATTLE

One idea explored for the final combat at Therinfal Redoubt featured an open rooftop with a clear panoramic view of a landscape very much in turmoil. The sloped floor keeps the ramparts below eye level, offering an unobstructed view of the chaos.

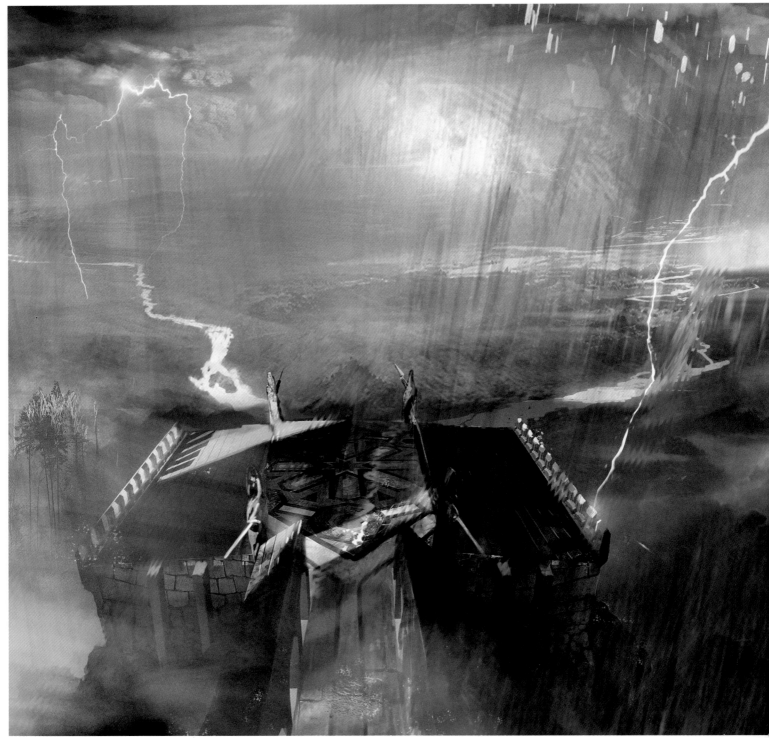

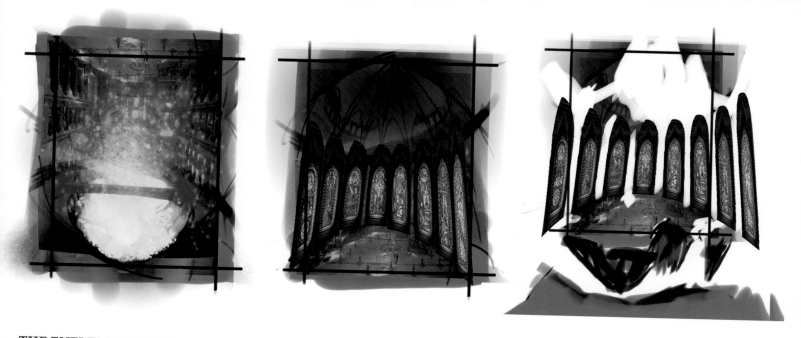

THE ENEMY AMONG US
Things are often not as they seem in Thedas. For our work on Therinfal Redoubt, we drew from the visual language of classic horror movies to elevate the sense of menace. Simple color was used as a visual anchor to help the scene read more clearly. The little icons in the corner indicate game play camera, cinematic camera, and dialogue choices.

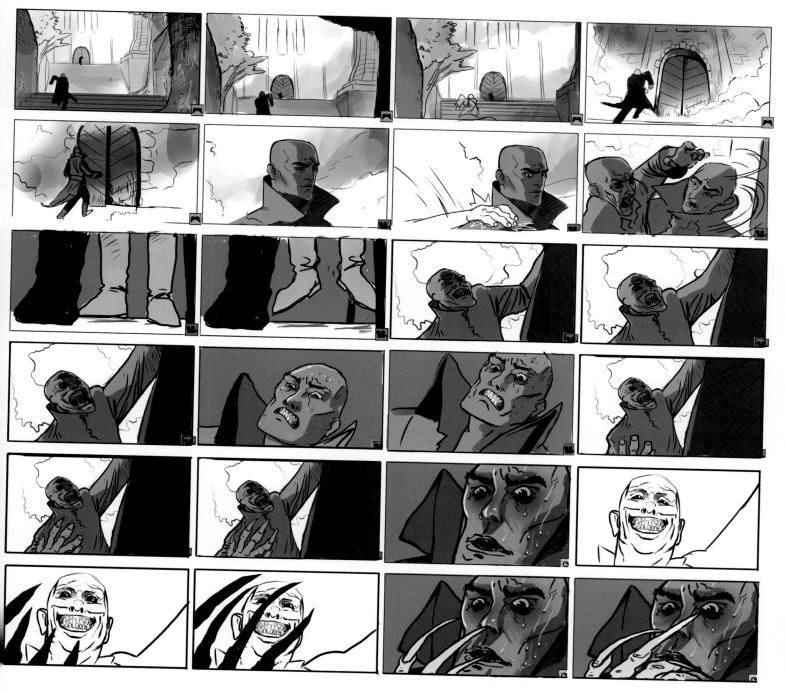

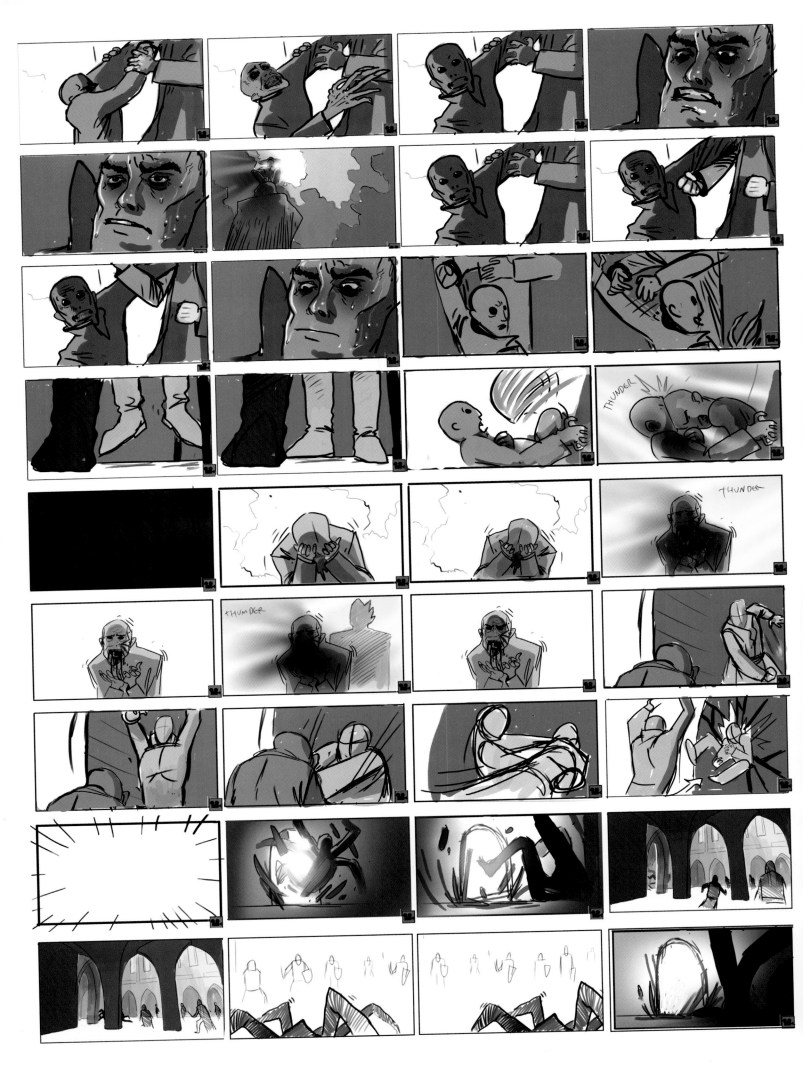

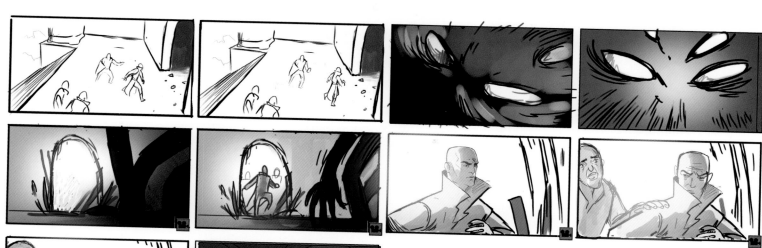

"kalushirat!"

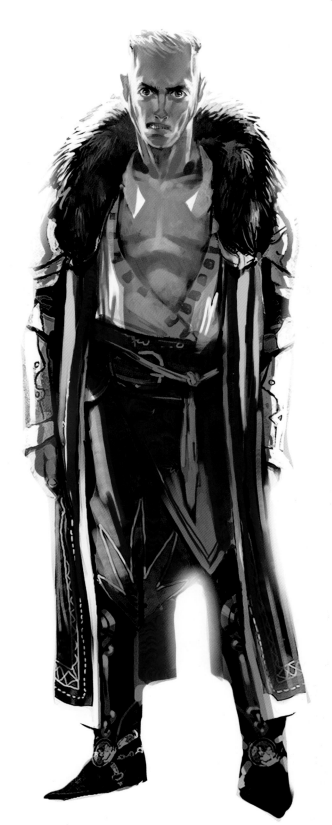

SOMETHING'S OFF
In this character study, we wanted to depict the impersonation of human expression. If the final images are unsettling, it is because they mimic something genuine.

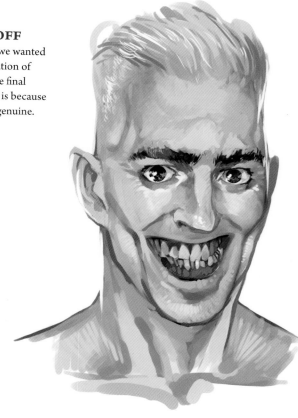

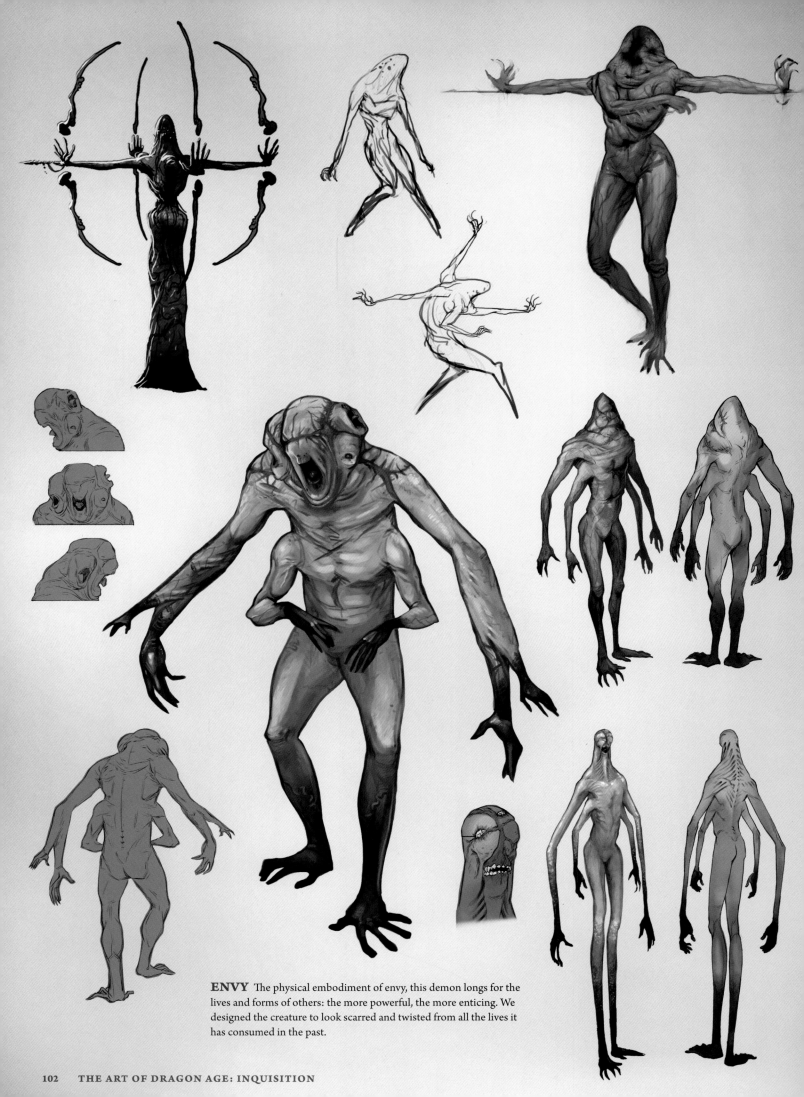

ENVY The physical embodiment of envy, this demon longs for the lives and forms of others: the more powerful, the more enticing. We designed the creature to look scarred and twisted from all the lives it has consumed in the past.

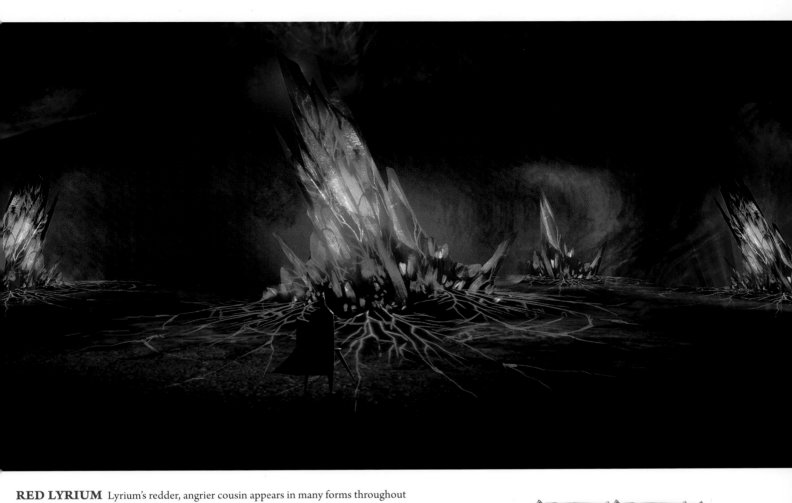

RED LYRIUM Lyrium's redder, angrier cousin appears in many forms throughout Thedas after the Breach is torn open. We created a consistent visual language that could be applied to its many manifestations. Crystal "tumors" grow out of, and are sustained by, "veins."

Below: Red lyrium is insidious, and prolonged exposure can lead to infection in just about anything, from templar supply caches to whatever statuary happens to be nearby.

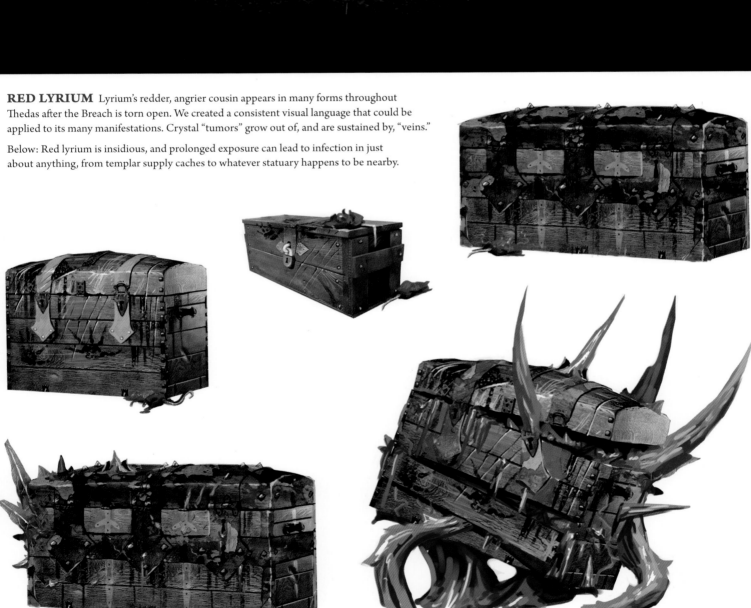

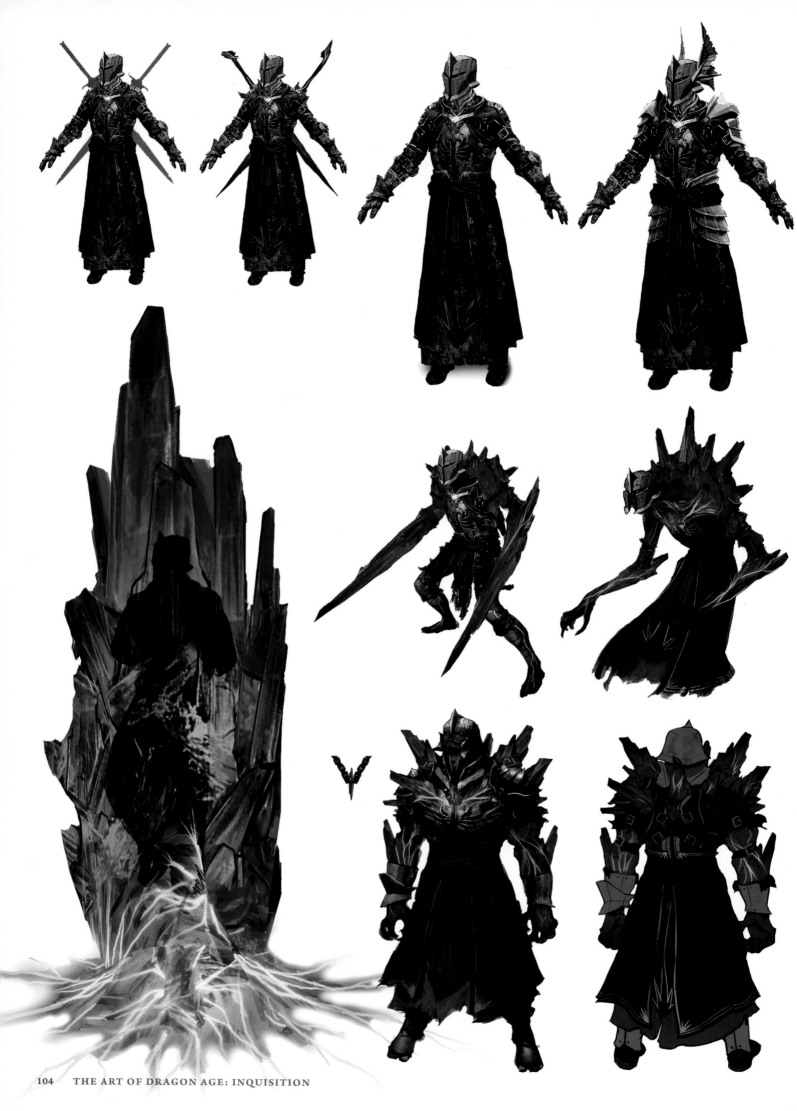

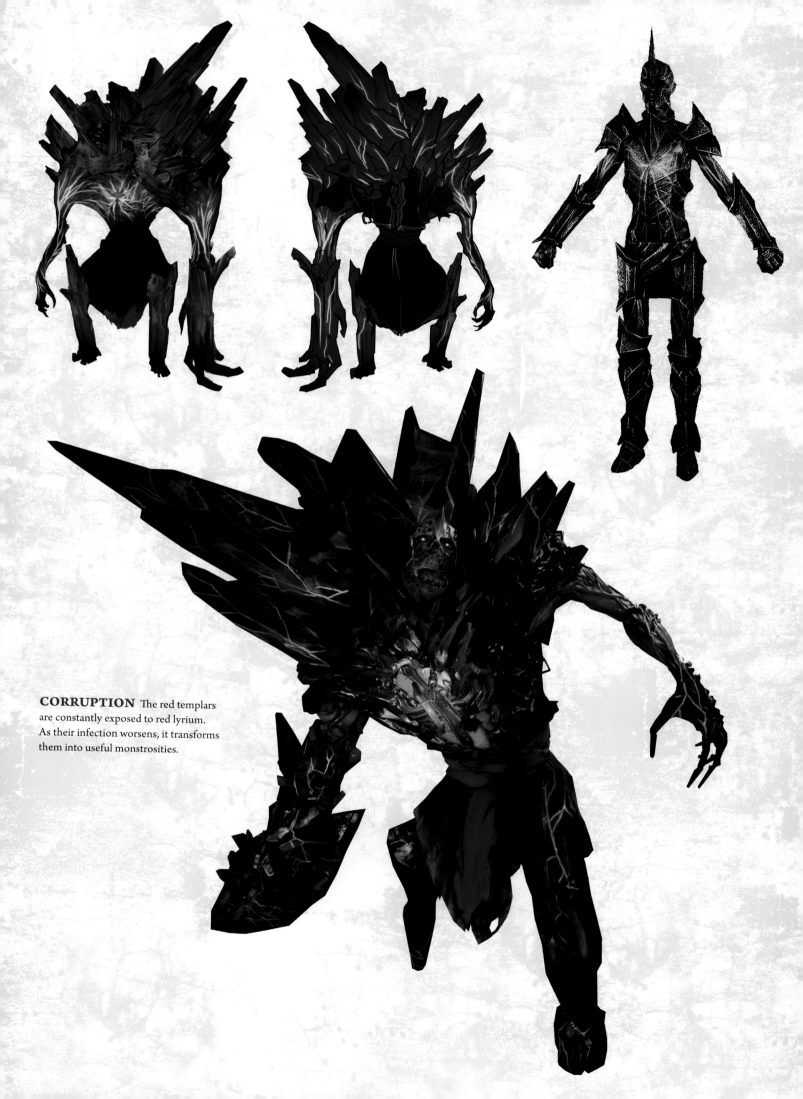

CORRUPTION The red templars are constantly exposed to red lyrium. As their infection worsens, it transforms them into useful monstrosities.

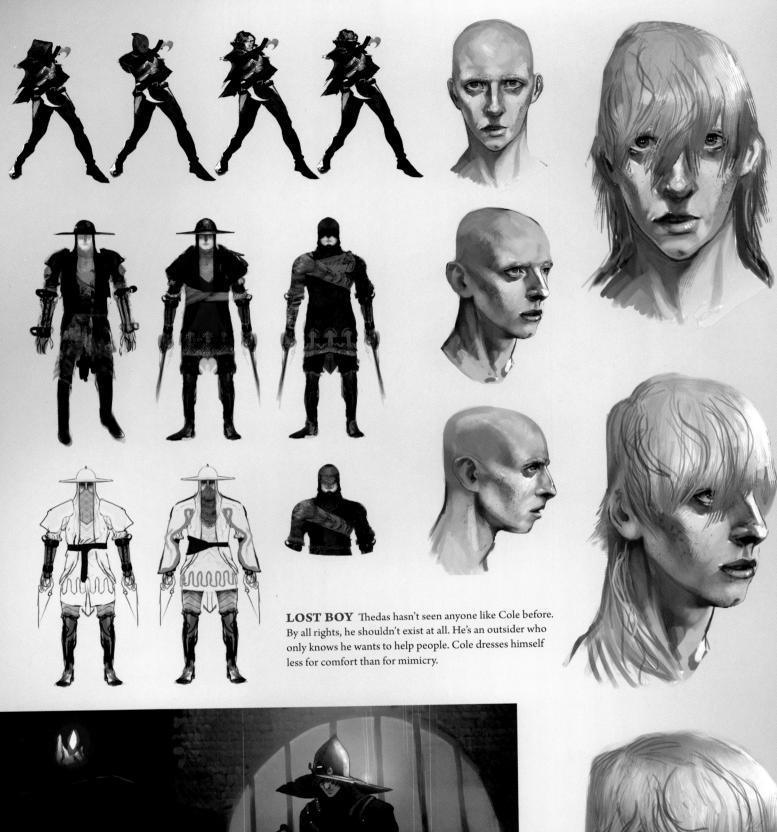

LOST BOY Thedas hasn't seen anyone like Cole before. By all rights, he shouldn't exist at all. He's an outsider who only knows he wants to help people. Cole dresses himself less for comfort than for mimicry.

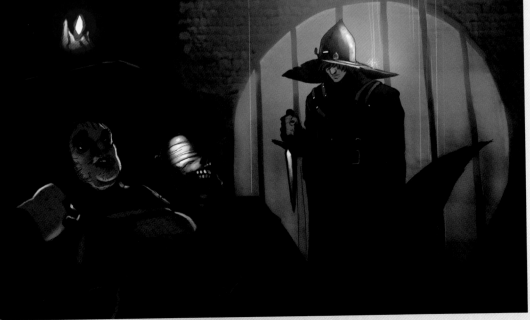

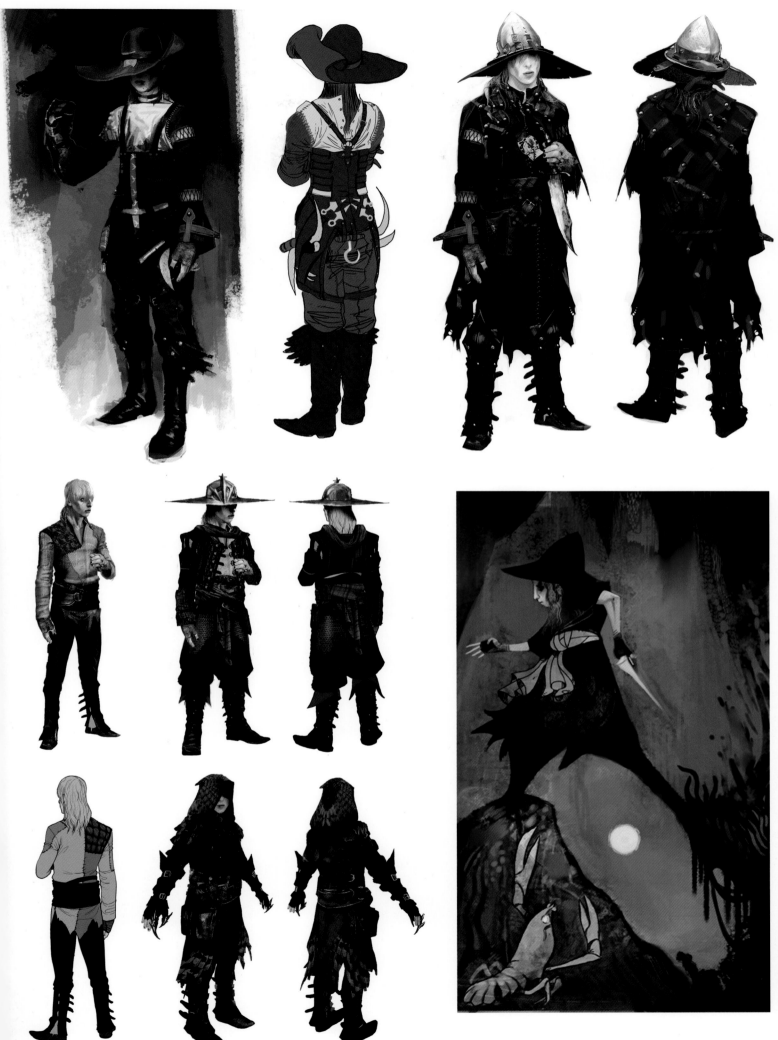

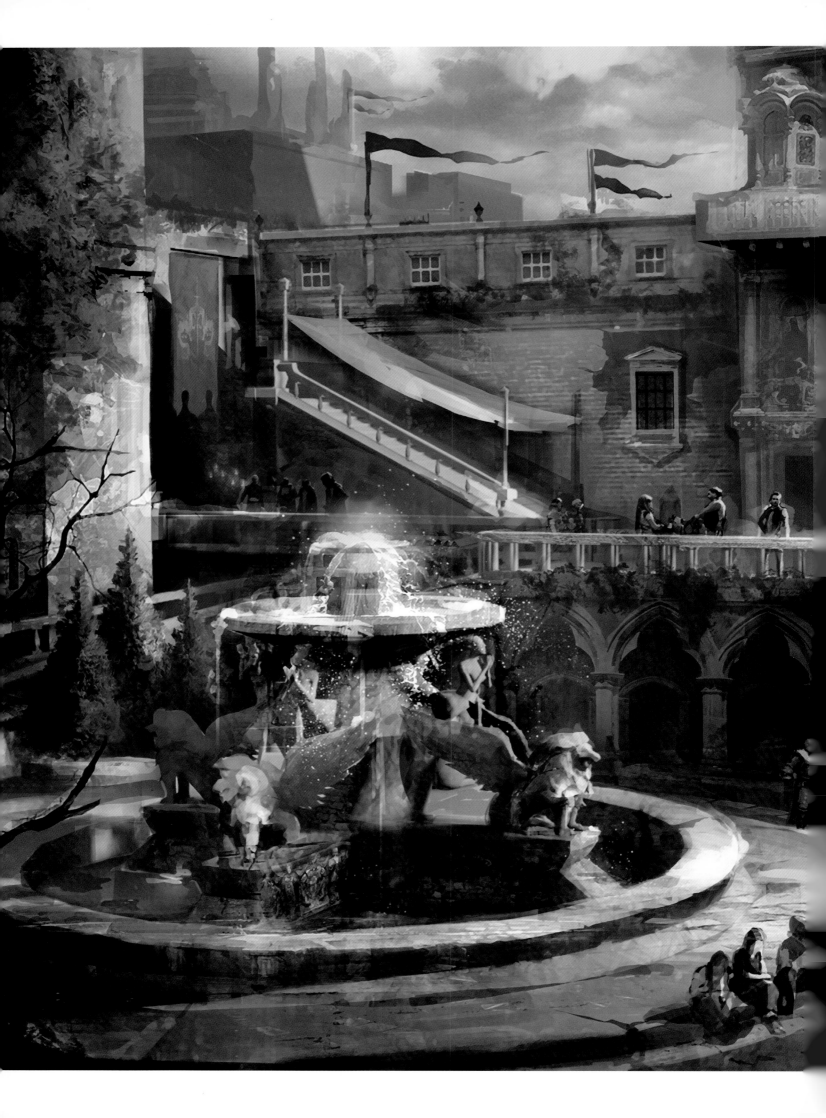

WICKED EYES & WICKED HEARTS

The culture of Orlais is all excess and appearances. We get to the heart of the nation's noble life in *Inquisition*, dropping players in the middle of grand markets and royal receptions. An emphasis on superficiality needed to be on full display in everything from Orlesian architecture to fashion, and even furniture. The richest nation in Thedas—and birthplace of the Chantry—may appear flawless at first glance, but it shows its cracks when you look just a little closer.

Orlesian cities have seen a lot of history. For the finer buildings, we were heavily influenced by secular Gothic architecture. Gold and white feature prominently, reminiscent of real-world religious centers such as Vatican City, and rare colors and materials imply the lengths to which Orlesians will go to make just the right impression. Over the ages, multiple, expensive renovations—made to keep up with trends and appearances—all but conceal the rough, unstable base Orlais is built upon: plaster over brick over rotting wood. In Orlais, it doesn't matter if something is weak so long as it doesn't *appear* weak.

This philosophy extends to Orlesian noble dress. Prominent figures don masks at parties and heels to battle; their clothing is made with rich dyes, complex patterns, and fine fabrics—as with the architecture, hiding all that is raw and imperfect about themselves under a carefully constructed veneer.

All this serves to make the dirty, poor, and ugly parts of Orlais more apparent in contrast. The extravagance of the capital, Val Royeaux, and royal centers such as the Winter Palace in Halamshiral, fades and frays the farther you get from anyone with real power.

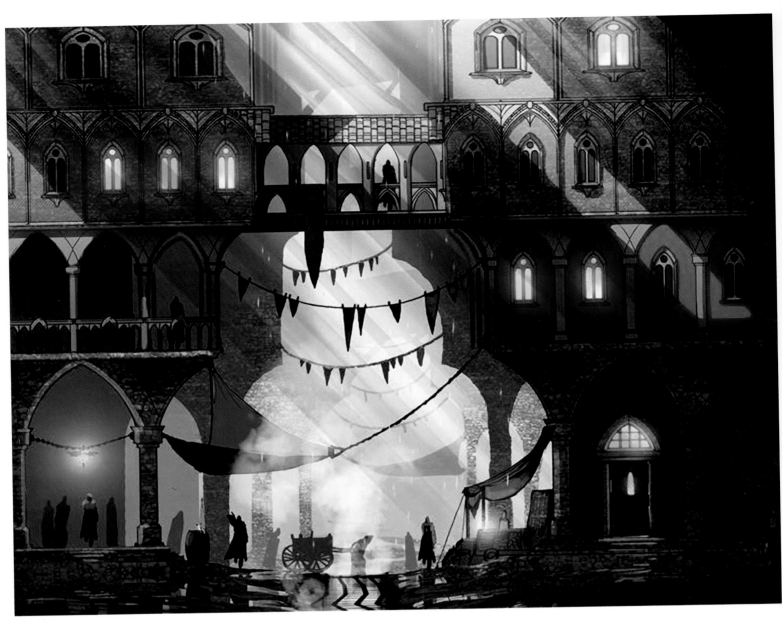

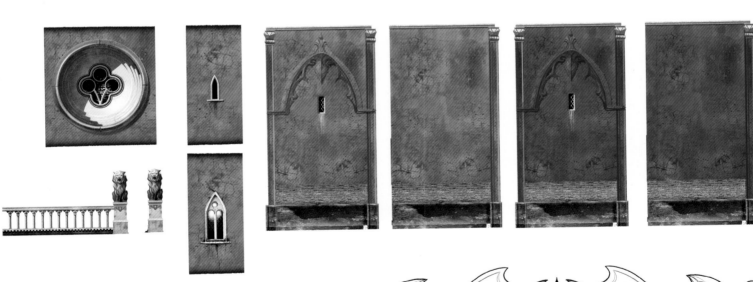

ORLESIAN STYLE In *Inquisition*, we spend a good deal of time in Orlais, a nation defined by decadence and corruption. It is also the birthplace of the Chantry, the prevailing religion of Thedas. In a lot of these early concepts, we explored the decay at the core of Orlais's extravagant exterior.

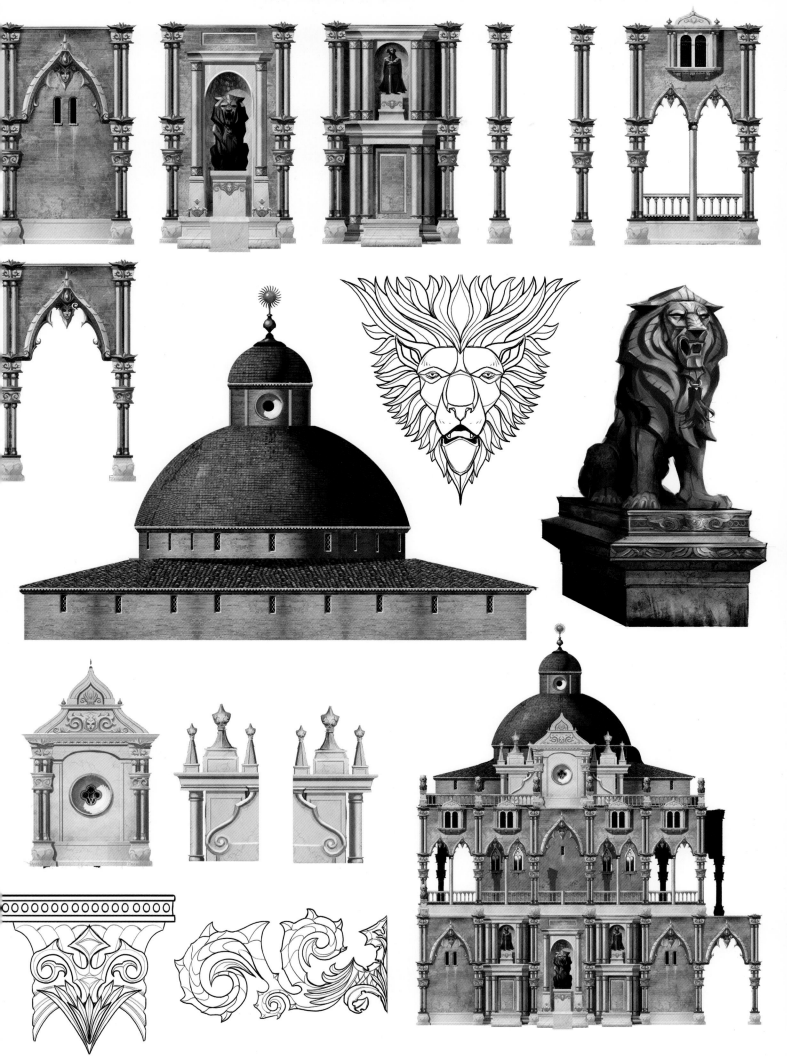

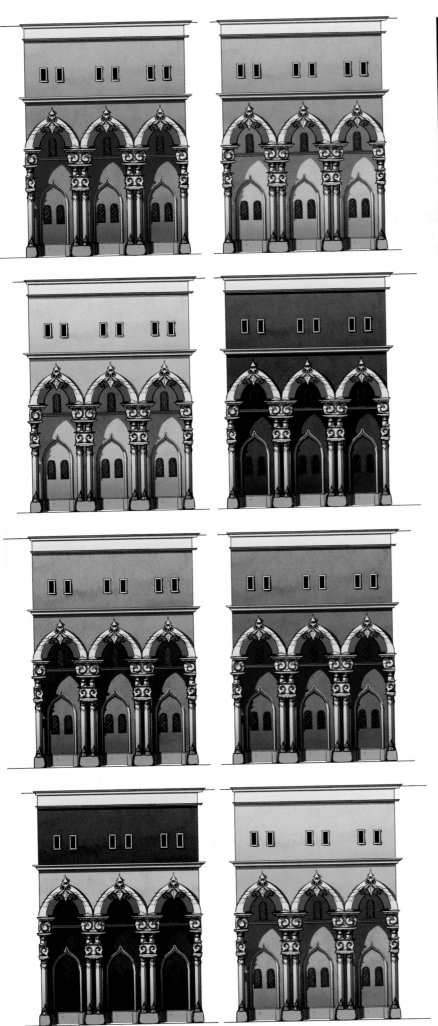

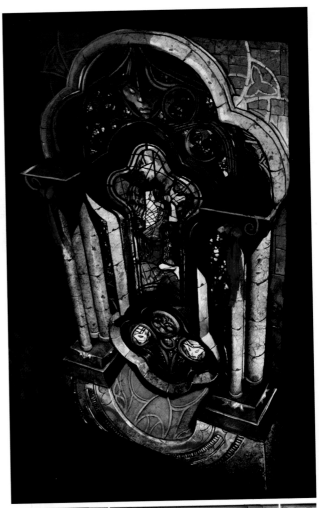

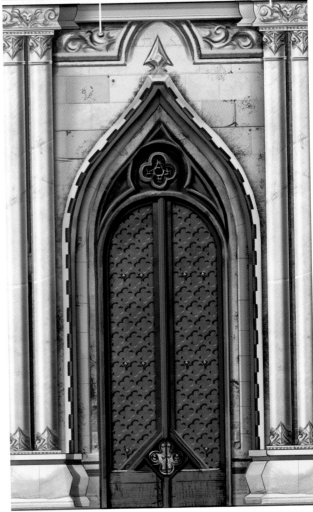

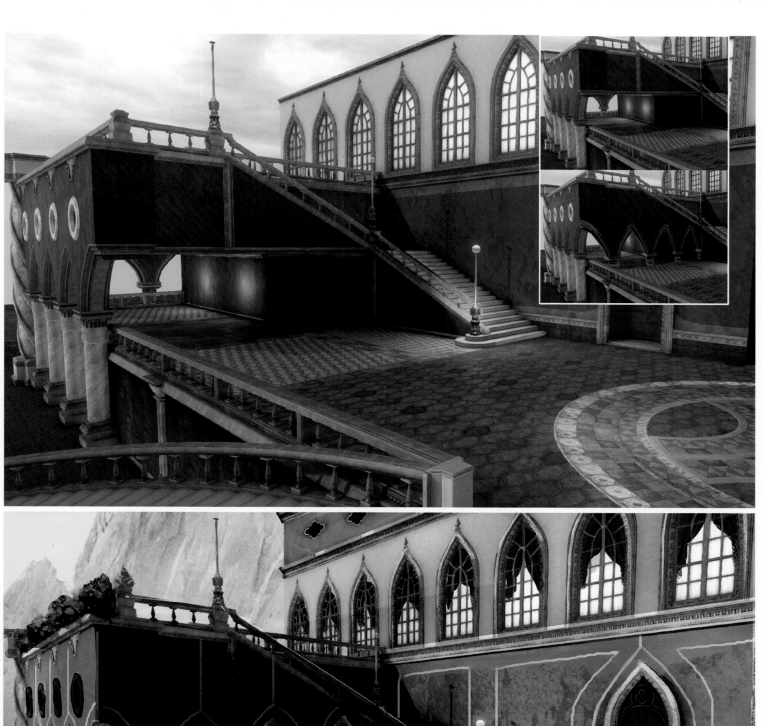

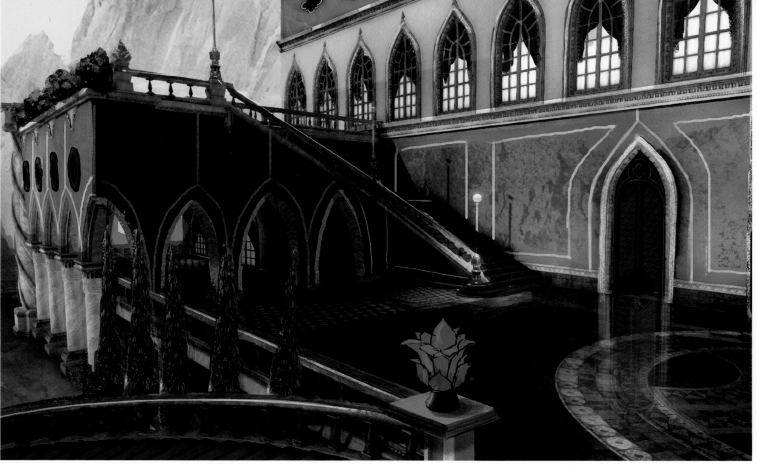

ORLESIAN COLOR Orlesian architects don't shy away from using color. They spare no expense in choosing their materials.

Opposite: These color studies were our timid first steps in making Orlais visually distinct. Blue, gold, and white became typical of Orlesian nobility.

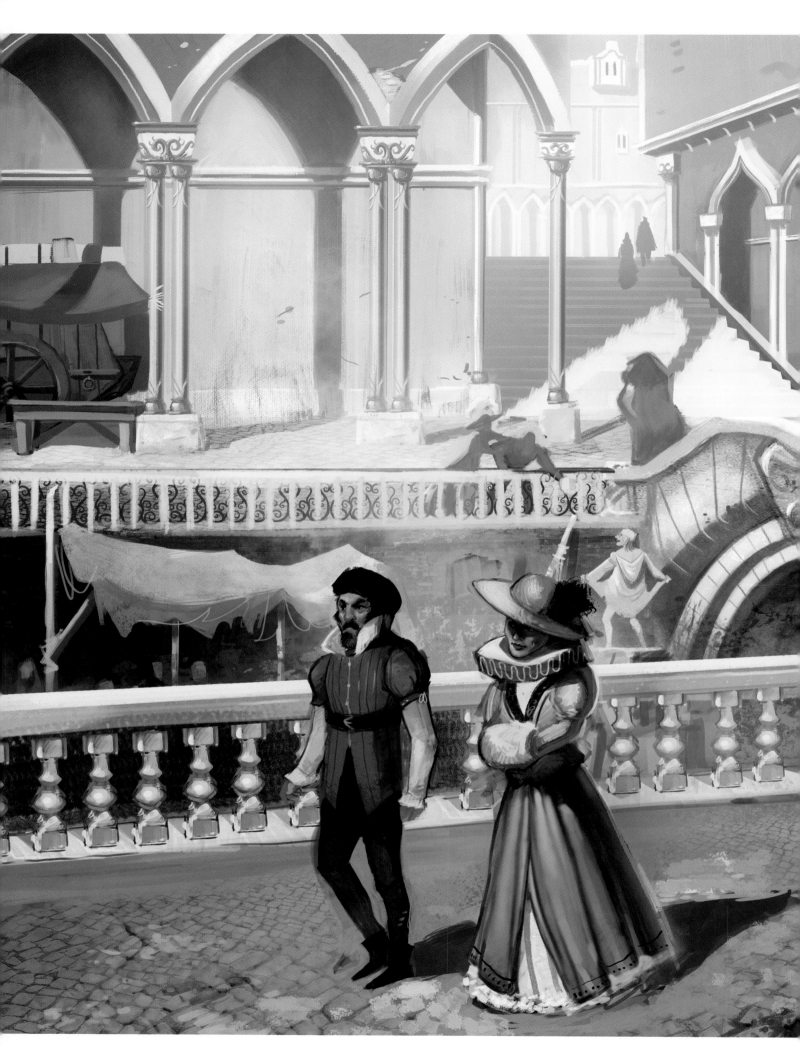

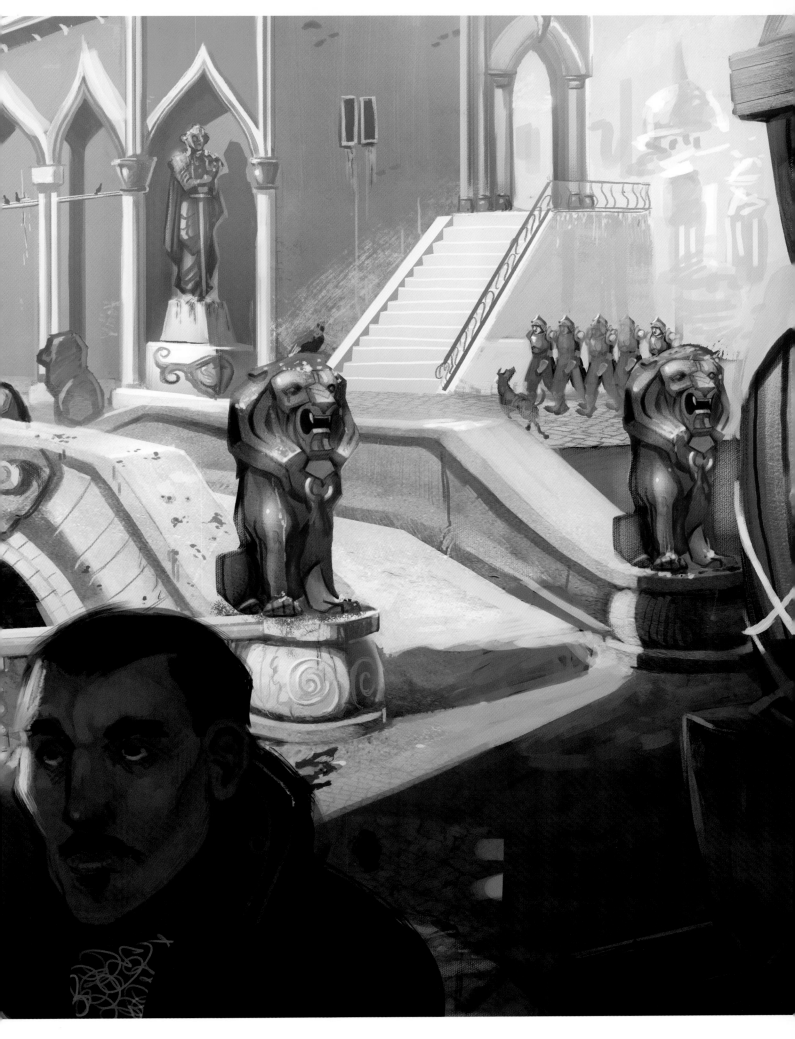

ORLESIAN DETAIL Even the most common objects in Orlais are built with a sense of flair. Aesthetics trump practicality among Orlesians, and what falls out of fashion may fall into disrepair.

Opposite top: White marble with gold details became the signature for Orlesian interiors. There is an absurdity to their aesthetics when compared to a culture such as Ferelden's, where sturdy buildings are made chiefly to withstand the harsh elements and harsher way of life.

Opposite bottom: Early concepts of Val Royeaux imagined a drained canal system inhabited by a slum class. We abandoned it because it felt too similar to Kirkwall.

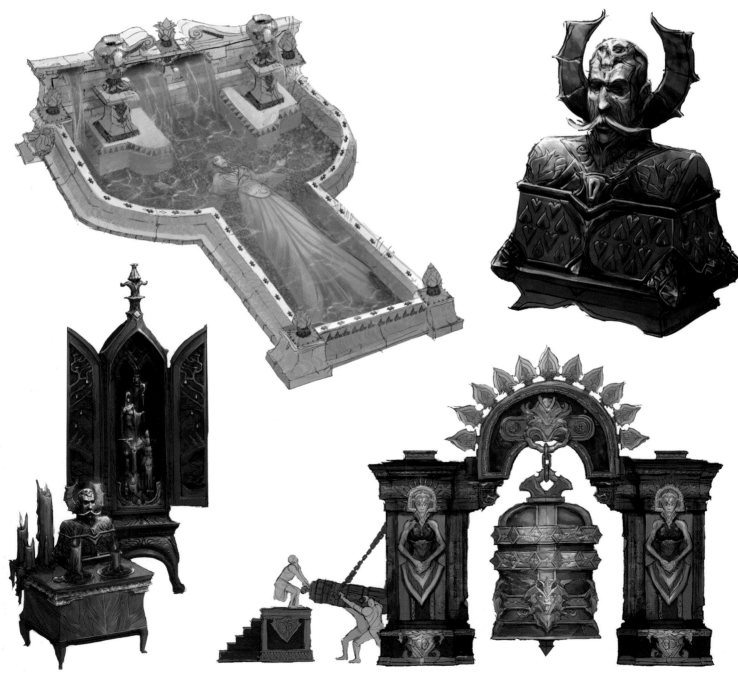

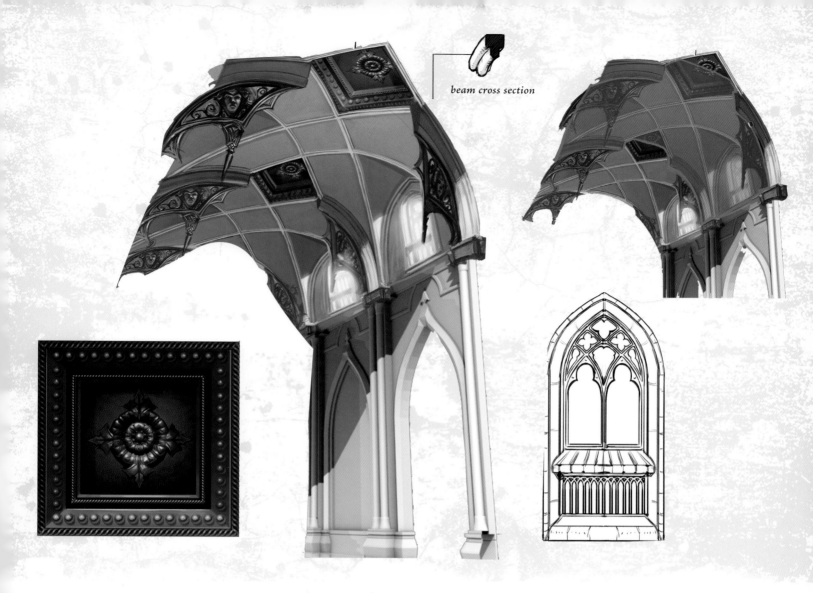

beam cross section

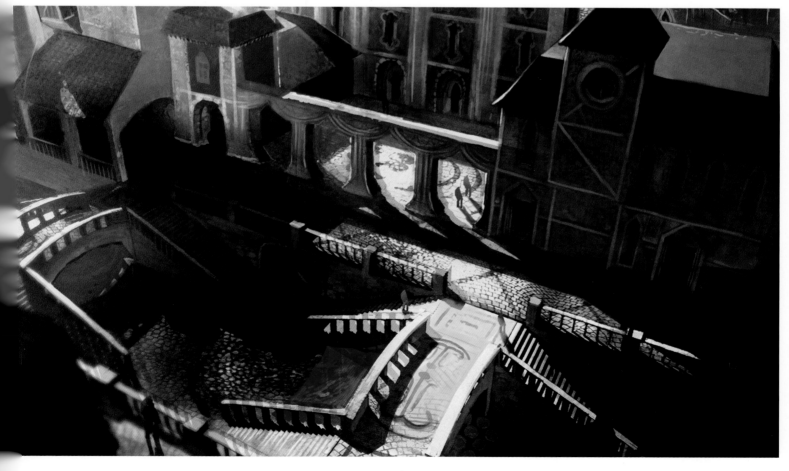

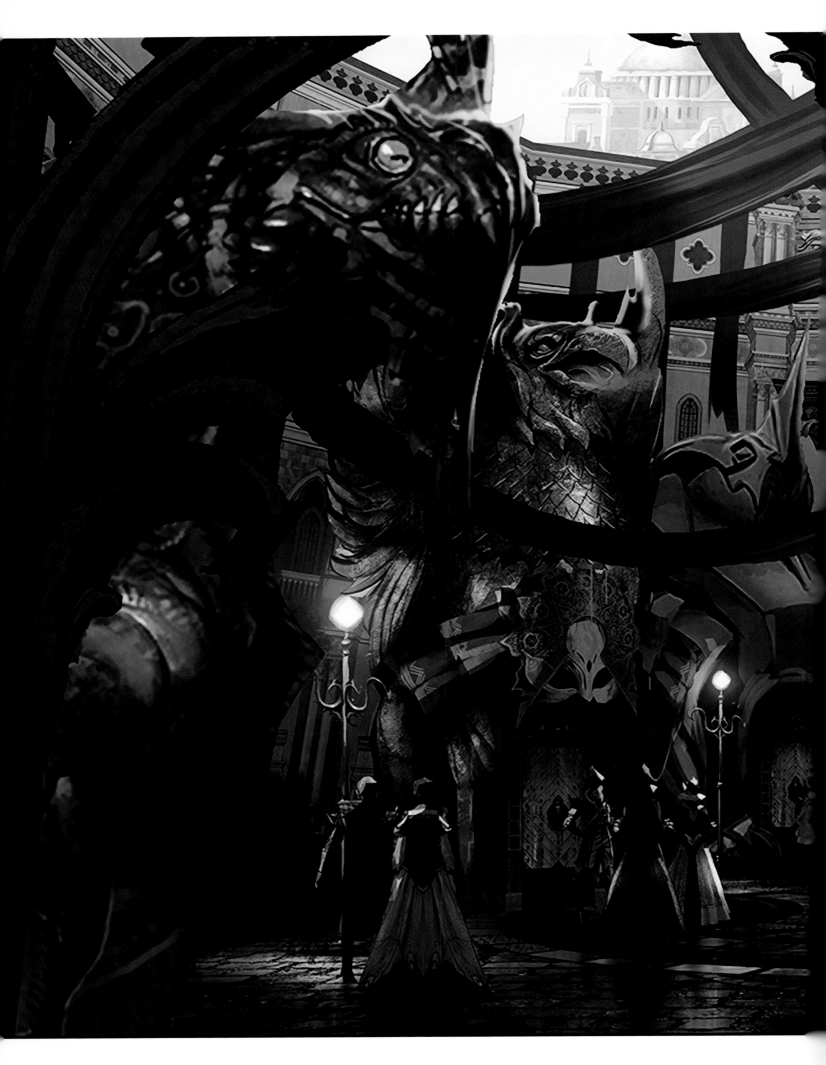

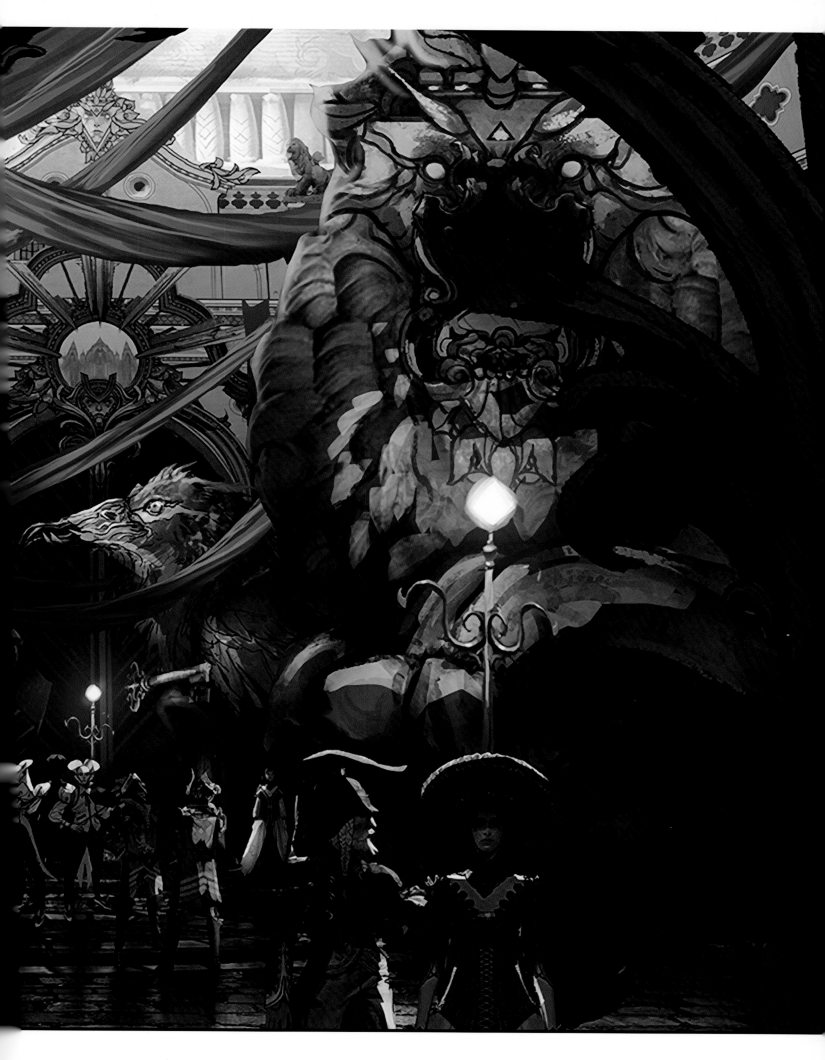

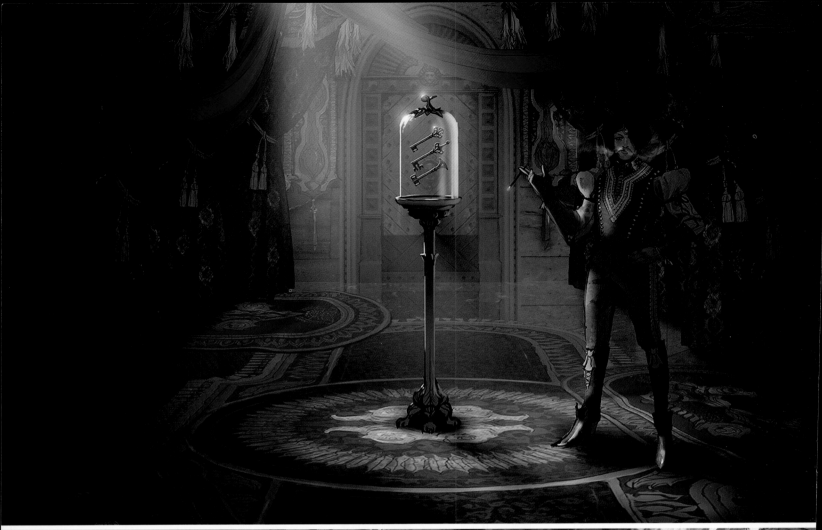

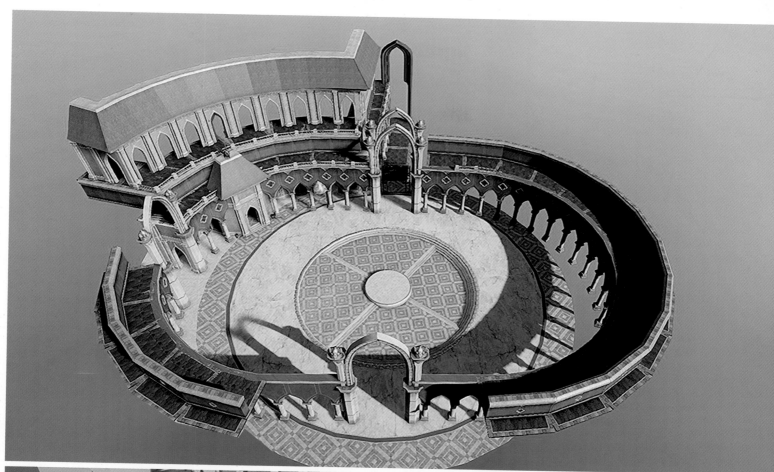

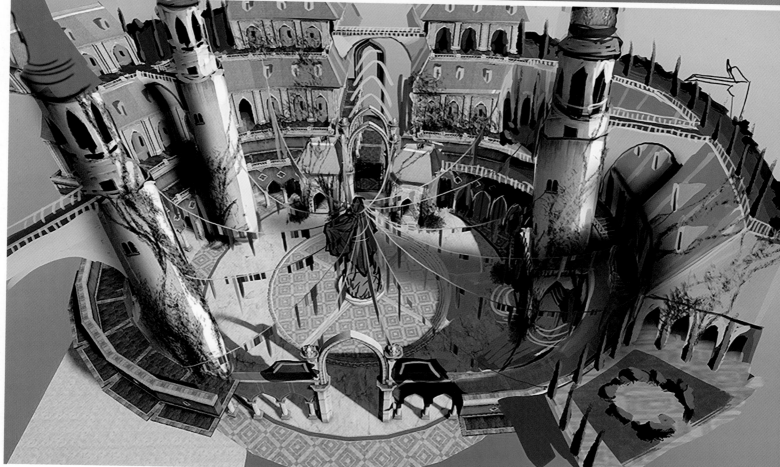

THE MARKET SQUARE We wanted to amplify the pomp and pageantry in Val Royeaux's Market Square. Additional tiers were added to the market when it didn't quite feel grand enough.

Opposite: One idea was to have a store with only one impossibly expensive item for sale. So decadent is the city that patterned cobblestone and colored walls decorate even the alleyways.

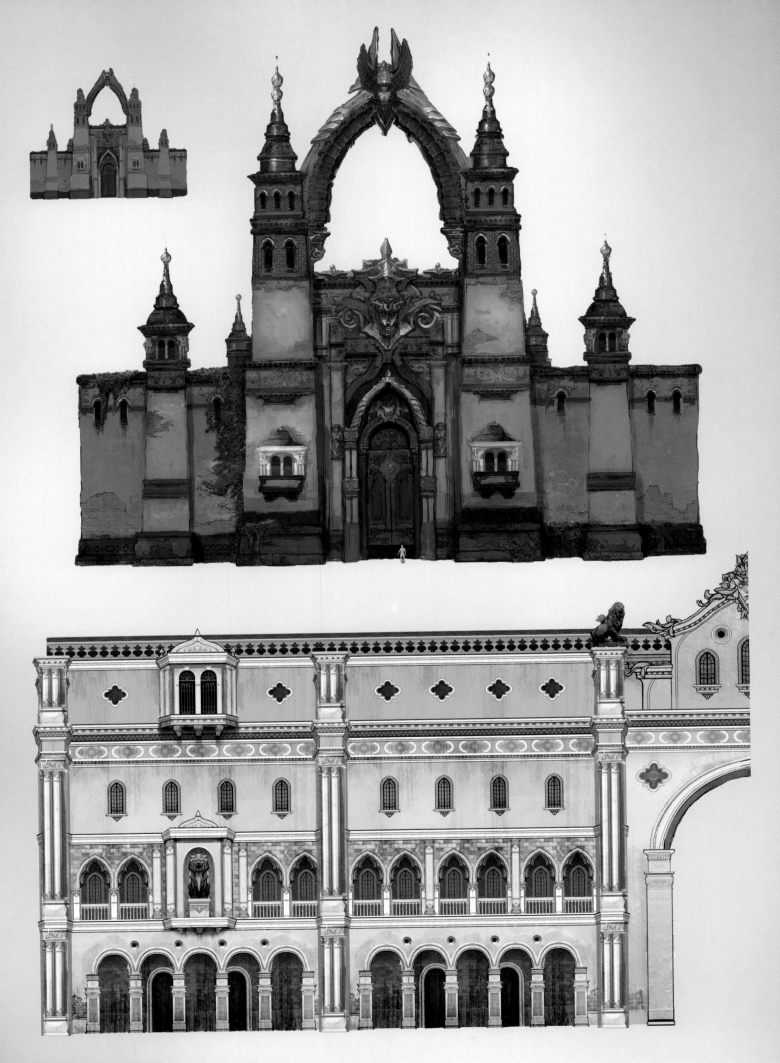

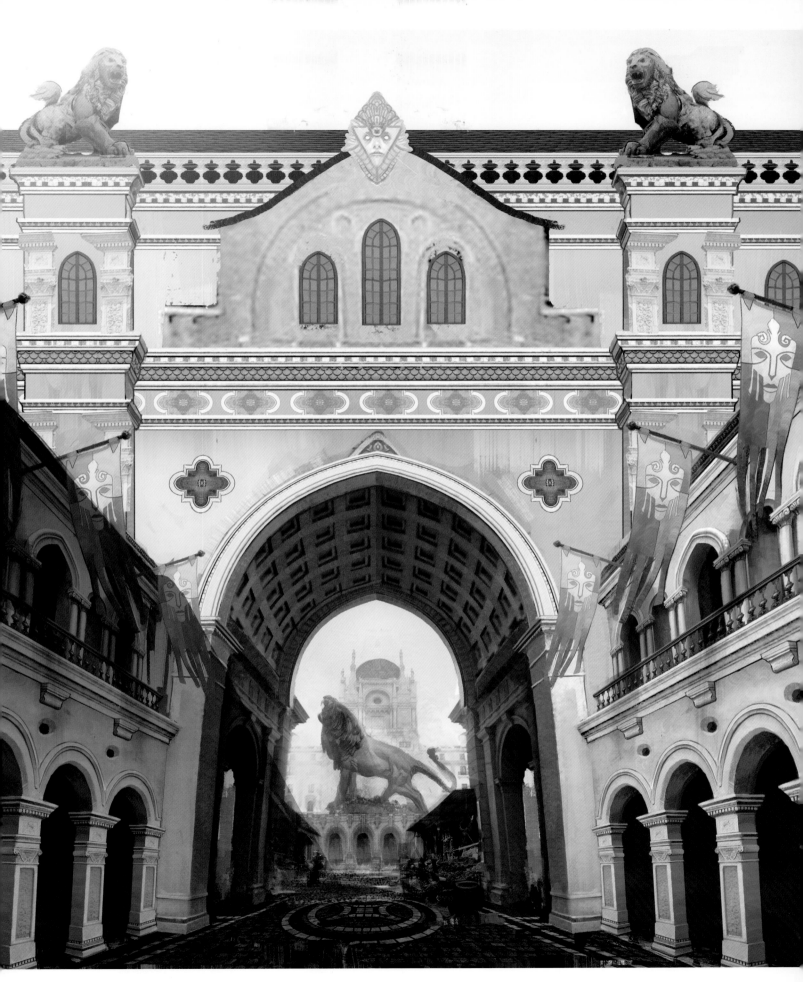

APPROACHING THE MARKET The center of the market was originally imagined with a nationalistic stone lion roaring at the sky, a symbol of Orlesian pride.

Opposite: Refined concepts of Orlesian architecture find a balance between color, pattern, and sculptural details. These drawings have a more polished feel than our original attempts.

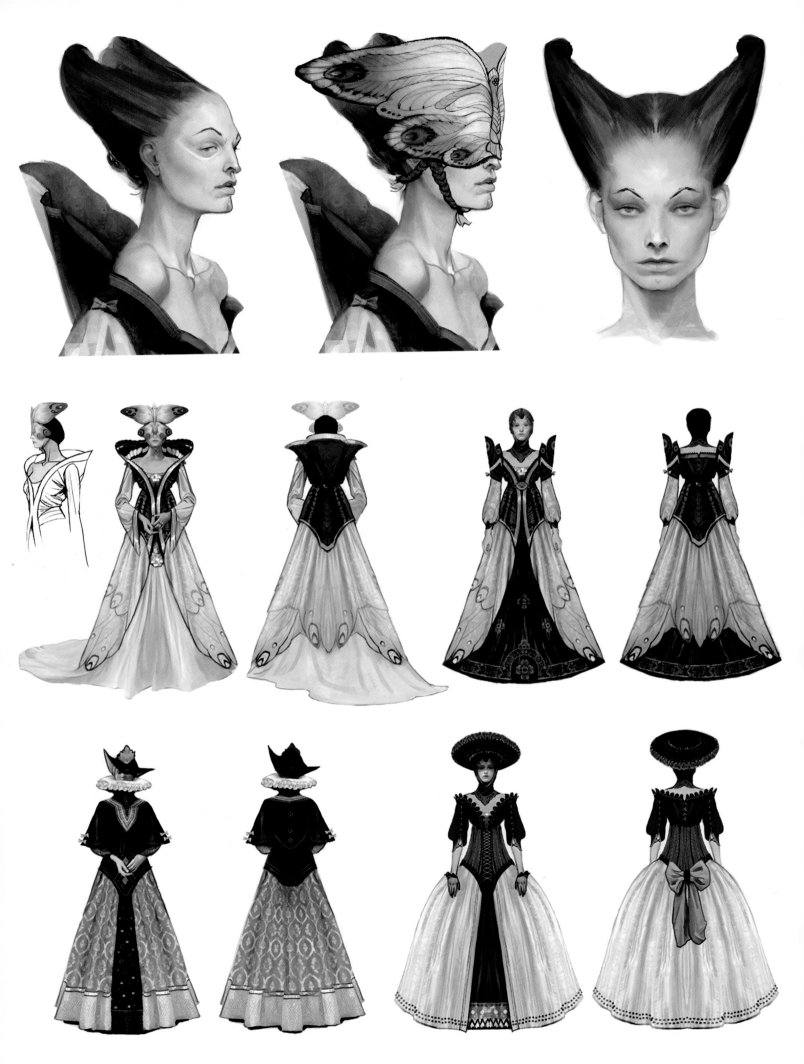

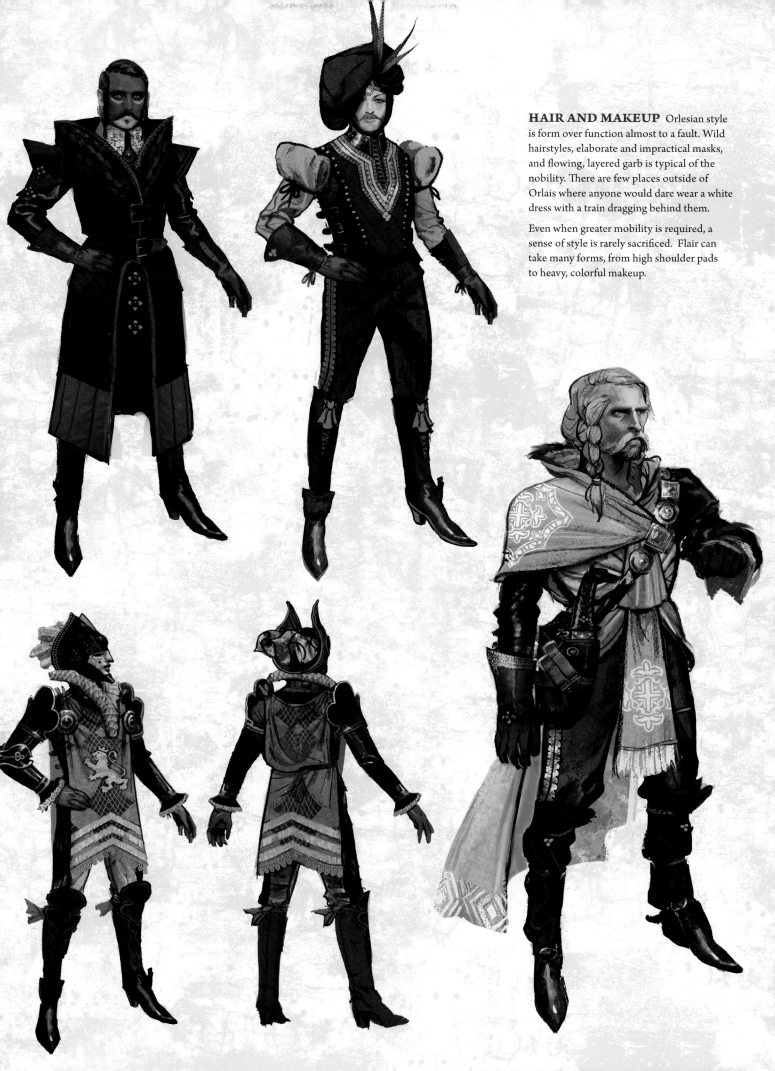

HAIR AND MAKEUP Orlesian style is form over function almost to a fault. Wild hairstyles, elaborate and impractical masks, and flowing, layered garb is typical of the nobility. There are few places outside of Orlais where anyone would dare wear a white dress with a train dragging behind them.

Even when greater mobility is required, a sense of style is rarely sacrificed. Flair can take many forms, from high shoulder pads to heavy, colorful makeup.

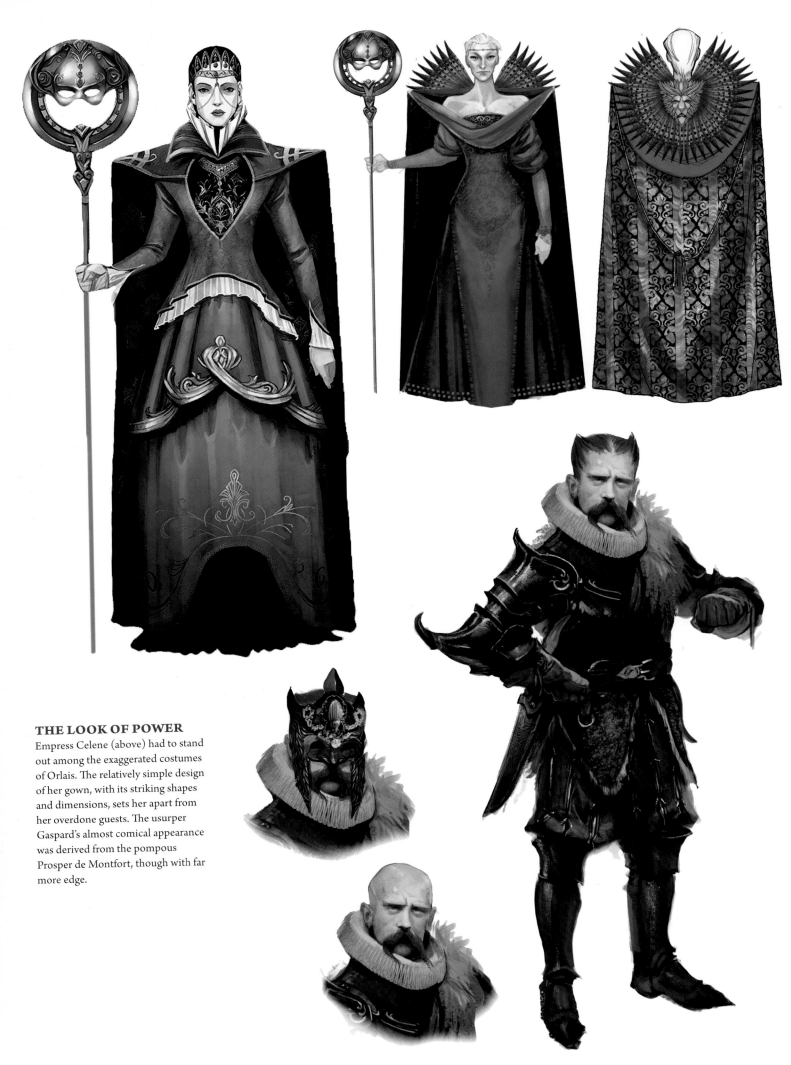

THE LOOK OF POWER

Empress Celene (above) had to stand out among the exaggerated costumes of Orlais. The relatively simple design of her gown, with its striking shapes and dimensions, sets her apart from her overdone guests. The usurper Gaspard's almost comical appearance was derived from the pompous Prosper de Montfort, though with far more edge.

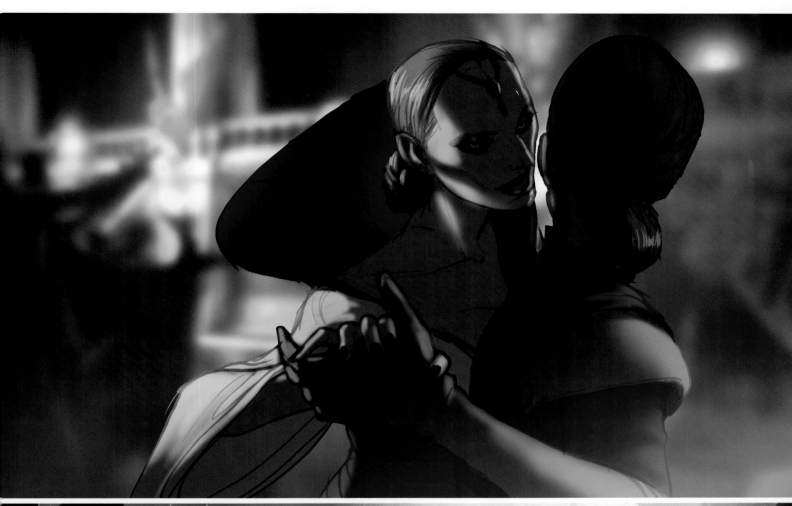

INTRIGUE AND UPHEAVAL Where there is Orlesian opulence, there is also treachery. This is the Great Game in action.

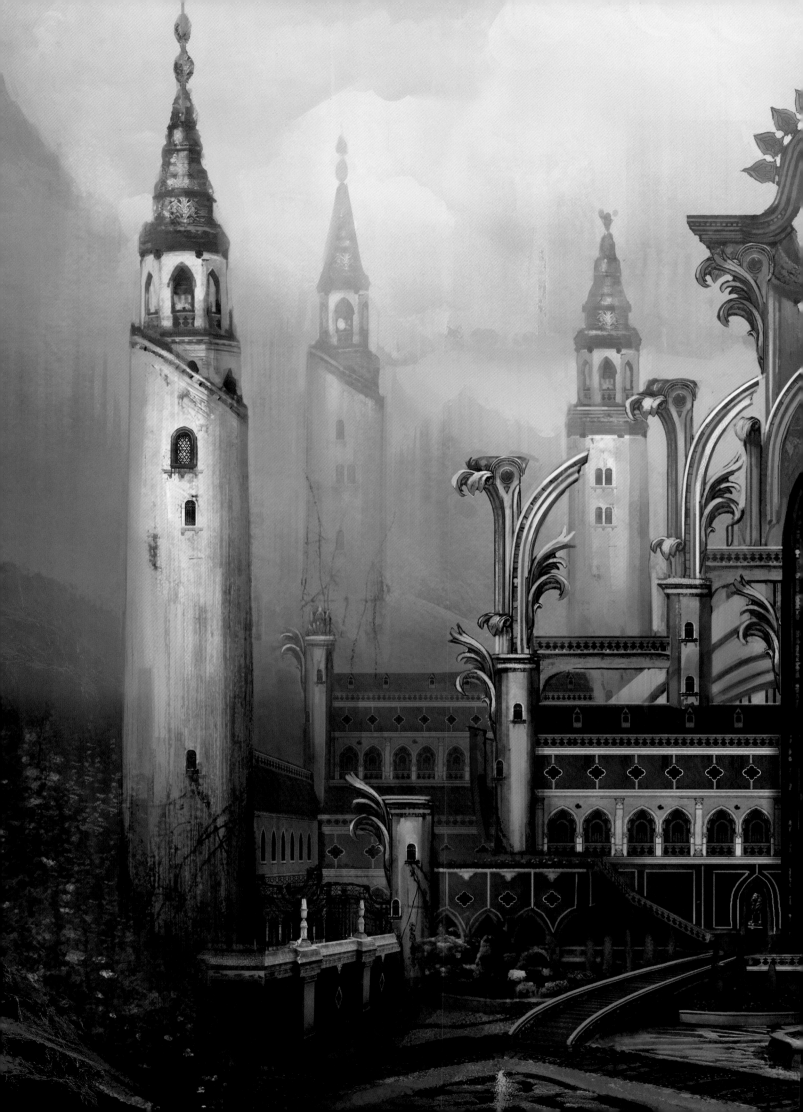

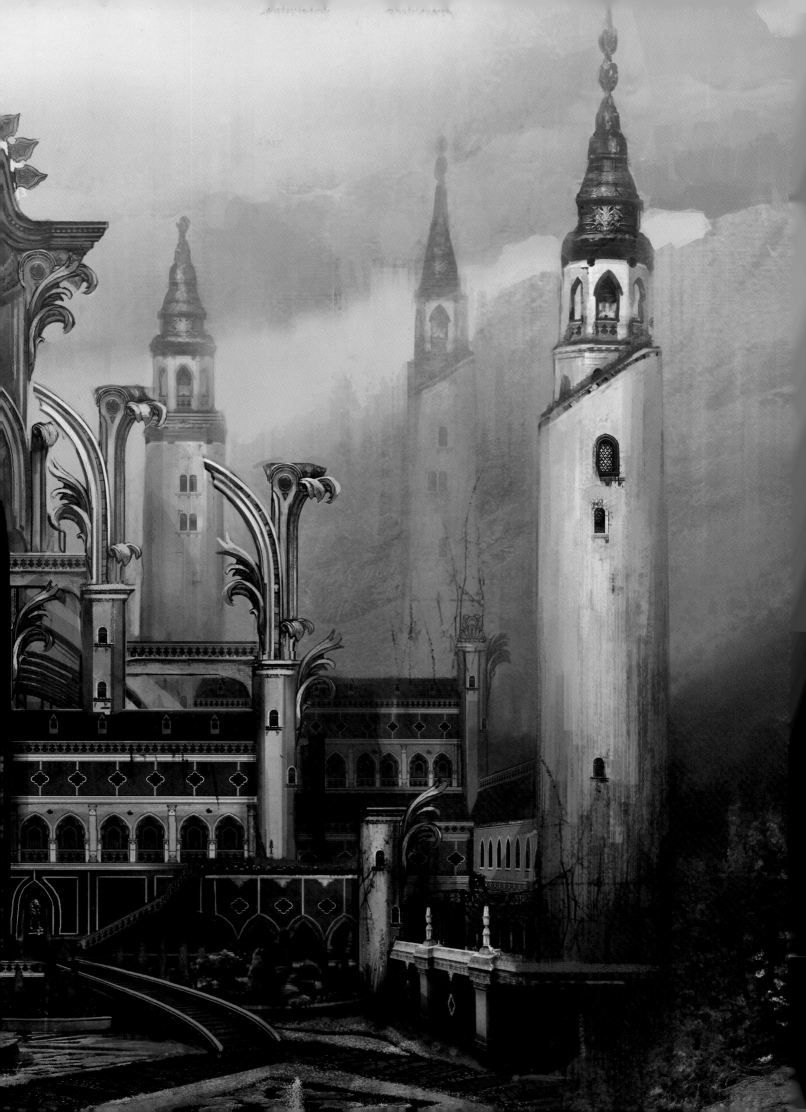

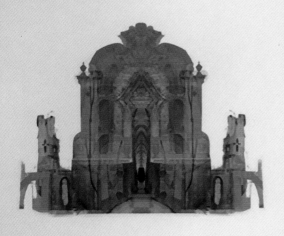

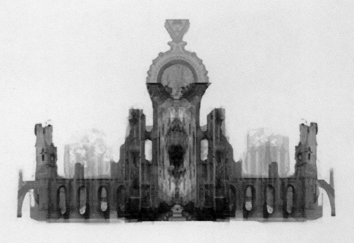

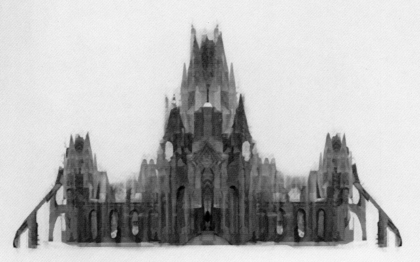

THE WINTER PALACE Far from the bustle of Val Royeaux, Halamshiral is where the Empress comes to escape. In *Inquisition*, her Winter Palace plays host to a lavish ball.

Opposite: Two interpretations of the Winter Palace show it alternatively as a secular court (above) and a more solemn, cavernous space.

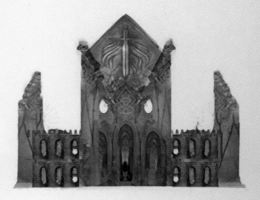

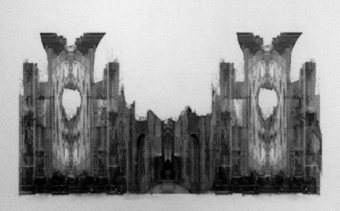

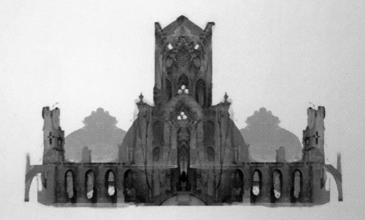

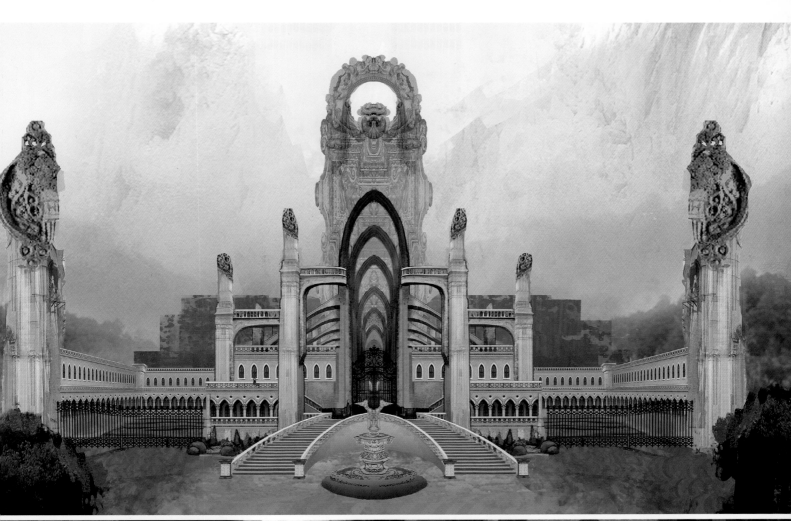

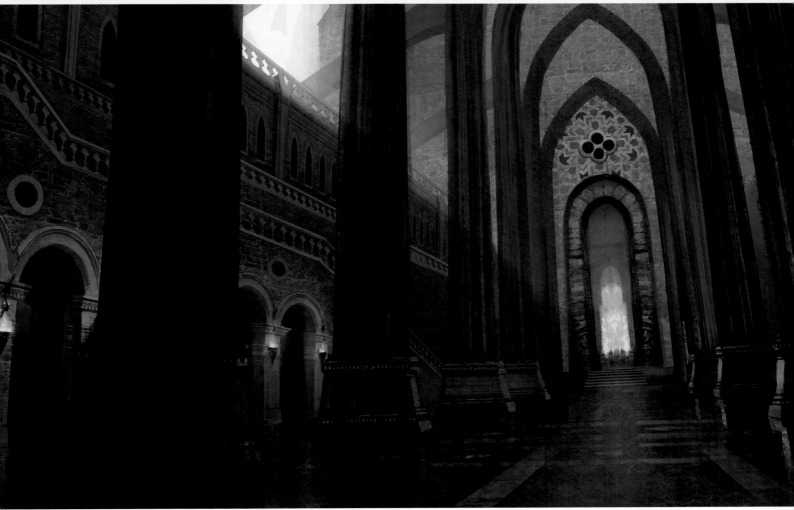

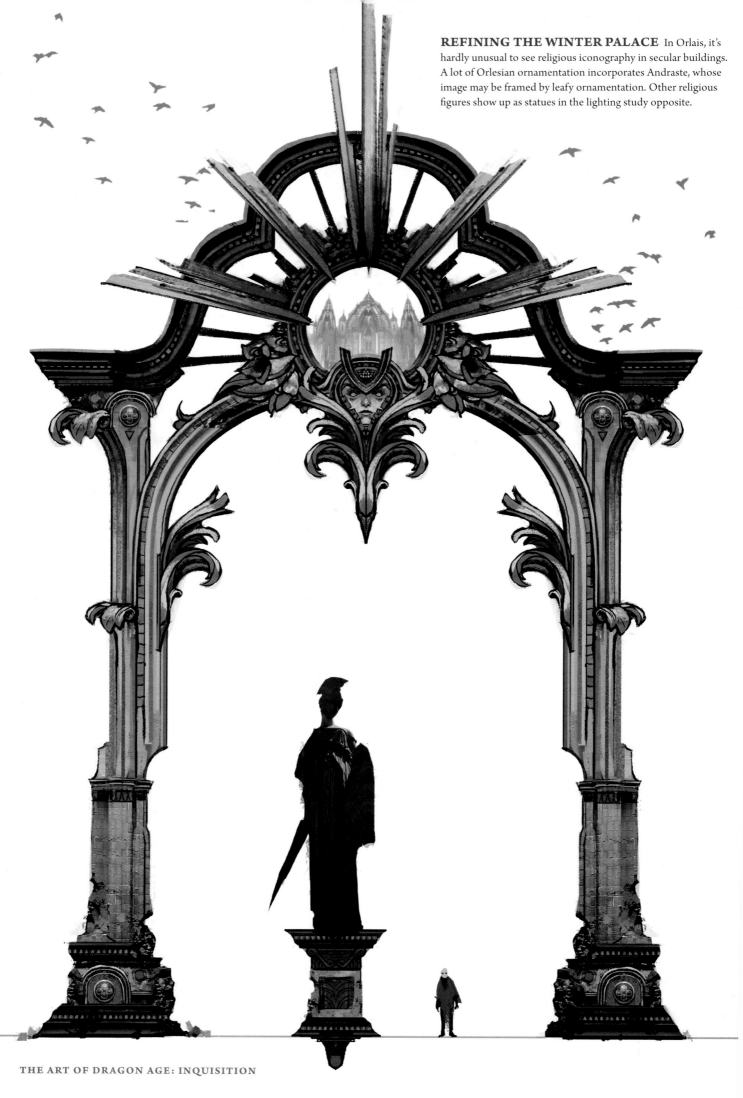

REFINING THE WINTER PALACE In Orlais, it's hardly unusual to see religious iconography in secular buildings. A lot of Orlesian ornamentation incorporates Andraste, whose image may be framed by leafy ornamentation. Other religious figures show up as statues in the lighting study opposite.

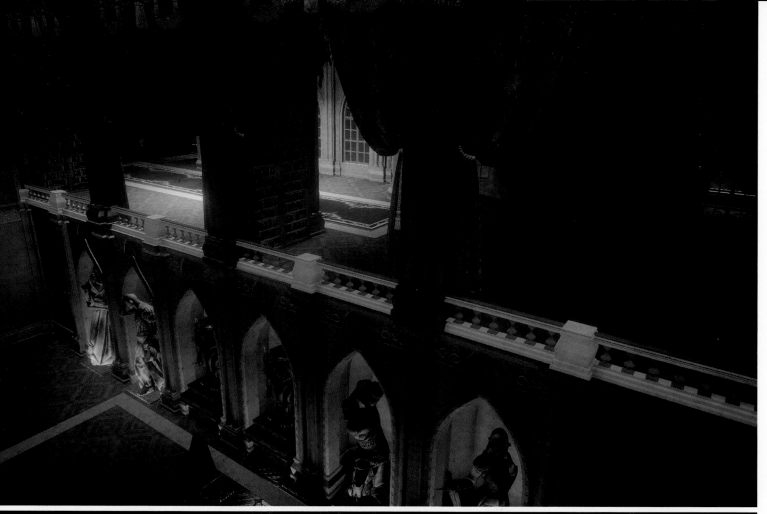

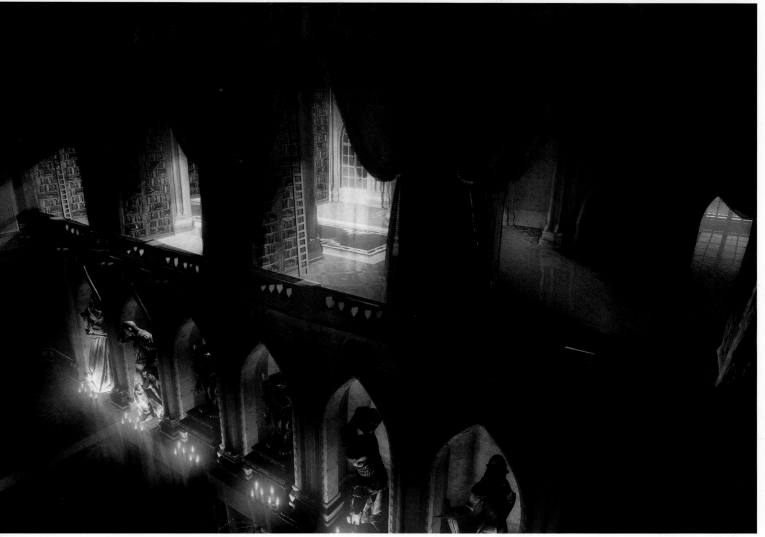

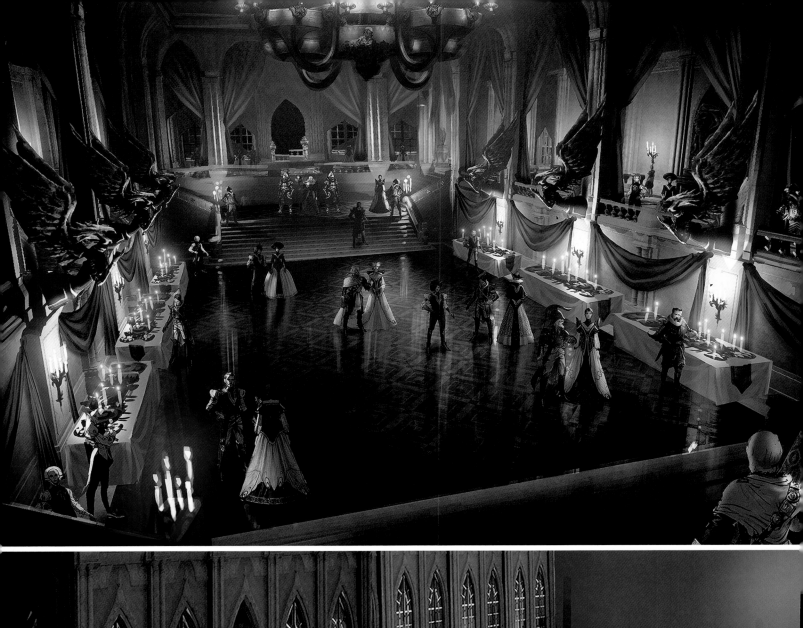
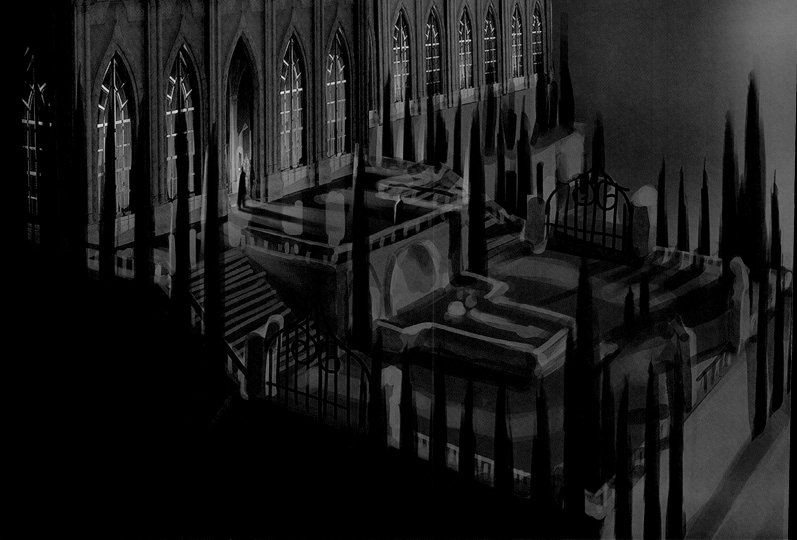

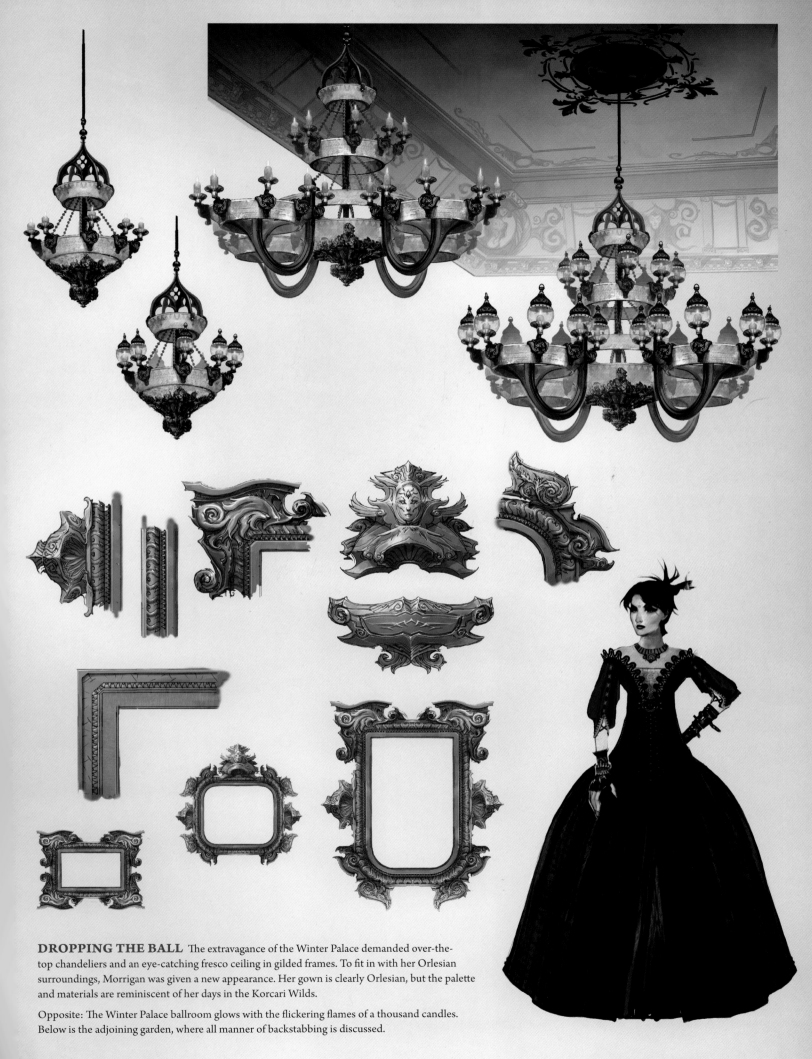

DROPPING THE BALL The extravagance of the Winter Palace demanded over-the-top chandeliers and an eye-catching fresco ceiling in gilded frames. To fit in with her Orlesian surroundings, Morrigan was given a new appearance. Her gown is clearly Orlesian, but the palette and materials are reminiscent of her days in the Korcari Wilds.

Opposite: The Winter Palace ballroom glows with the flickering flames of a thousand candles. Below is the adjoining garden, where all manner of backstabbing is discussed.

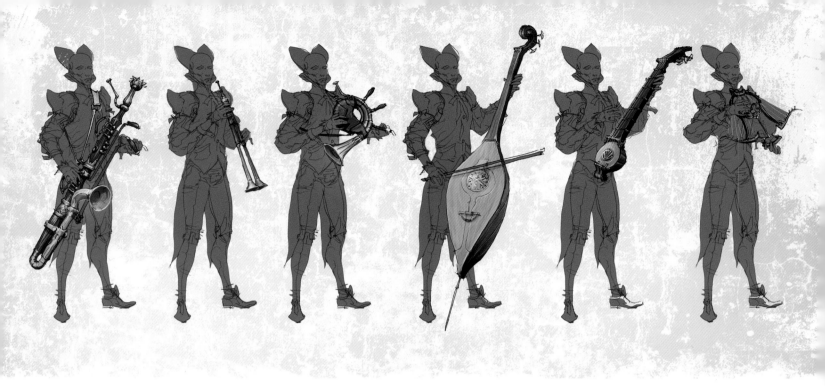

MUSICAL INSTRUMENTS What is a ball held by an Empress without music? We put an Orlesian twist on familiar instrument shapes for the Imperial ensemble. You can almost imagine the sounds they would make just by looking at them.

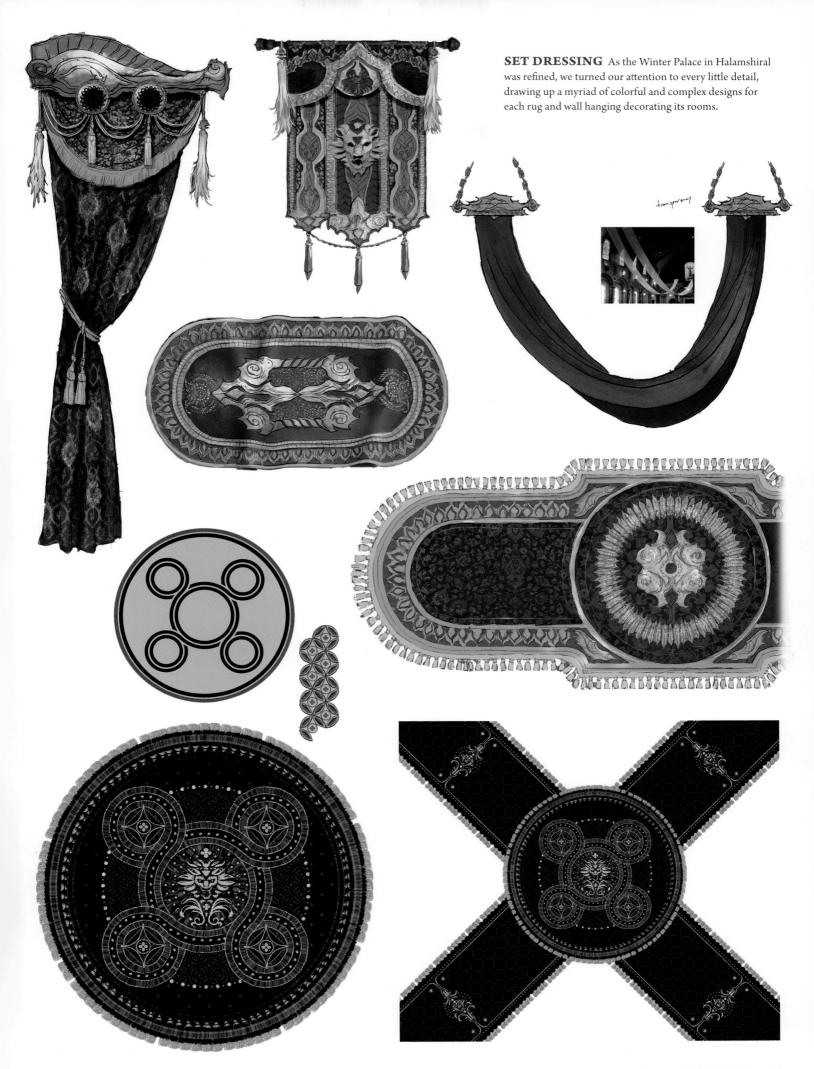

SET DRESSING As the Winter Palace in Halamshiral was refined, we turned our attention to every little detail, drawing up a myriad of colorful and complex designs for each rug and wall hanging decorating its rooms.

transparency.

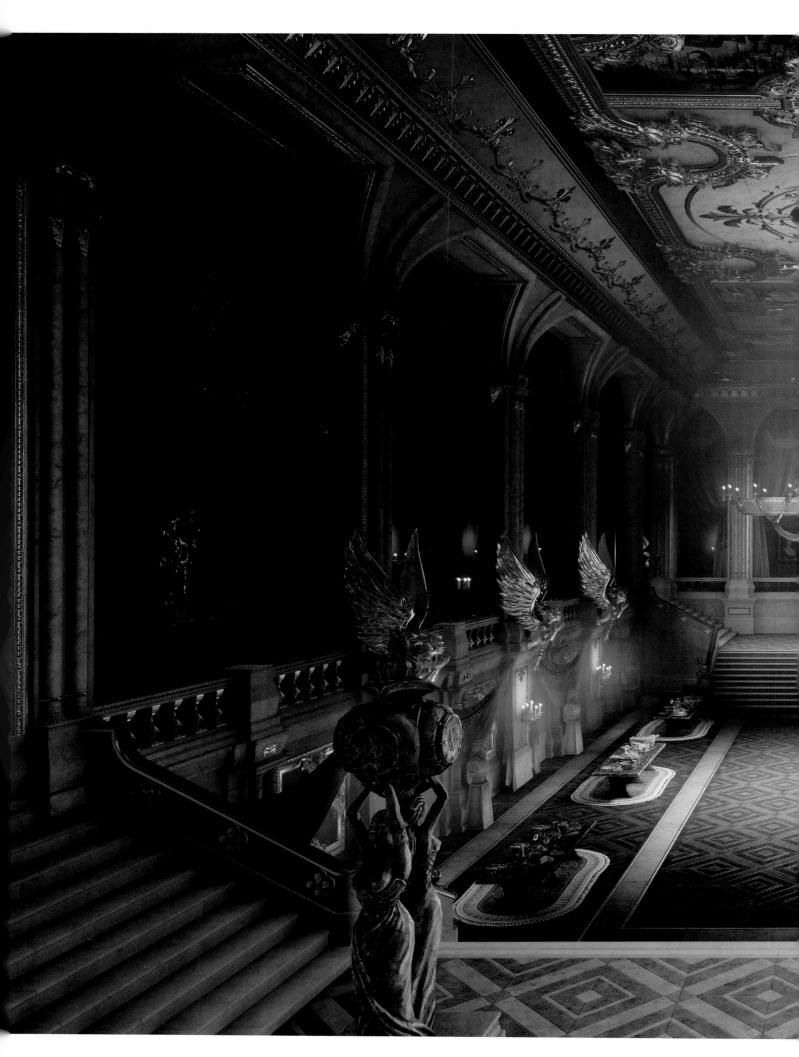

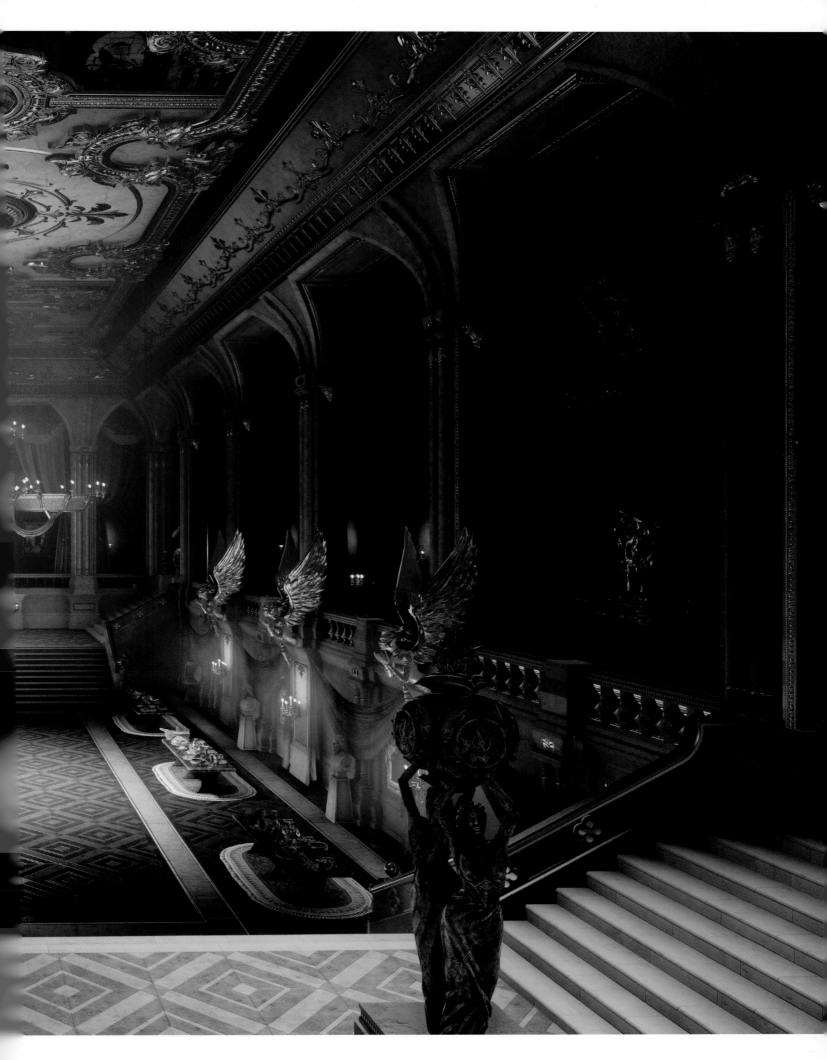

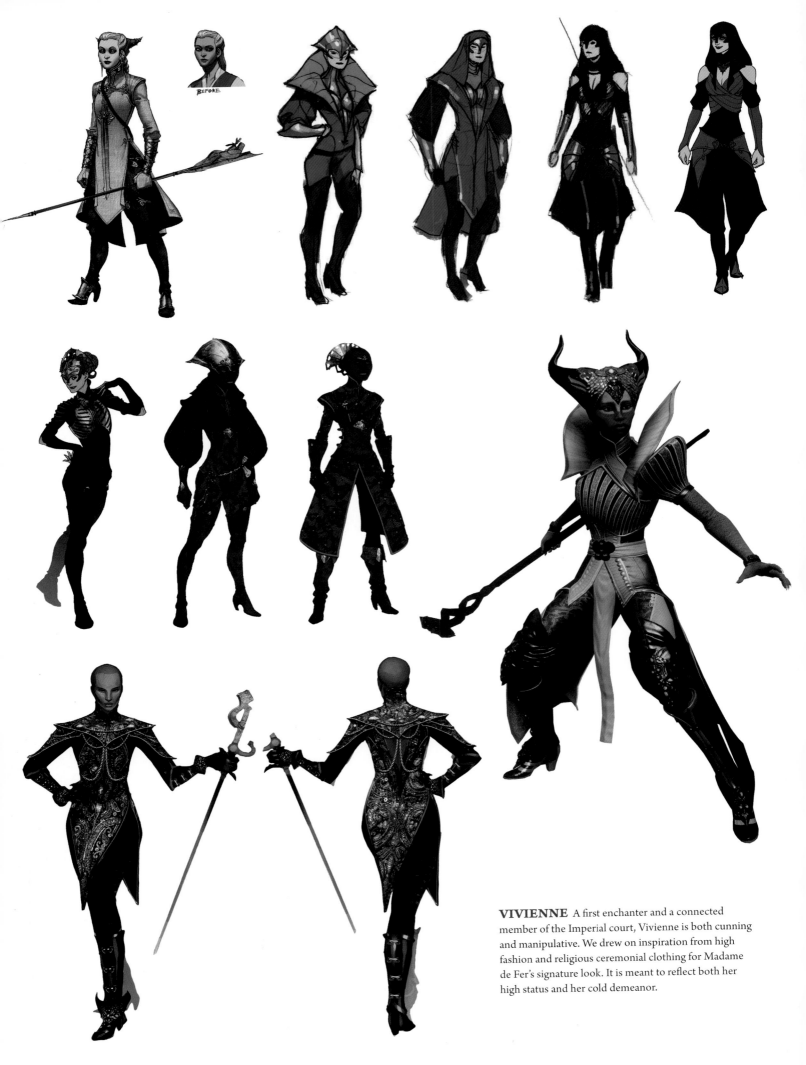

VIVIENNE A first enchanter and a connected member of the Imperial court, Vivienne is both cunning and manipulative. We drew on inspiration from high fashion and religious ceremonial clothing for Madame de Fer's signature look. It is meant to reflect both her high status and her cold demeanor.

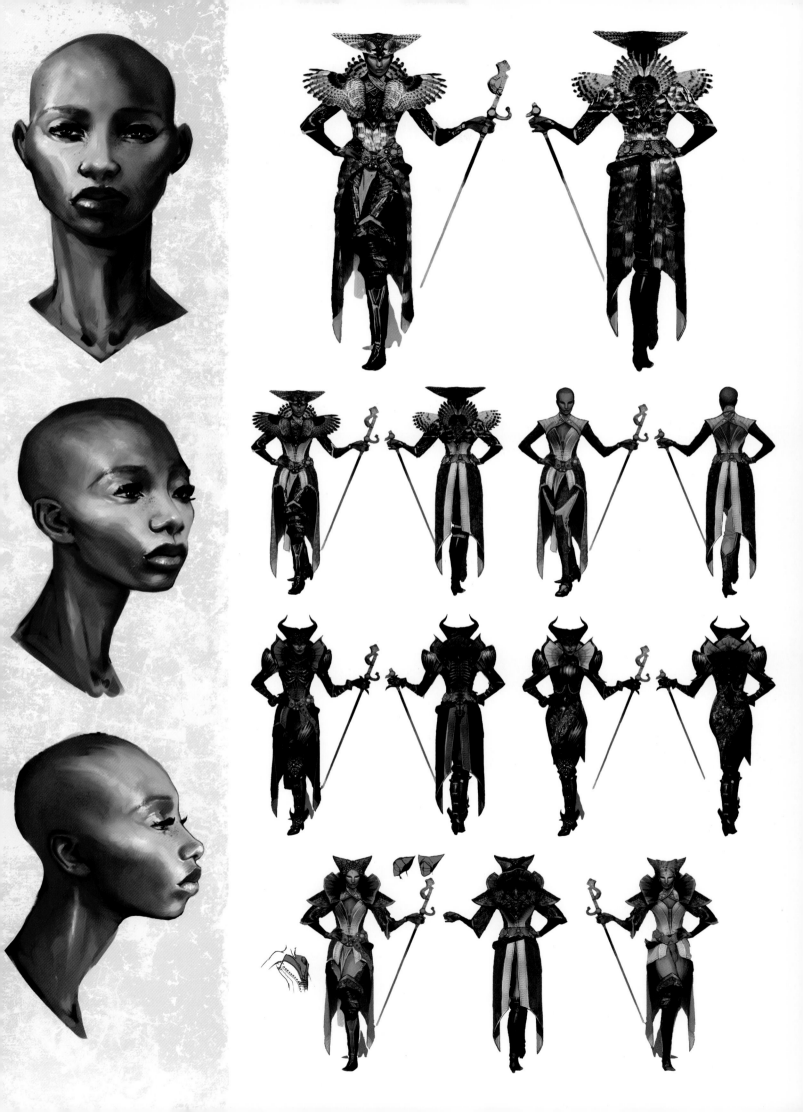

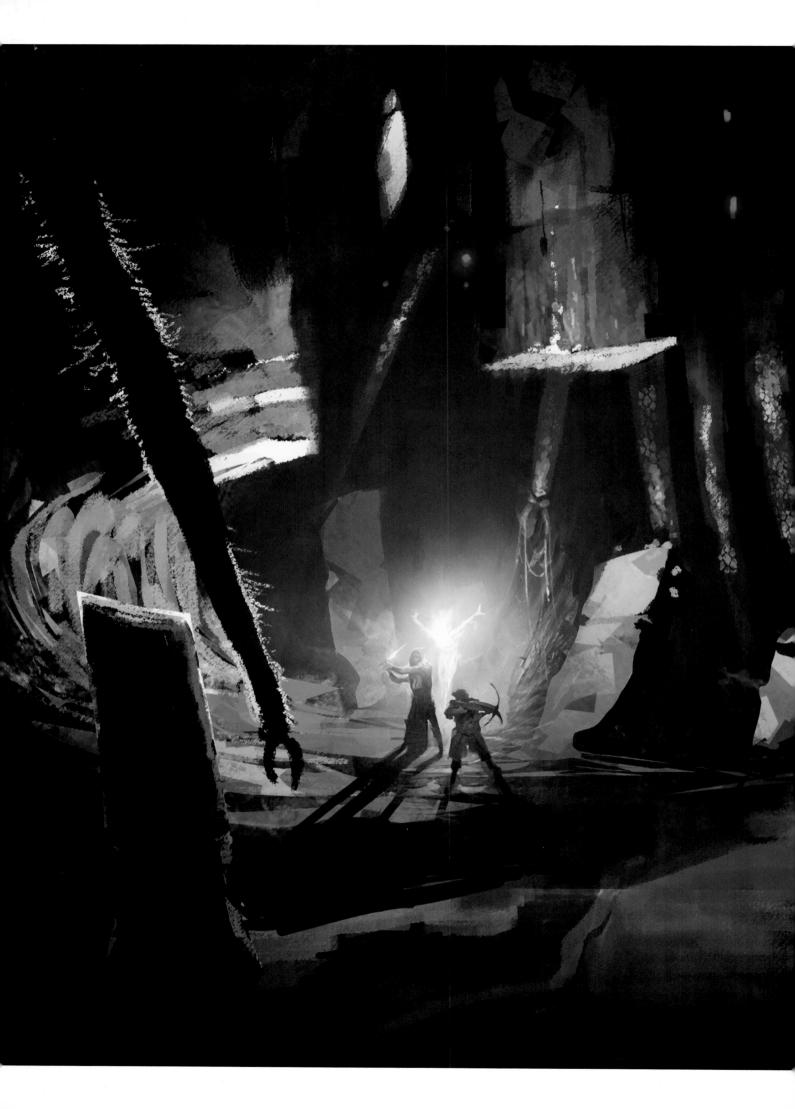

HERE LIES THE ABYSS

In *Inquisition*, we visit the fabled Grey Warden fortress known as Adamant and, by way of a catastrophe, return to the Fade. This realm of dreamers retains the ghostly green and otherworldly landscapes from *Origins* while doubling down on the spooky and abstract. The Fade's permanent residents—spirits and demons that embody and obsess over mortal emotions—create the realm's appearance based on what they perceive of the waking world, and they get it very wrong. Everything is a bent reflection of reality, an interpretation of the familiar through unfamiliar eyes.

The Fade needed to be a world players would be excited to explore while also fearing the consequences of each step. We worked hard to imply the rules governing the physics of the realm. At the center is the Black City. The Chantry teaches that it once held the seat of the Maker and was known as the Golden City until corrupted by humanity. The Fade's nucleus looks like the epicenter of a great explosion in slow motion, with fragments flung in all directions. The closer you get to the Black City, the more chaotic it gets.

Improved technology through Frostbite meant we could animate huge pieces of geometry, giving the space life and immense scale. There is no *up* in the Fade. Islands in the sky rotate because of some localized gravity. Below, the ground swirls in places from unknown forces. Flickering lights in the distance are almost windows, watching your every move.

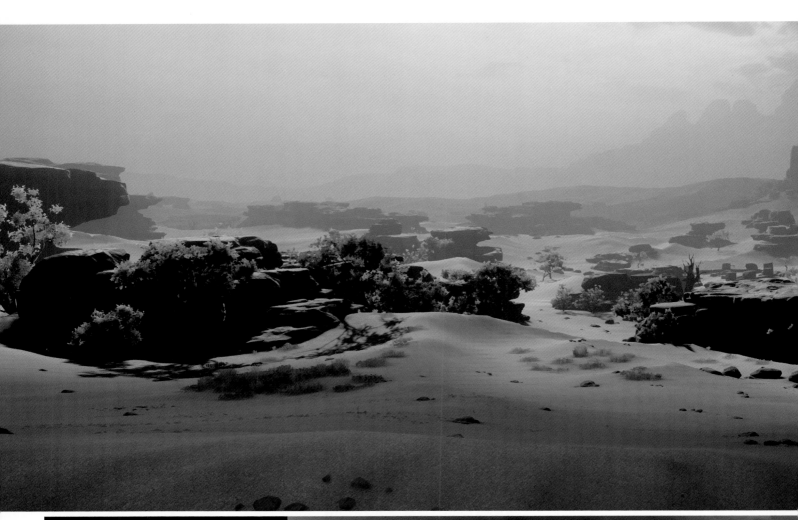

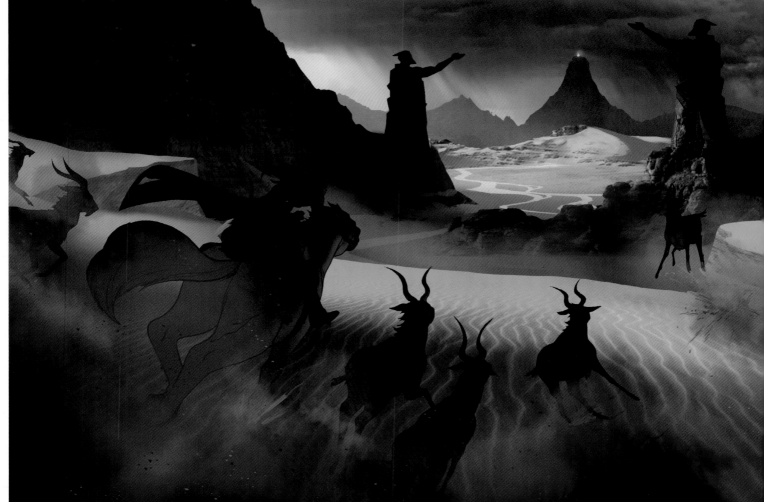

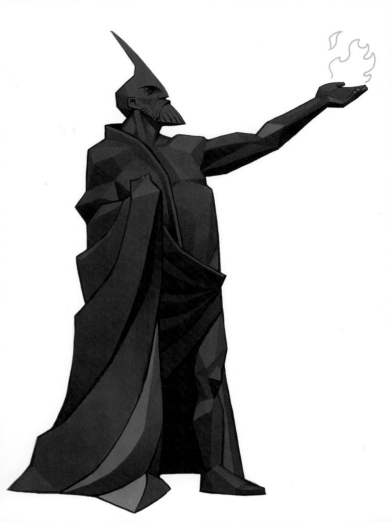

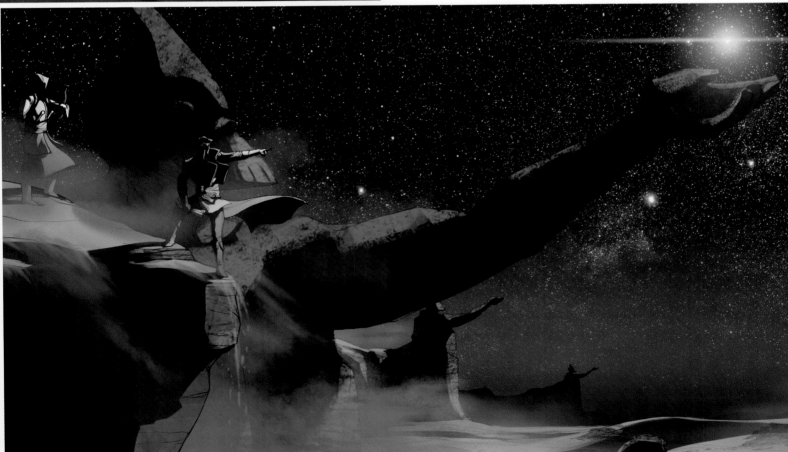

THE WESTERN APPROACH Wilderness areas were an artist's playground. We could finally knock down the walls and stretch our artistic legs, creating a sense of scale that simply wasn't possible before in Thedas. The Western Approach is a large desert that surrounds the Warden fortress Adamant, and our work here was all about creating vast stretches of sand, dotted with inviting geology and mysterious ruins. It's a lonely place with a lot to see.

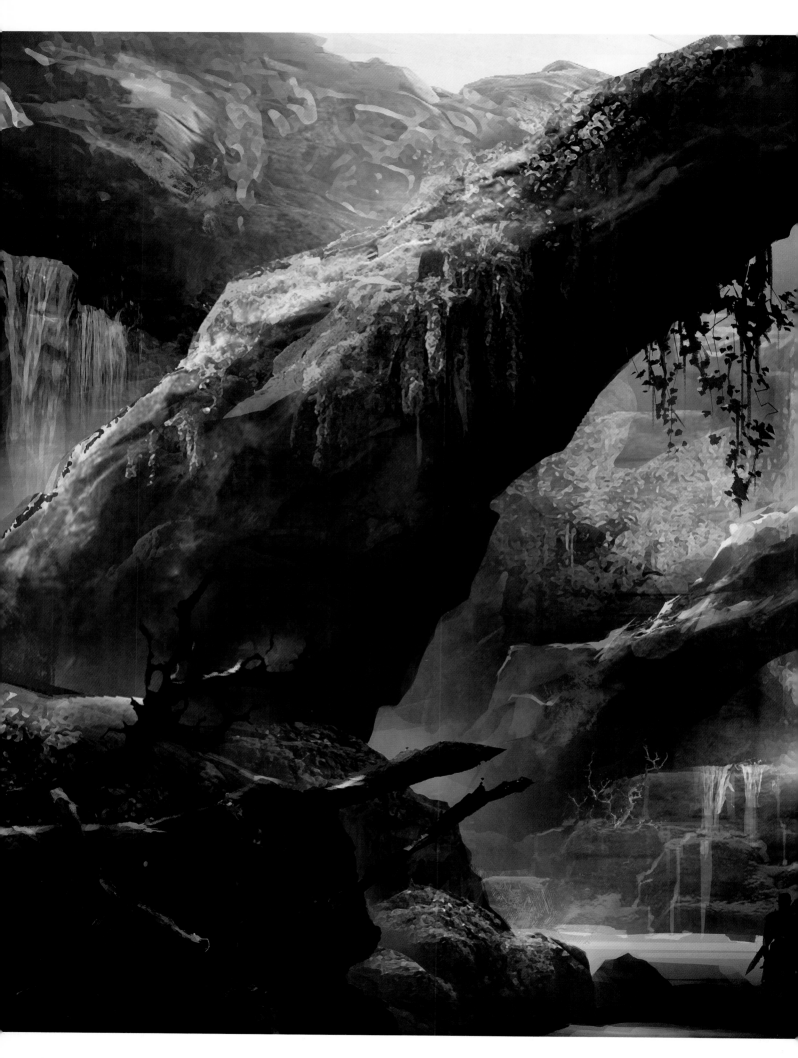

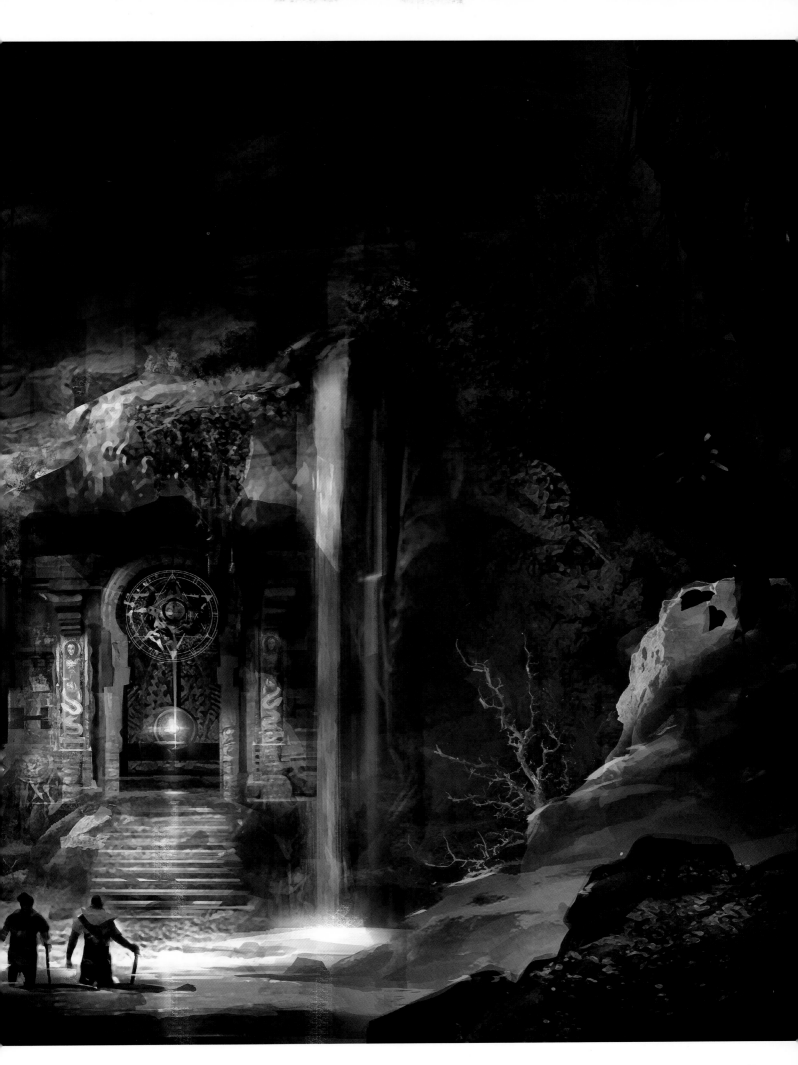

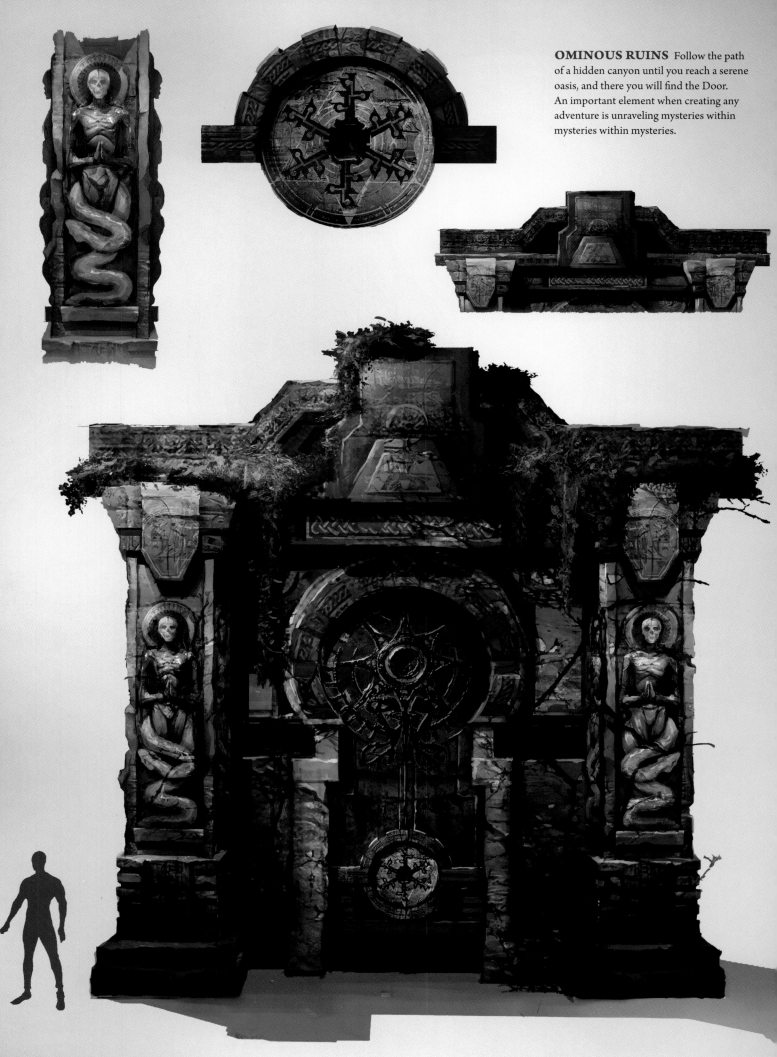

OMINOUS RUINS Follow the path of a hidden canyon until you reach a serene oasis, and there you will find the Door. An important element when creating any adventure is unraveling mysteries within mysteries within mysteries.

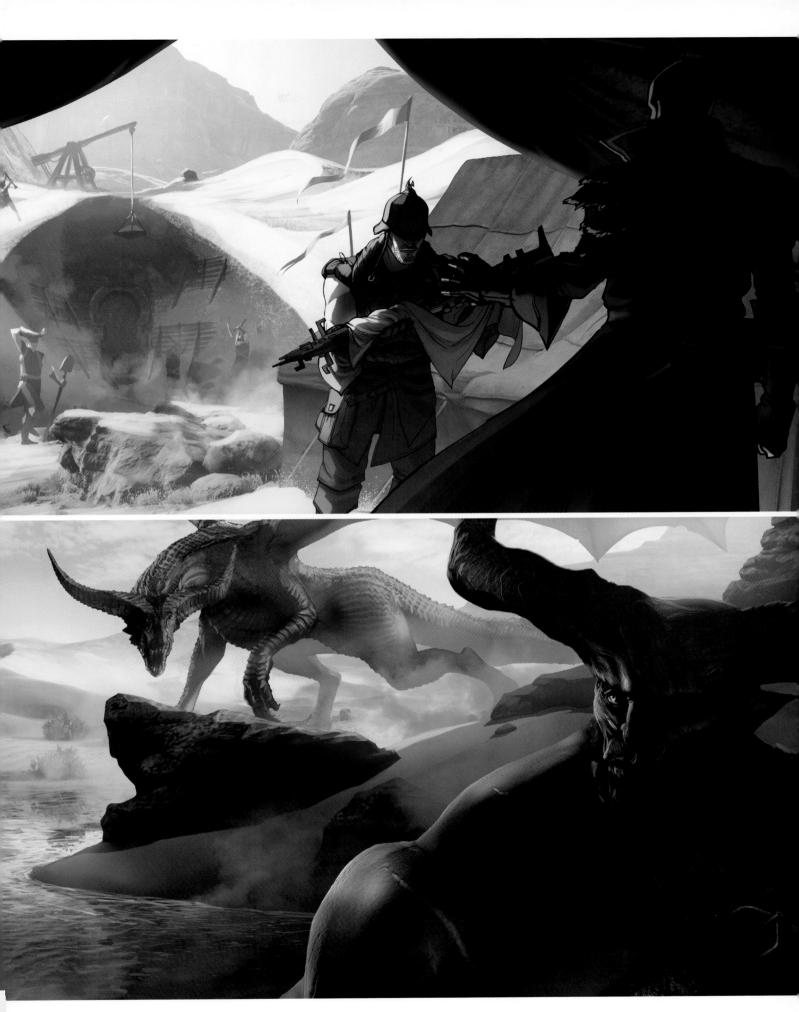

EXPOSED The desert setting provided a variety of narrative opportunities that we were excited to explore, from excavating long-buried secrets to the constant threat of being caught in the open by apex predators.

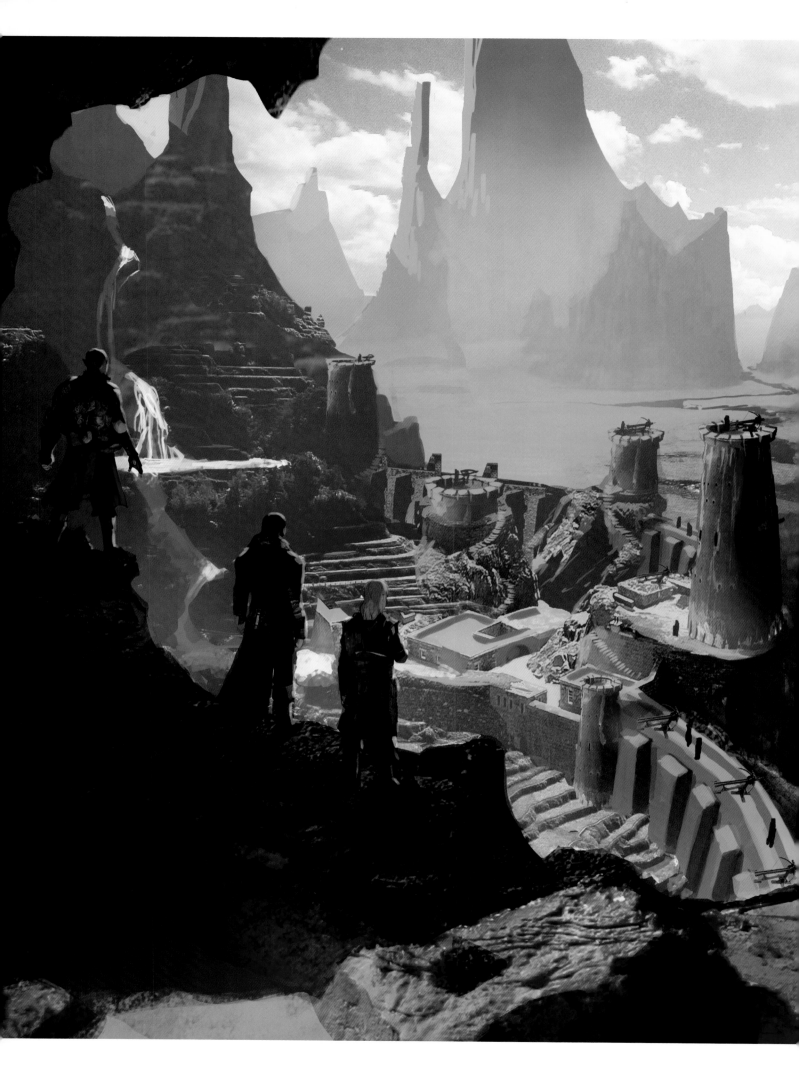

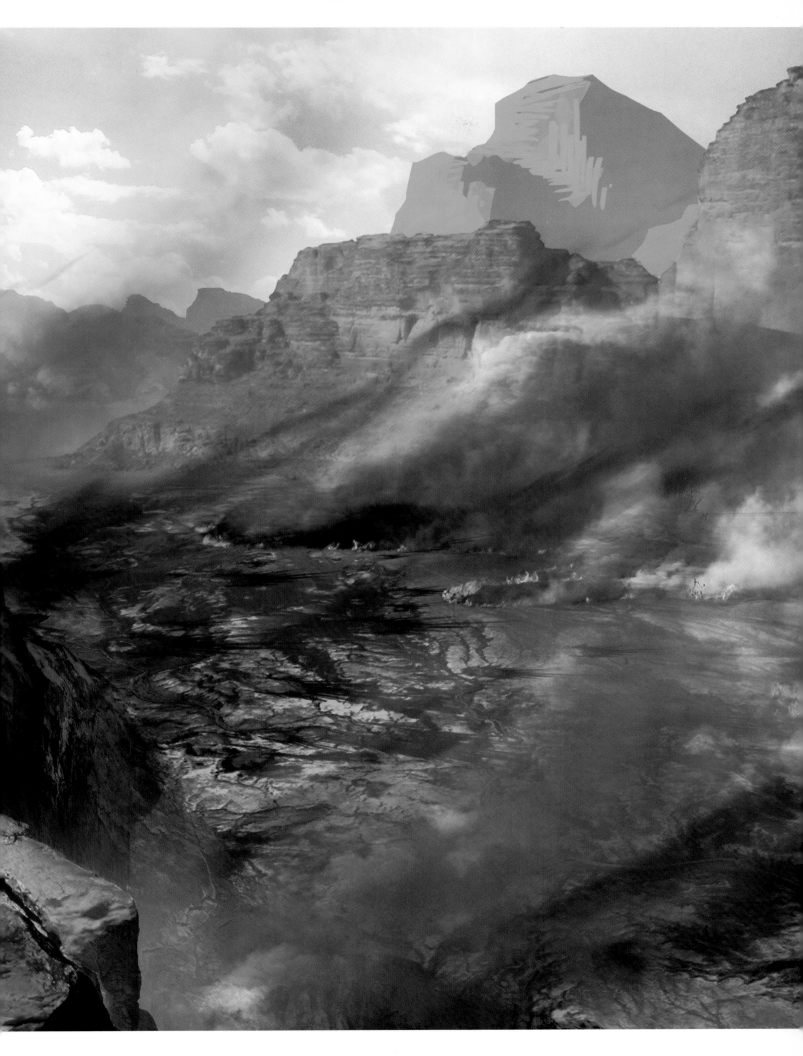

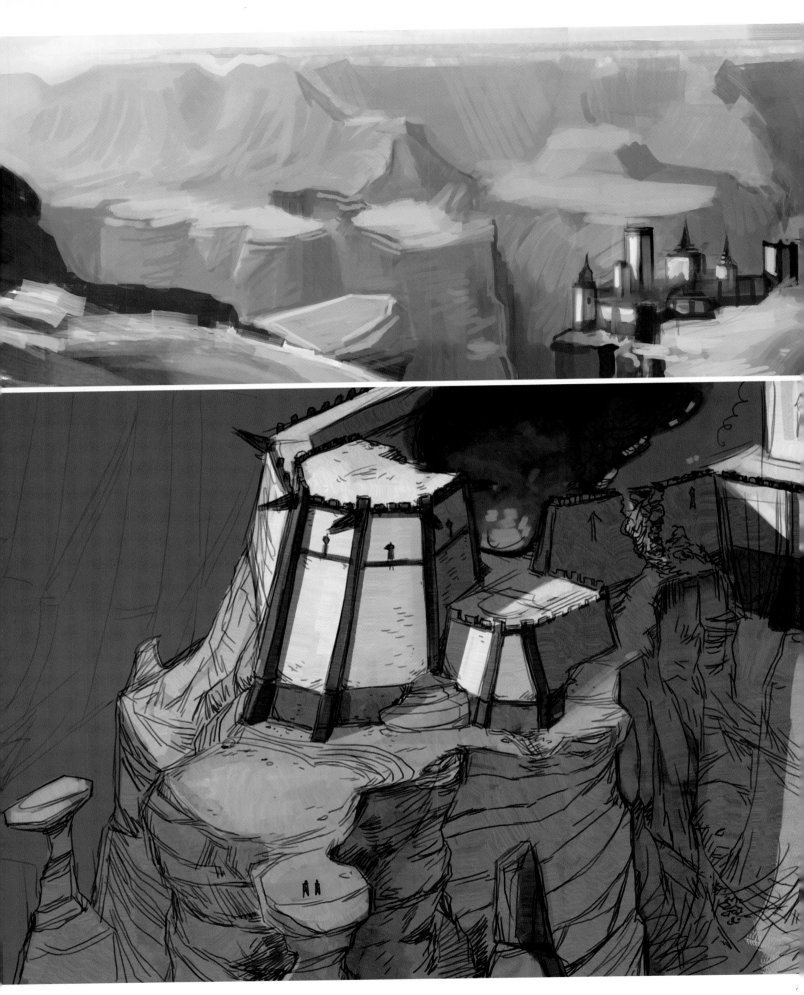

GEOGRAPHICAL CONTEXT When designing a structure, you start by understanding the location. To help flesh out Adamant Fortress, we put it in its proper context. What would you see from the walls? What topography would lead people to build the fortress on this particular edge of the Abyssal Rift?

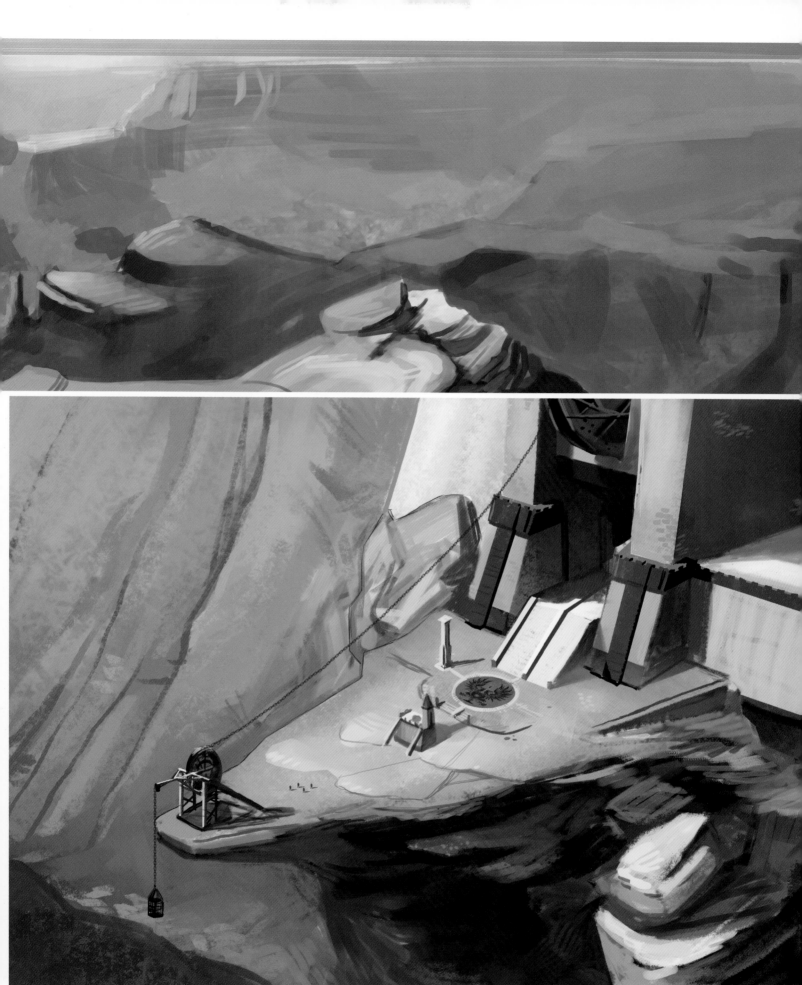

CORNERSTONES Once it was established that Adamant was a converted Tevinter ruin, we explored how the old Tevinters would have constructed the structure. Rather than build with the natural stone, they would have sought to subdue it. The stone would make way for their walls and towers, not the other way around.

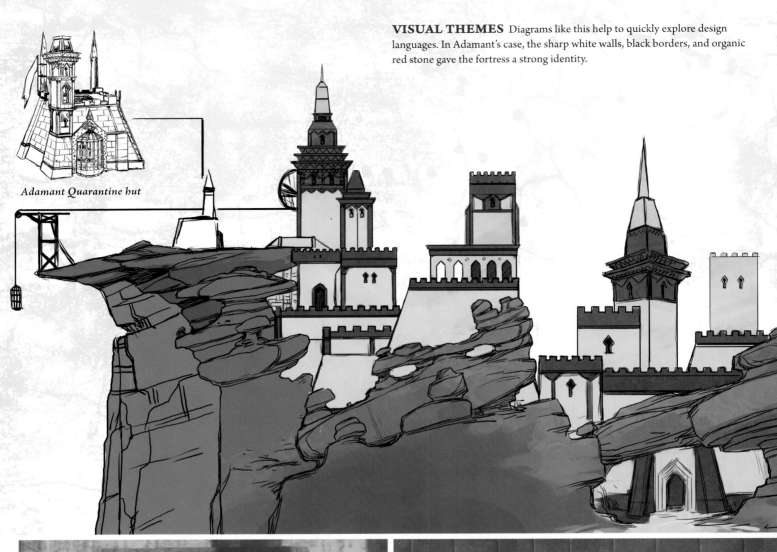

VISUAL THEMES Diagrams like this help to quickly explore design languages. In Adamant's case, the sharp white walls, black borders, and organic red stone gave the fortress a strong identity.

Adamant Quarantine hut

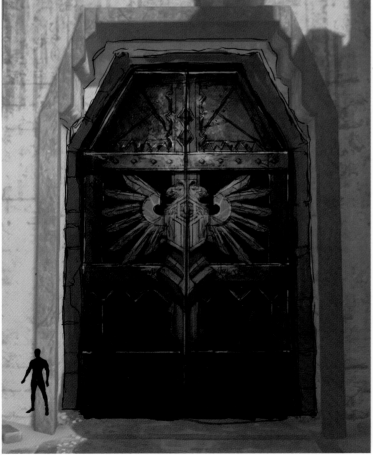

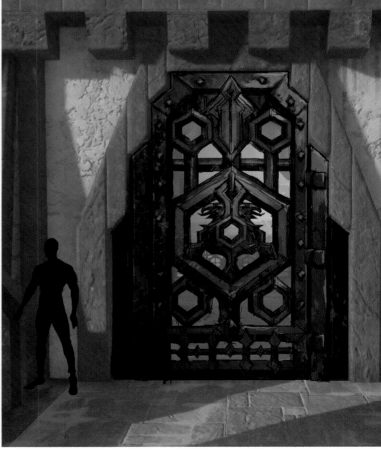

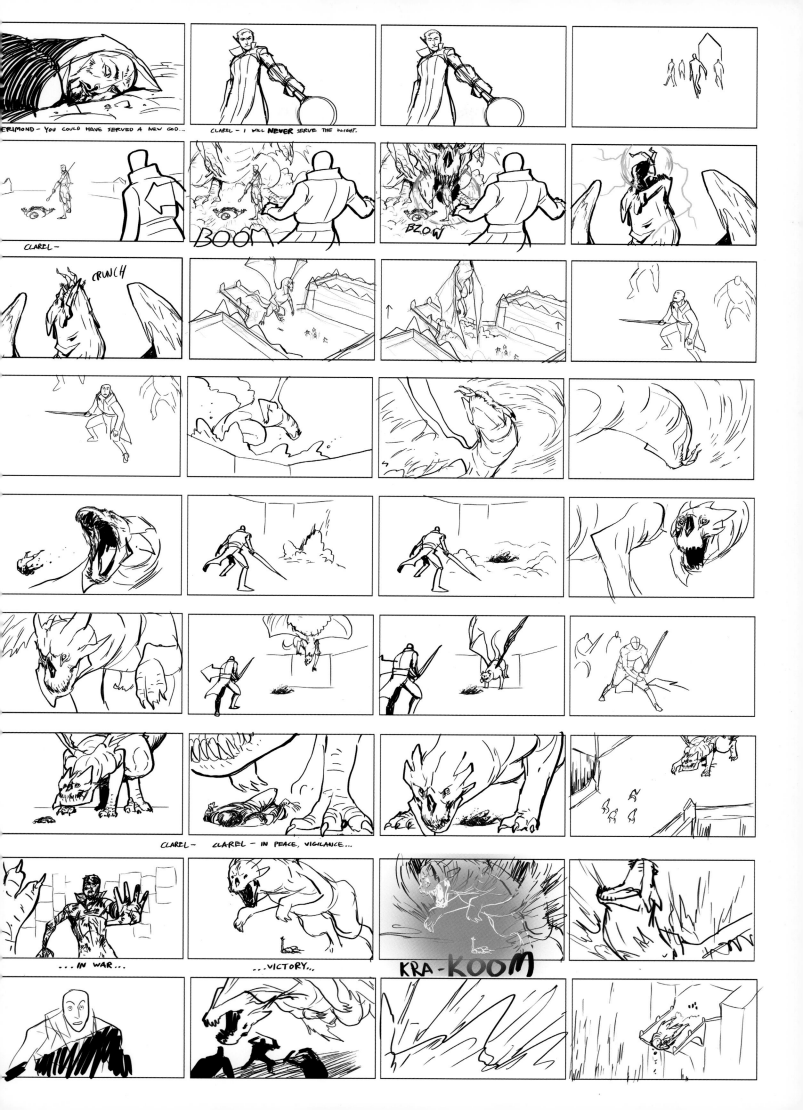

FIRST FORAYS INTO TEVINTER

We had the opportunity to uncover more of Tevinter culture through the ruins of their once-expansive empire in the south of Thedas. We started with the severe lines and razor-sharp edges of the slave city of Kirkwall as our guidepost.

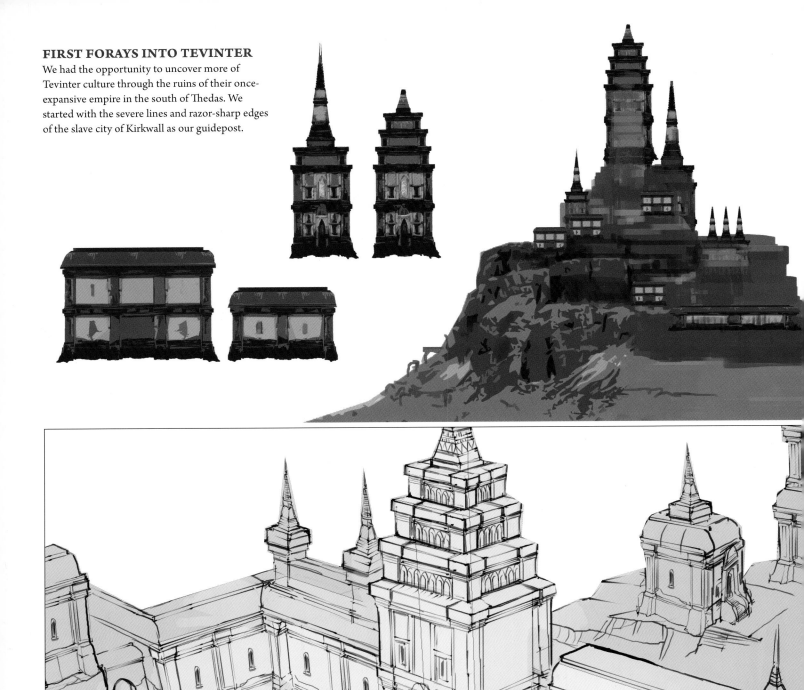

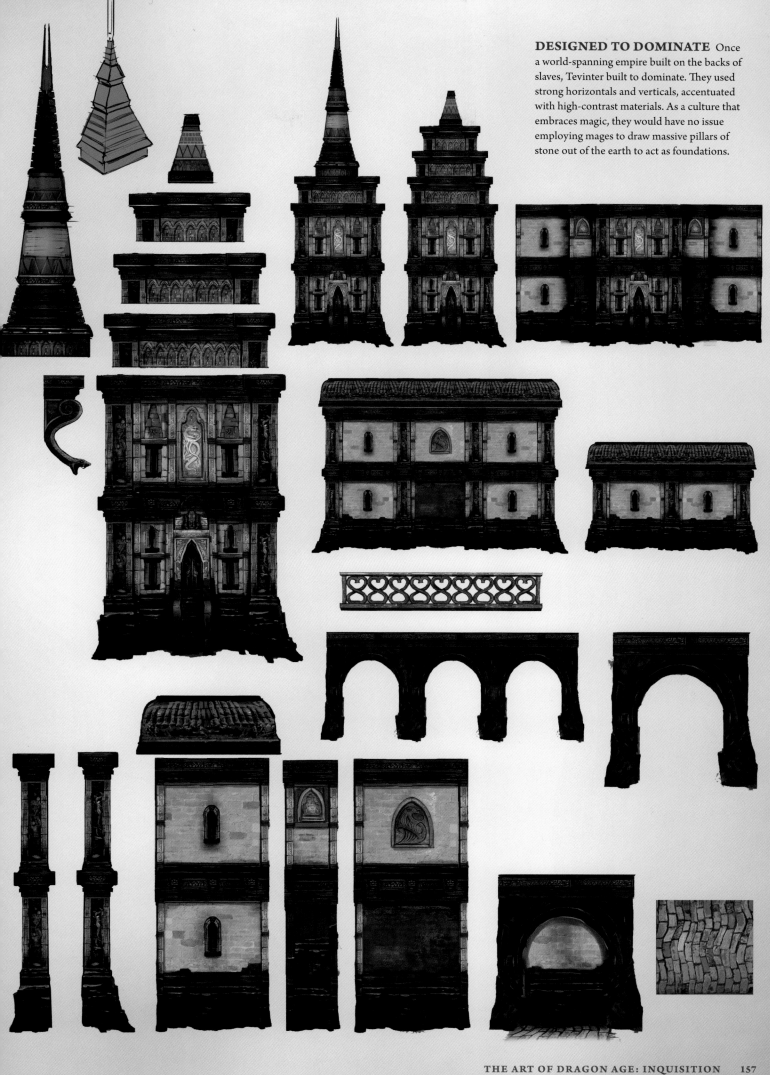

DESIGNED TO DOMINATE Once a world-spanning empire built on the backs of slaves, Tevinter built to dominate. They used strong horizontals and verticals, accentuated with high-contrast materials. As a culture that embraces magic, they would have no issue employing mages to draw massive pillars of stone out of the earth to act as foundations.

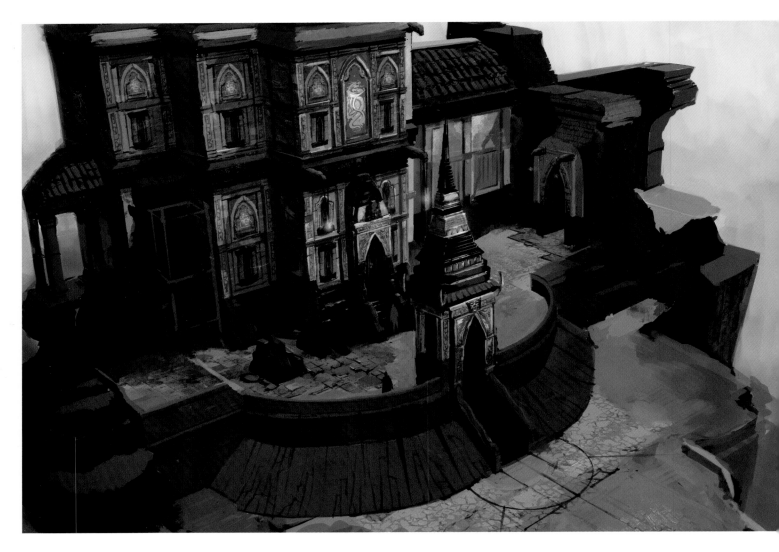

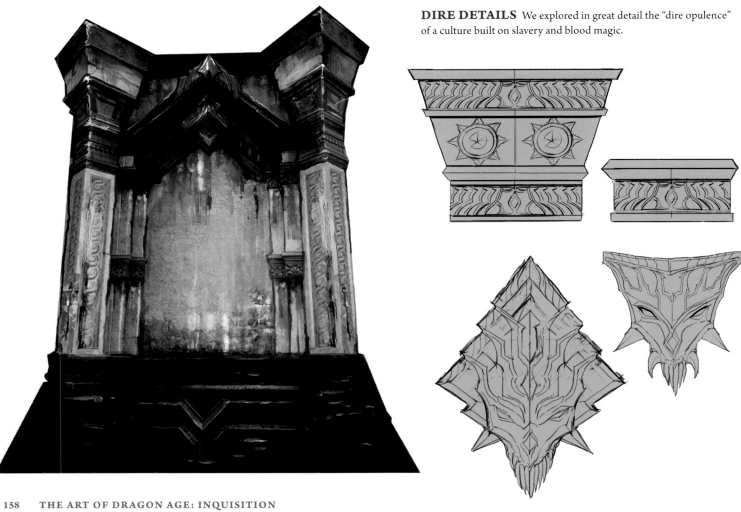

DIRE DETAILS We explored in great detail the "dire opulence" of a culture built on slavery and blood magic.

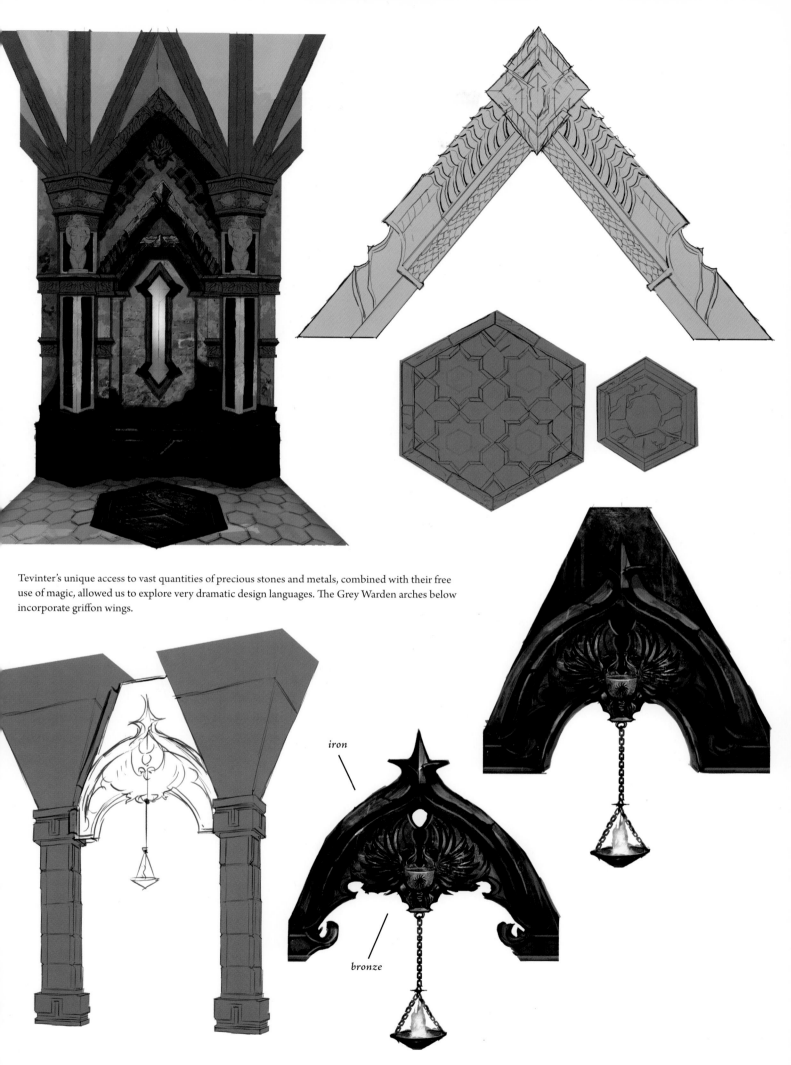

Tevinter's unique access to vast quantities of precious stones and metals, combined with their free use of magic, allowed us to explore very dramatic design languages. The Grey Warden arches below incorporate griffon wings.

iron

bronze

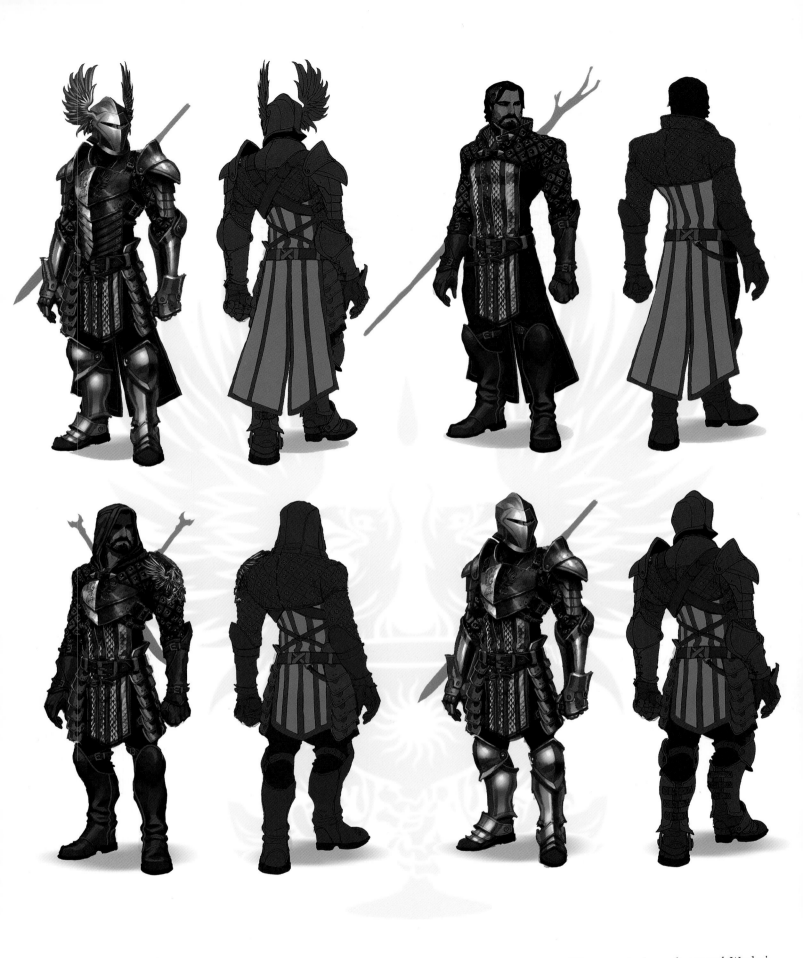

THE GREY WARDENS For *Inquisition*, we gave the Grey Wardens a uniform. We built a scalable suit that could be customized according to each Warden's preferences. Warriors could pile on the plates, and mages would typically travel light. While we study and reference real-world armor extensively, we wanted to establish a different philosophy for the armor in *Dragon Age*. Thedas is filled with bandits, mages, demons, the undead, dragons, the blight, and so many other threats. We needed armor that could be kept beside your bed and thrown on as you sprint out the door with your sword drawn.

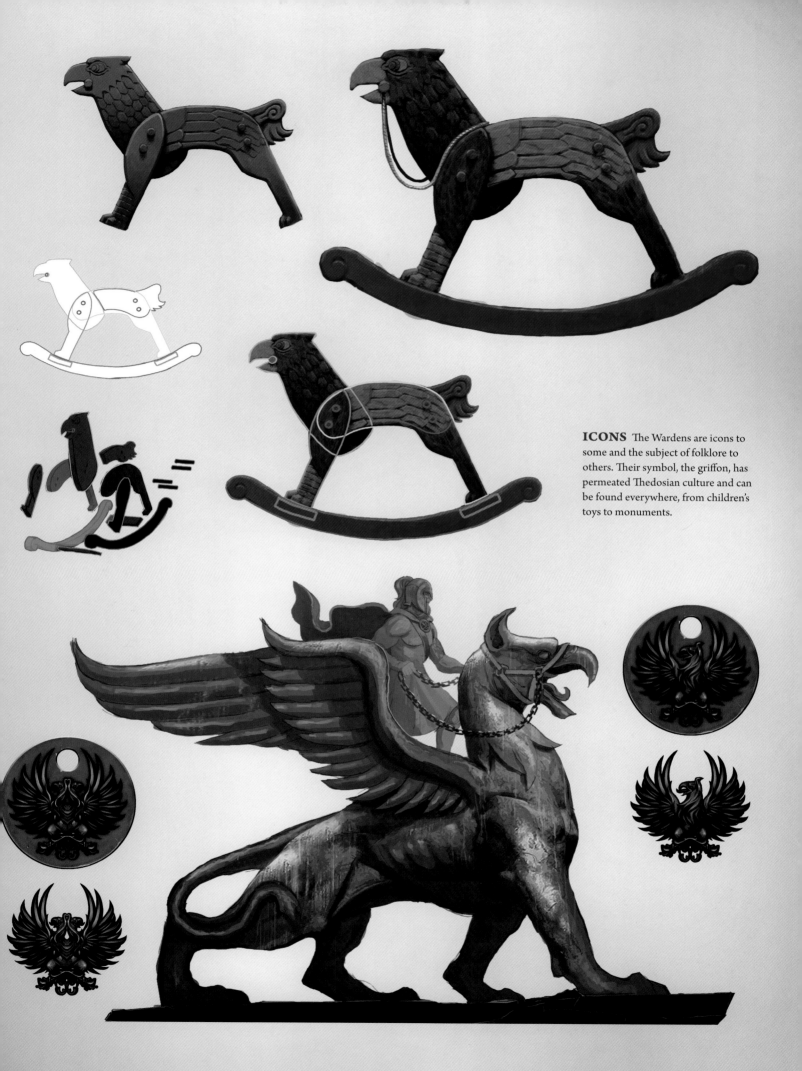

ICONS The Wardens are icons to some and the subject of folklore to others. Their symbol, the griffon, has permeated Thedosian culture and can be found everywhere, from children's toys to monuments.

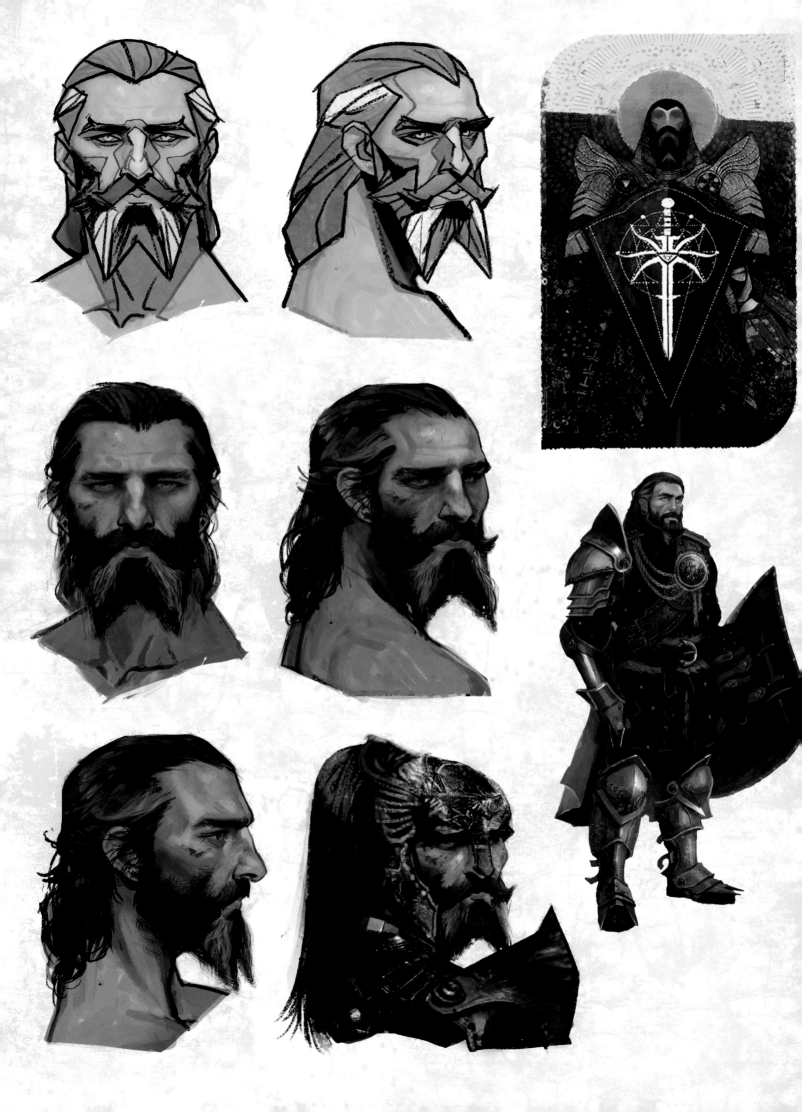

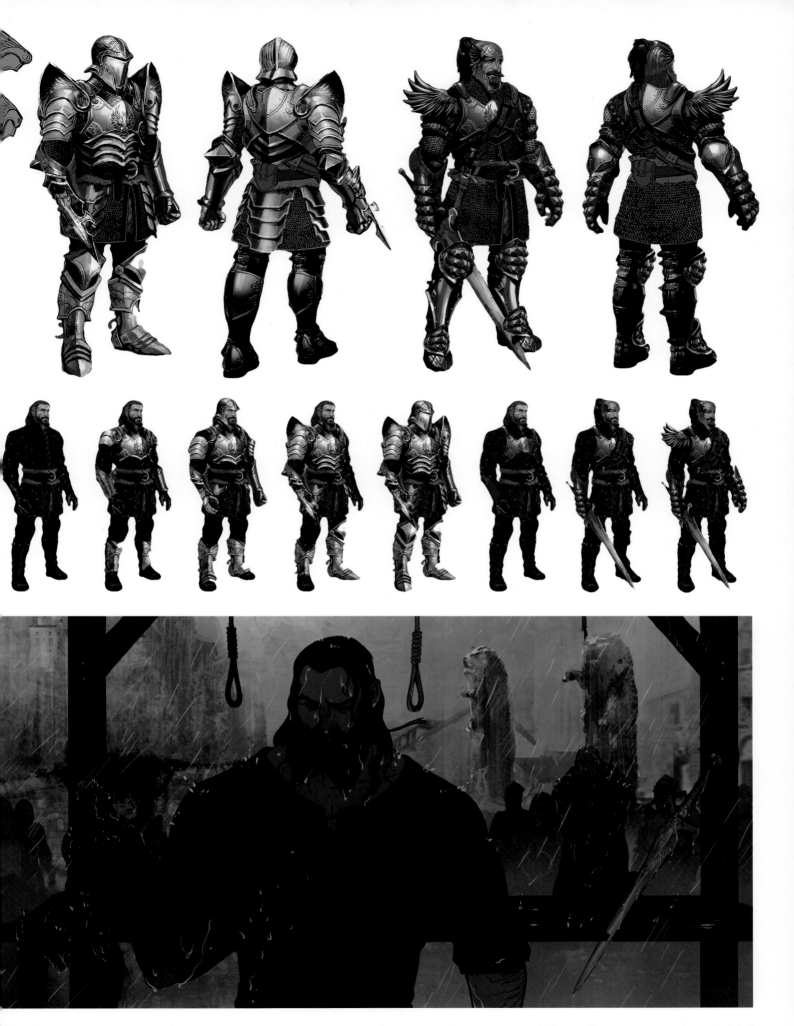

BLACKWALL We explored many designs for the Warden known as Blackwall. The sturdy, weathered warrior provided an excellent opportunity to depict the "ideal Warden," the kind of hero that children picture when they hear the old stories.

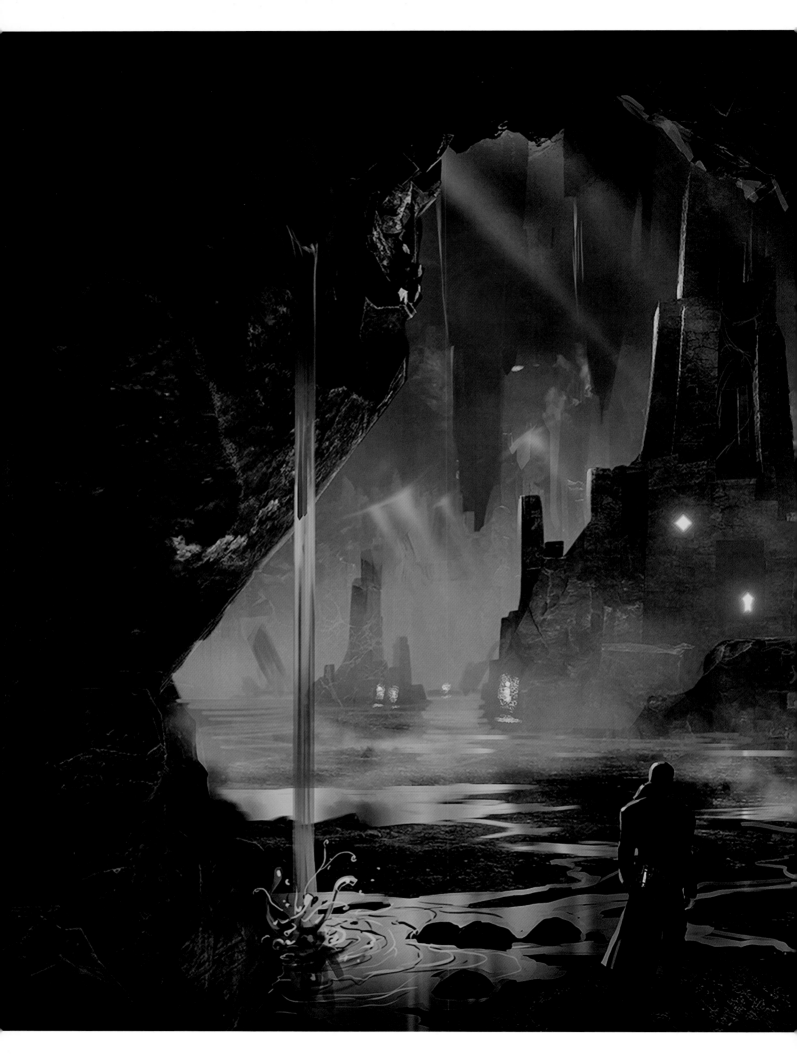

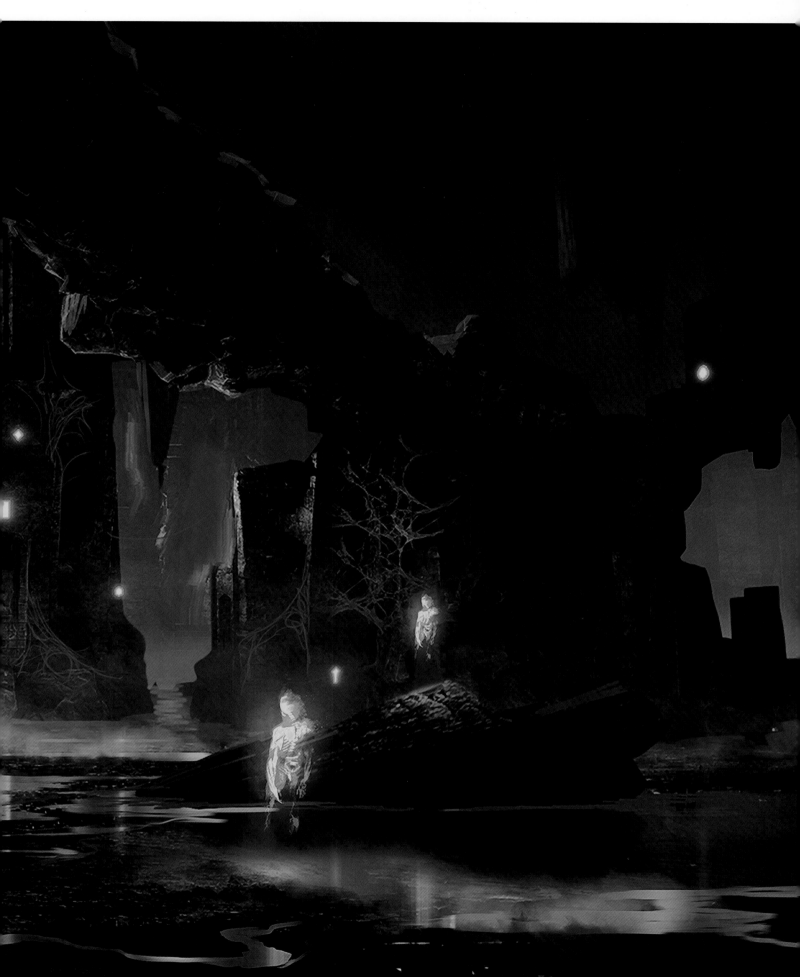

THE FADE Imagine being hunted through the ship-breaking yard of the world's nightmares at low tide. In previous *Dragon Age* games, you travel to the Fade through dreams. In *Inquisition*, you go there for real. This provided the perfect opportunity to rewrite the Fade's visual language.

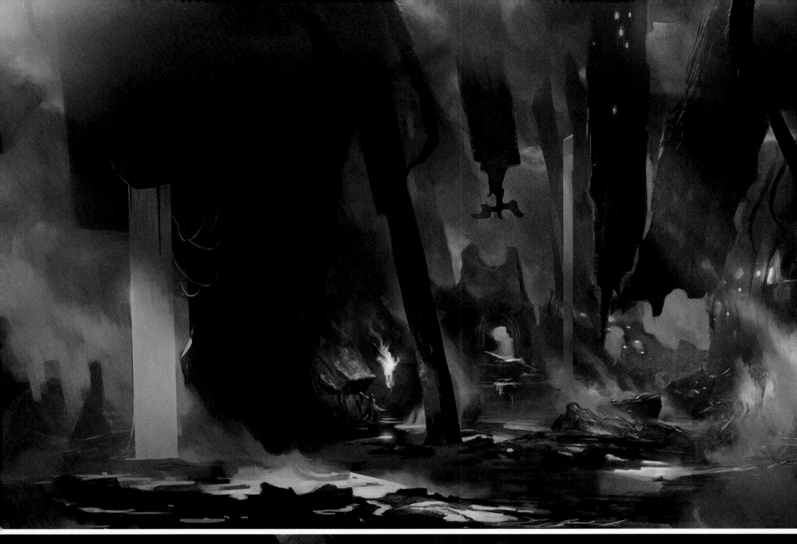

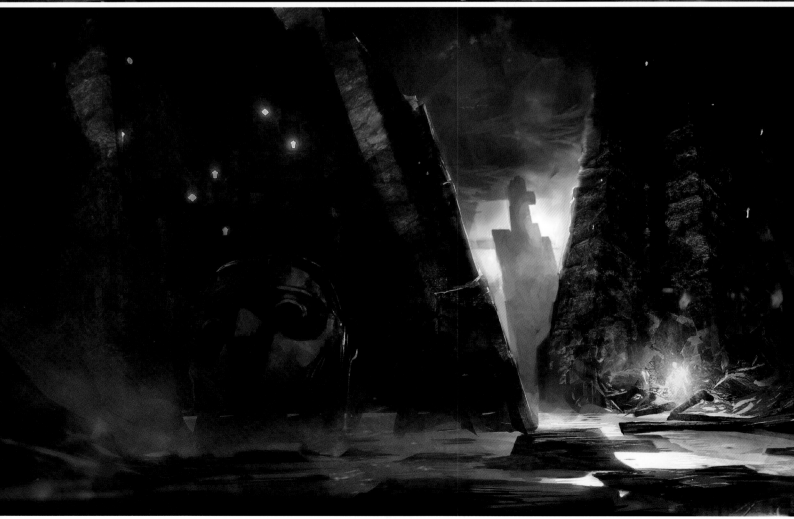

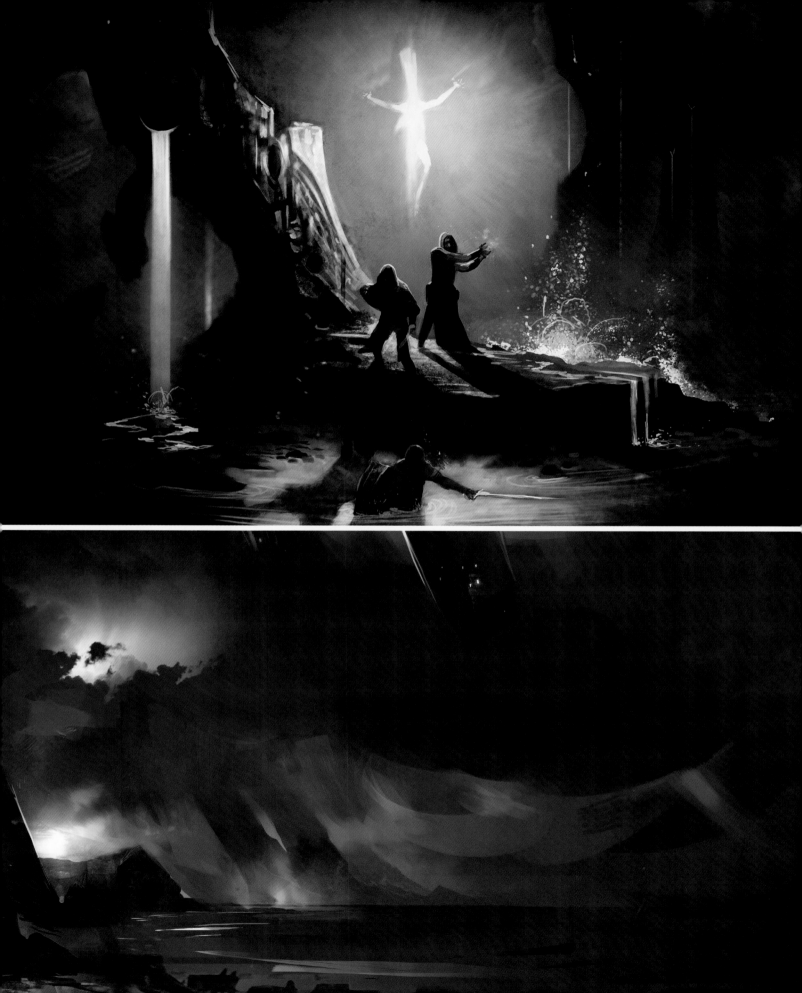

WE SHOULDN'T BE HERE We wanted to bring a sense of immensity to the Fade, of grand-scale violence happening all around you, coupled with the hungry quiet you feel when you're watched by a thousand eyes. It needed to feel like a place where no mortal foot was meant to tread.

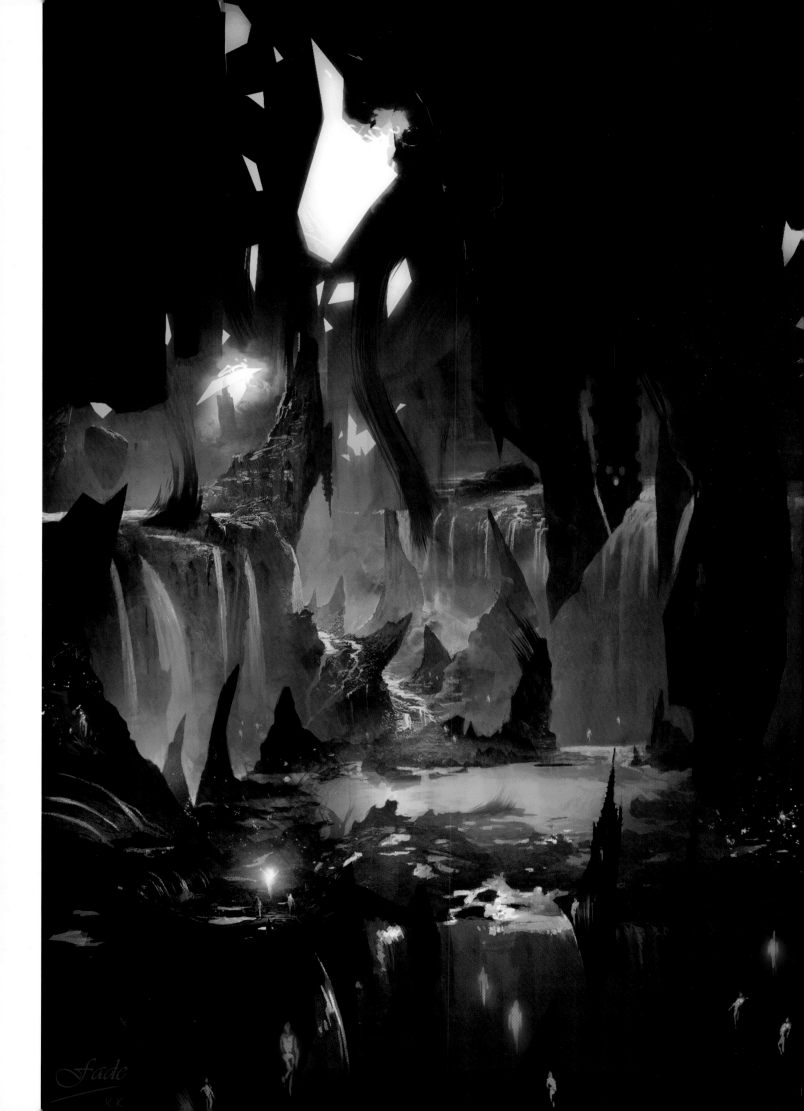

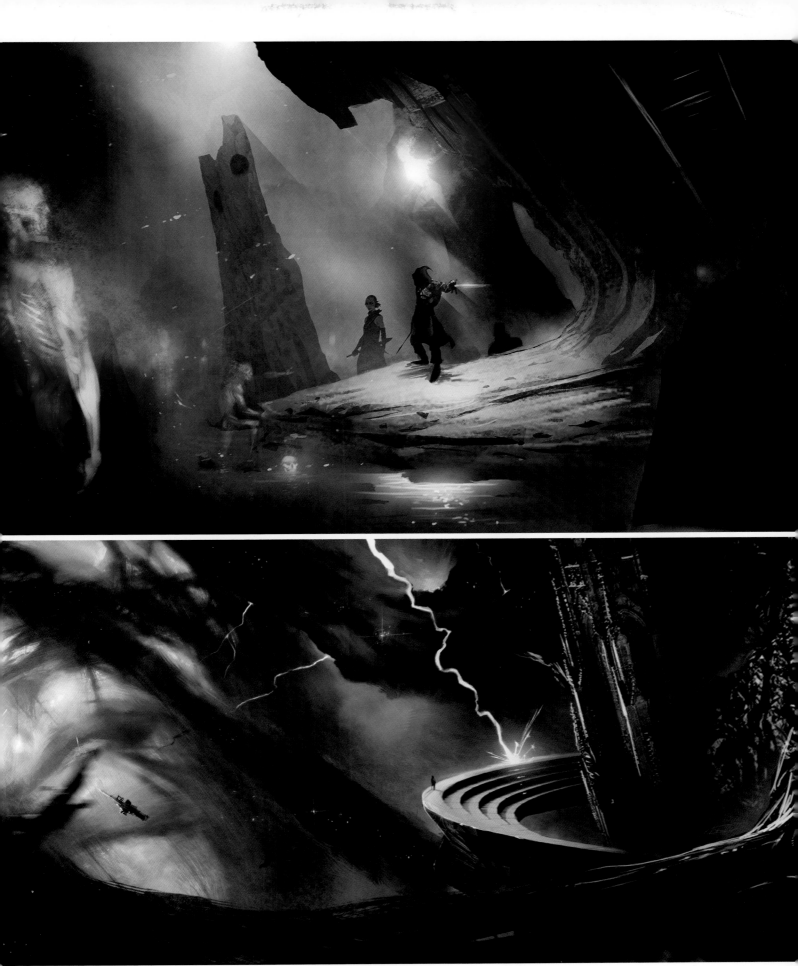

A DAY HIKE THROUGH THE ABSTRACT The Fade is deadly and surreal. It is also where magic appears to come from. We explored many directions in search of the right feeling, one that could also feasibly be displayed on a screen. What if gravity, space, and time followed different rules? What if you were hunted by demons across frozen storms? What if you could physically walk through the Fade from its apocalyptic end toward its creation?

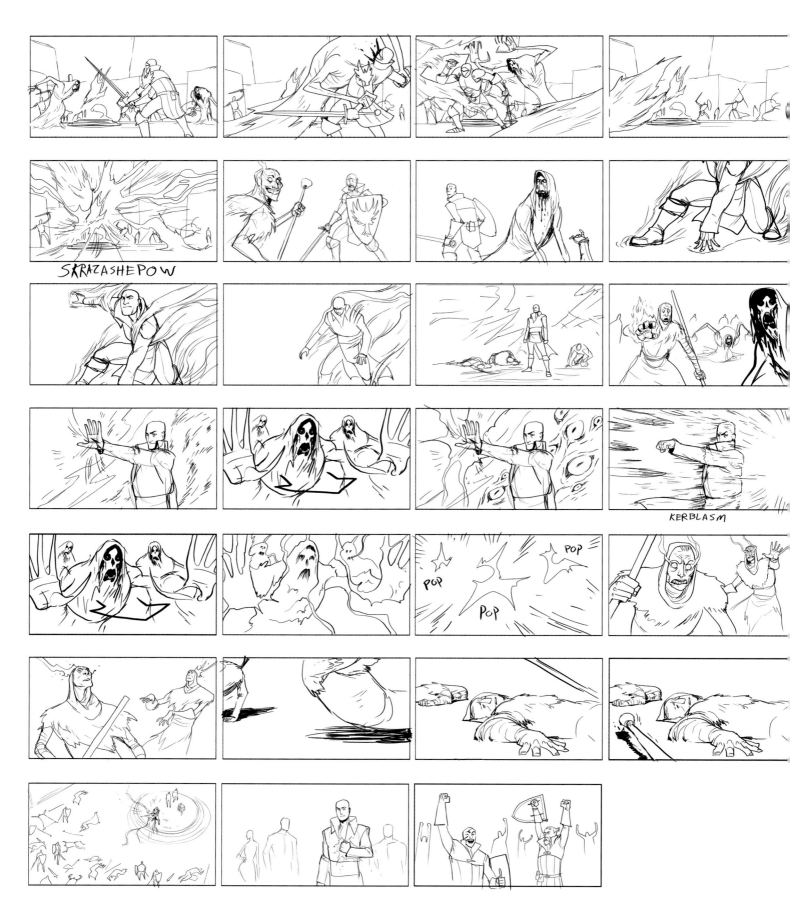

The ability to quickly draft and revise storyboards helped visualize key beats in the game's narrative. Often during brainstorms, we would sketch out frames on the fly just to see how they might work.

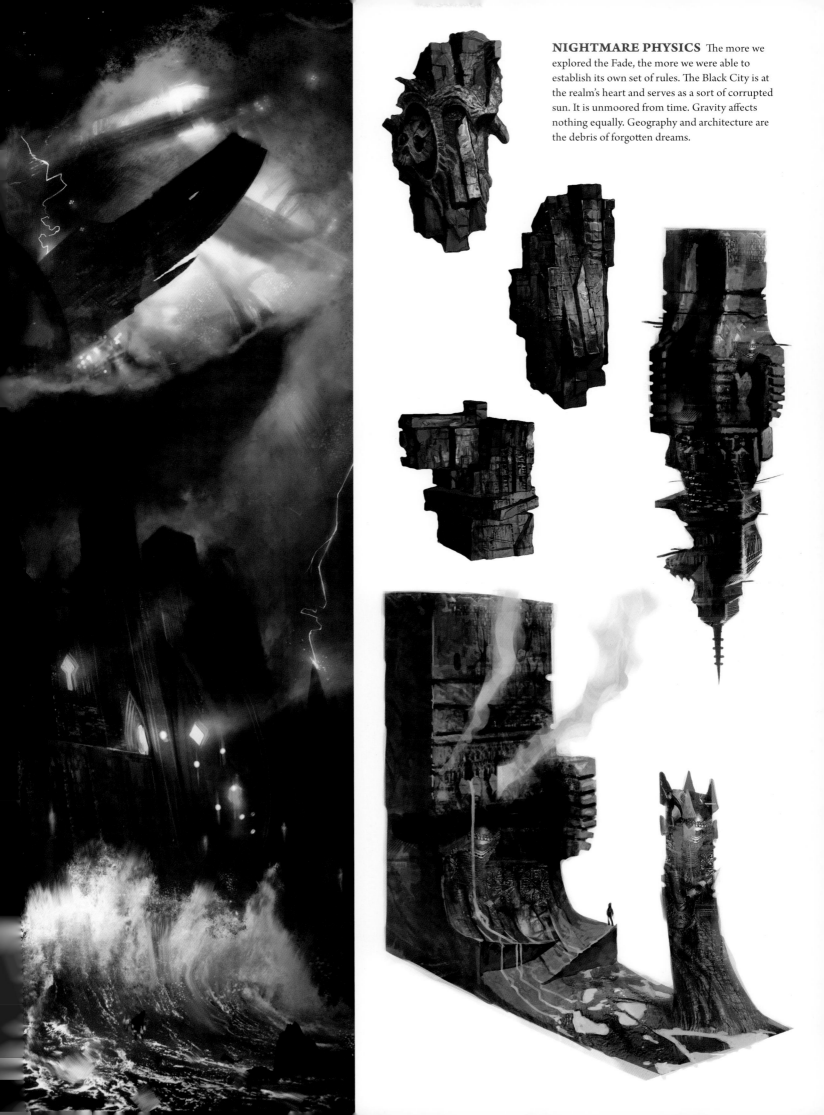

NIGHTMARE PHYSICS The more we explored the Fade, the more we were able to establish its own set of rules. The Black City is at the realm's heart and serves as a sort of corrupted sun. It is unmoored from time. Gravity affects nothing equally. Geography and architecture are the debris of forgotten dreams.

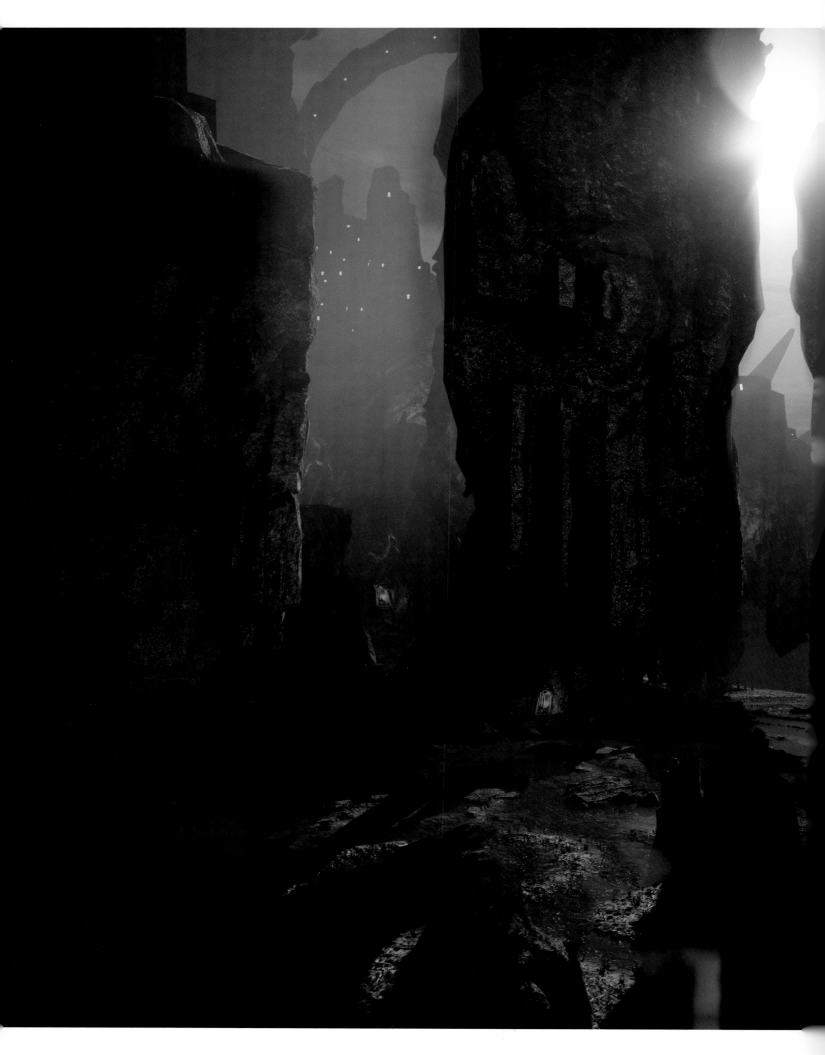

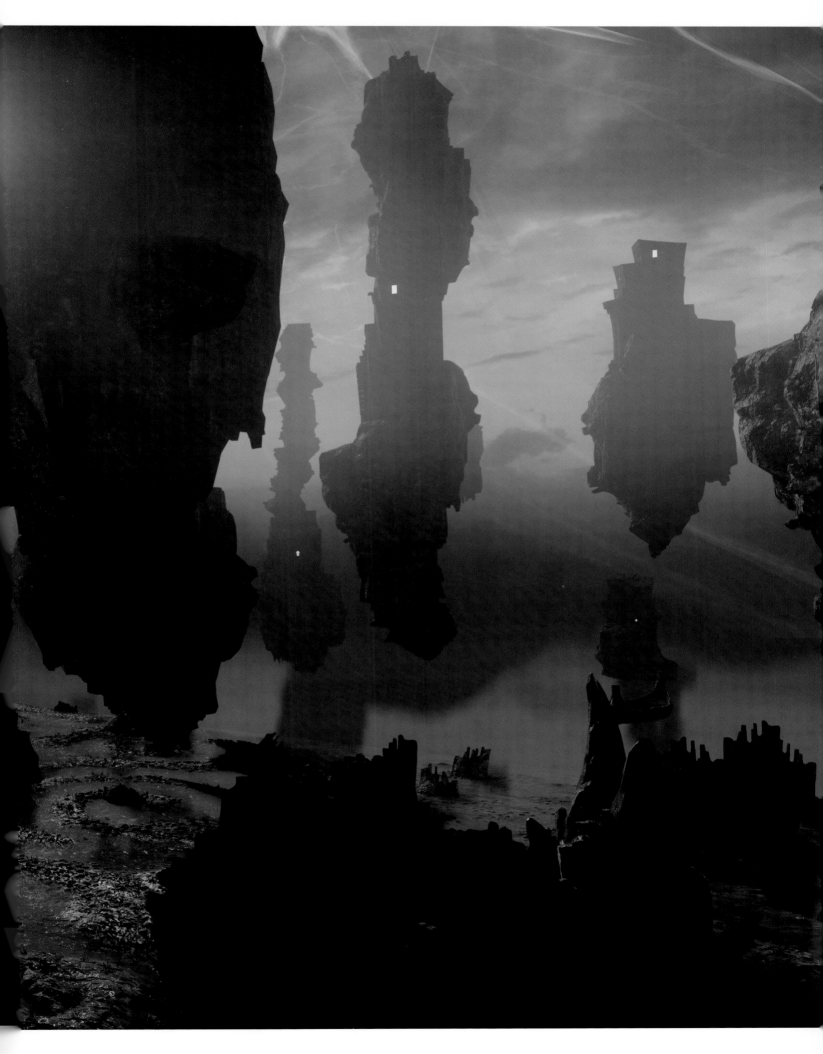

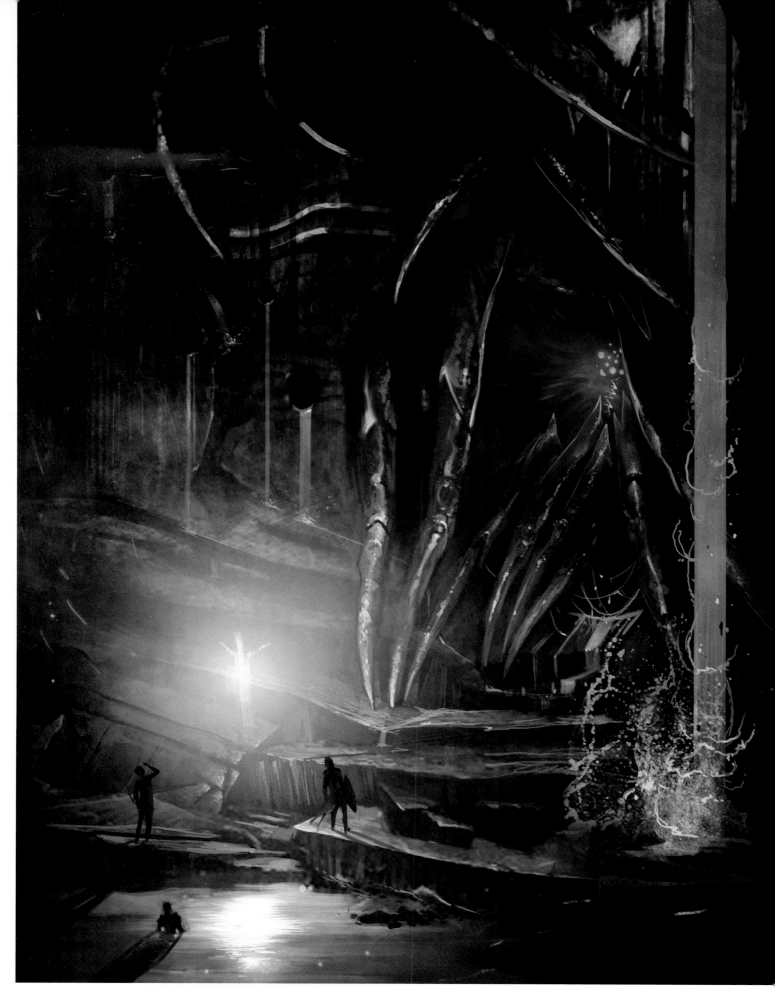

ECOLOGY OF FEAR The creatures of the Fade are scavengers, feeding off the remains of nightmare debris from which they themselves were born. Visceral fears such as sharp teeth and claws, eyes glowing in the darkness, disease, and claustrophobia all coalesced for us in the form of a hideous spider that feeds off listless dreamers stumbling through the realm.

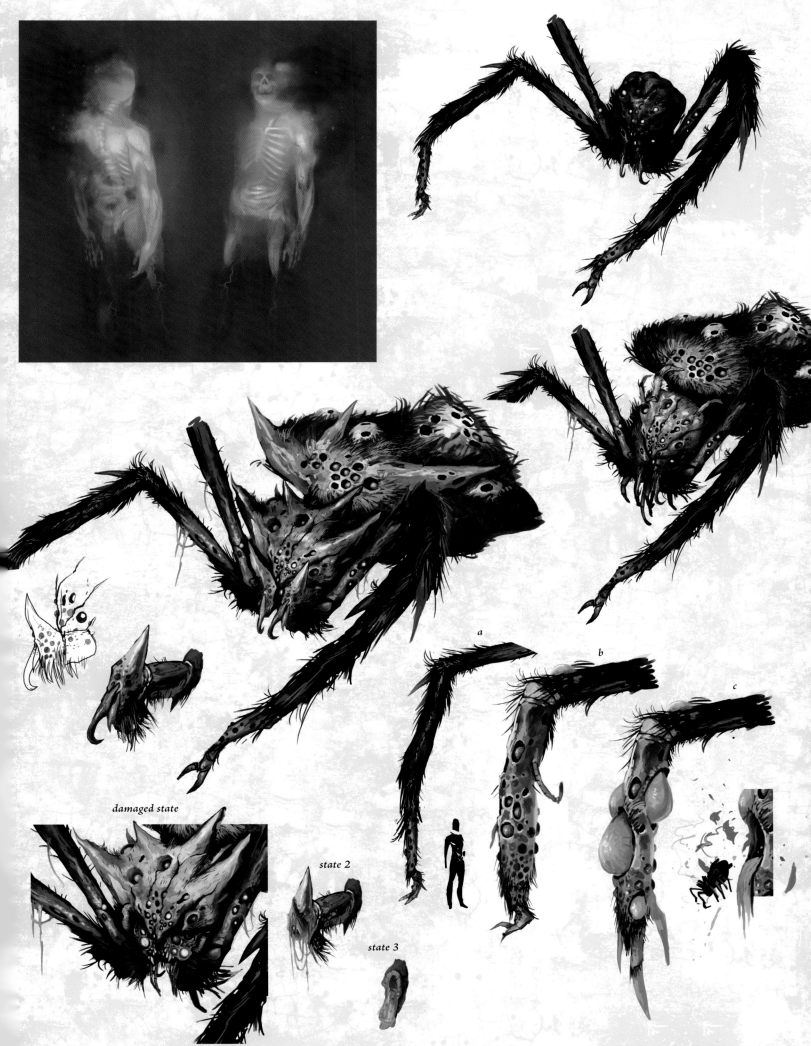

damaged state

state 2

state 3

a

b

c

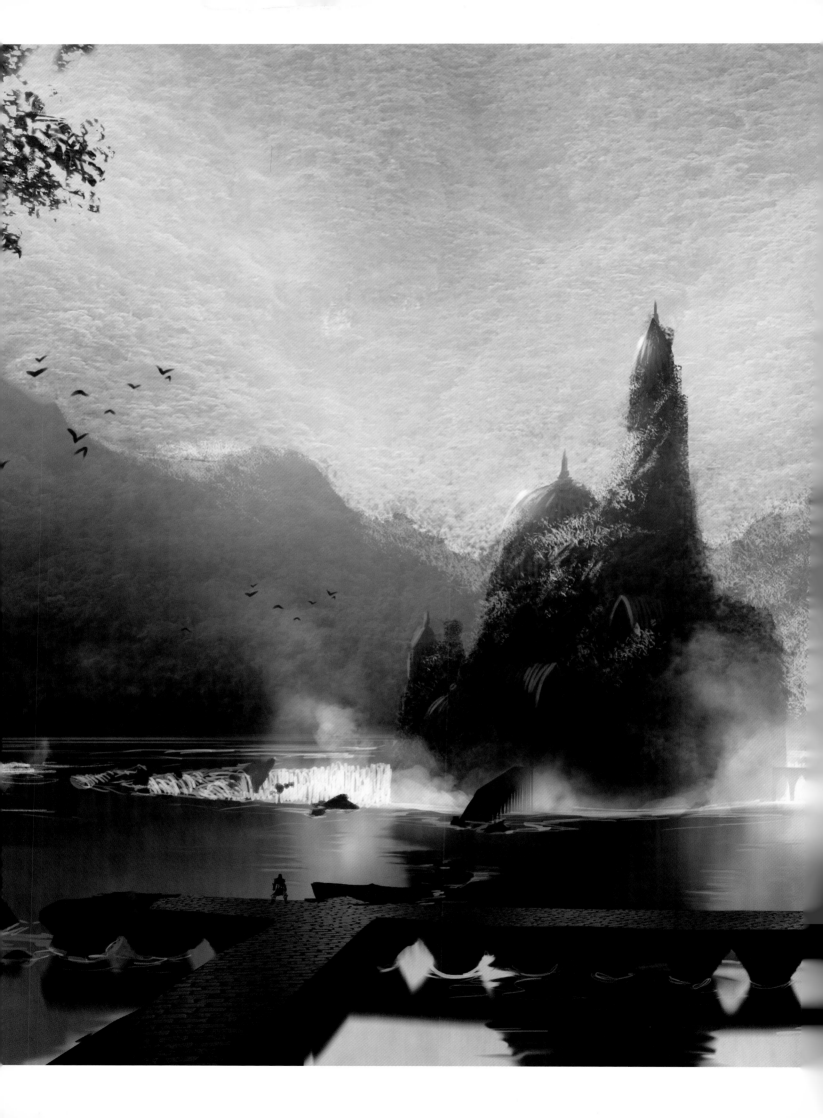

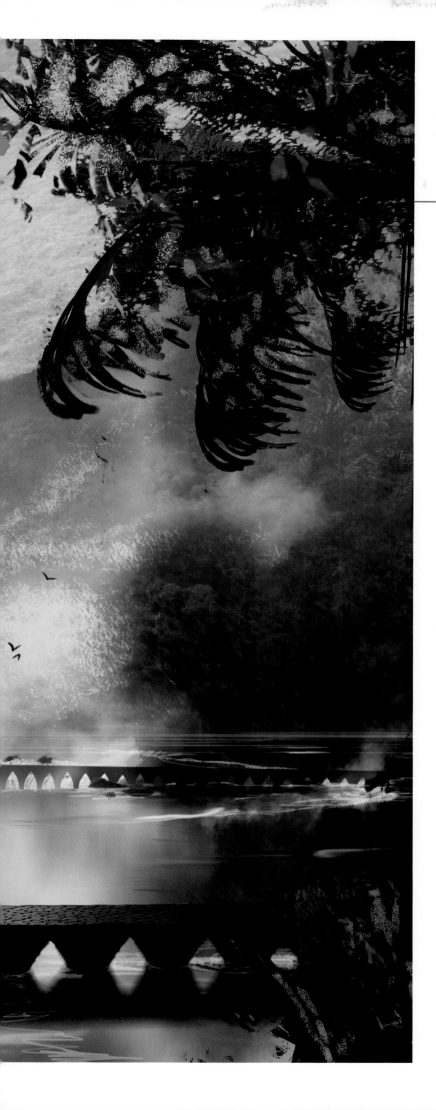

WHAT PRIDE HAD WROUGHT

In past *Dragon Age* titles, the lost culture of the ancient elves was relegated to ruins, relics, and historical bread crumbs. *Inquisition* gave us the opportunity to explore what that culture looked like, to provide a glimpse of the glory days.

The temple in the heart of the Arbor Wilds is stuck in time, a magnificent piece of elven architecture imagined in verdant, emerald greens and fine gold. The old trees of the wilds grow thickly, implying the age and untouchable quality of the environment. Lichen, moss, and vines crawl out of every bare face, crack, and crevice. To build this magical place, we took inspiration and textures from primal forests in places such as New Zealand and Vancouver Island—very real places with their own kind of magic.

Ambitious technology and scope helped us get here. In past games, players might have teleported into the center of the forest. Now they can discover the temple for themselves on a proper journey through the wilds, in a massive level packed with all the mystery and danger this kind of otherworldly overgrowth can hide.

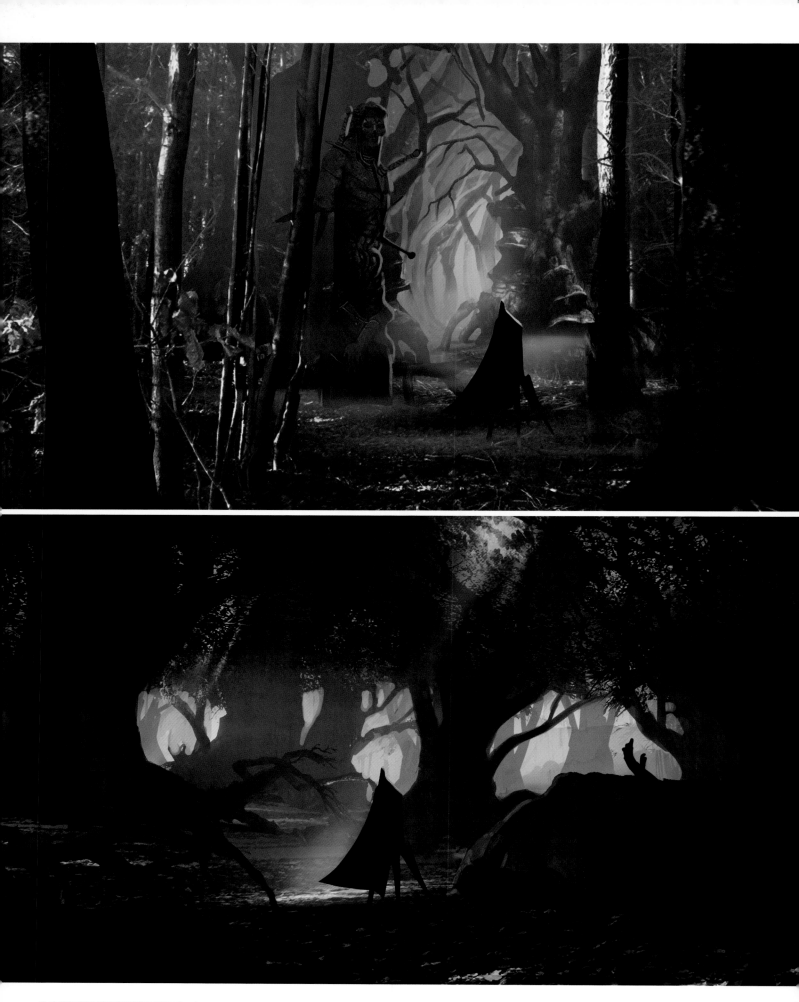

LOST IN THE WOODS The natural pillars and vaulted canopy of the Arbor Wilds conceal the most ancient secrets of Thedas. Recognizable forms seem to emerge from the layers of growth. Perhaps they are the weathered impressions of a forgotten people. Or they are natural formations tricking the eye. Regardless, the roots of the Arbor Wilds run deep, and we wanted to explore this visually.

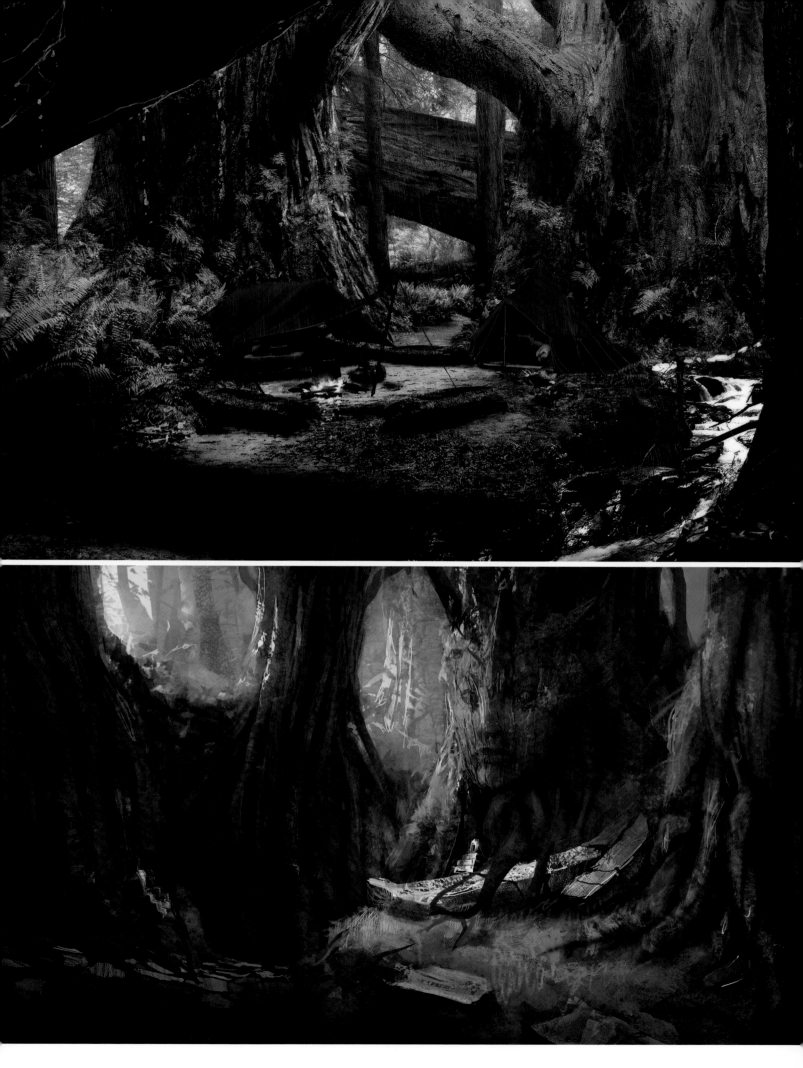

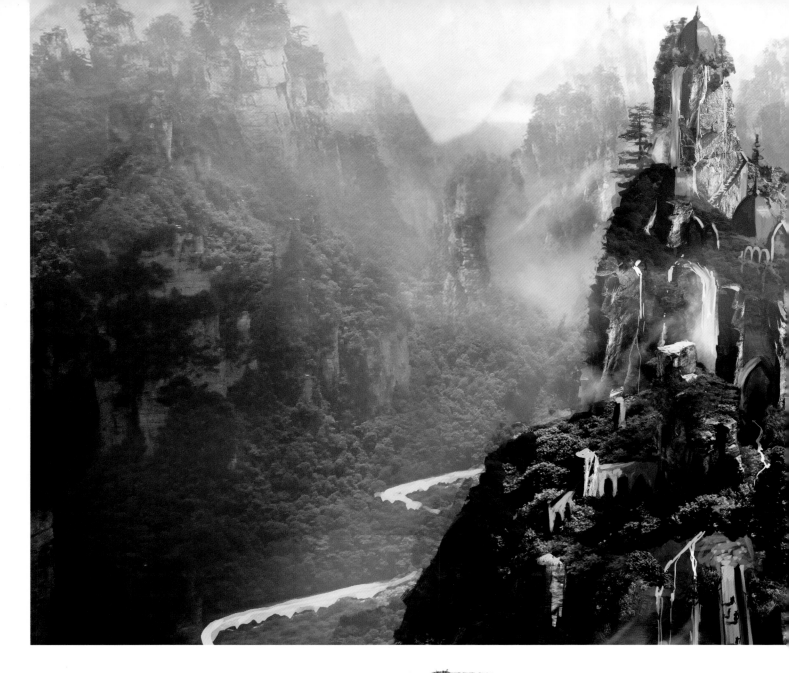

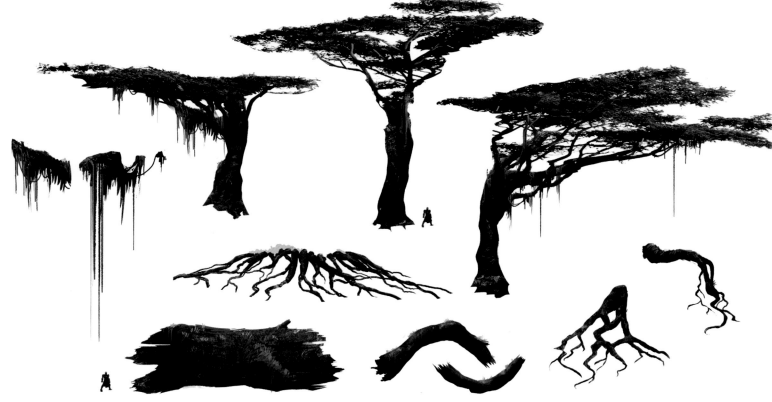

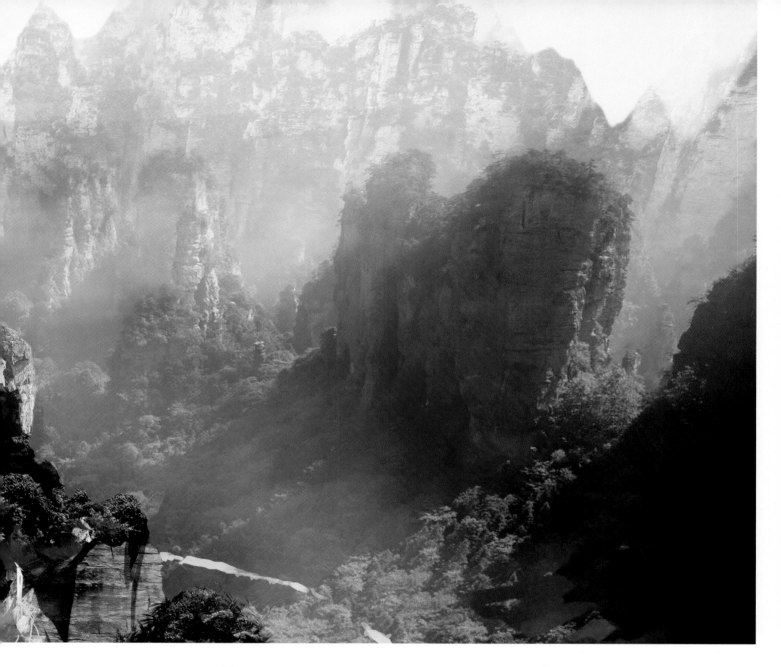

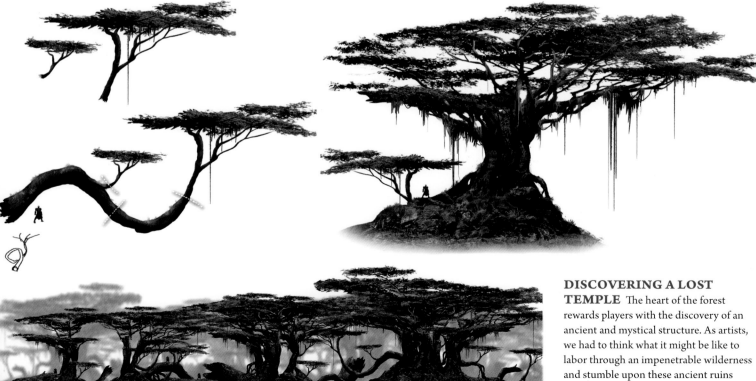

DISCOVERING A LOST TEMPLE The heart of the forest rewards players with the discovery of an ancient and mystical structure. As artists, we had to think what it might be like to labor through an impenetrable wilderness and stumble upon these ancient ruins deep in a pristine, natural environment.

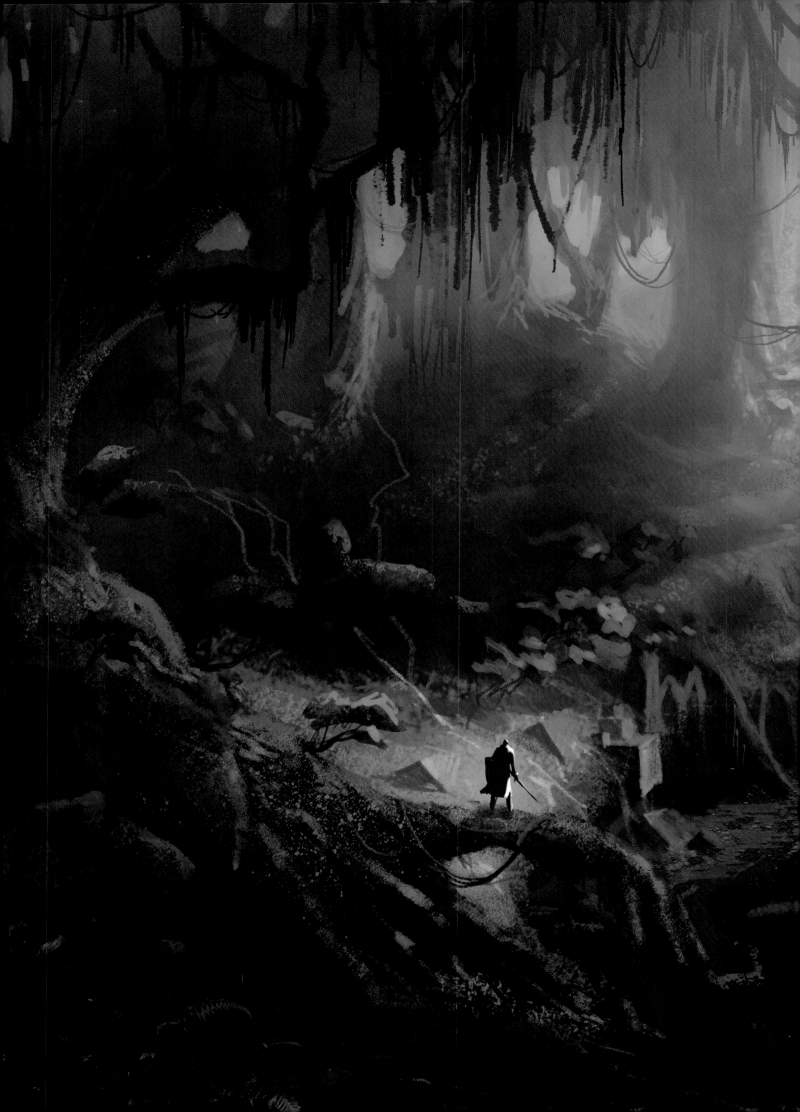

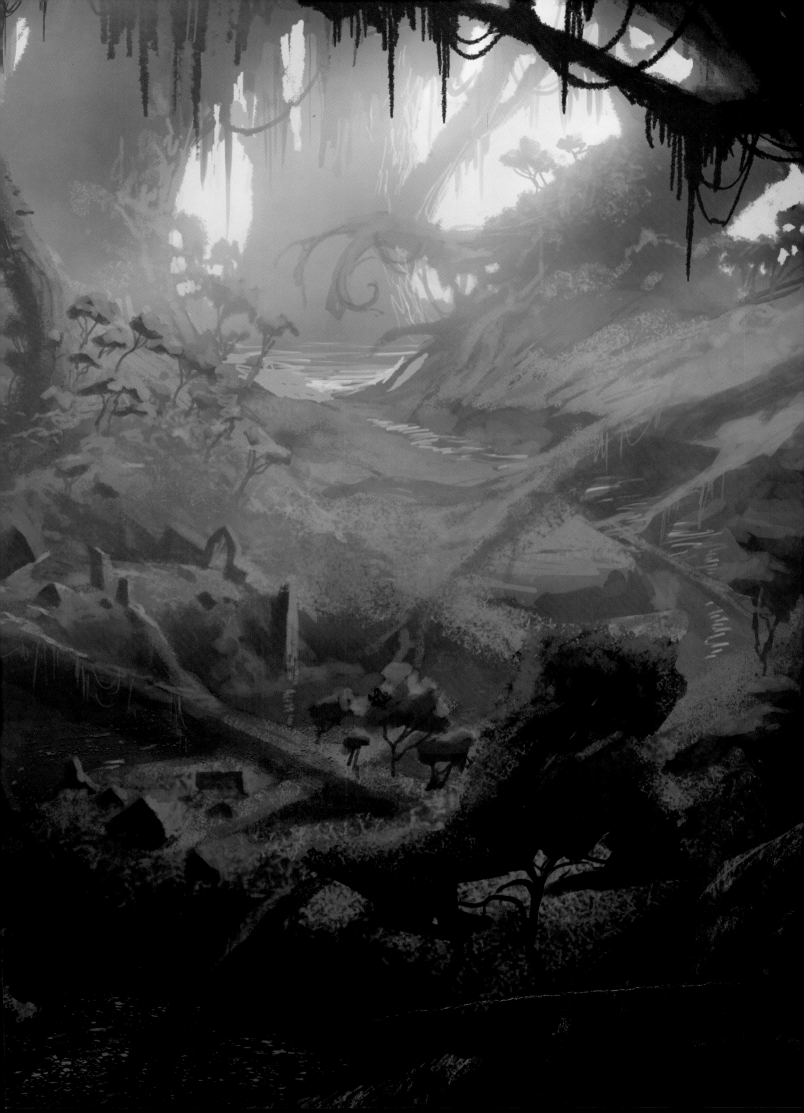

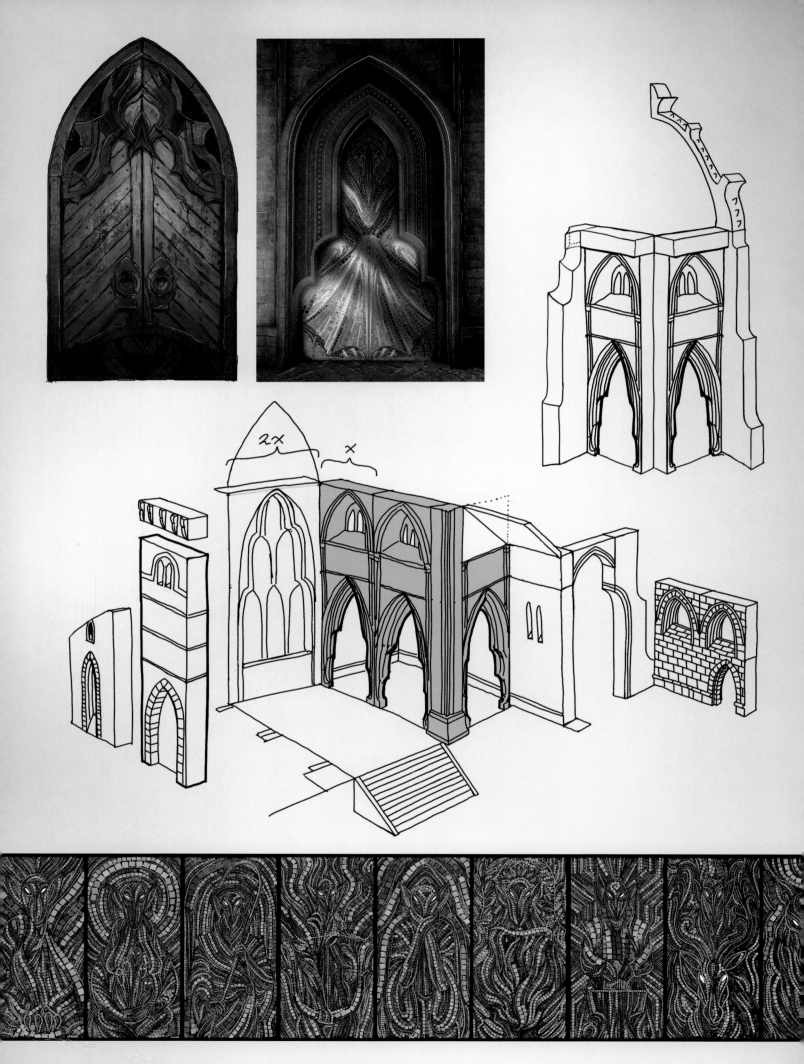

The labeled diagram shows:

$$2x$$

$$x$$

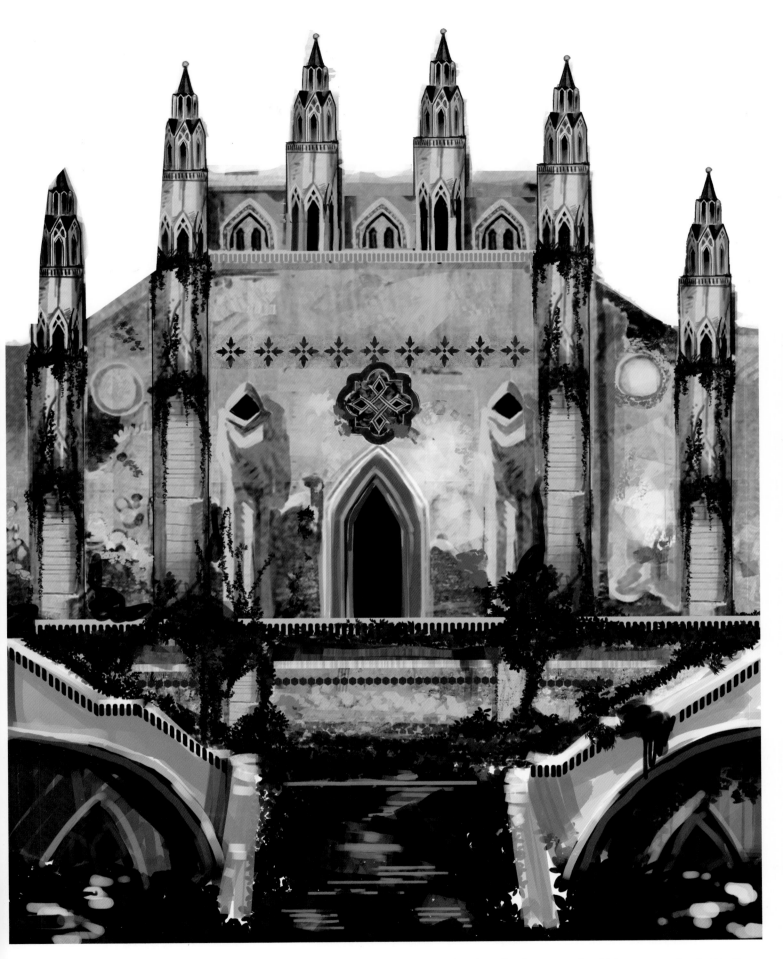

SPLENDOR OF THE ANCIENTS The gold mosaics and vertical structures had to speak to this culture's reverence for a higher power, rather than vanity. This is a big distinction from the Orlesians, who also like to encrust their world in pretty things for pretty's sake. The unkempt growth infiltrating every crack and corner only adds to the beauty of the location.

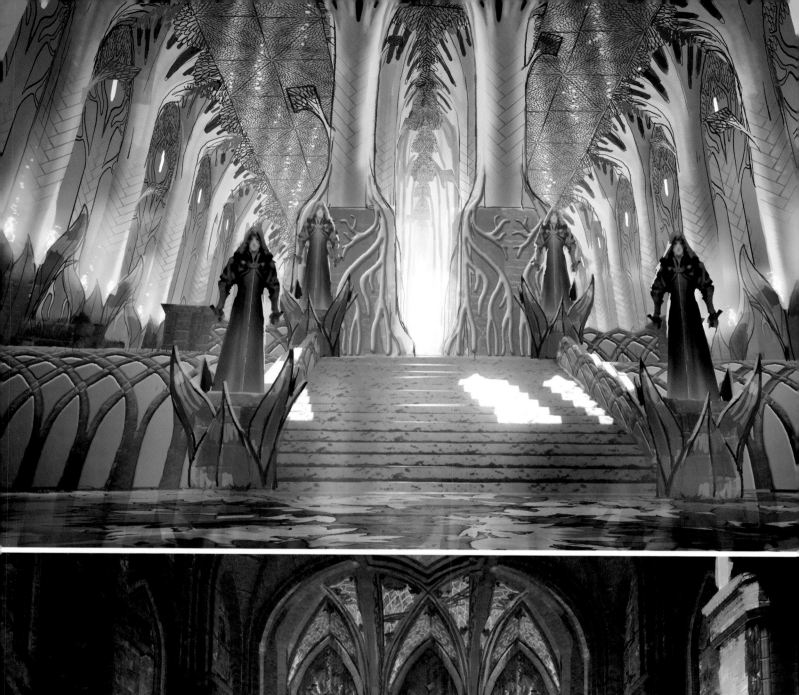

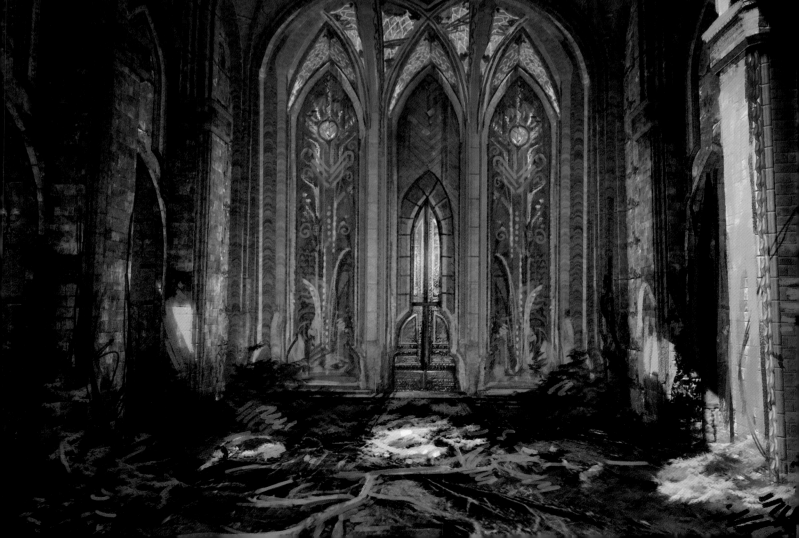

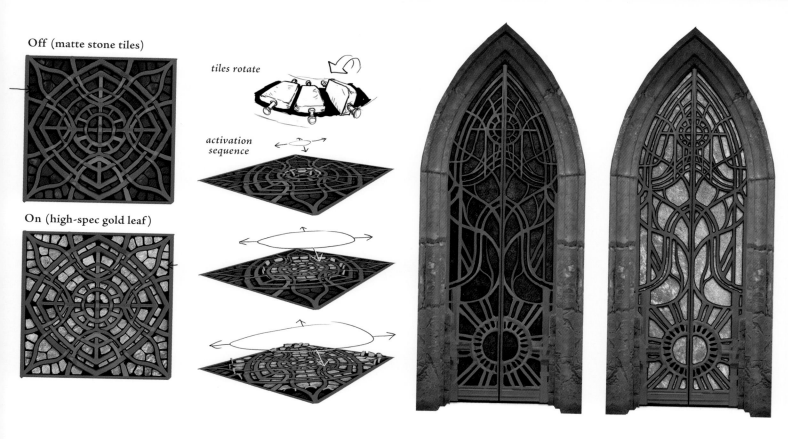

Off (matte stone tiles)

tiles rotate

activation sequence

On (high-spec gold leaf)

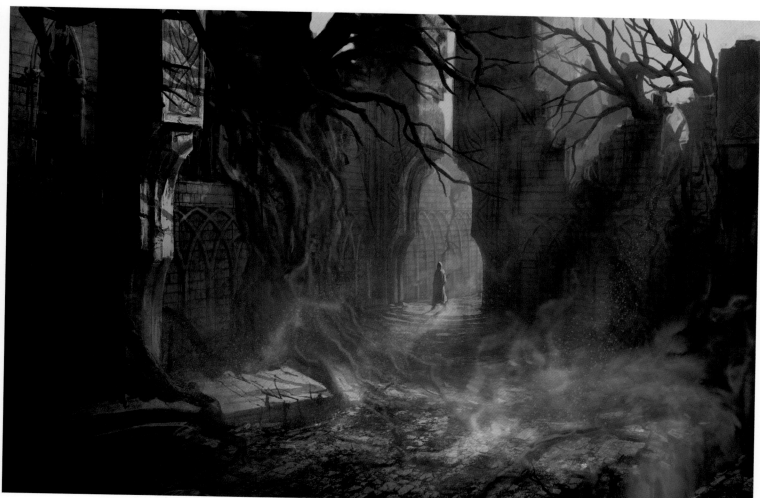

HISTORY CLAD IN GOLD So many real ruins were once painted brilliant colors or adorned with precious metals and stone. All we have today is the underlying structures, and their original magnificence is left to our imagination. The page opposite imagines the temple in its original glory; it was a useful tool to ground subsequent studies.

Above: We wanted to avoid clichéd methods of rendering the temple's magic puzzle tiles and doors, such as having them glow. We came up with a mechanical solution involving rotating, golden tiles that are consistent with the architecture.

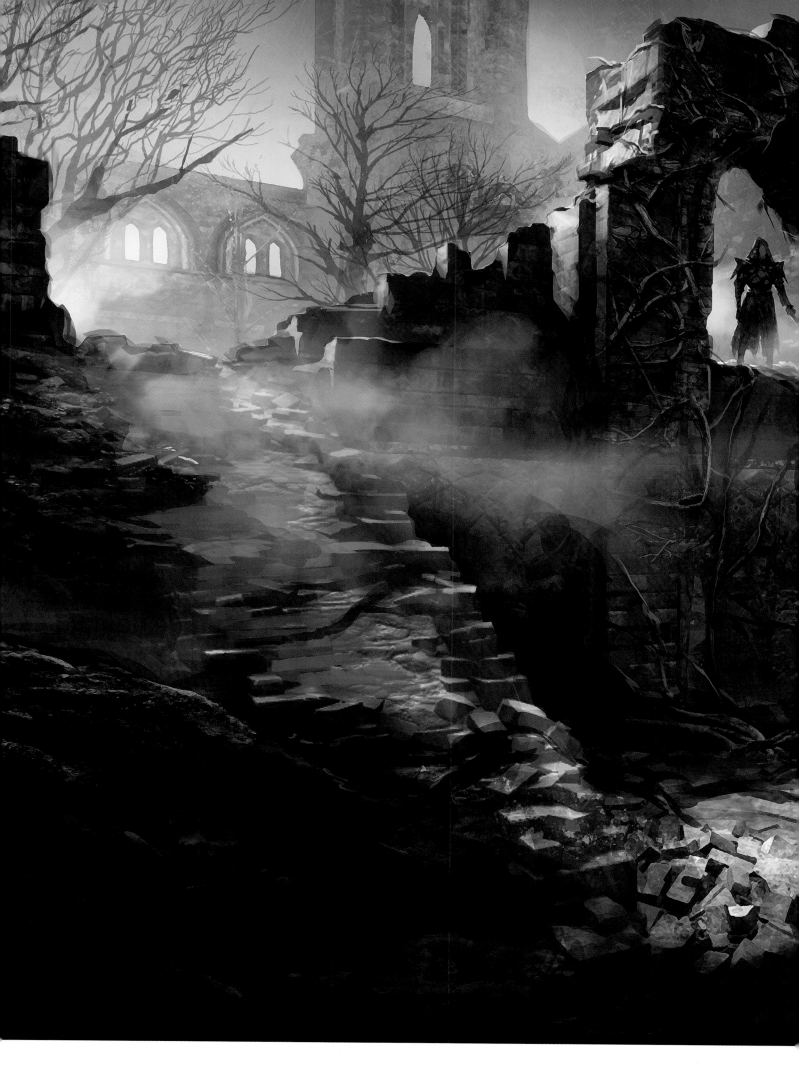

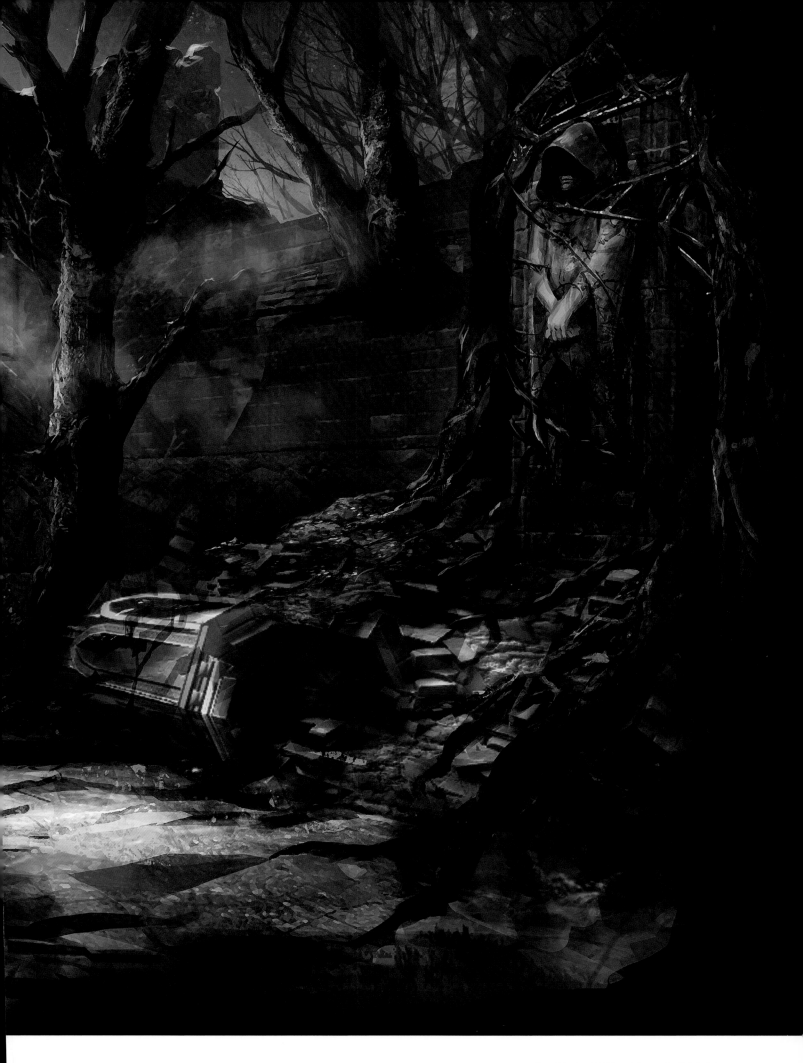

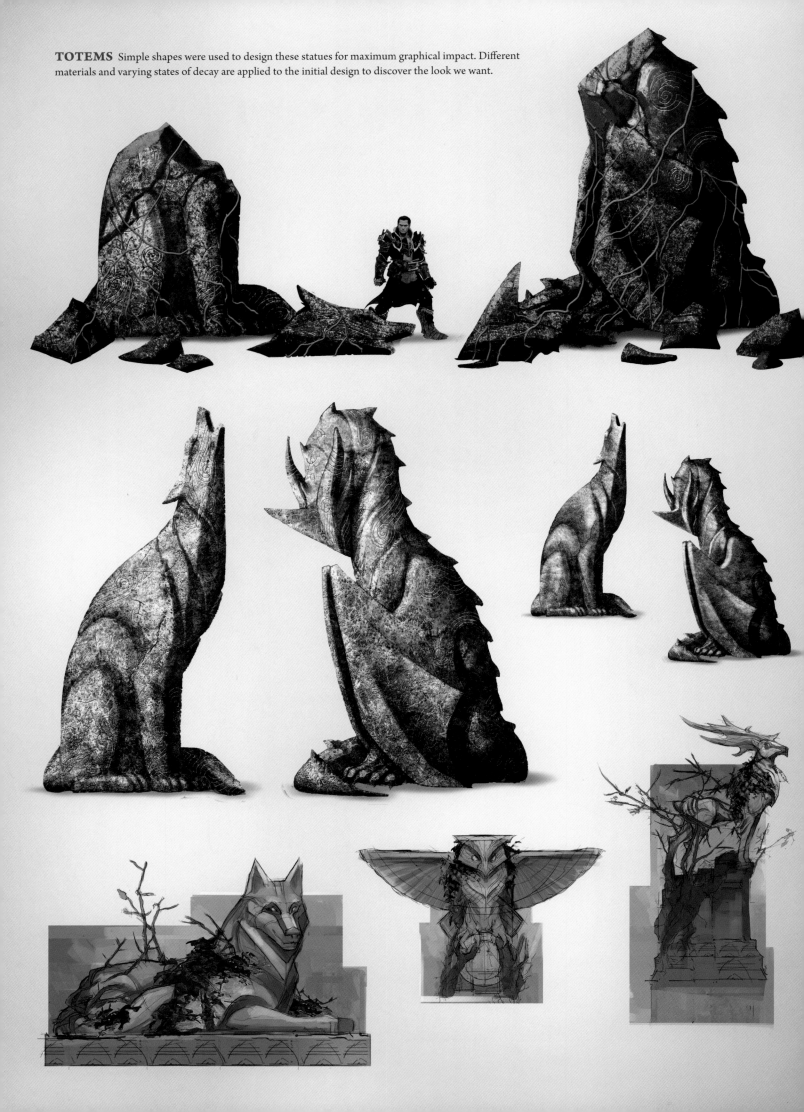

TOTEMS Simple shapes were used to design these statues for maximum graphical impact. Different materials and varying states of decay are applied to the initial design to discover the look we want.

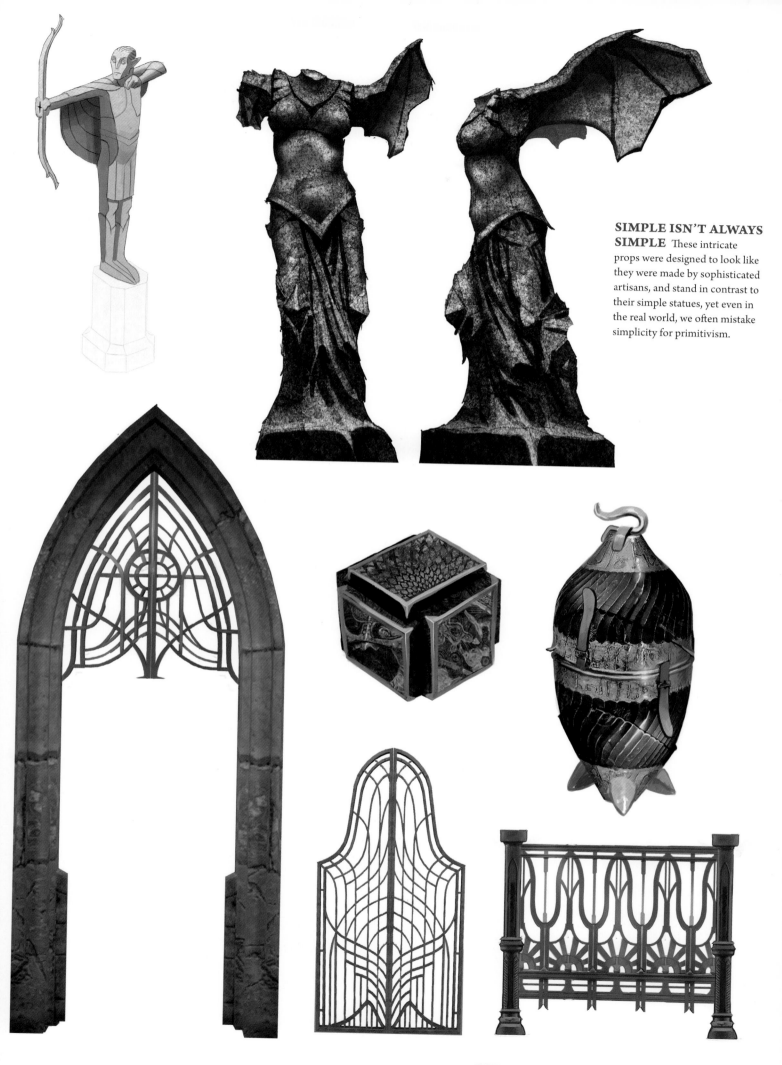

SIMPLE ISN'T ALWAYS SIMPLE These intricate props were designed to look like they were made by sophisticated artisans, and stand in contrast to their simple statues, yet even in the real world, we often mistake simplicity for primitivism.

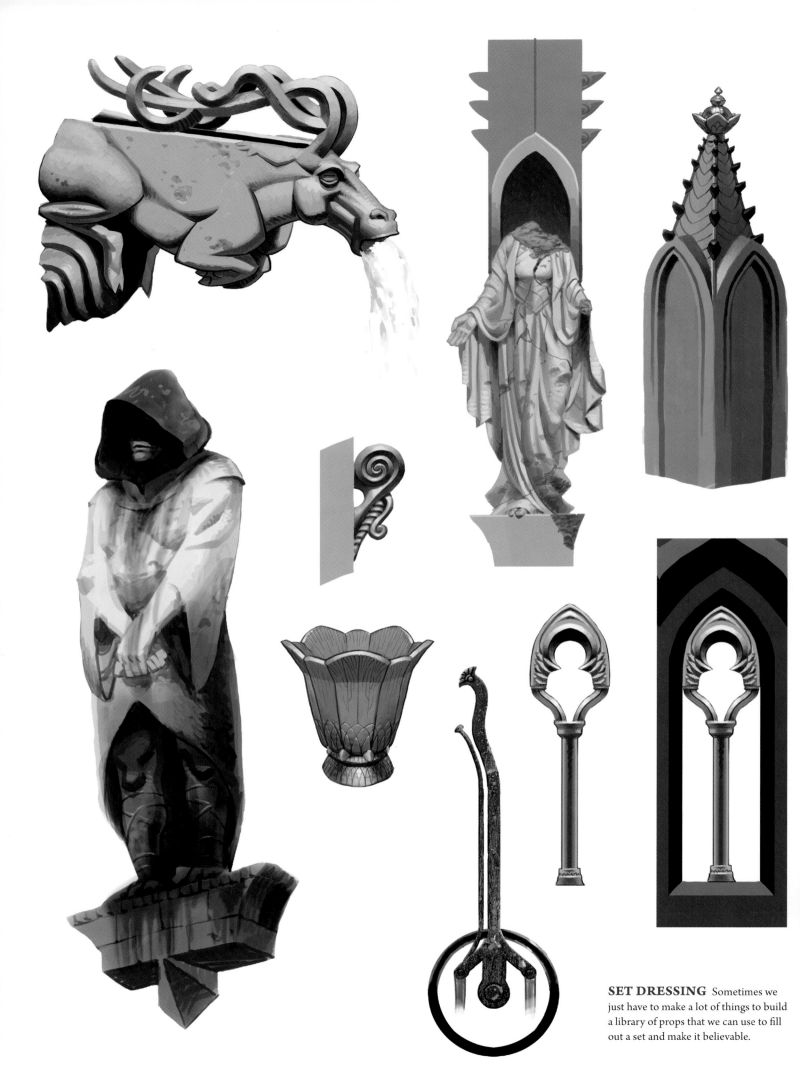

SET DRESSING Sometimes we just have to make a lot of things to build a library of props that we can use to fill out a set and make it believable.

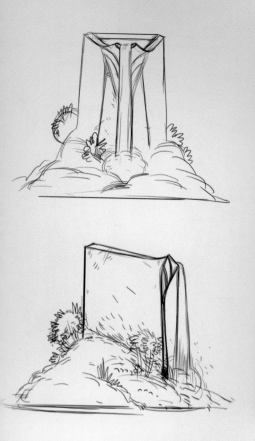

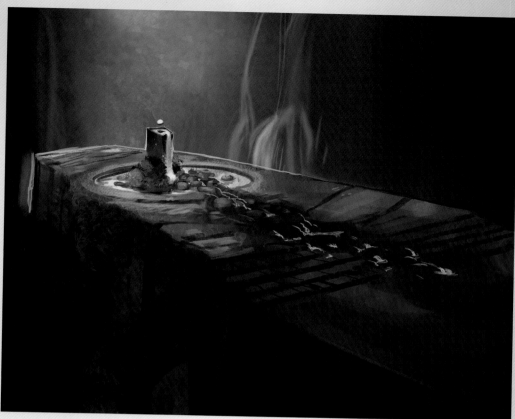

A SACRED SITE An early take on the main chamber of the temple. Although its final appearance evolved considerably, the well always retained a spare and minimalist appearance.

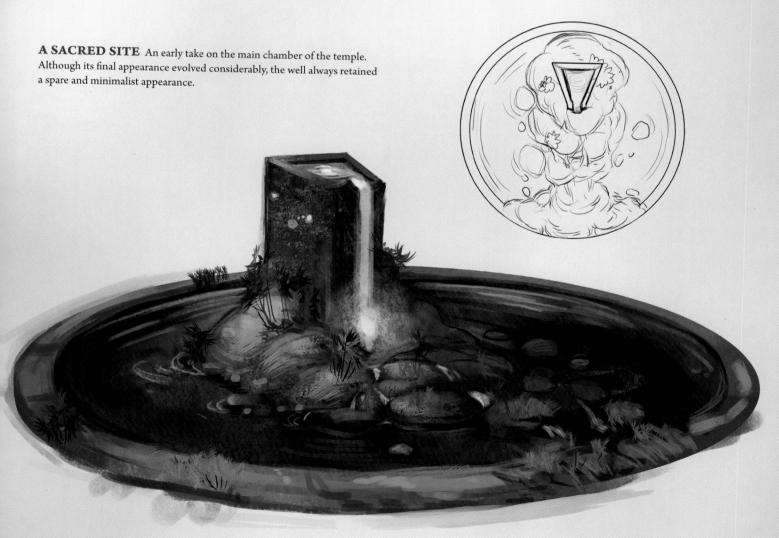

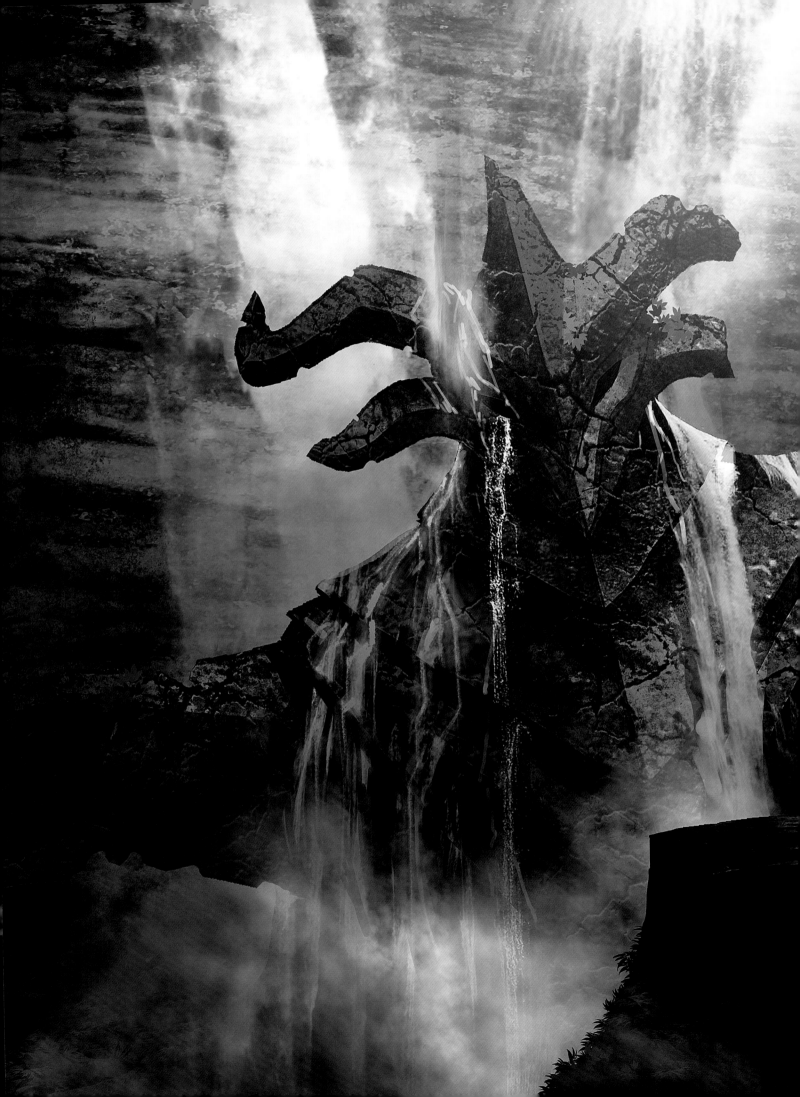

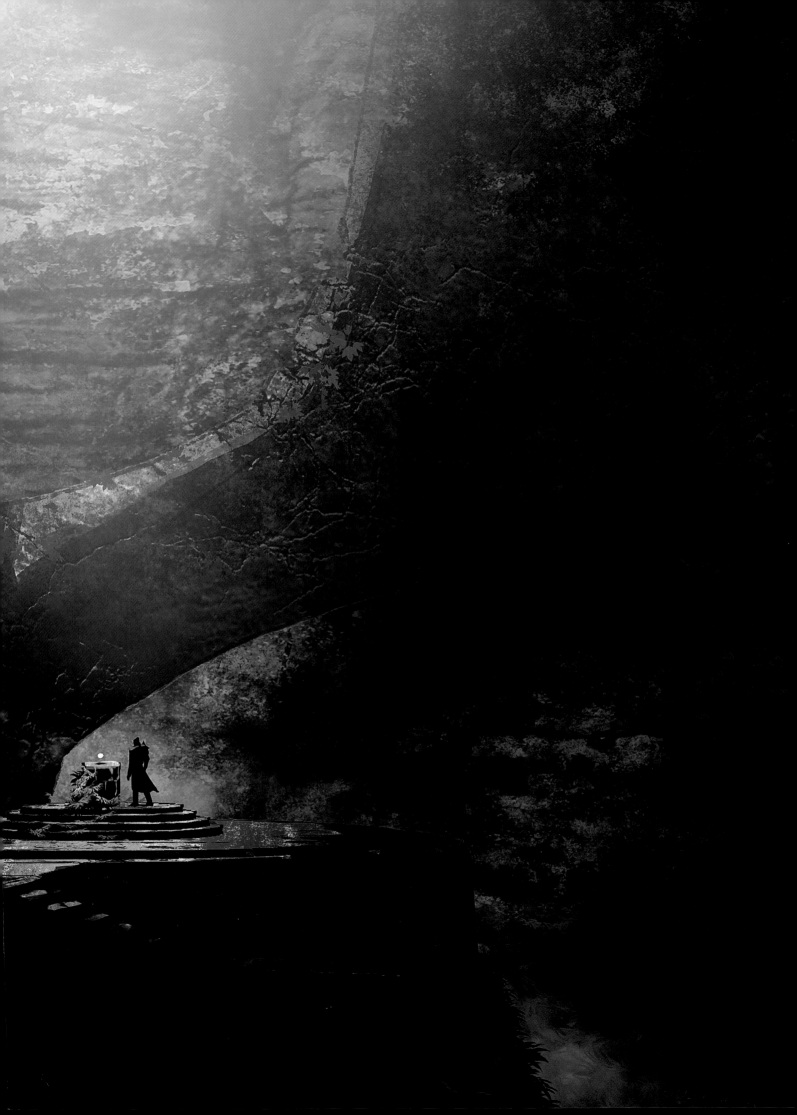

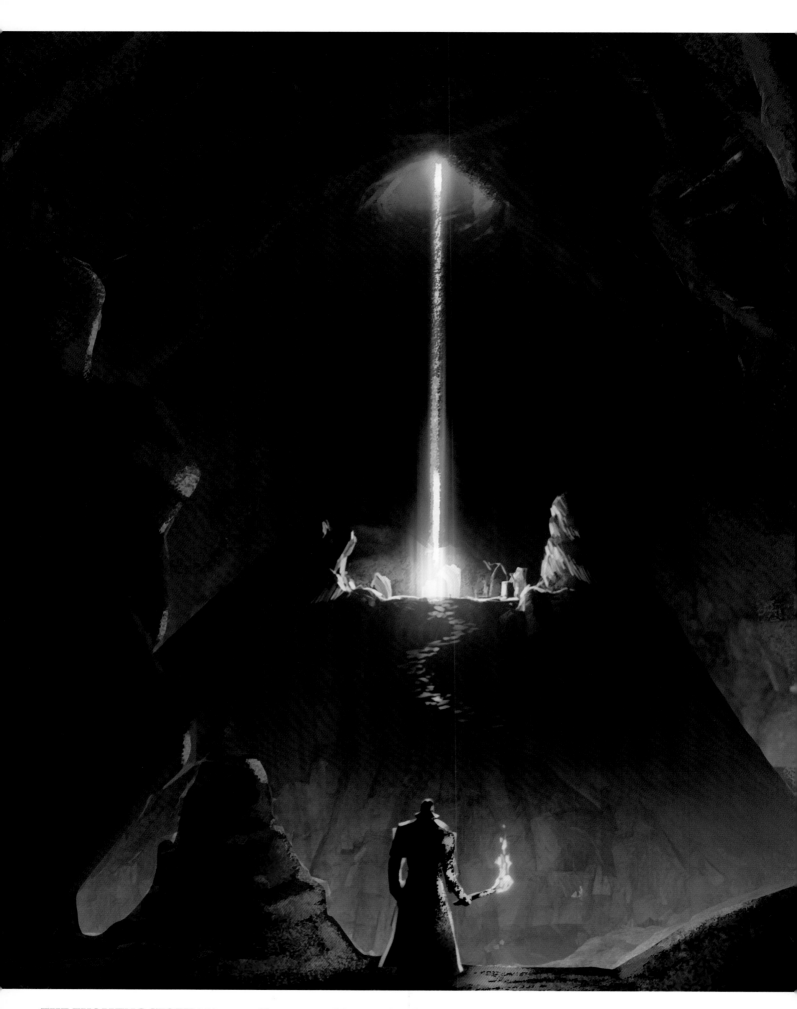

THE EVOLVING STORY Making a world as massive and diverse as that of *Dragon Age* is naturally a collaborative process. These studies of the well reflect changes made in the story and were drawn from suggestions made by the cinematic animators.

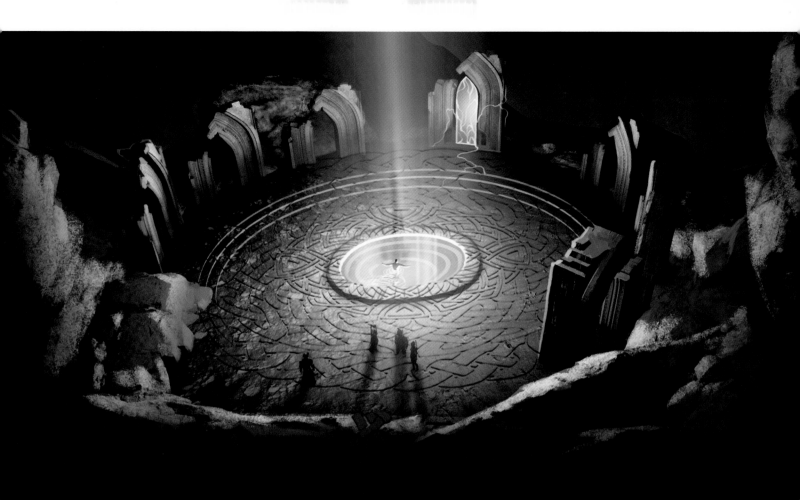

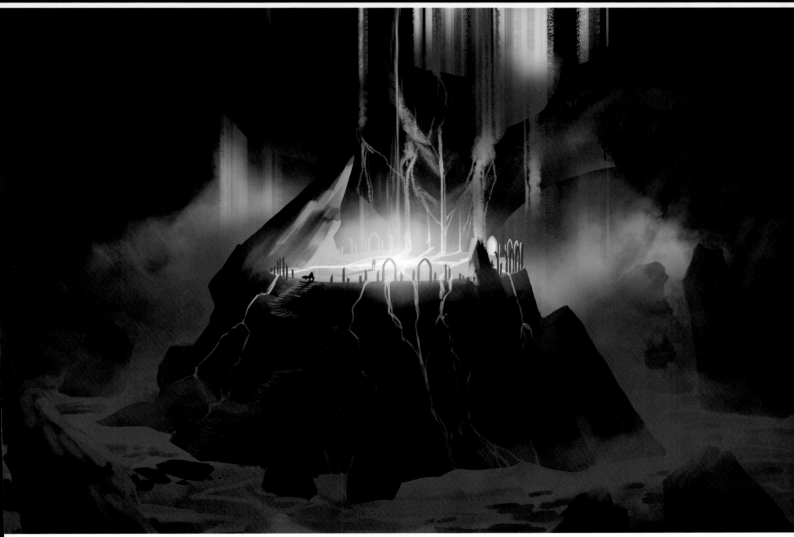

ATTACK OF THE BIG BAD Storyboards are an incredibly useful tool to tackle a complicated scene like this. From a narrative standpoint, these drawings had to communicate a lot of important information to the player. But for the art team, they were also used to orchestrate all of the demands of the scene, including adjustments to level art, visual effects planning, and cinematic flow. Many artists and designers had a stake in this scene and how it played out.

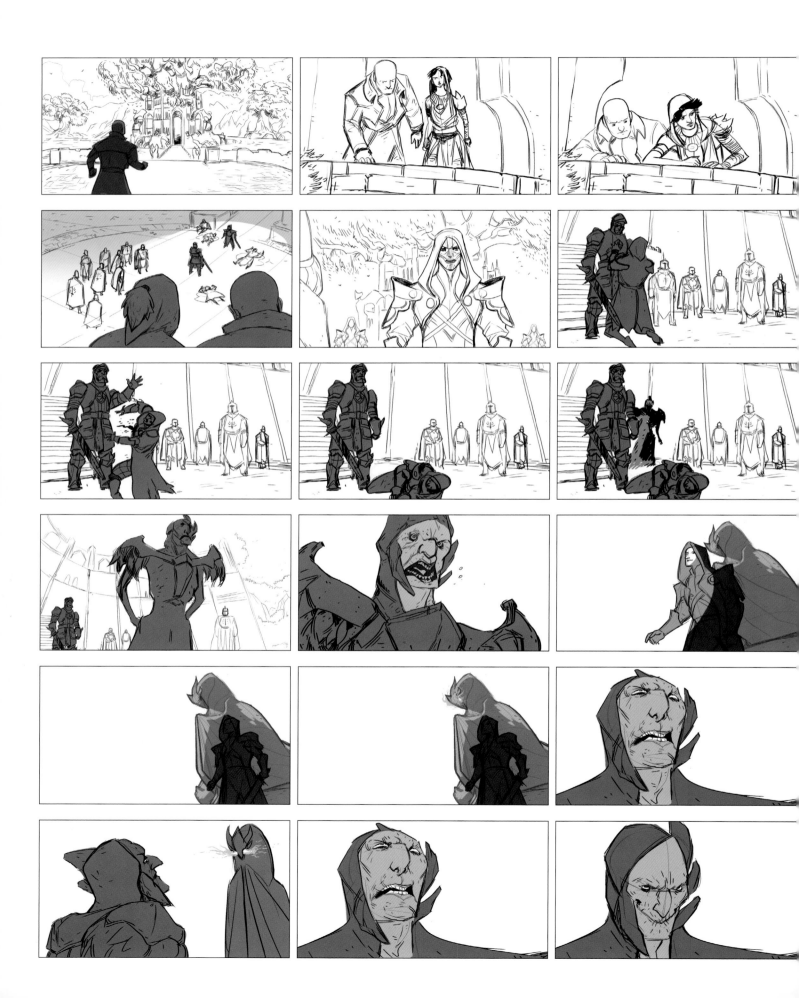

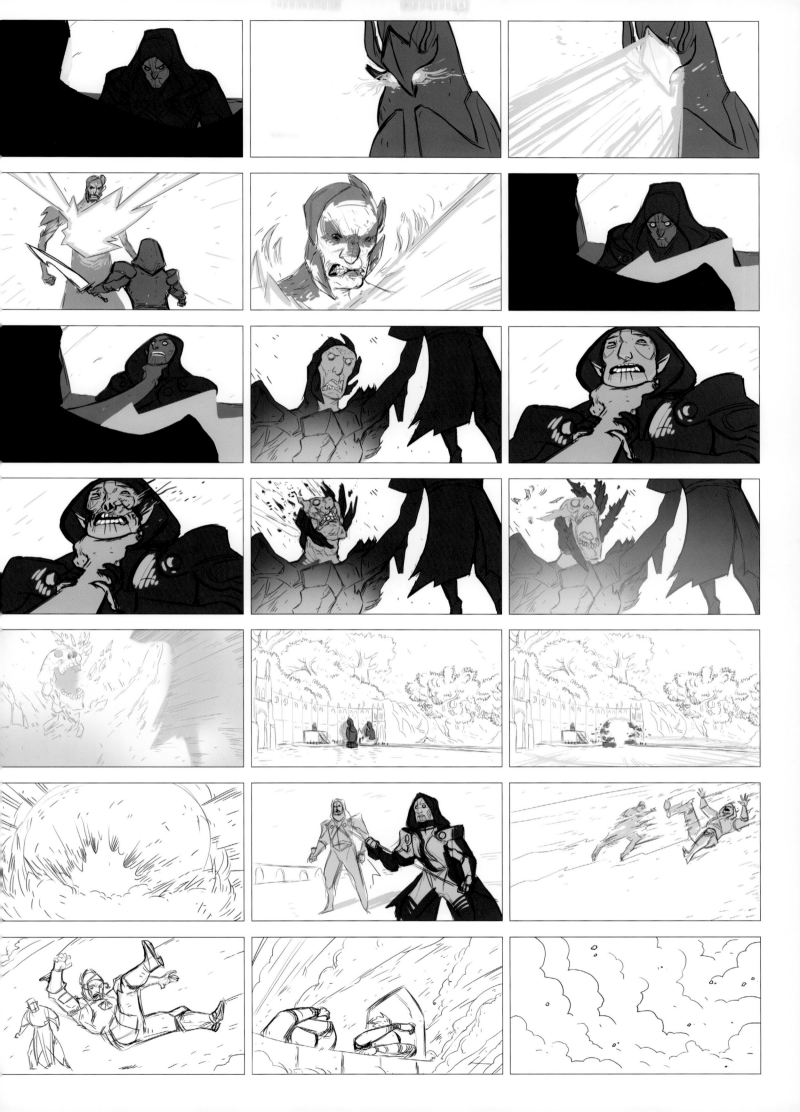

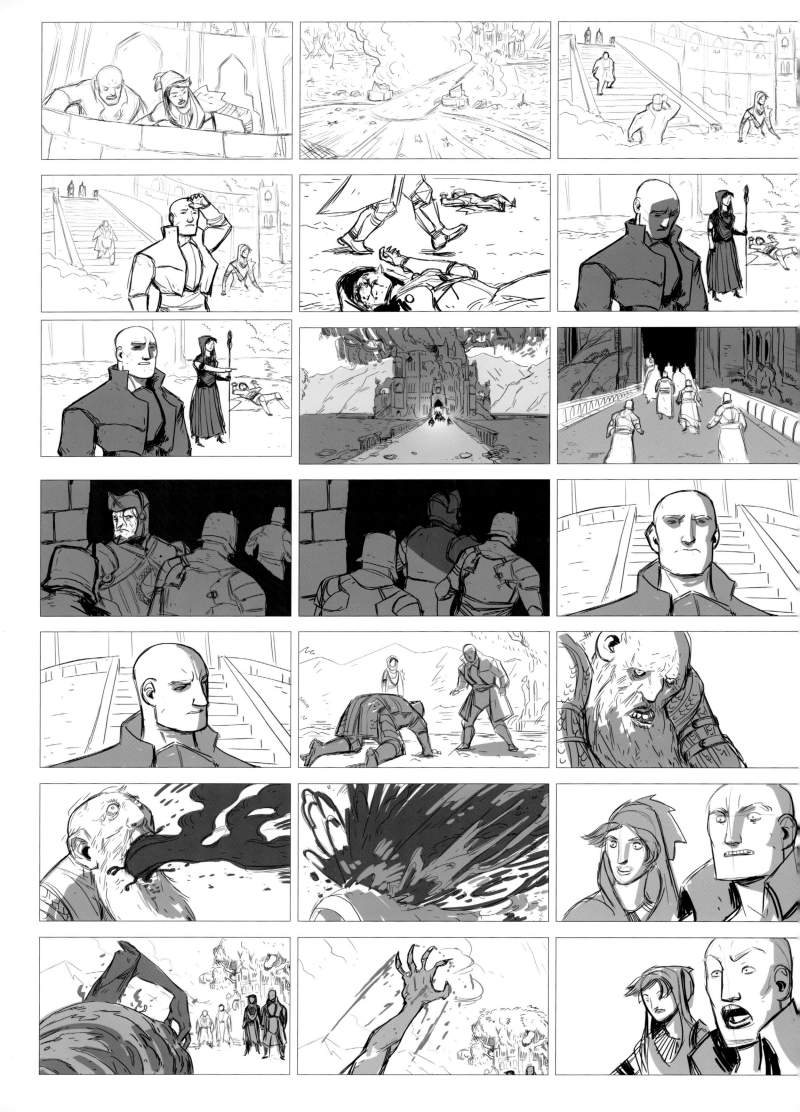

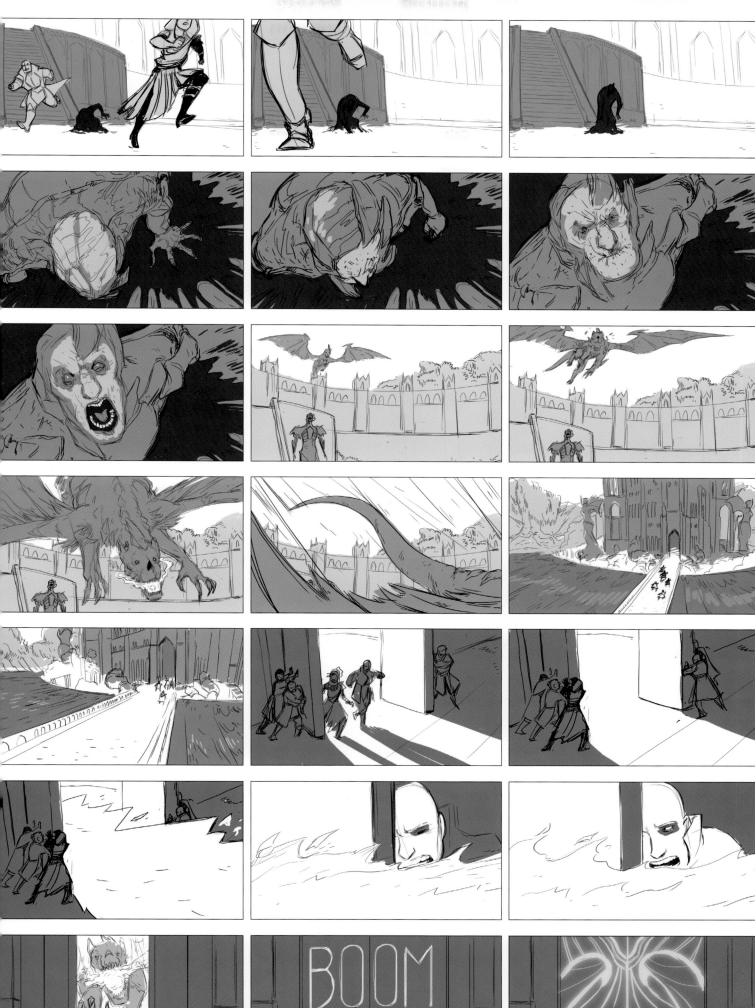
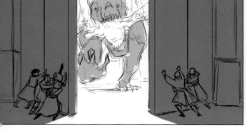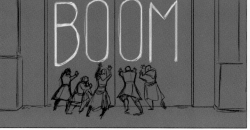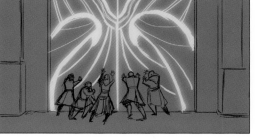

BOOM

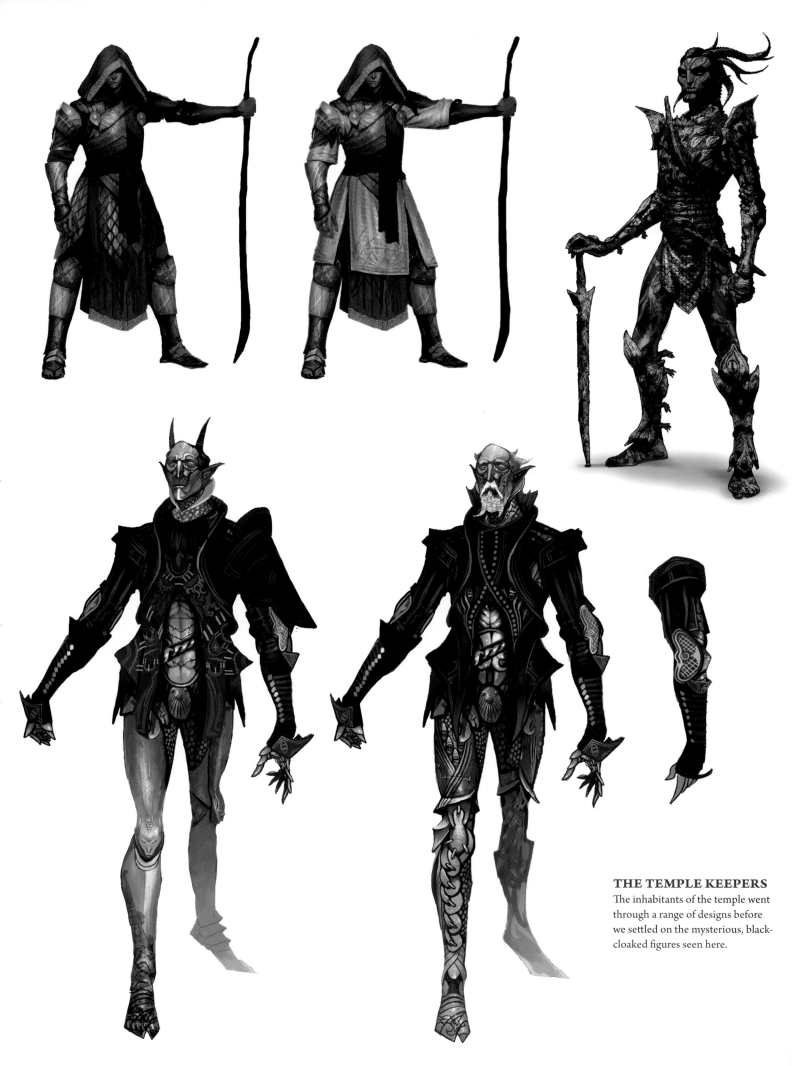

THE TEMPLE KEEPERS

The inhabitants of the temple went through a range of designs before we settled on the mysterious, black-cloaked figures seen here.

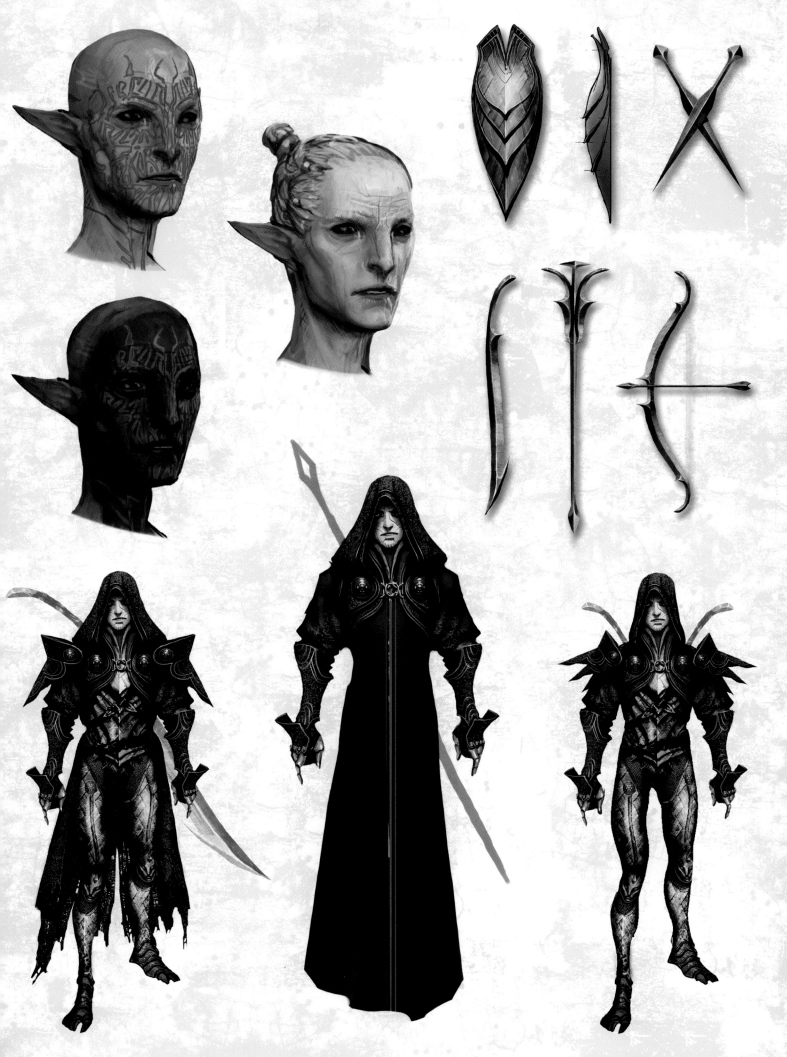

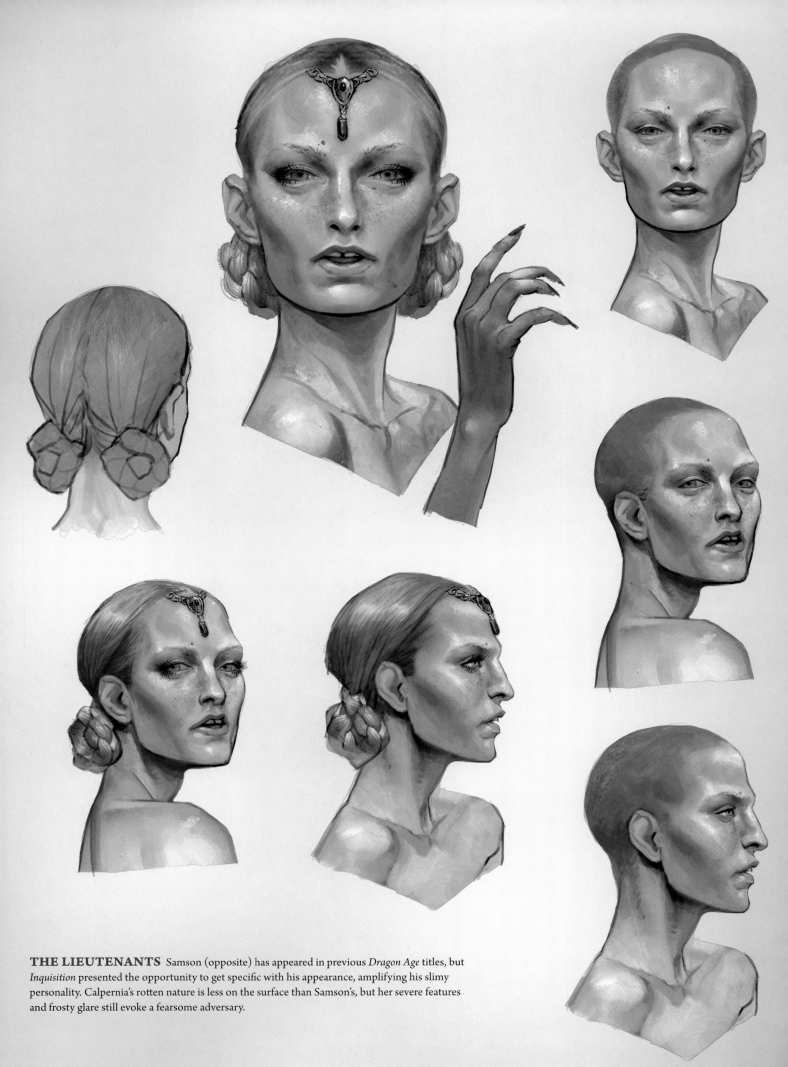

THE LIEUTENANTS Samson (opposite) has appeared in previous *Dragon Age* titles, but *Inquisition* presented the opportunity to get specific with his appearance, amplifying his slimy personality. Calpernia's rotten nature is less on the surface than Samson's, but her severe features and frosty glare still evoke a fearsome adversary.

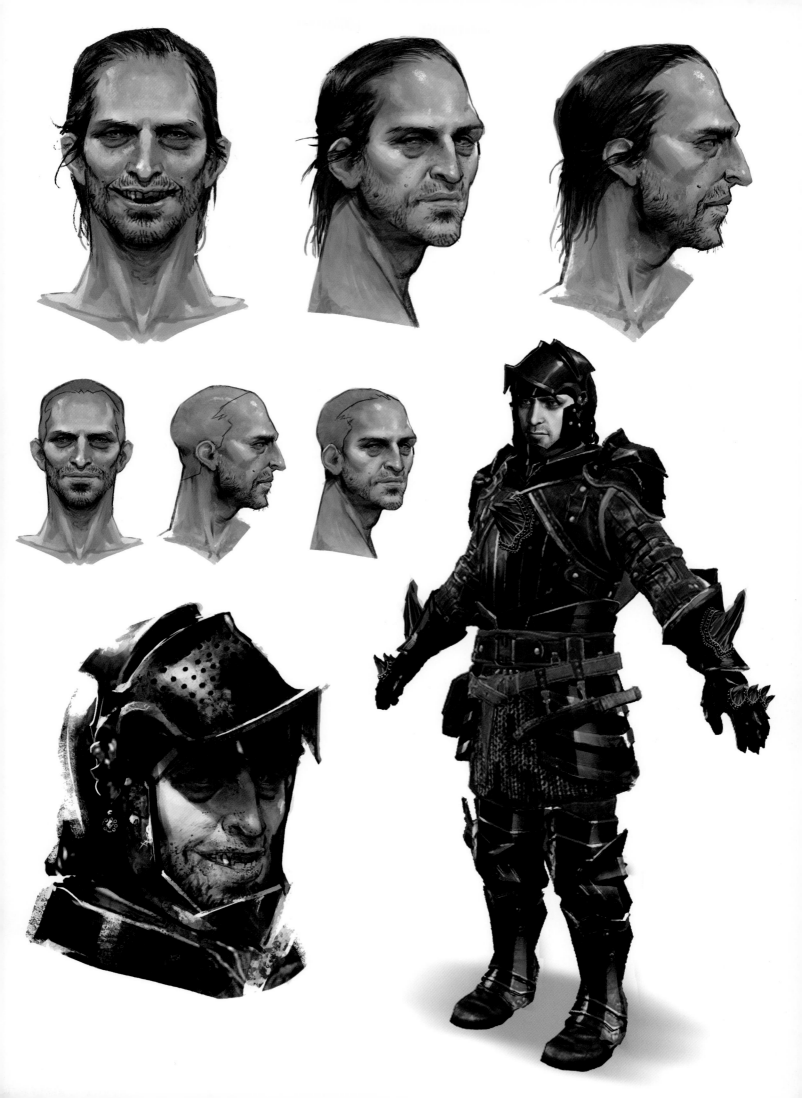

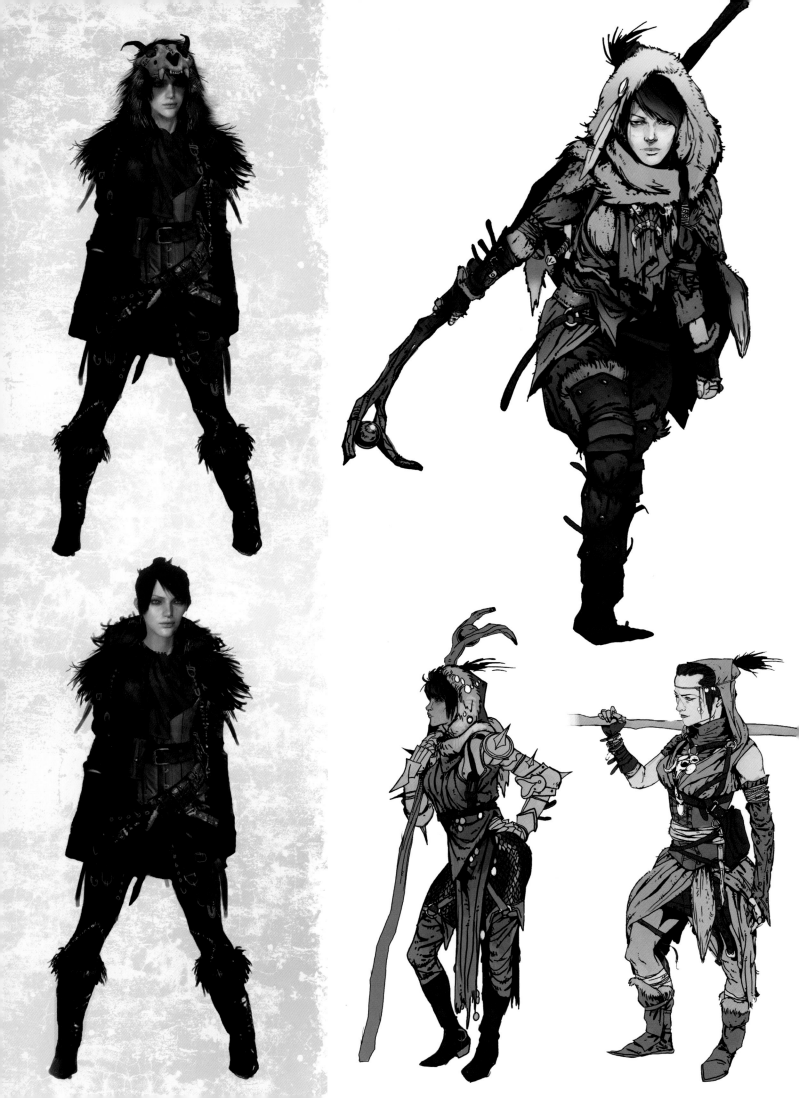

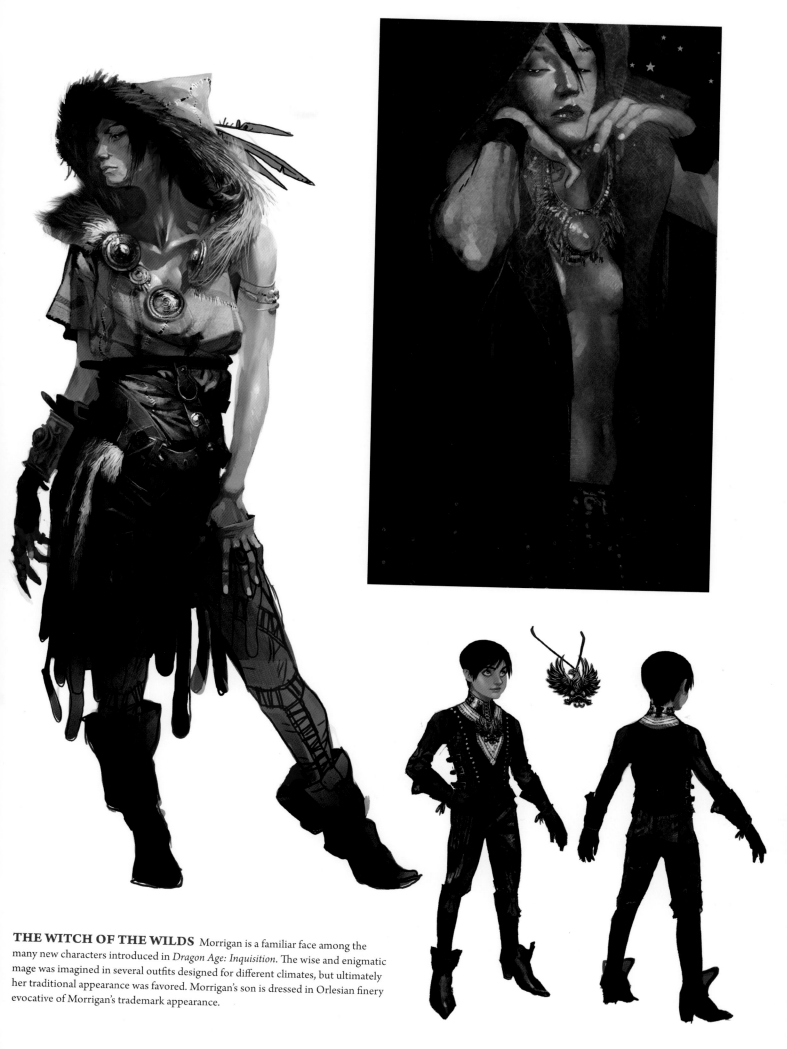

THE WITCH OF THE WILDS Morrigan is a familiar face among the many new characters introduced in *Dragon Age: Inquisition*. The wise and enigmatic mage was imagined in several outfits designed for different climates, but ultimately her traditional appearance was favored. Morrigan's son is dressed in Orlesian finery evocative of Morrigan's trademark appearance.

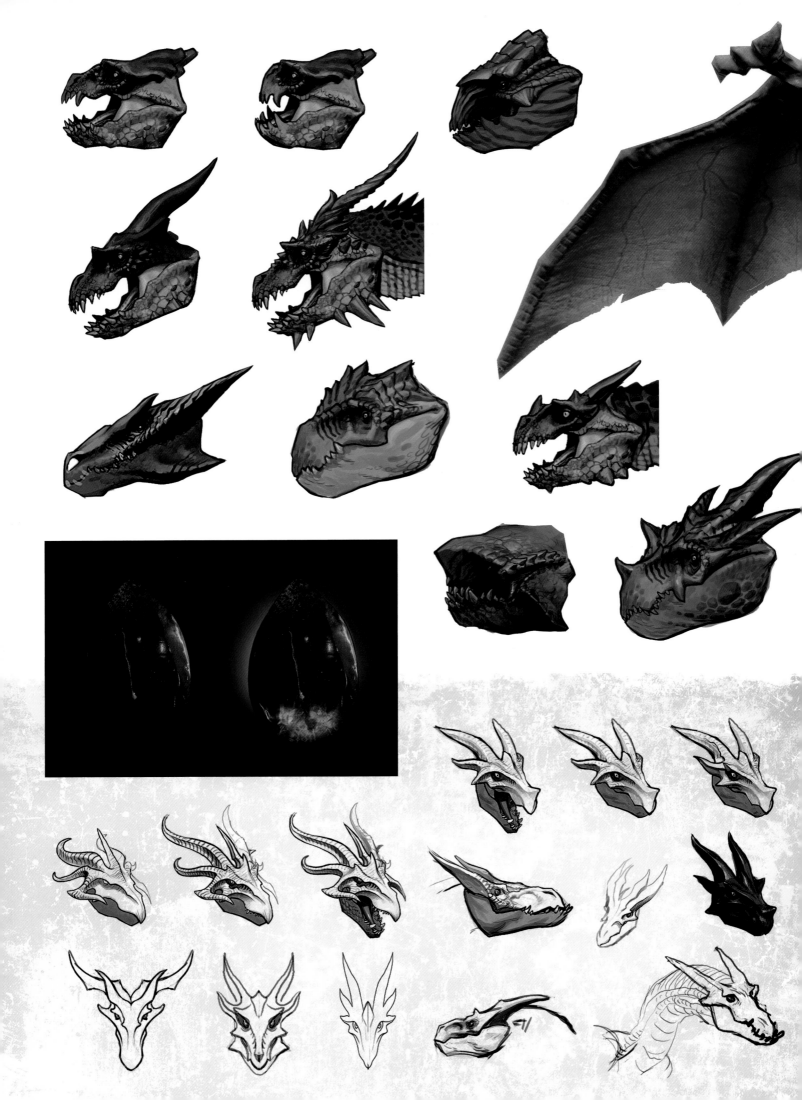

THE AGE OF DRAGONS These creatures are at the top of the food chain, so they ought to look, feel, and sound like the impressive apex predators that they are. No matter what quest or adventure you are pursuing, the sound of a dragon's roar should send a chill through you and become top priority. We redesigned the dragons from the ground up in *Inquisition*, looking at real-world predators to ground their appearance in actual animal anatomy. We referenced everything from prehistoric reptiles to large jungle cats, with the intent of triggering a fight-or-flight response in the player.

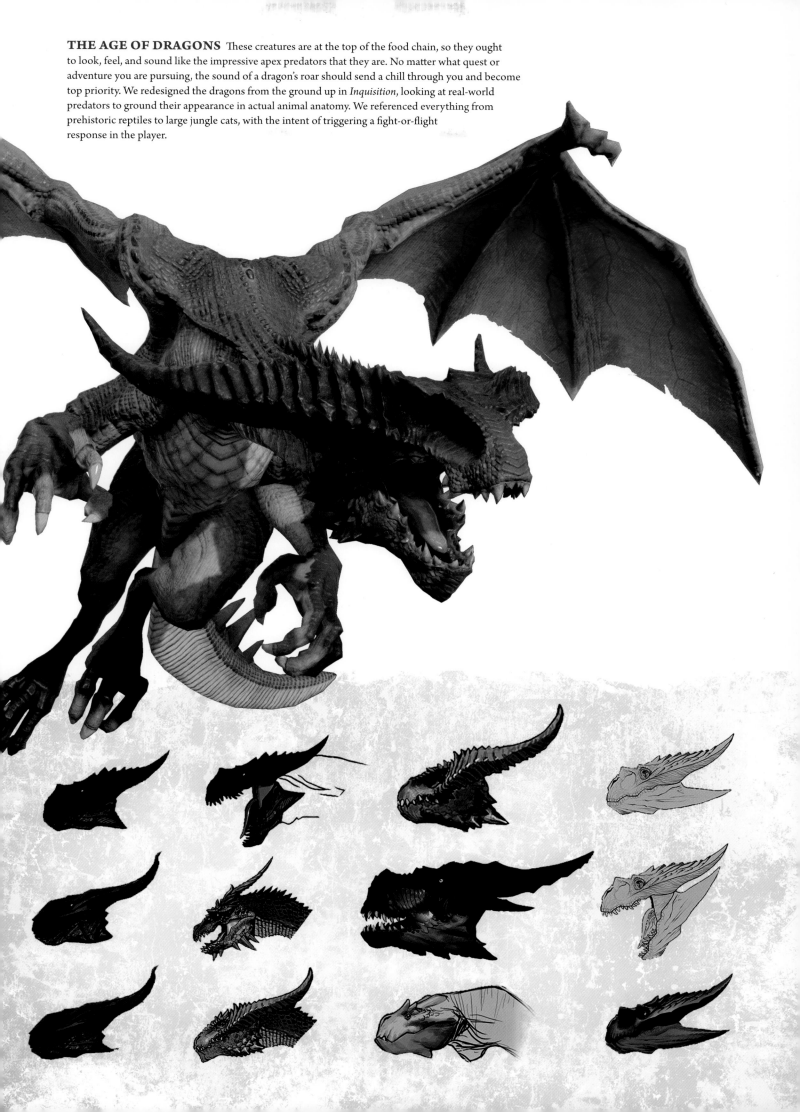

THE FACE BEHIND THE CHAOS The designs for Corypheus and his dragon hark back to early darkspawn design work in the *Dragon Age* universe. They are an abominable mash-up of twisted metal, chains, and organic mass, literally signifying their corruption. By contrast, Corypheus's weapon is pure: a simple, unadorned sphere. Its reflective surface is marked with an organic fingerprint pattern. Below, further sketches explore the particulars of dragon anatomy.

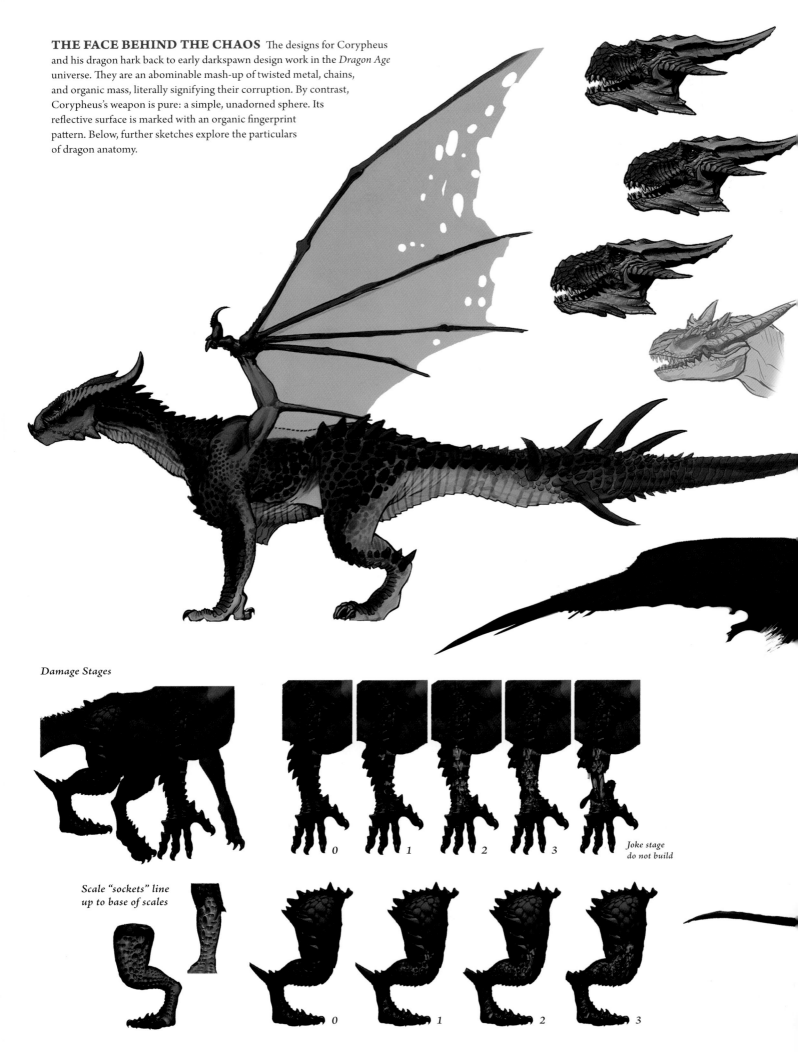

Damage Stages

0

1

2

3

Joke stage do not build

Scale "sockets" line up to base of scales

0

1

2

3

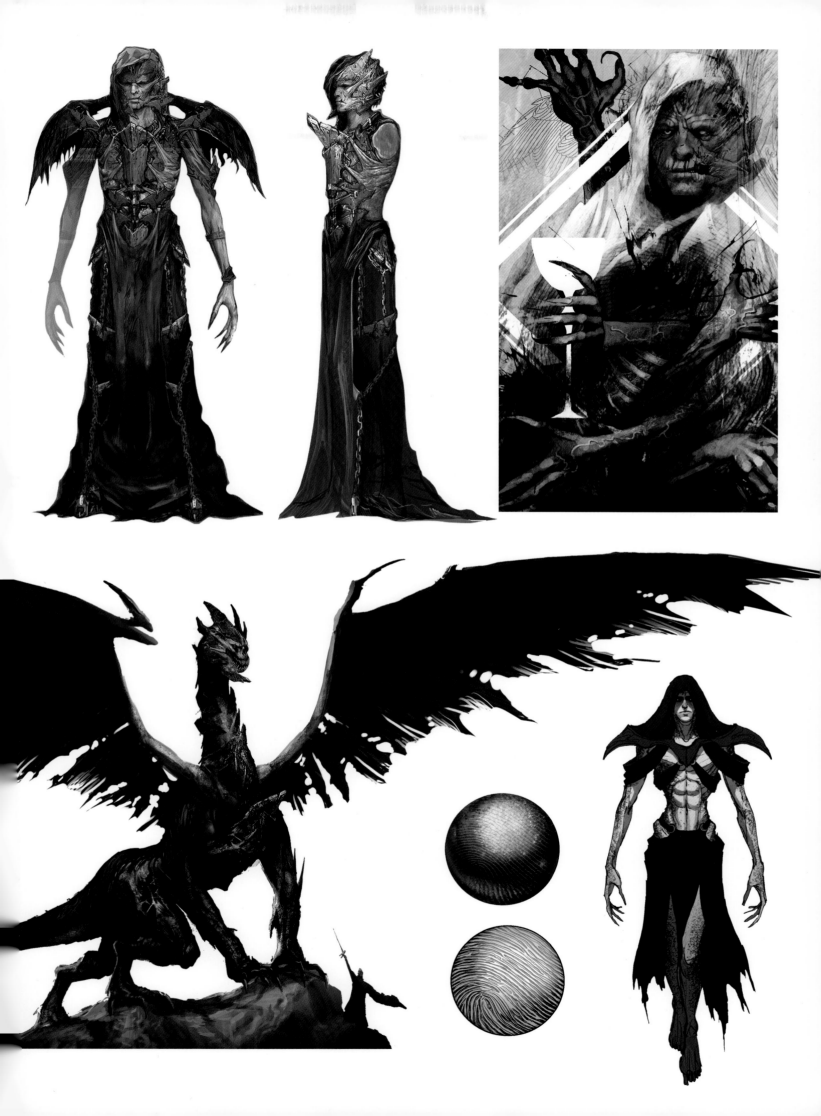

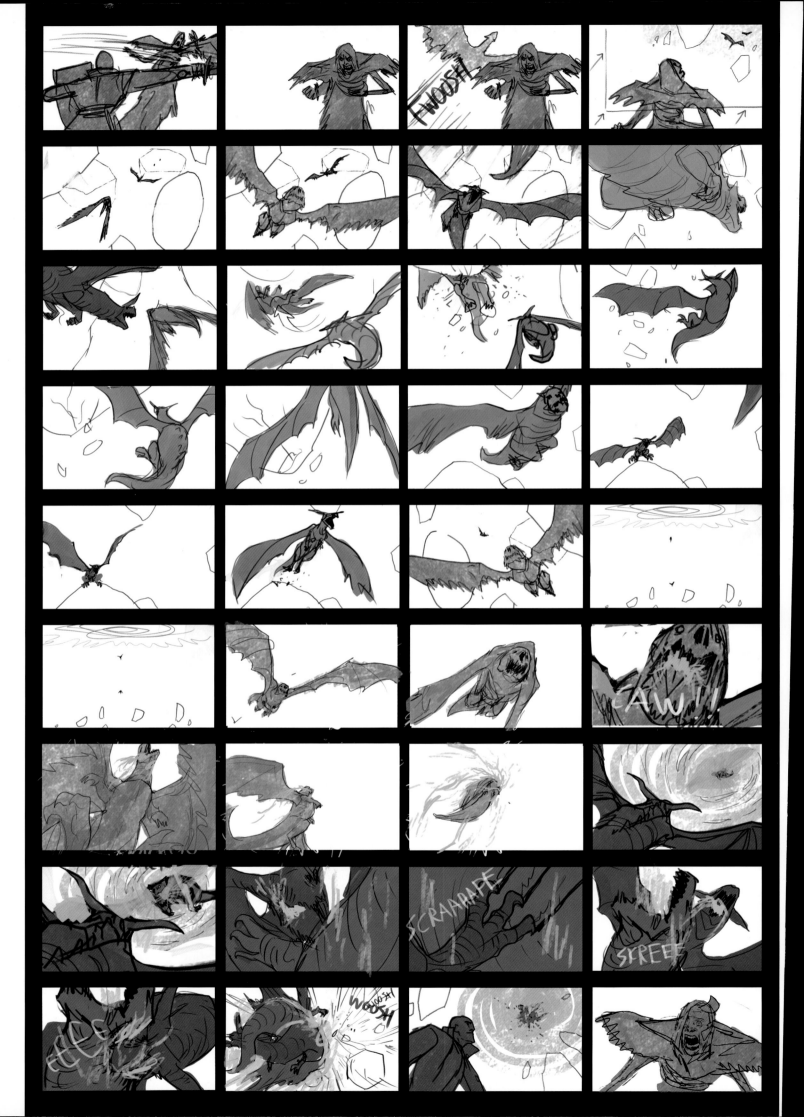

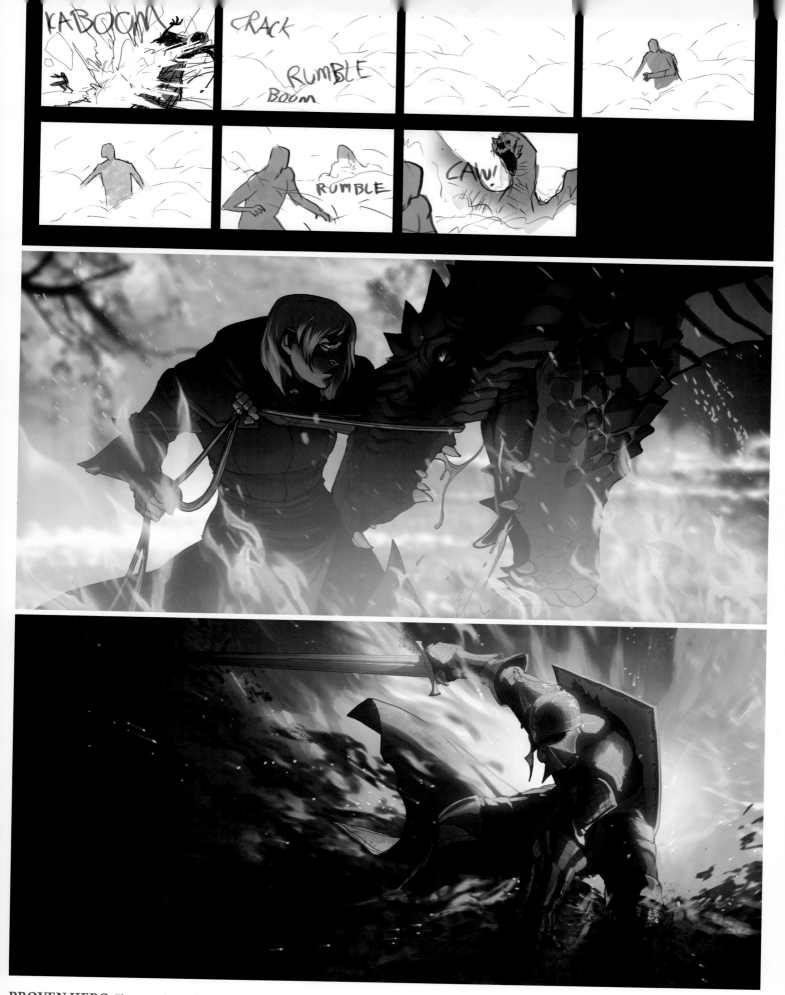

PROVEN HERO These rough storyboards outline a spectacular dogfight between dragons. Rough and quick drawings like this are useful when exploring ideas with the larger development team.

Above: Beat-board illustrations are inspirational touchstones for player fantasy fulfillment.

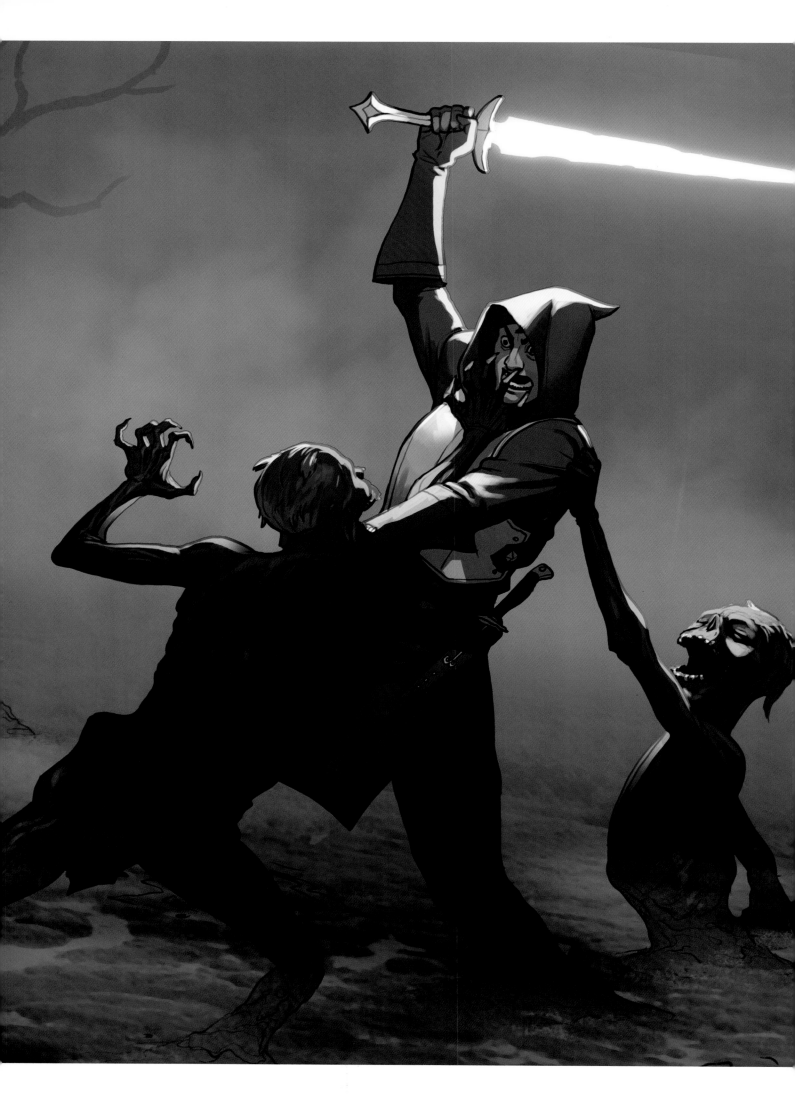

THE WIDER WORLD OF THEDAS

*D*ragon Age: Inquisition is a portrait of an epic world writ large, but Thedas truly comes to life in the smallest details: Raw elements. Rare herbs. Birds scattering and apex predators on the hunt. In any given region, entire food chains are at work, with unique flora giving creatures plenty of places to hide.

For those who explore carefully, history is also visible, from the remnants of Tevinter occupation in the hills, to skeletons of elven war in the plains and sand-worn outposts in the desert. Look again, through an ancient astrarium or a crystalline occularum, to plumb hidden depths for treasures.

These elements combine to give areas as diverse as the Western Approach, the Dales, and the Fereldan Hinterlands a sense of variety—and Thedas a sense of scale.

Where the single-player experience allowed us to explore geography, multiplayer let us meet some of the Inquisition's unsung heroes: the elite warriors, mages, and rogues who carry out the Inquisitor's will in far-flung places. With signature outfits, weapons, and demeanors, these characters are perhaps a bit more eccentric than their single-player counterparts, but they work just as hard to expand the Inquisitor's influence.

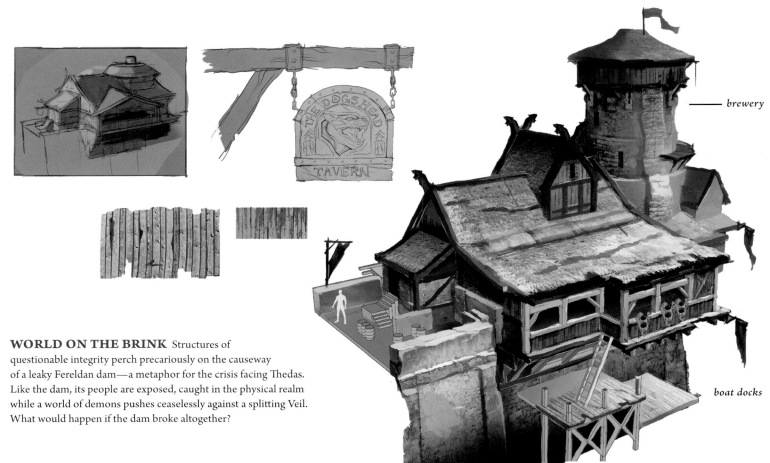

brewery

boat docks

WORLD ON THE BRINK Structures of
questionable integrity perch precariously on the causeway
of a leaky Fereldan dam—a metaphor for the crisis facing Thedas.
Like the dam, its people are exposed, caught in the physical realm
while a world of demons pushes ceaselessly against a splitting Veil.
What would happen if the dam broke altogether?

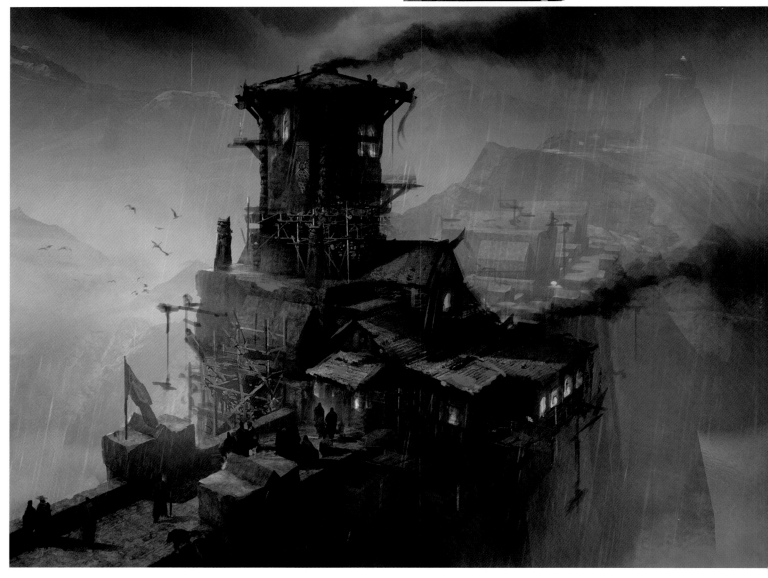

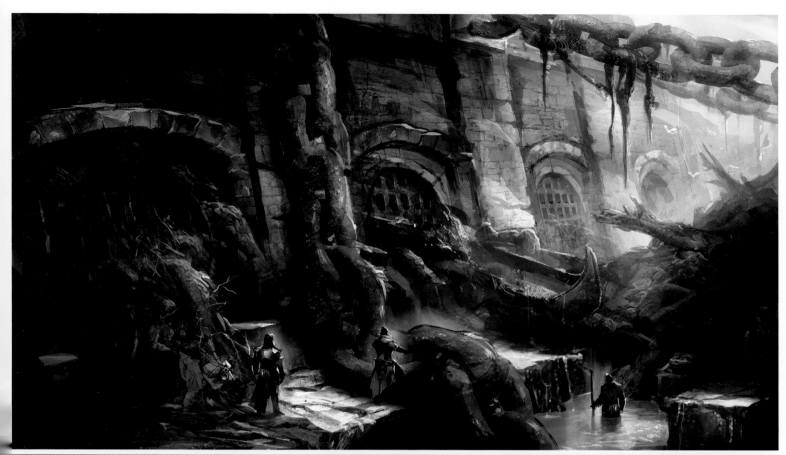

EXPLORING THE DEPTHS

What secrets may be revealed when this Fereldan lake, pictured at the top, is drained? At center and below, subtle lighting is applied to these images of deeper caves and corridors to dramatize the spaces and create a stronger sense of depth and mystery.

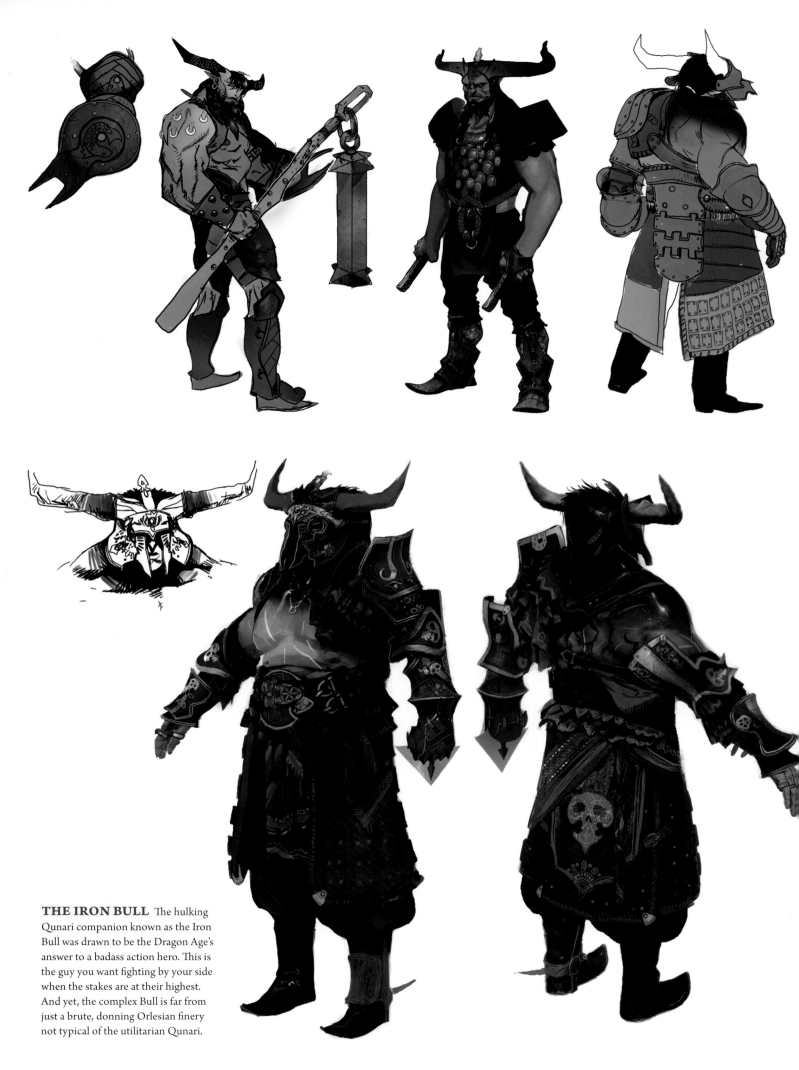

THE IRON BULL The hulking Qunari companion known as the Iron Bull was drawn to be the Dragon Age's answer to a badass action hero. This is the guy you want fighting by your side when the stakes are at their highest. And yet, the complex Bull is far from just a brute, donning Orlesian finery not typical of the utilitarian Qunari.

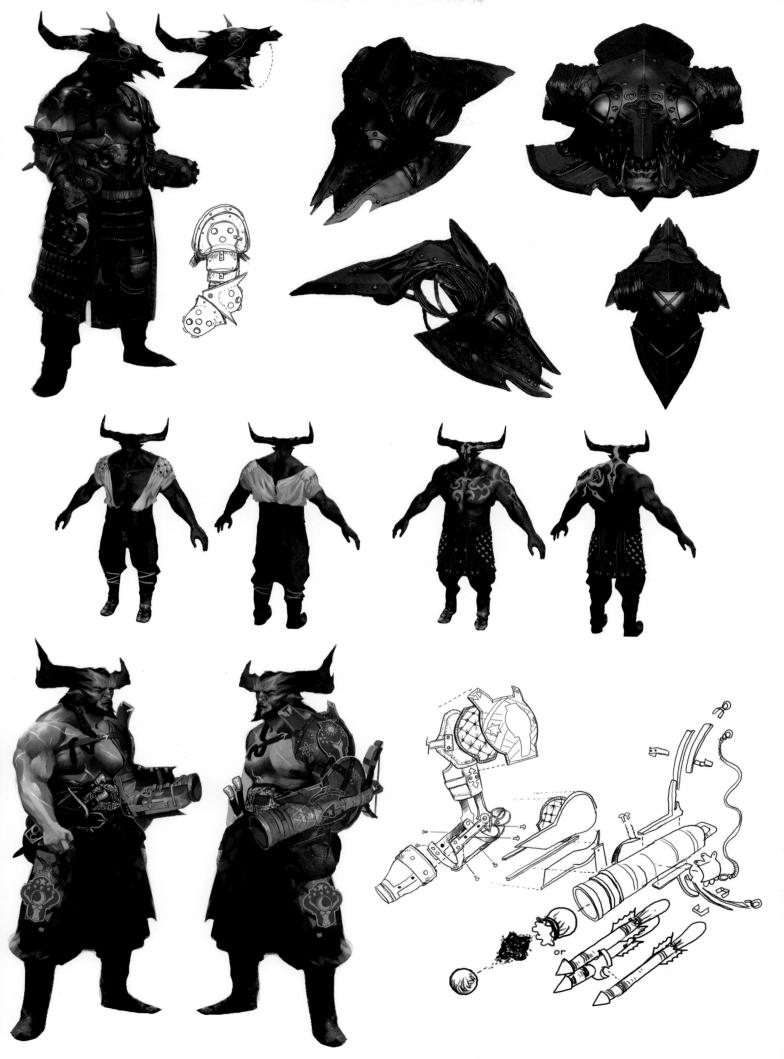

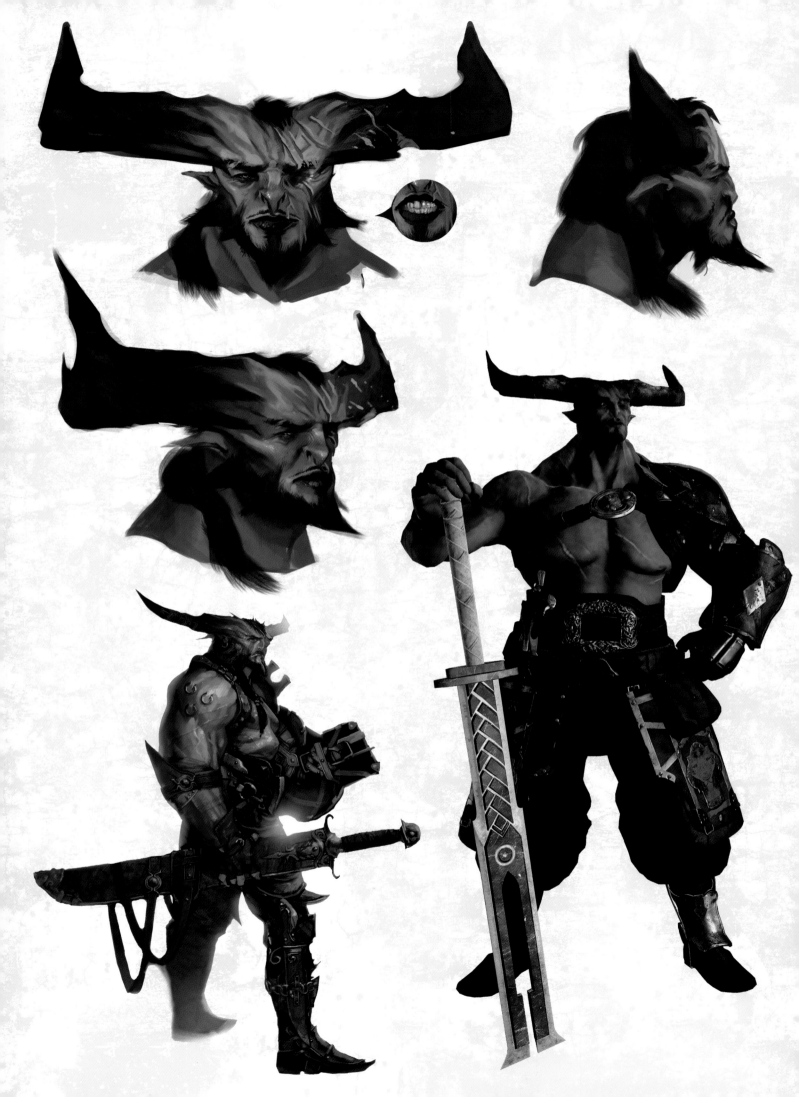

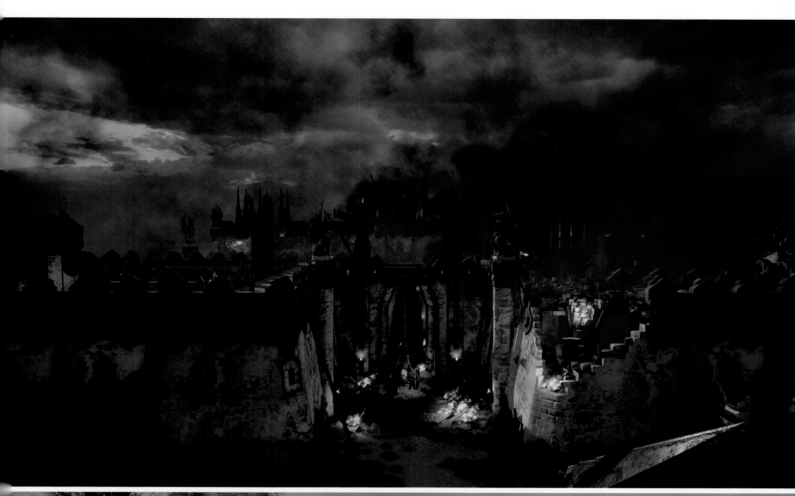

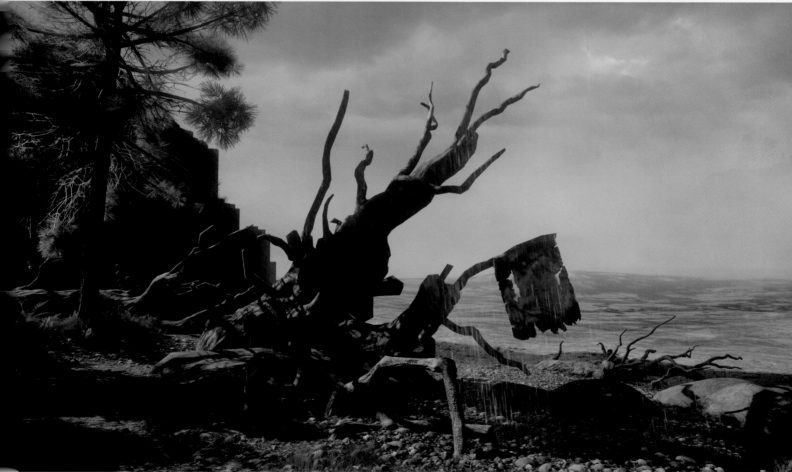

BUILDING ATMOSPHERE In *Inquisition*, the Frostbite engine freed us up to establish not just what Thedas *looks* like, but what it *feels* like. To that end, we explored a myriad of exotic locales, from ancient Tevinter outposts—built in the desert of the Western Approach at the height of their reign—to the dreary basalt cliffs of the Storm Coast.

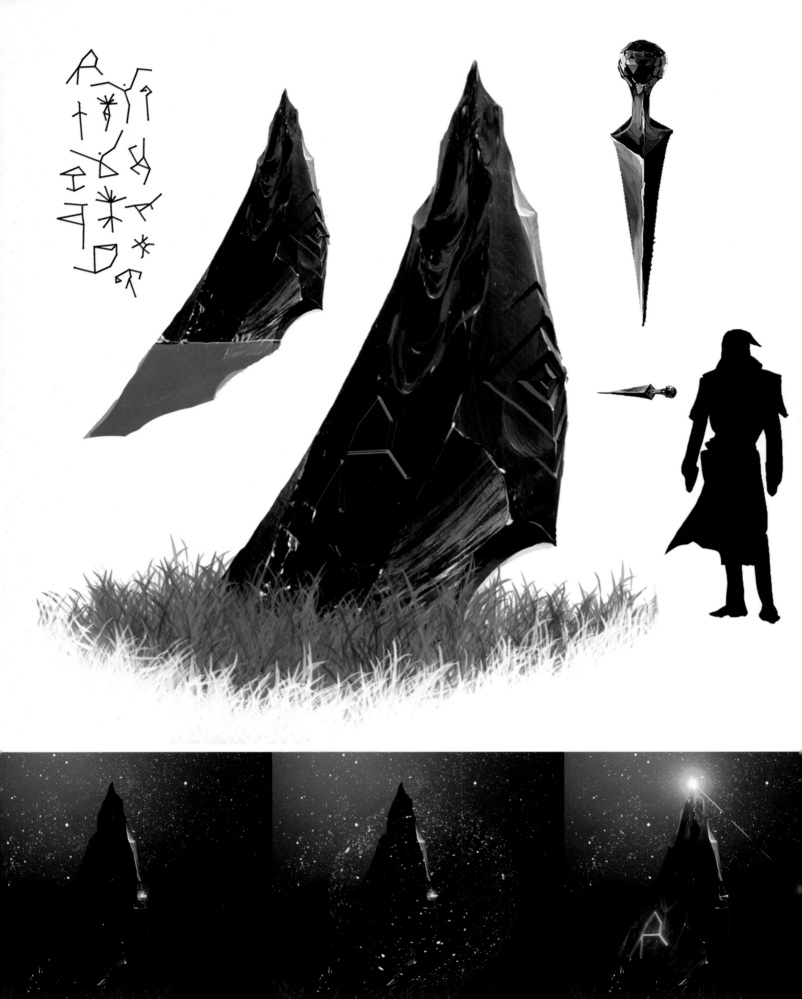

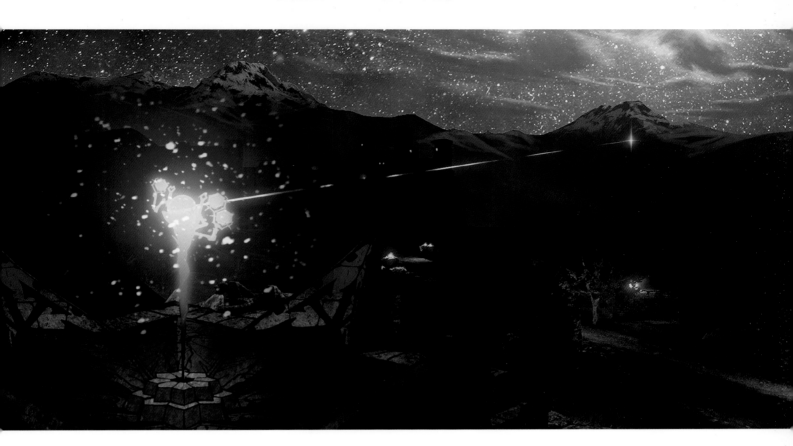

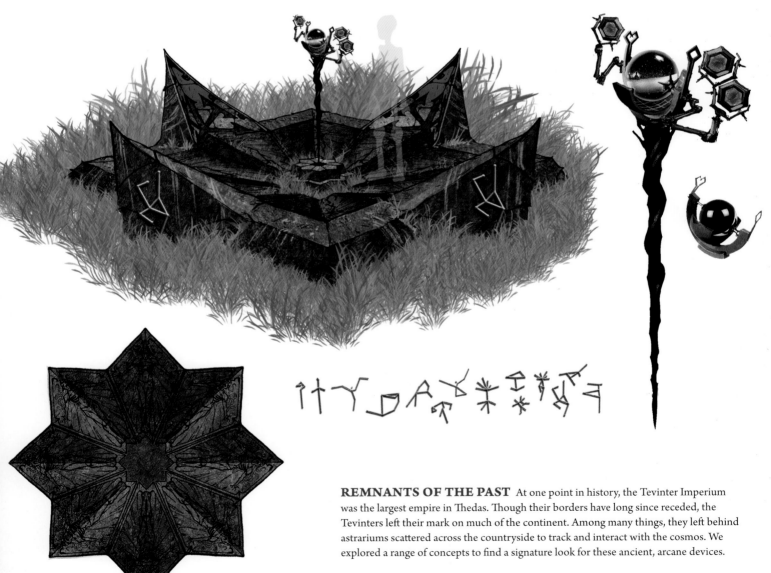

REMNANTS OF THE PAST At one point in history, the Tevinter Imperium was the largest empire in Thedas. Though their borders have long since receded, the Tevinters left their mark on much of the continent. Among many things, they left behind astrariums scattered across the countryside to track and interact with the cosmos. We explored a range of concepts to find a signature look for these ancient, arcane devices.

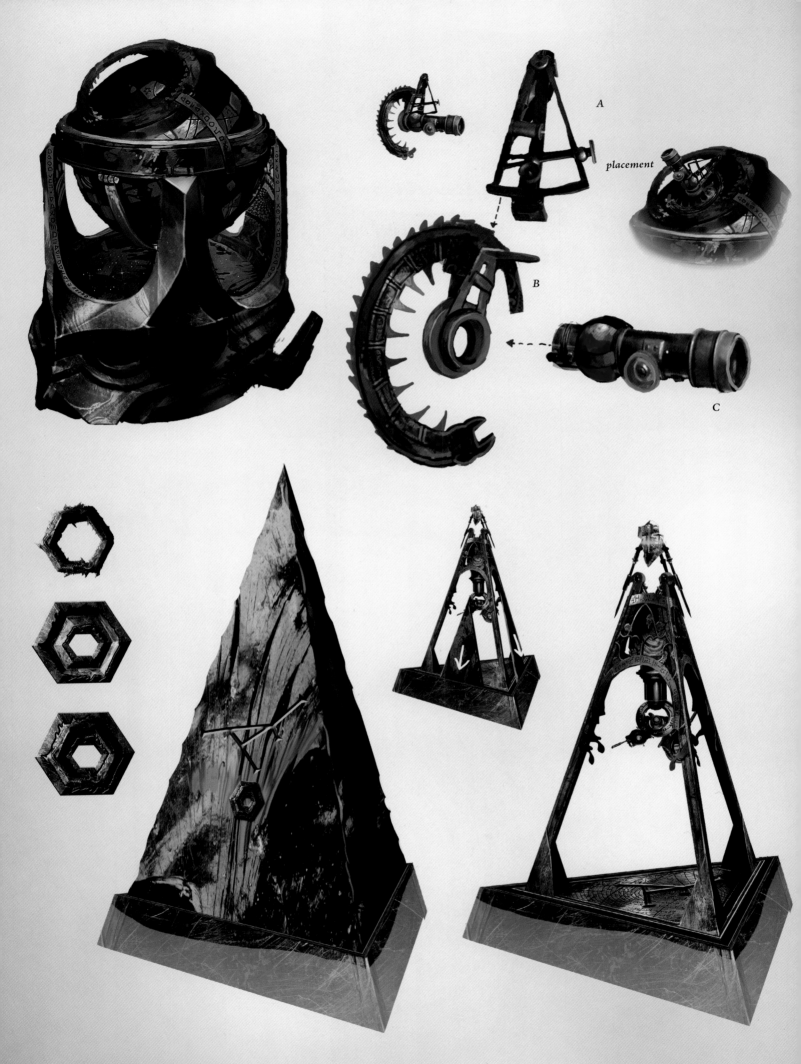

A

placement

B

C

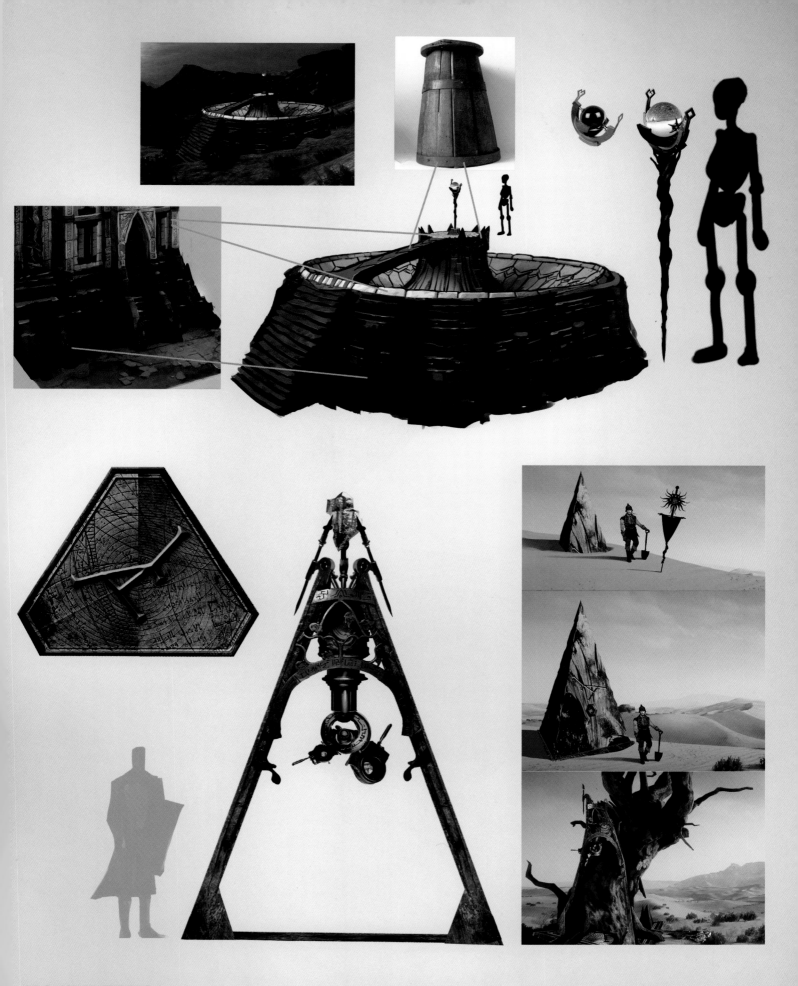

ARCANE MARKERS The challenge with the astrarium was to design an object that appeared durable enough to survive the ages, while also embodying the mystical and technical prowess of its creators. The gimbal globe design at the top left proved ideal.

FERELDAN FINERIES High-end Fereldan wares are fashioned out of wood, stone, and ore. The Fereldan people prefer to exhibit wealth through displays of strength and permanence, leaving ornamental beauty and more delicate materials to Orlesian nobles. Their musical instruments suggest a more rustic and folksy tradition.

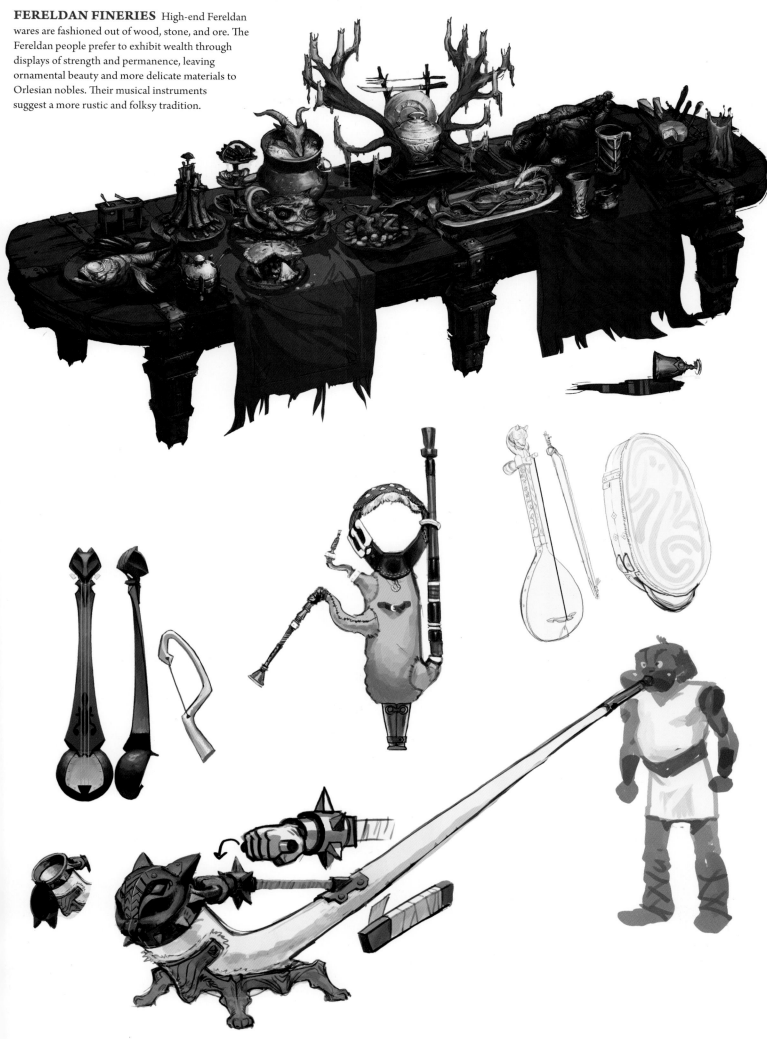

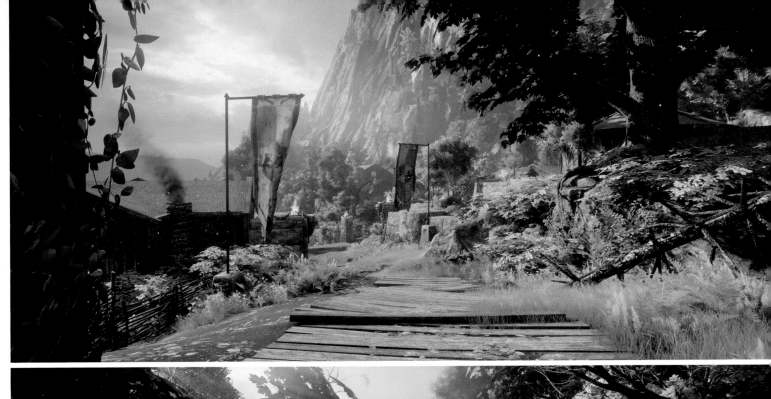

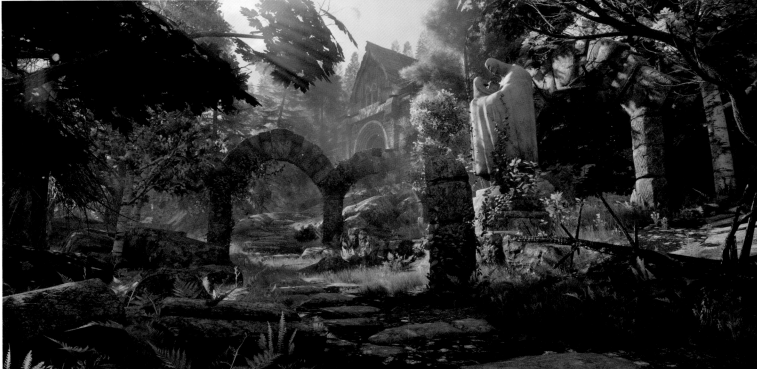

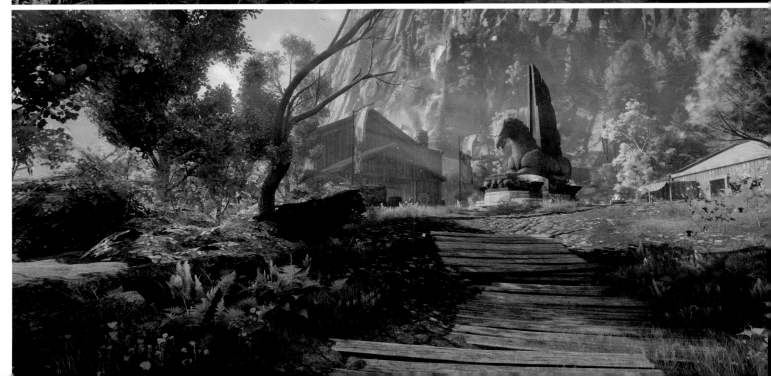

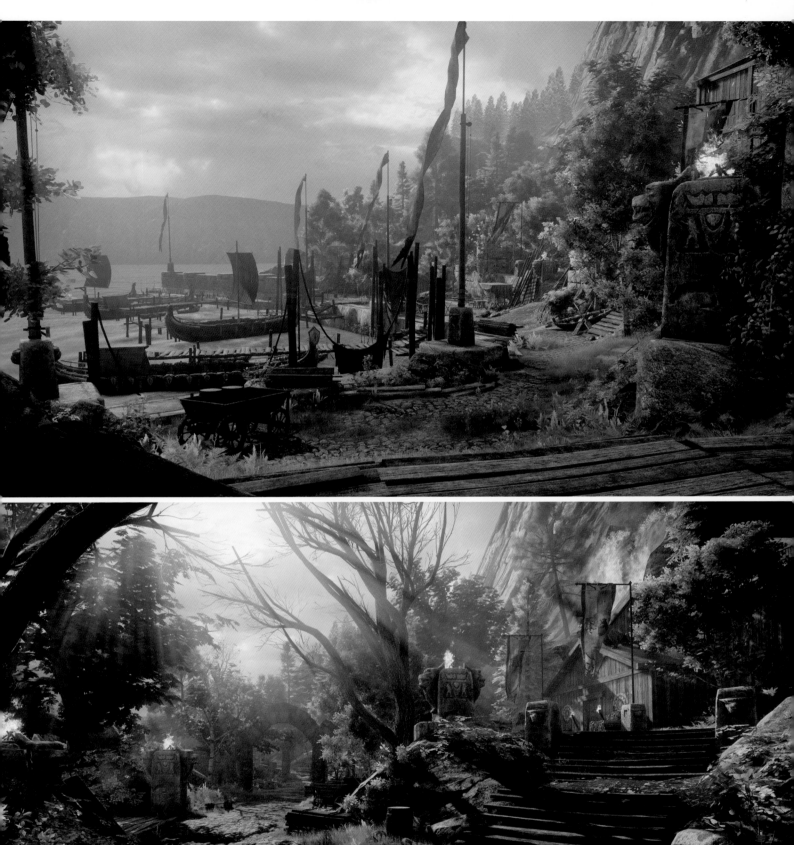

REVISITING REDCLIFFE With new technology, Redcliffe came alive in a way we could have never envisioned in prior games. Some evidence of the Blight that swept across Ferelden remains here ten years later, but the village has lived on and grown out. If only its residents didn't keep getting into trouble . . .

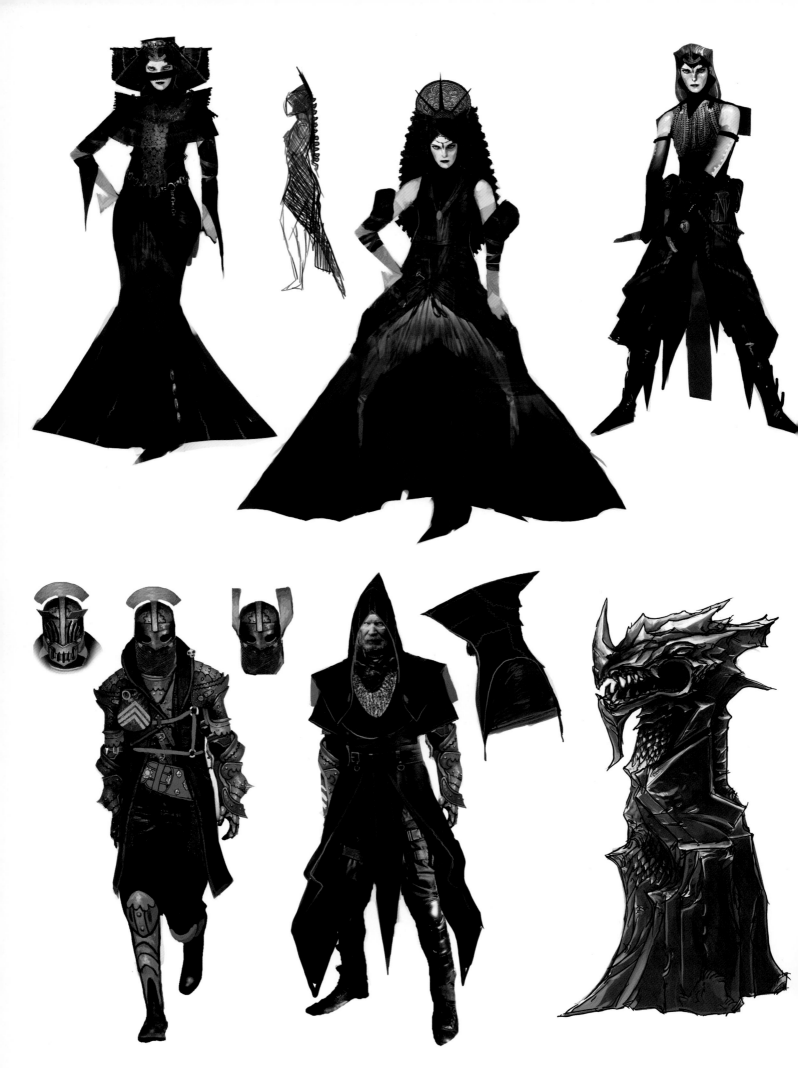

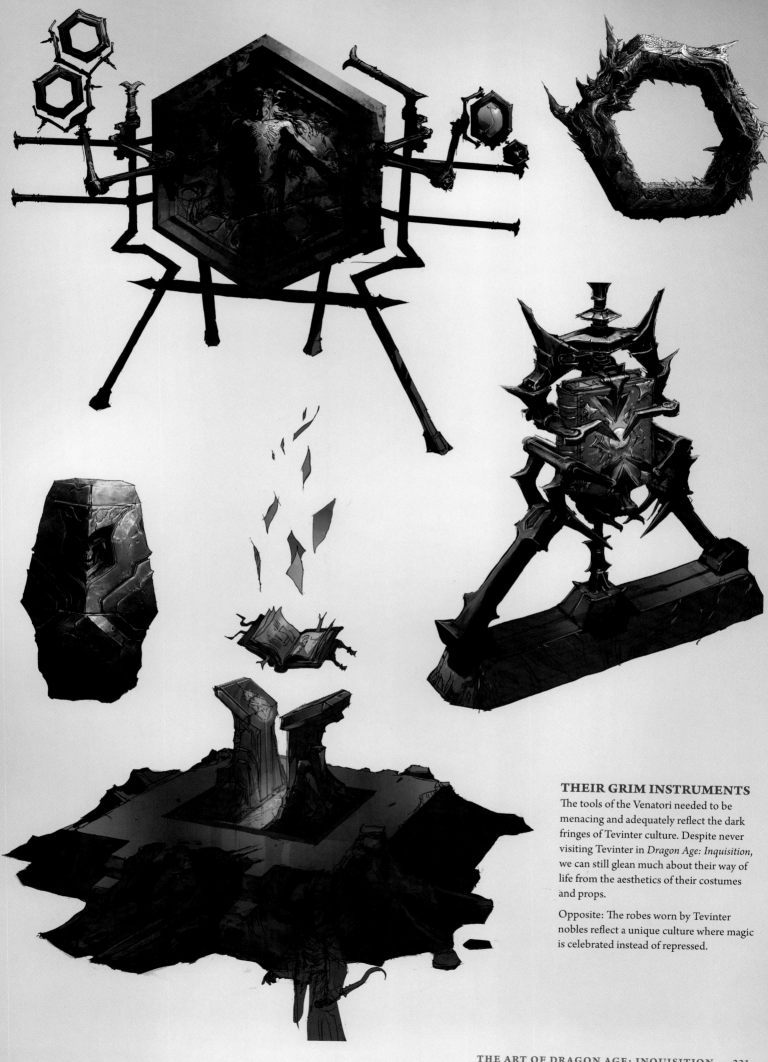

THEIR GRIM INSTRUMENTS

The tools of the Venatori needed to be menacing and adequately reflect the dark fringes of Tevinter culture. Despite never visiting Tevinter in *Dragon Age: Inquisition*, we can still glean much about their way of life from the aesthetics of their costumes and props.

Opposite: The robes worn by Tevinter nobles reflect a unique culture where magic is celebrated instead of repressed.

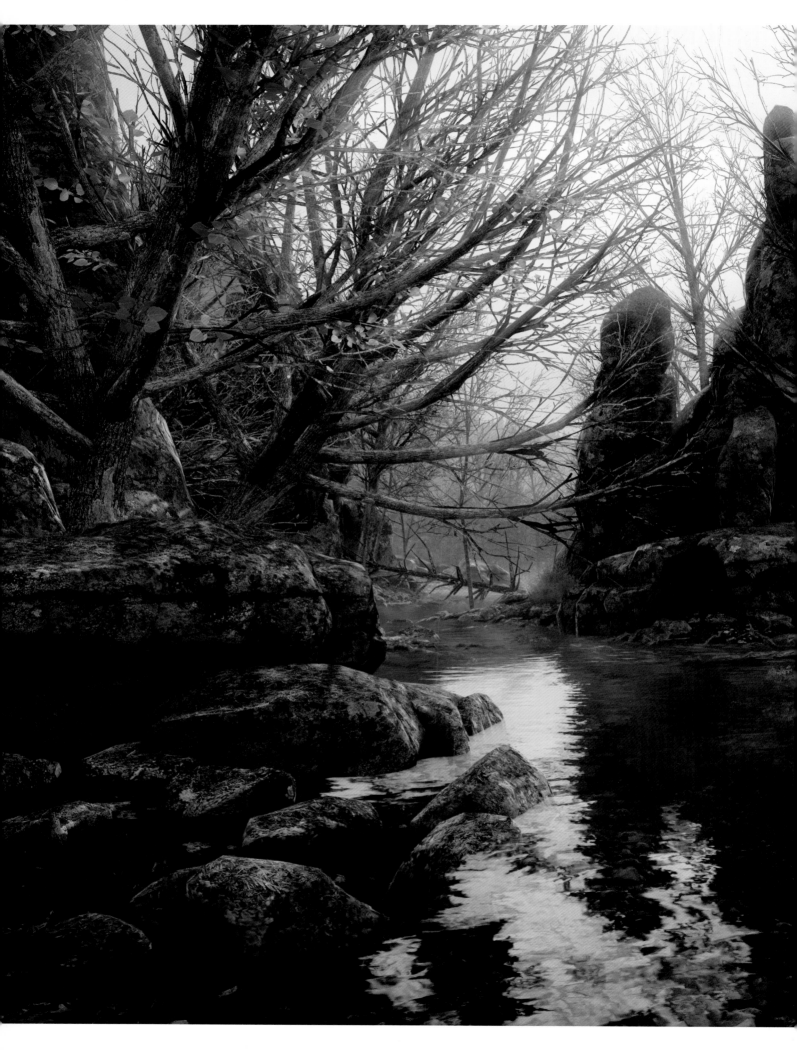

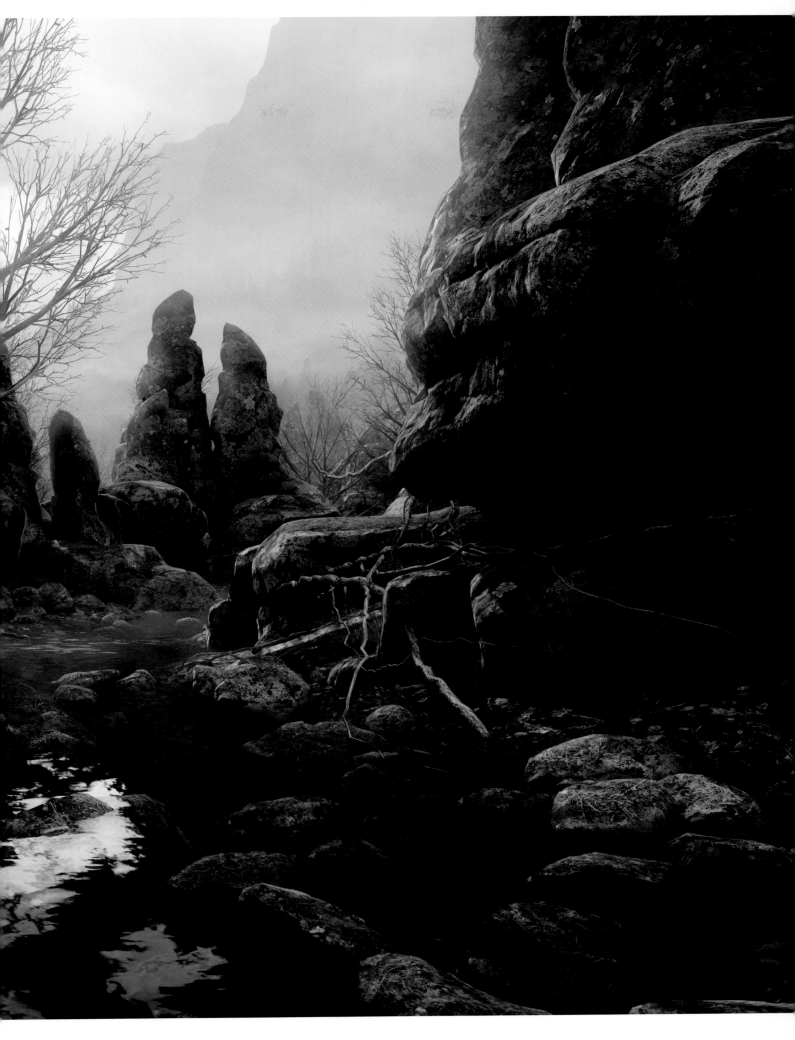

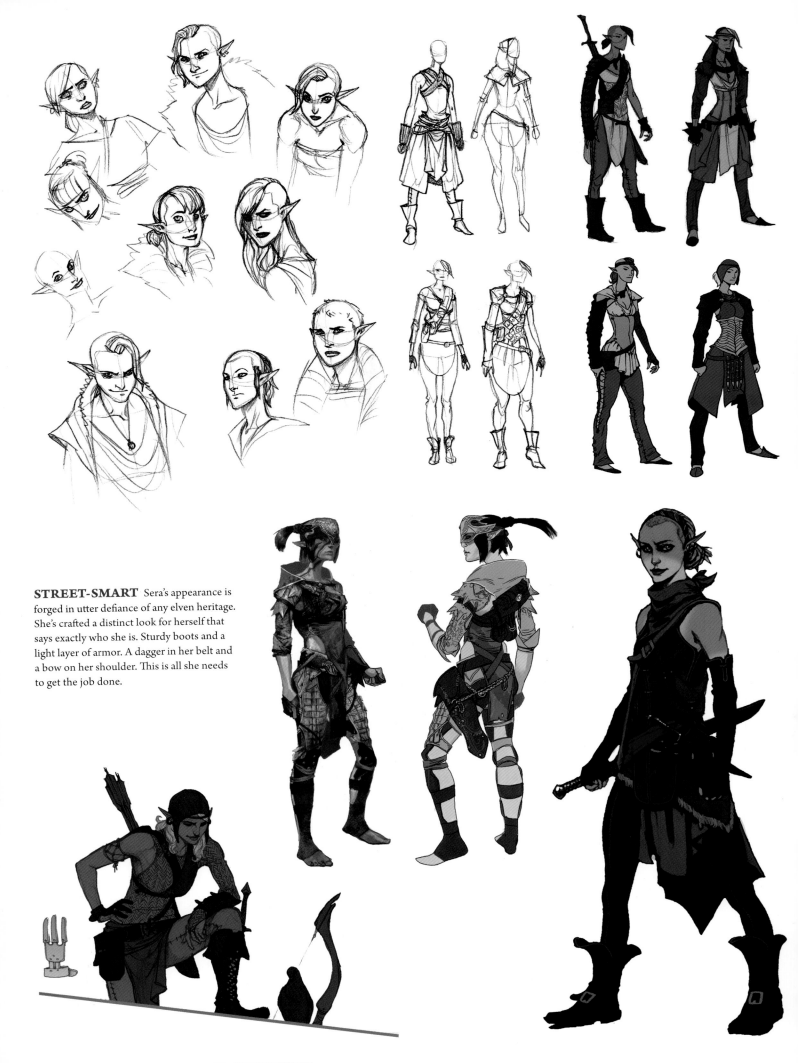

STREET-SMART Sera's appearance is forged in utter defiance of any elven heritage. She's crafted a distinct look for herself that says exactly who she is. Sturdy boots and a light layer of armor. A dagger in her belt and a bow on her shoulder. This is all she needs to get the job done.

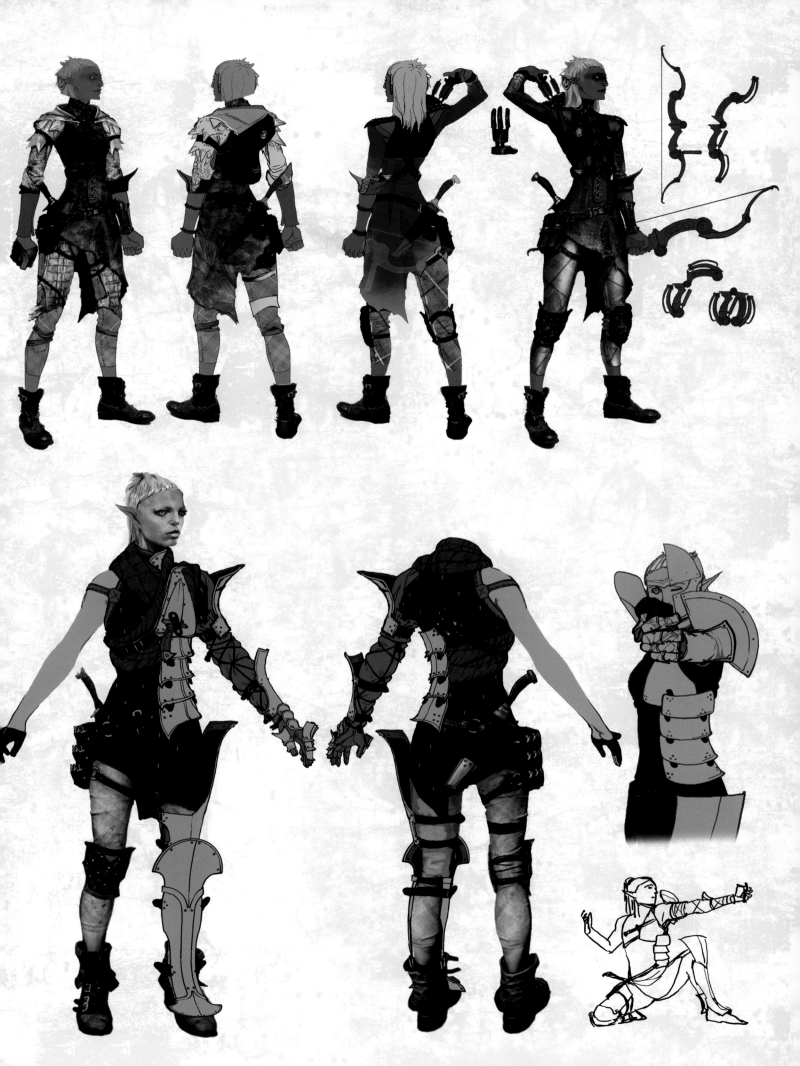

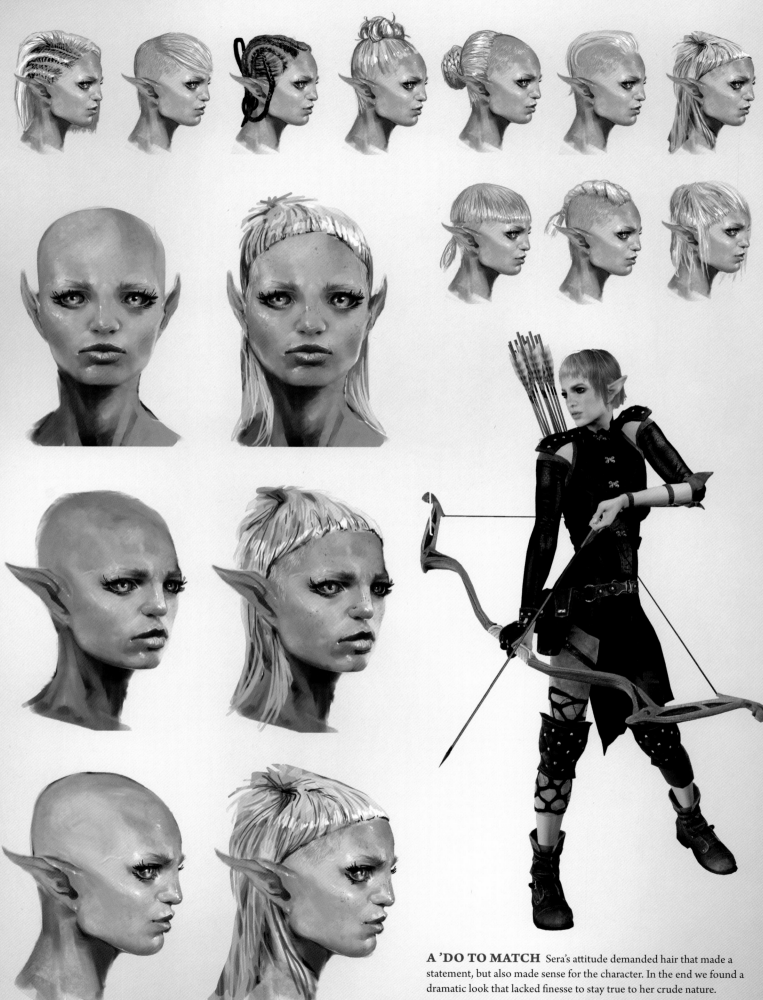

A 'DO TO MATCH Sera's attitude demanded hair that made a statement, but also made sense for the character. In the end we found a dramatic look that lacked finesse to stay true to her crude nature.

Opposite: Despite the crisis and the grim realities facing the world, there are elements of real beauty in Thedas. This is a world worth saving.

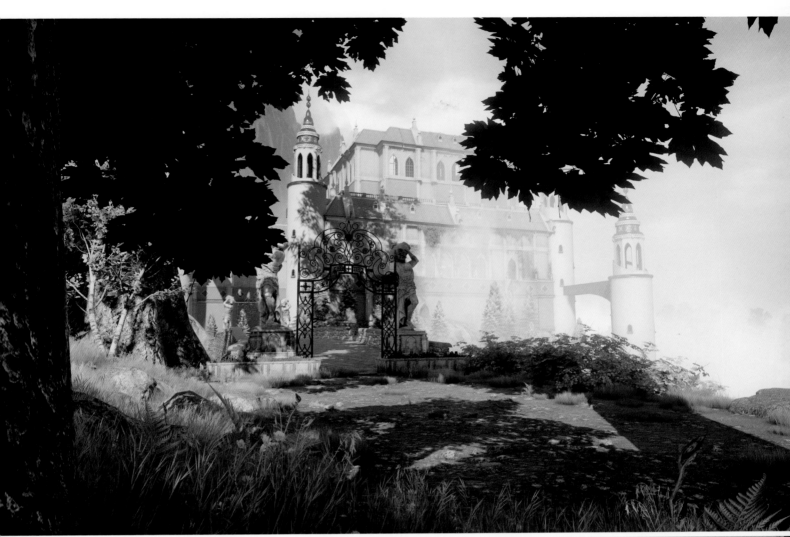

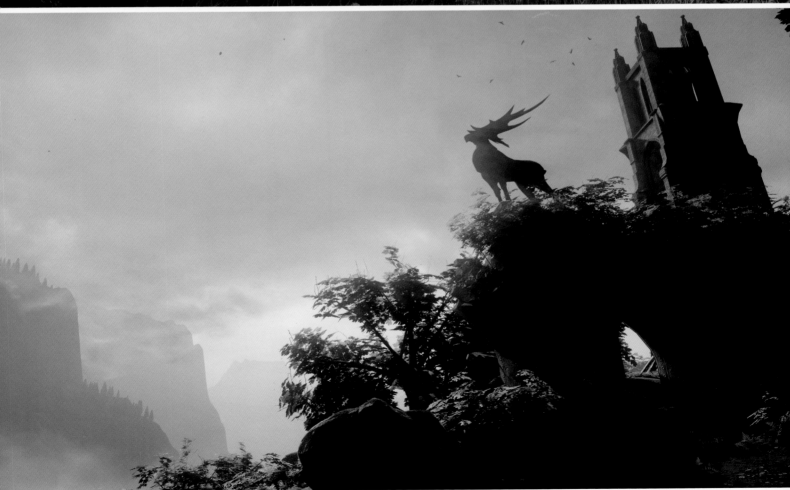

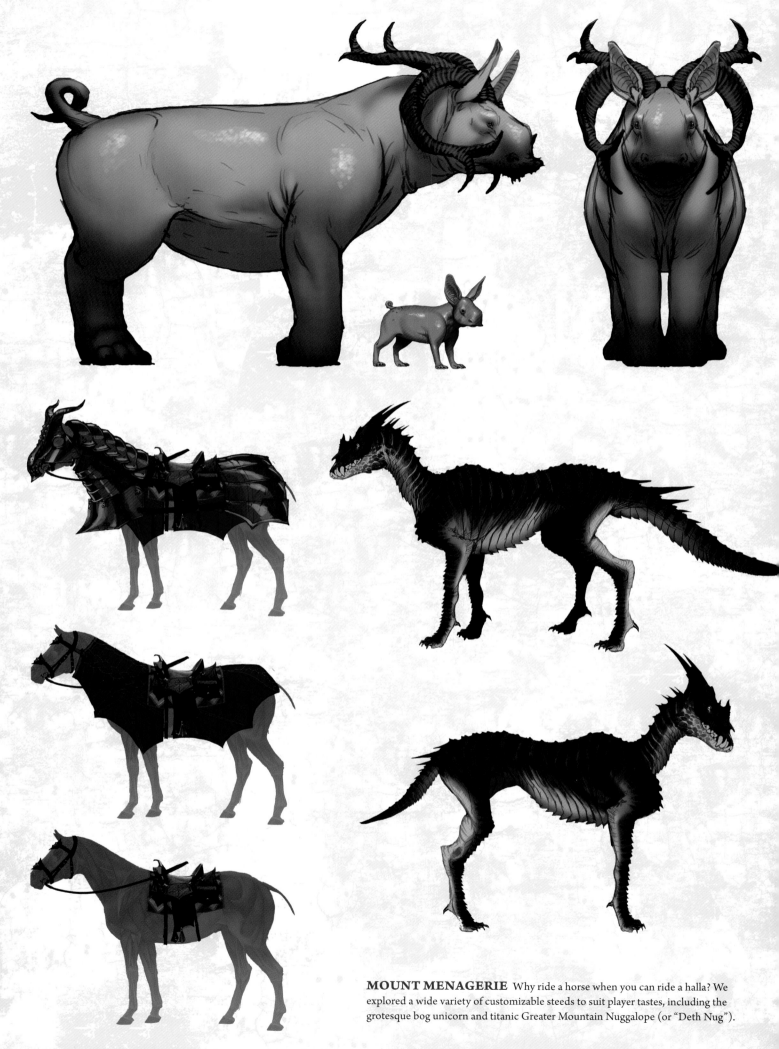

MOUNT MENAGERIE Why ride a horse when you can ride a halla? We explored a wide variety of customizable steeds to suit player tastes, including the grotesque bog unicorn and titanic Greater Mountain Nuggalope (or "Deth Nug").

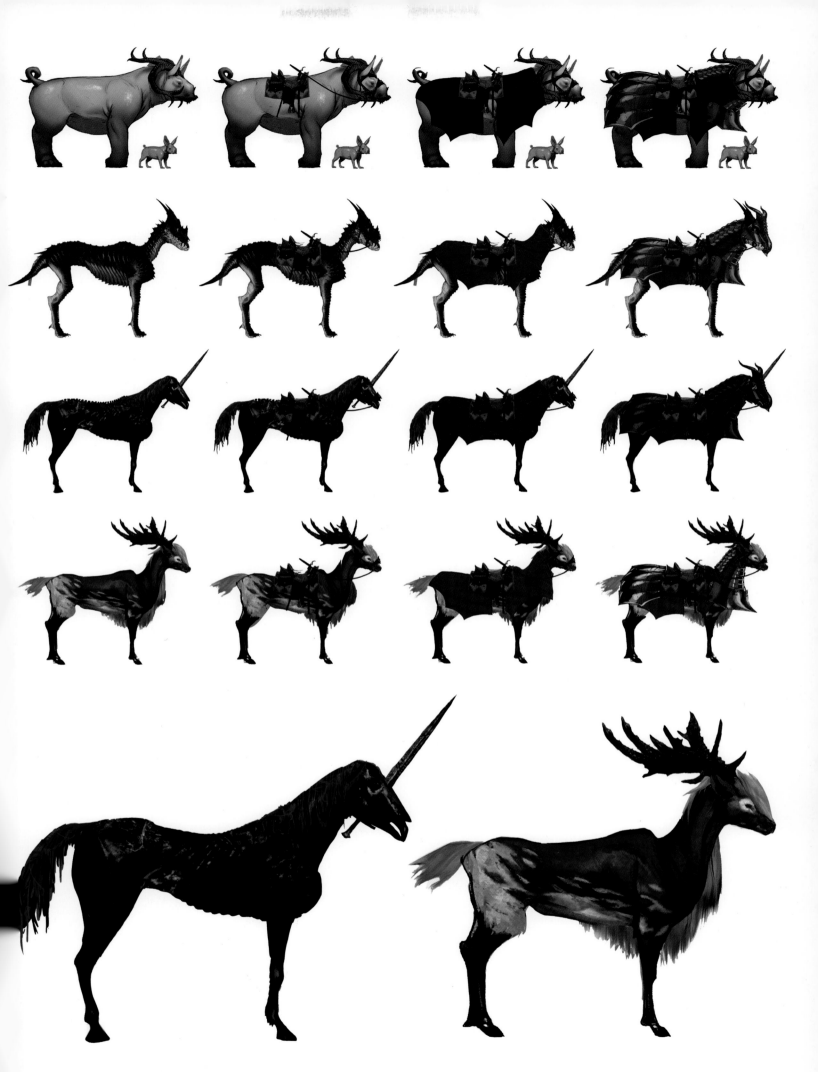

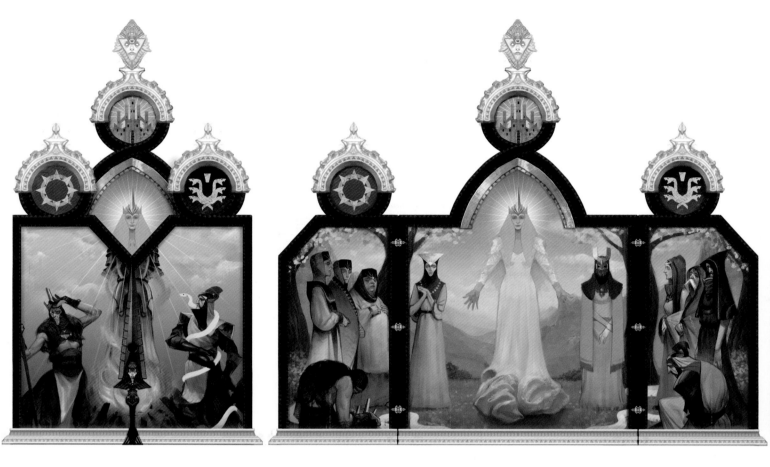

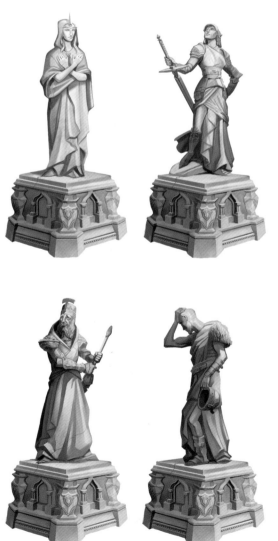

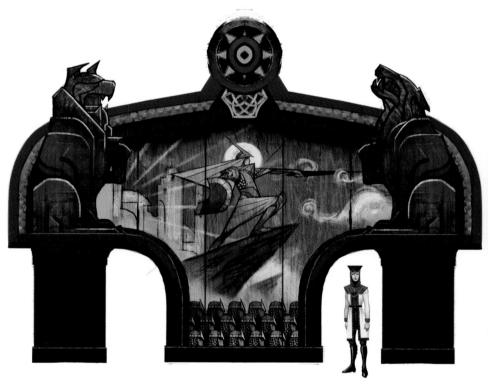

UNITED BY FAITH An Orlesian triptych depicts Andraste as a warrior and a matriarch where a more crudely drawn Fereldan panel focuses principally on her as a warrior. Images based on and illuminating the Chant differ depending on culture, even if the subject matter is the same.

Opposite: Fereldan tapestries convey key moments in the Chant of Light. Religious imagery helps to define the cultures of Thedas and reinforces the themes of faith and doubt prevalent in *Dragon Age: Inquisition*.

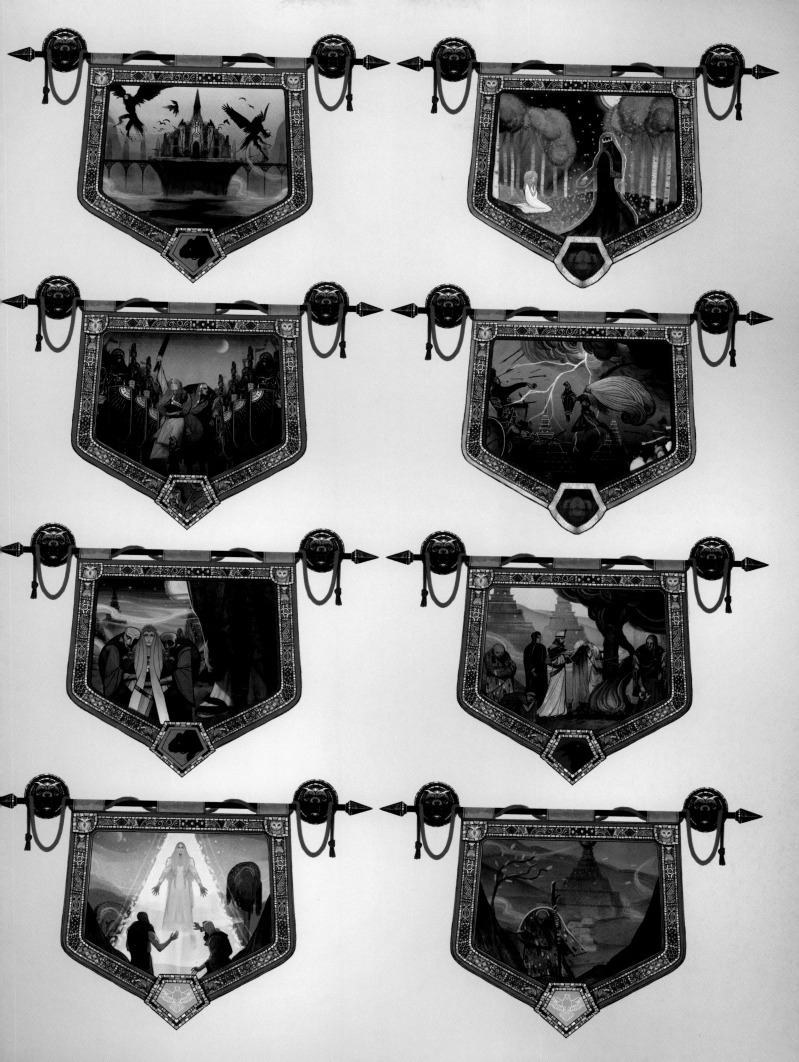

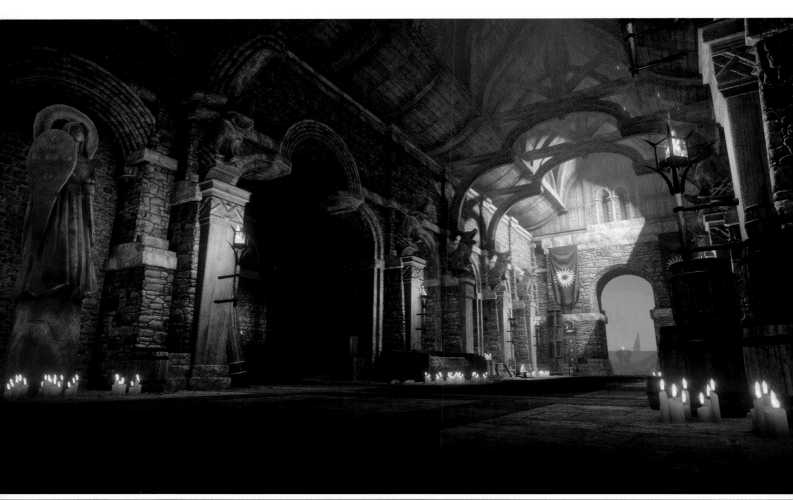

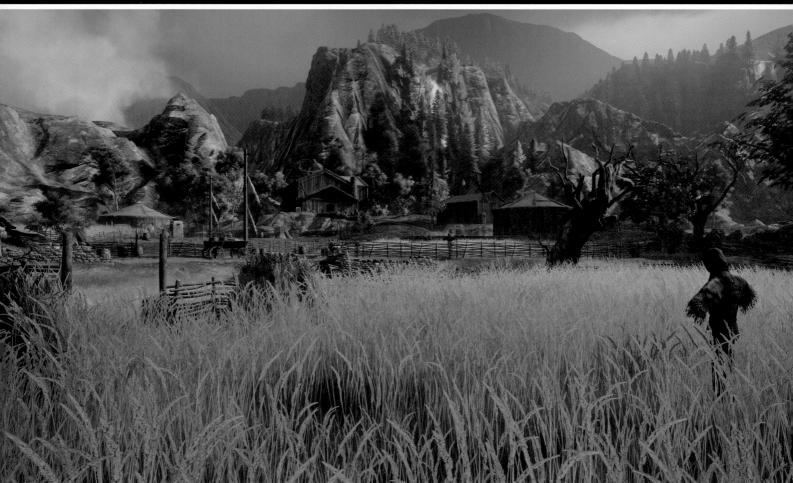

FERELDEN NEVER LOOKED SO GOOD Bringing a place to life is all in the details. Murals and dirt-stained standards decorate the countryside. In farther-flung corners, nature crawls over crumbling towers to show the lack of civilization, while trees lean at obscure angles to show its return.

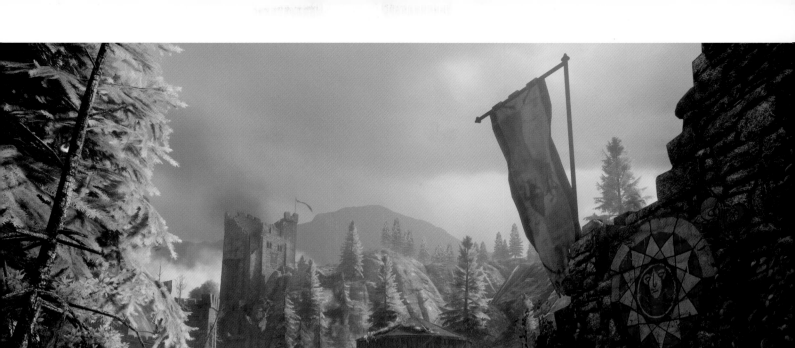

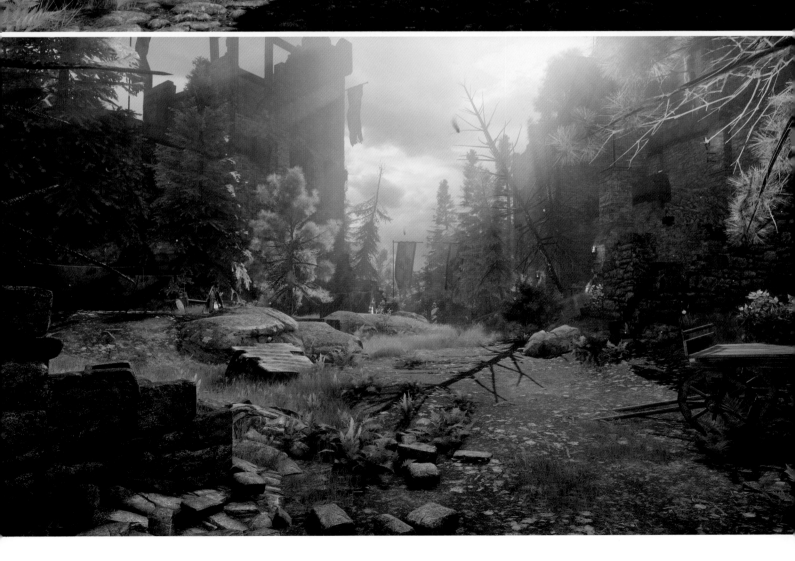

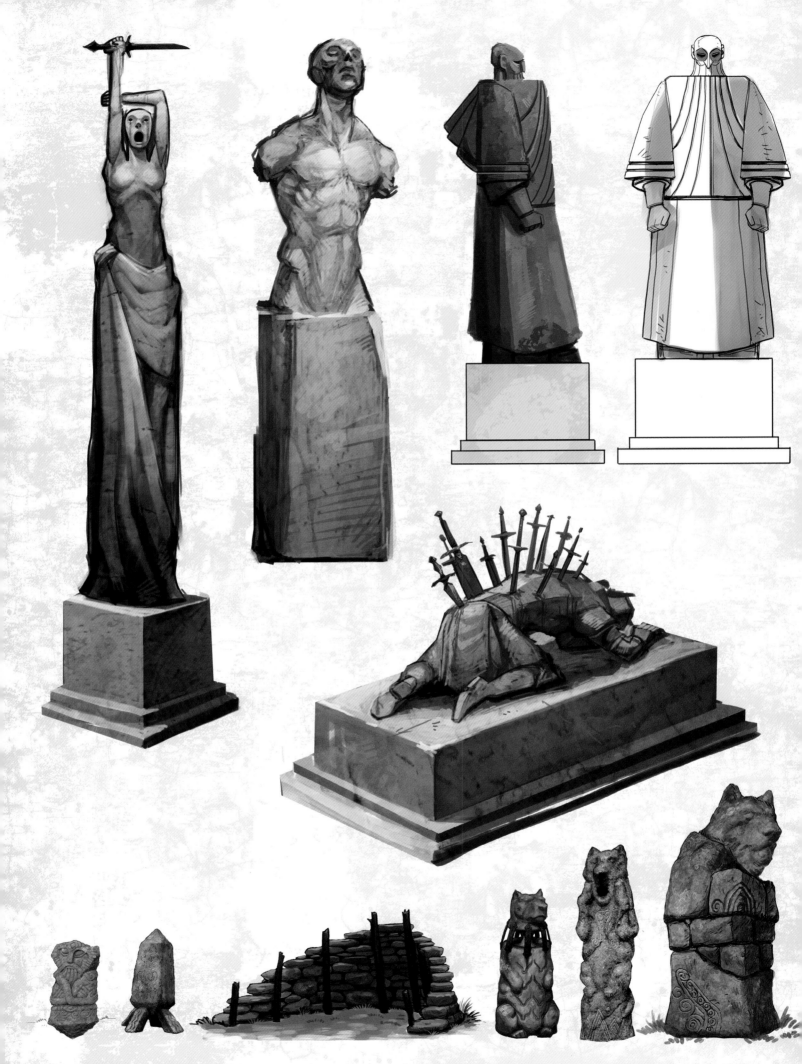

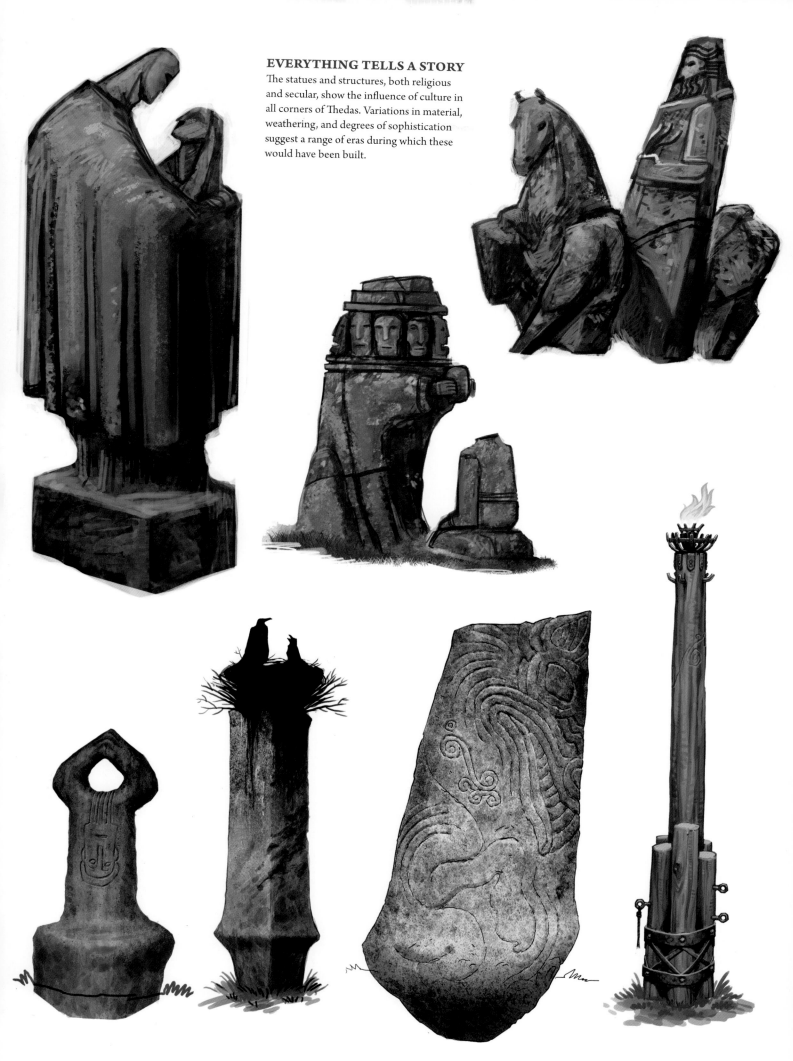

EVERYTHING TELLS A STORY

The statues and structures, both religious and secular, show the influence of culture in all corners of Thedas. Variations in material, weathering, and degrees of sophistication suggest a range of eras during which these would have been built.

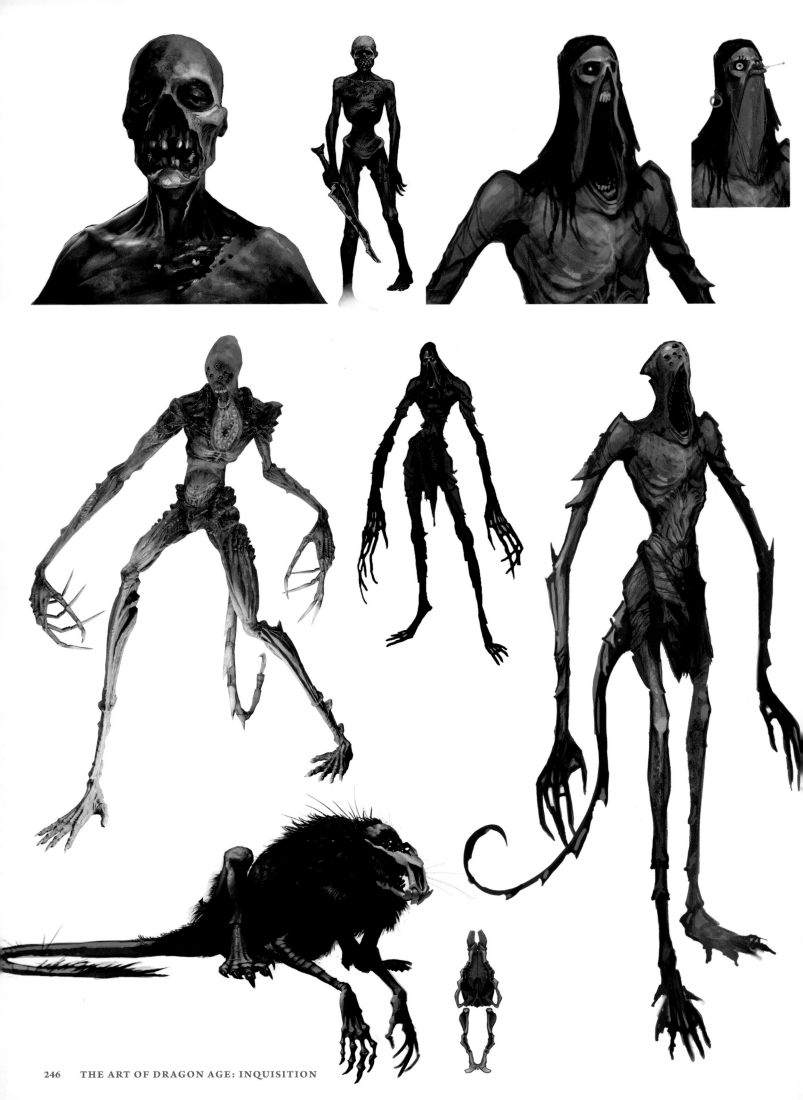

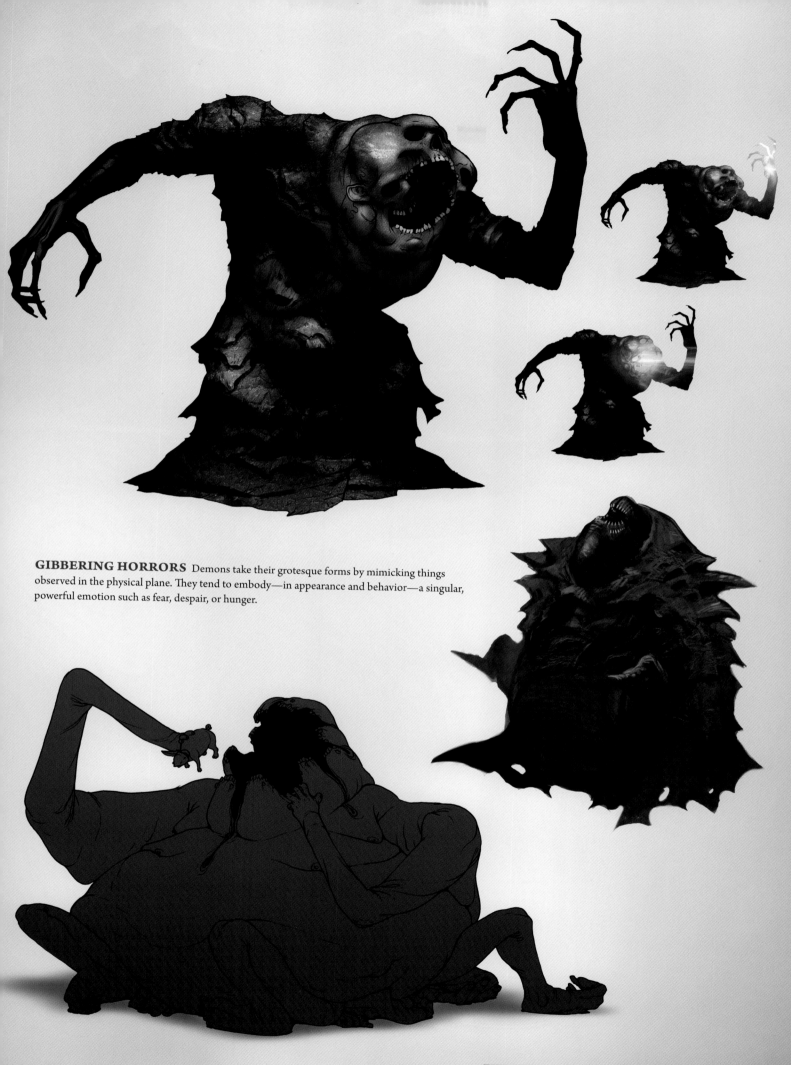

GIBBERING HORRORS Demons take their grotesque forms by mimicking things observed in the physical plane. They tend to embody—in appearance and behavior—a singular, powerful emotion such as fear, despair, or hunger.

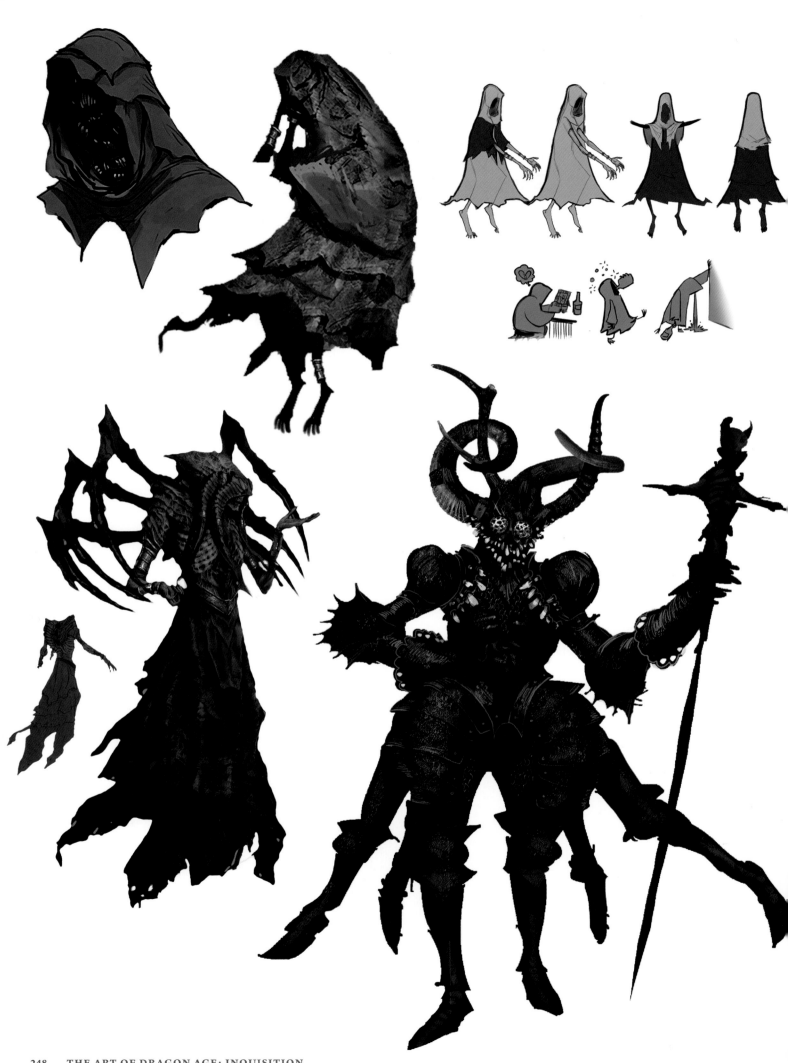

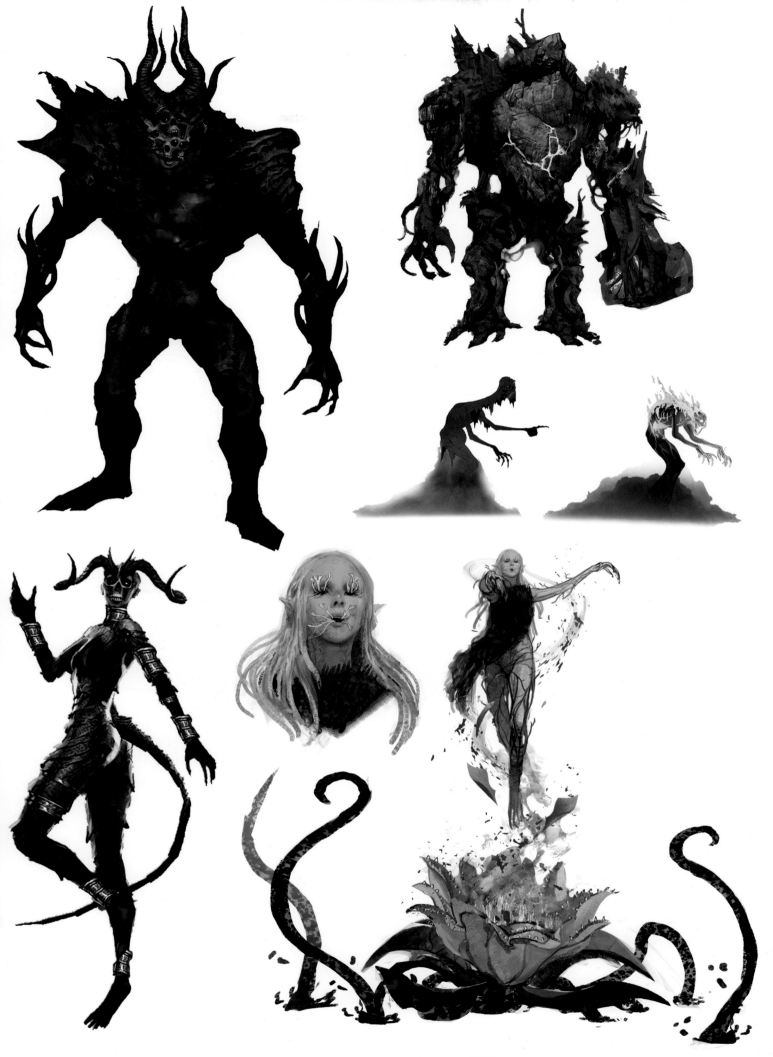

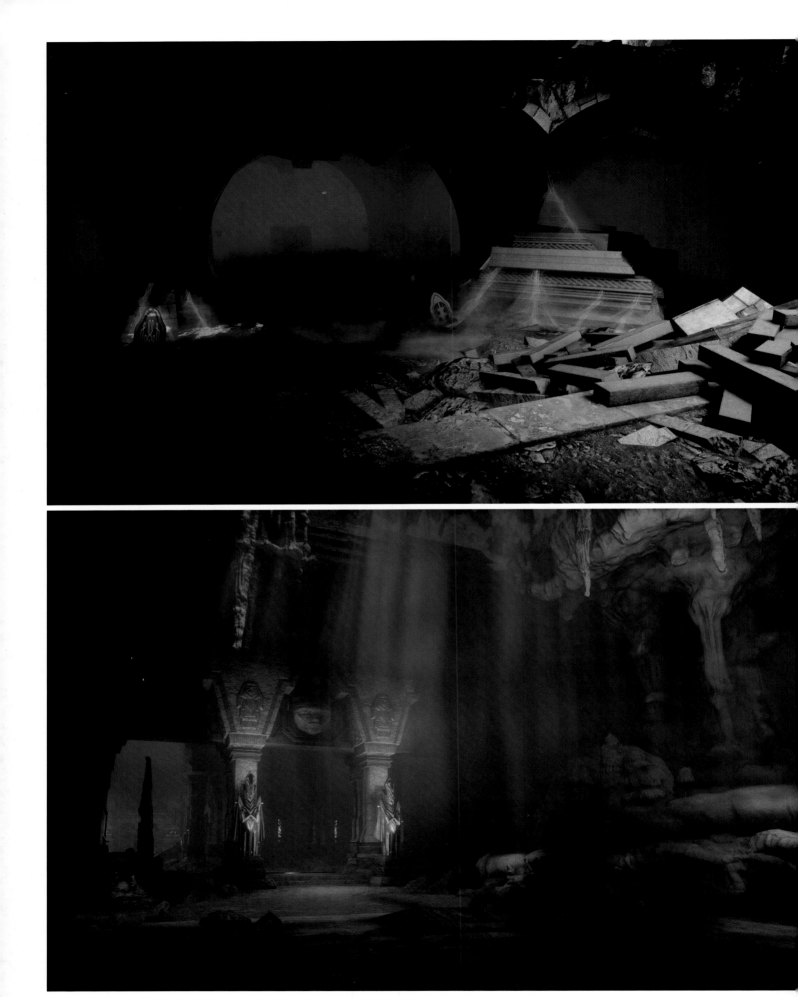

THE MURKY CORNERS The Deep Roads are lit in a green haze, as though the air down there is foul. Much of the detail is left in shadow.

Opposite: Even the grandest structures may fall into disrepair. Still, everything has a purpose, even if that purpose isn't what was originally intended.

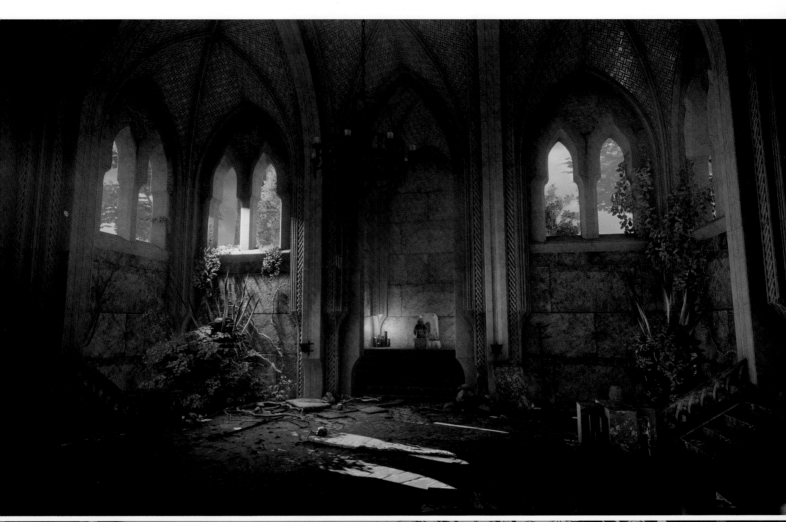

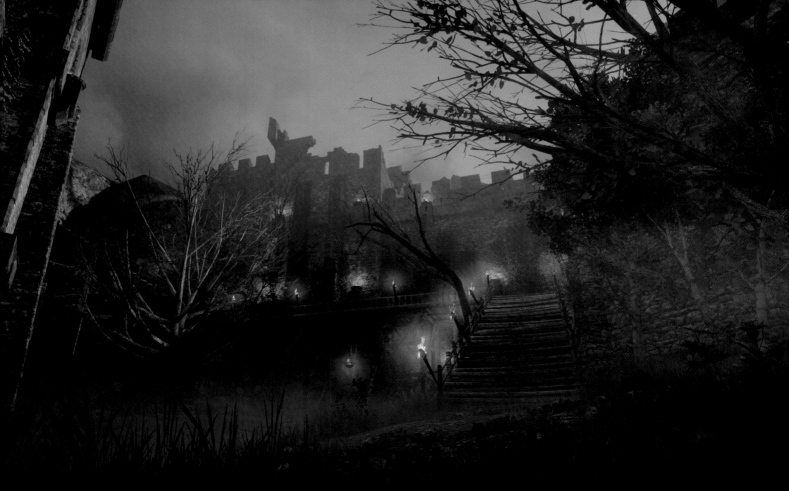

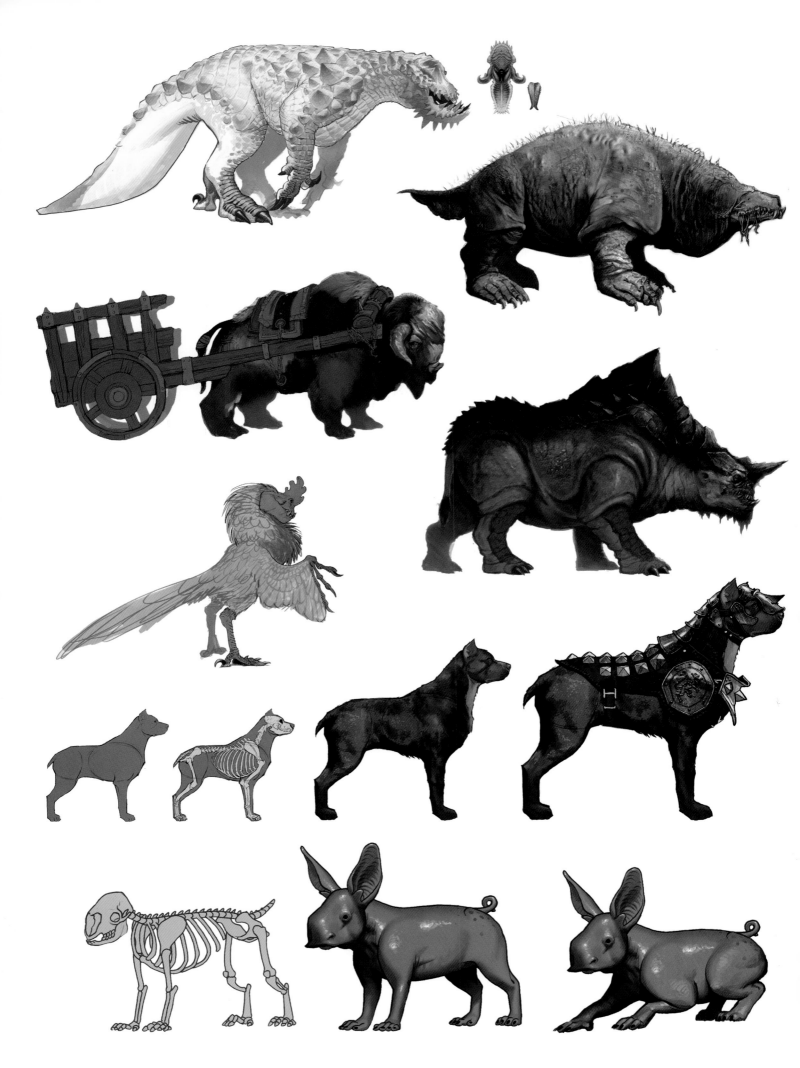

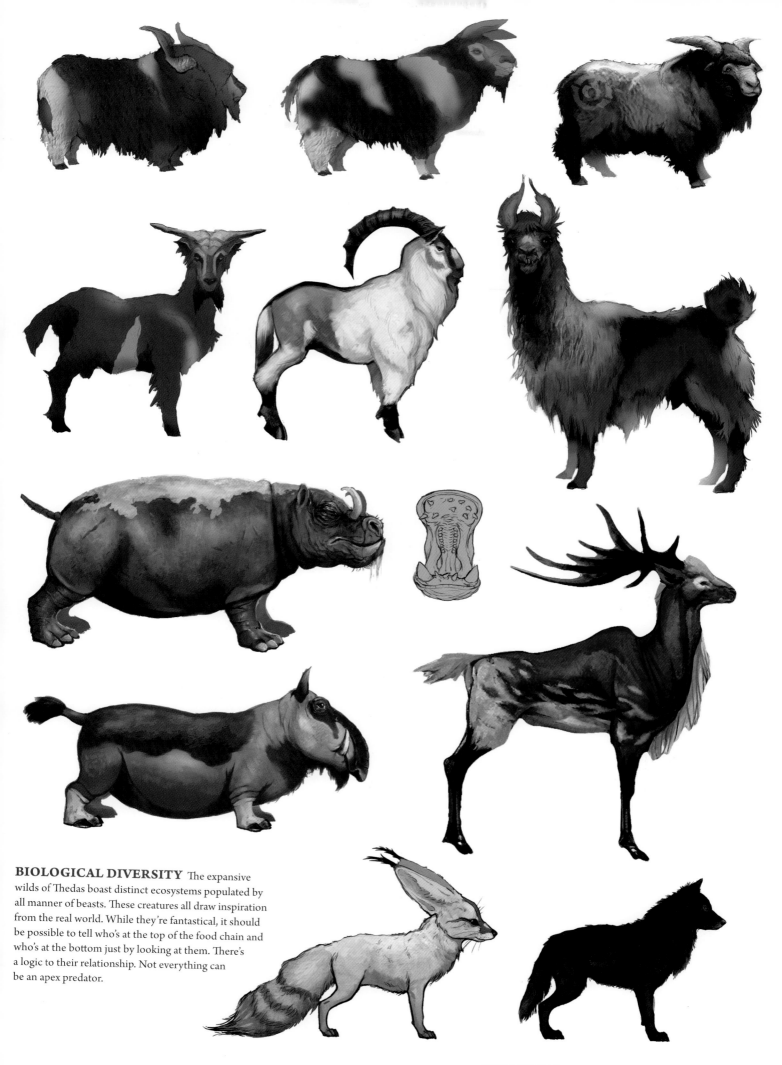

BIOLOGICAL DIVERSITY The expansive wilds of Thedas boast distinct ecosystems populated by all manner of beasts. These creatures all draw inspiration from the real world. While they're fantastical, it should be possible to tell who's at the top of the food chain and who's at the bottom just by looking at them. There's a logic to their relationship. Not everything can be an apex predator.

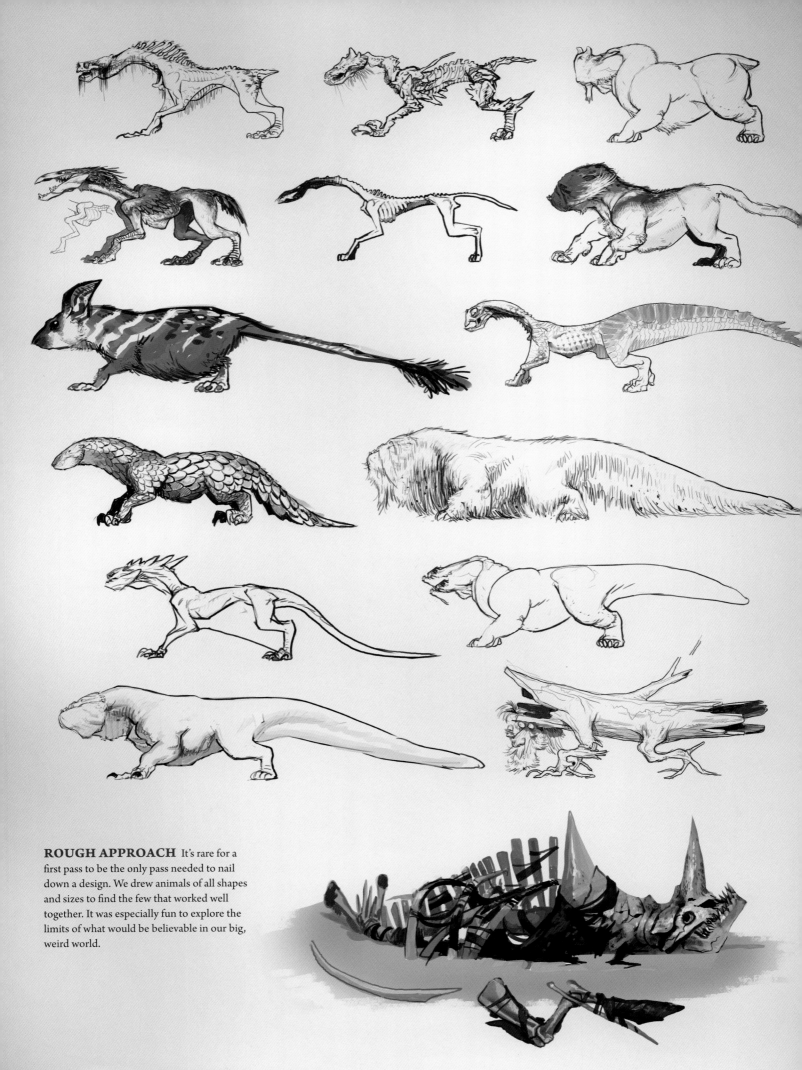

ROUGH APPROACH It's rare for a first pass to be the only pass needed to nail down a design. We drew animals of all shapes and sizes to find the few that worked well together. It was especially fun to explore the limits of what would be believable in our big, weird world.

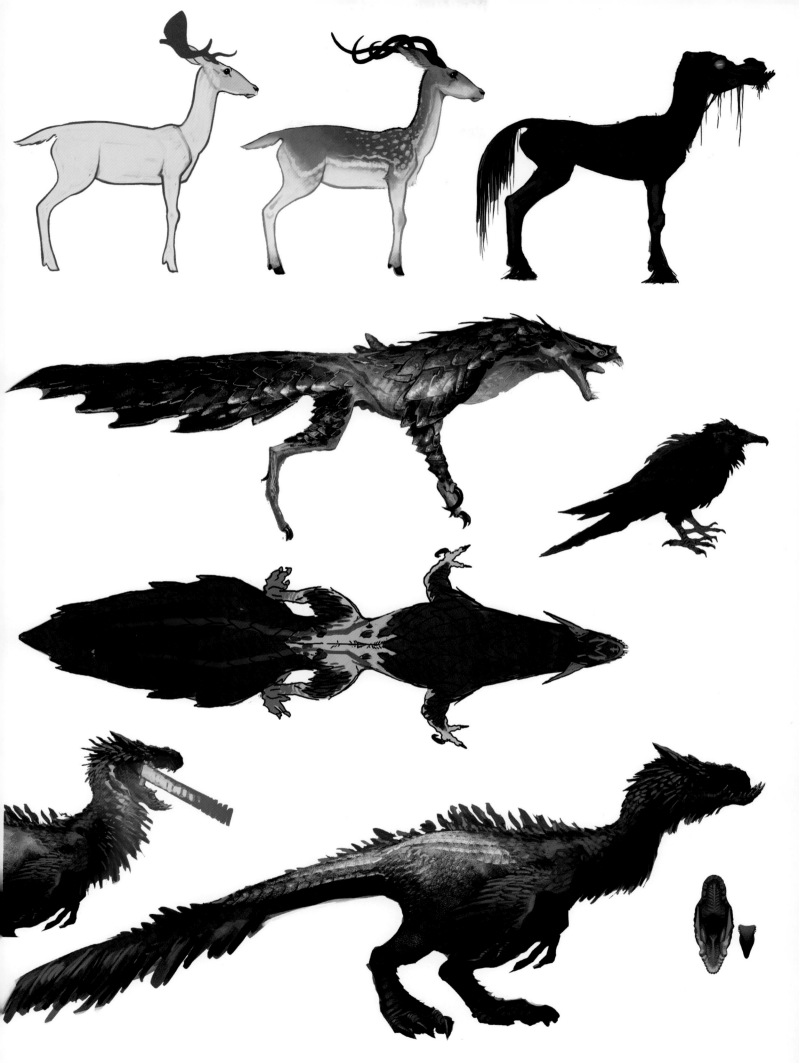

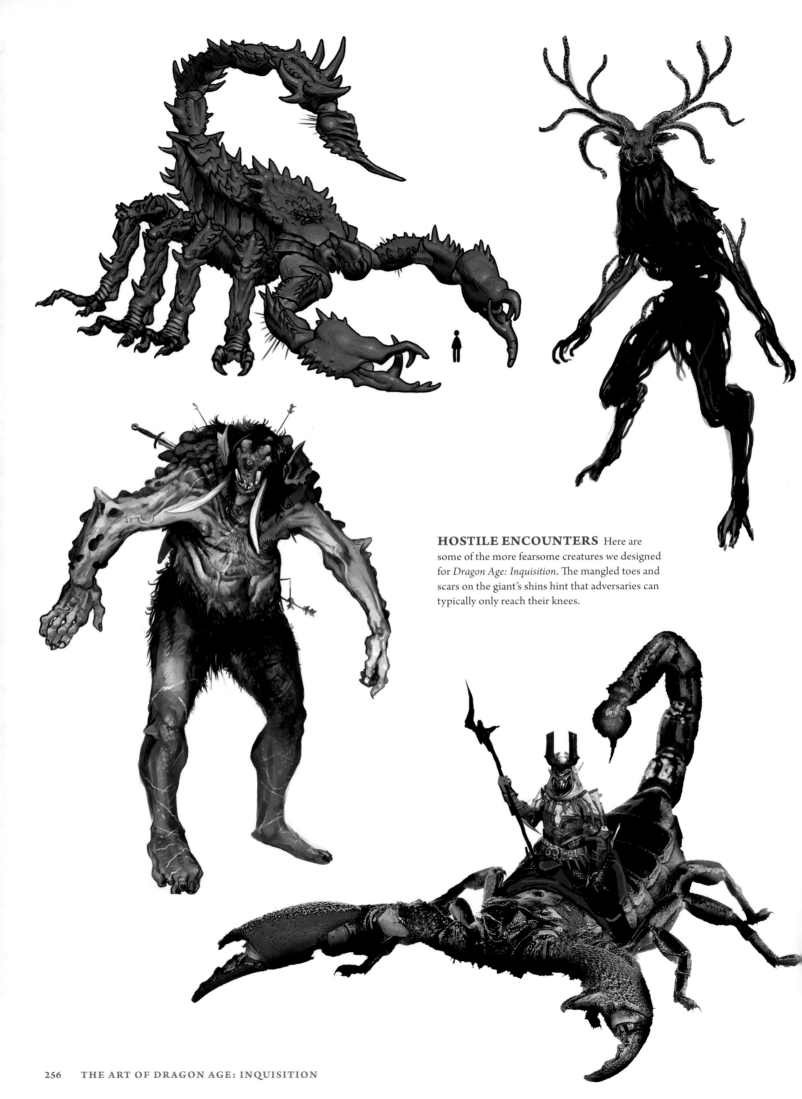

HOSTILE ENCOUNTERS Here are some of the more fearsome creatures we designed for *Dragon Age: Inquisition*. The mangled toes and scars on the giant's shins hint that adversaries can typically only reach their knees.

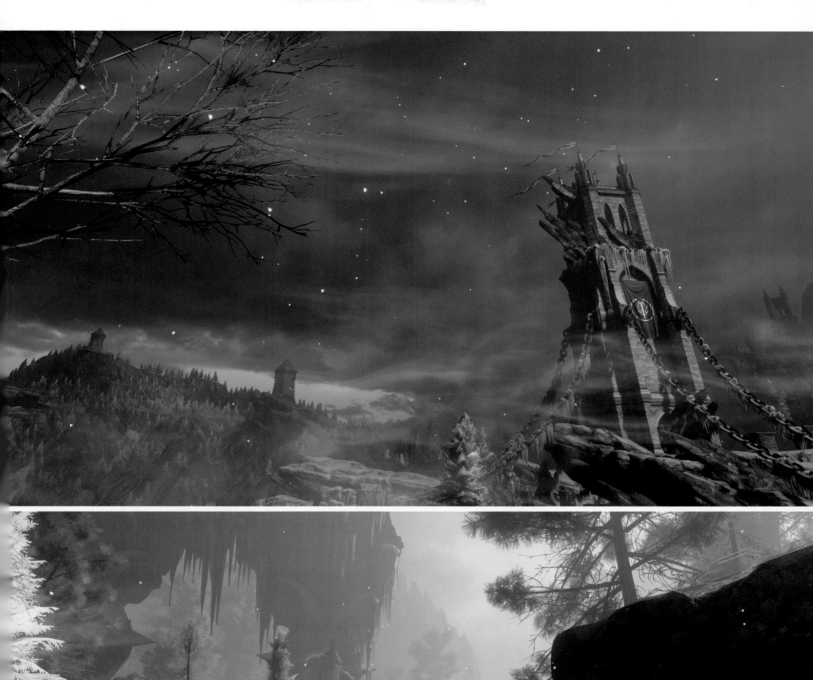

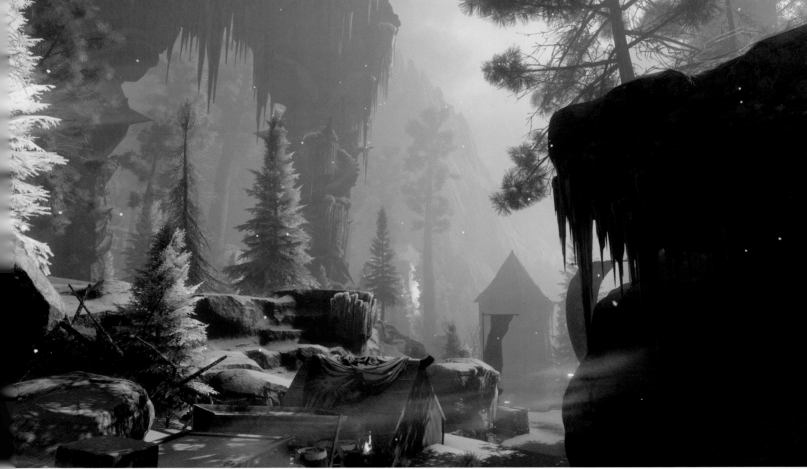

WINTER CLIME Though remote, the frozen regions of the continent are not immune to corruption. The presence of red lyrium implies just how far the trouble has spread, while serving as a visual counterpoint to the steely gray and blue palette.

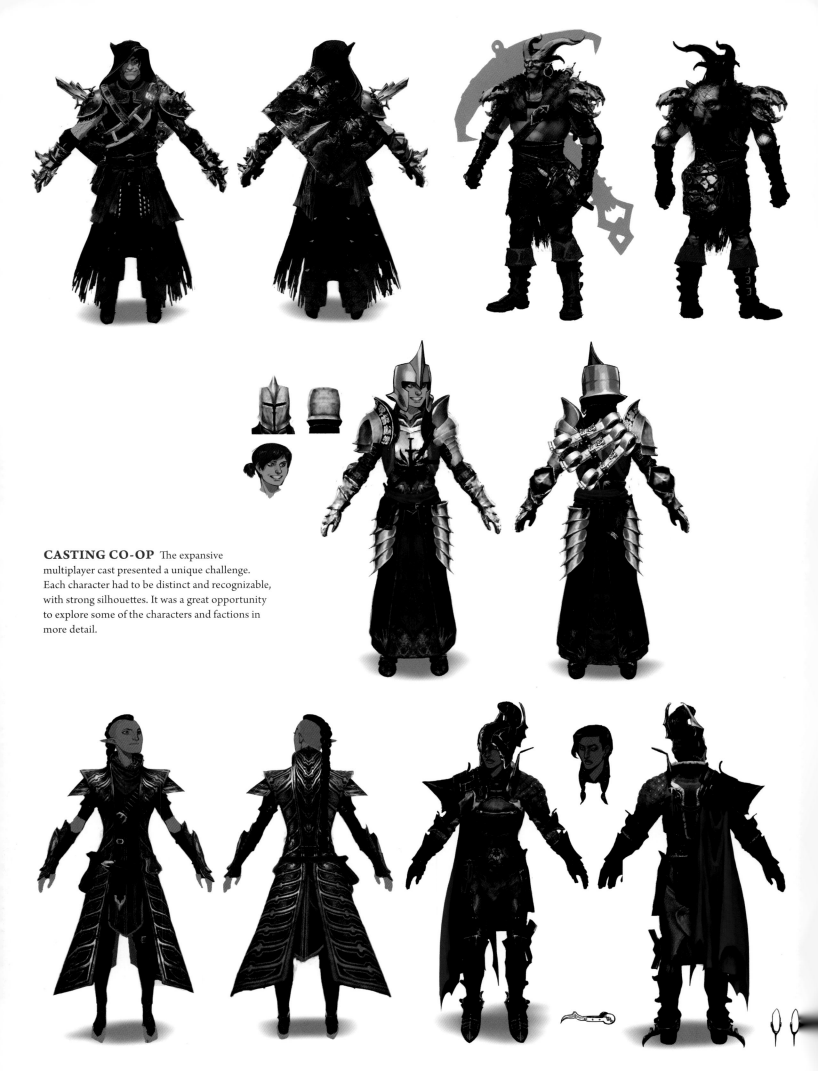

CASTING CO-OP The expansive multiplayer cast presented a unique challenge. Each character had to be distinct and recognizable, with strong silhouettes. It was a great opportunity to explore some of the characters and factions in more detail.

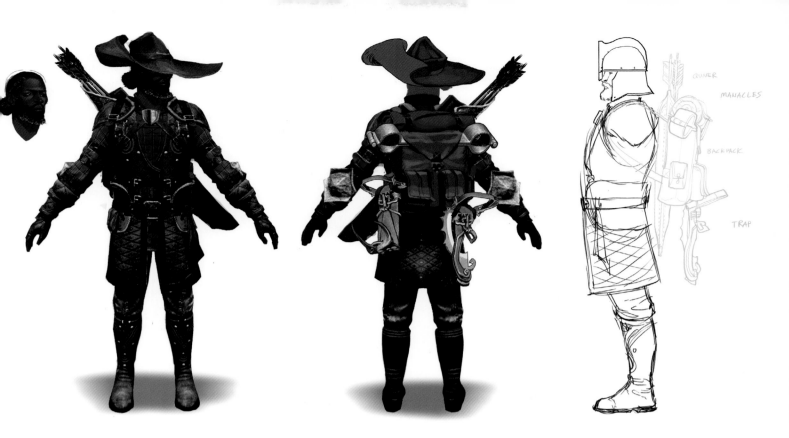

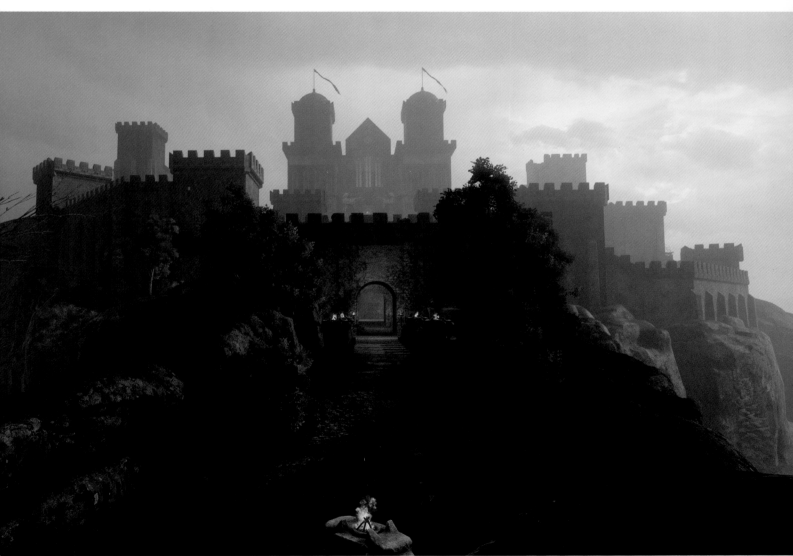

A SEEKER FORTRESS Squat, and approached by a narrow path, Therinfal Redoubt needed to look impenetrable, but also lived in—with all the trappings of a tough and exclusive order dedicated to Chantry justice.

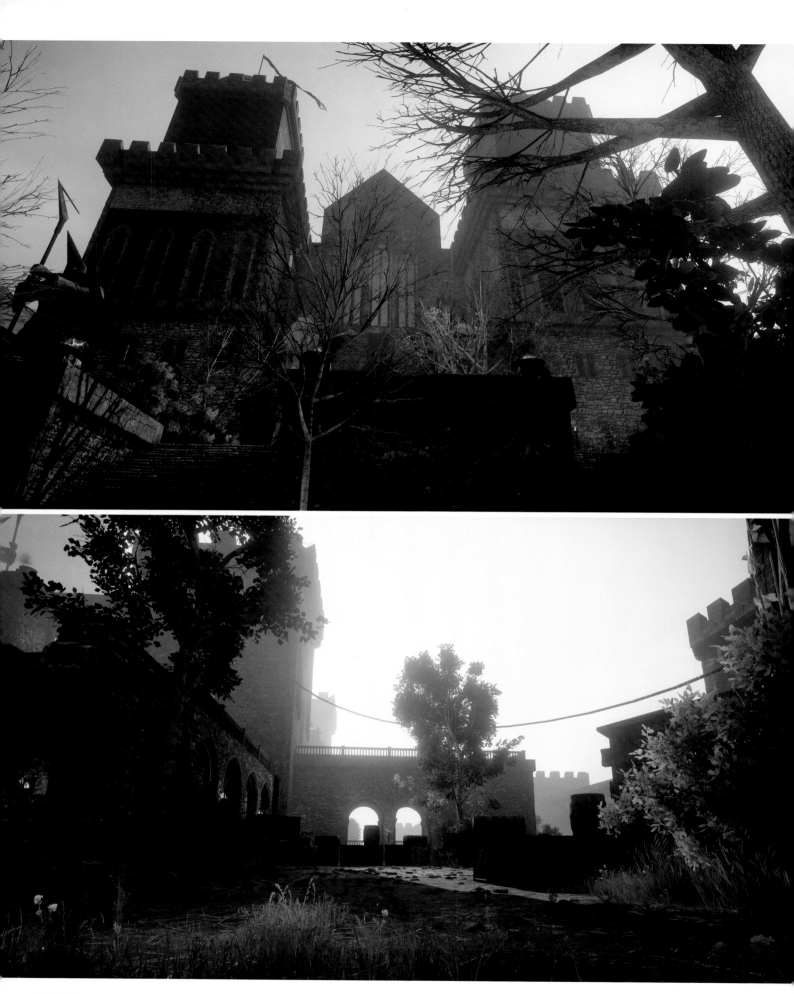

FUNCTIONAL SPACE The Seeker Fortress is not terribly ornate. It is, after all, a militaristic building. The odd statue and decorative window is a tasteful reminder of the traditions of the order and its ties to the Chantry.

Opposite: The chambers of the Orlesian elite are glossy and polished, especially when contrasted with the quarters occupied by their servants.

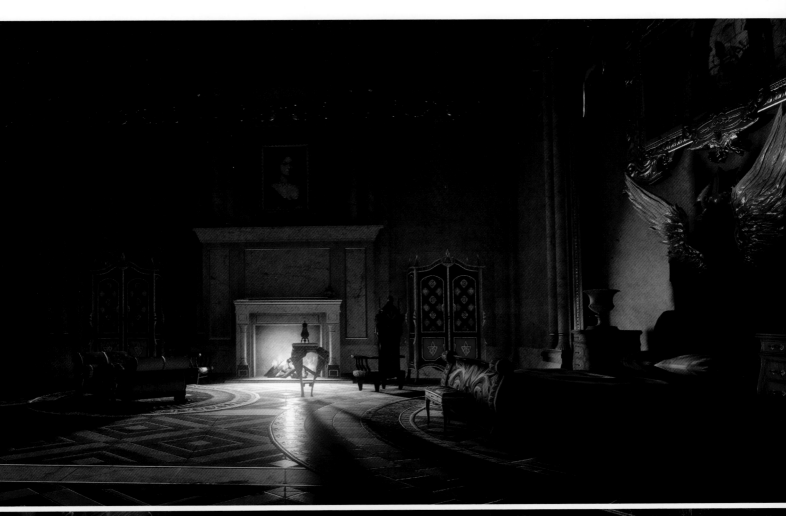

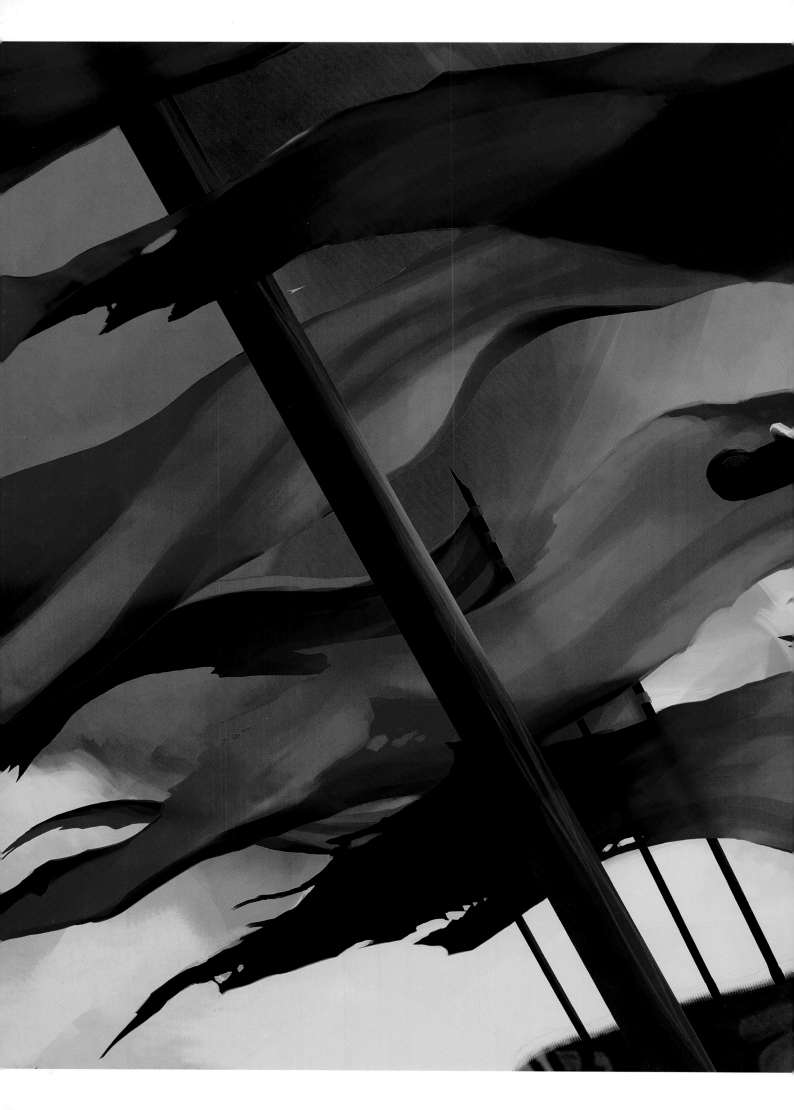

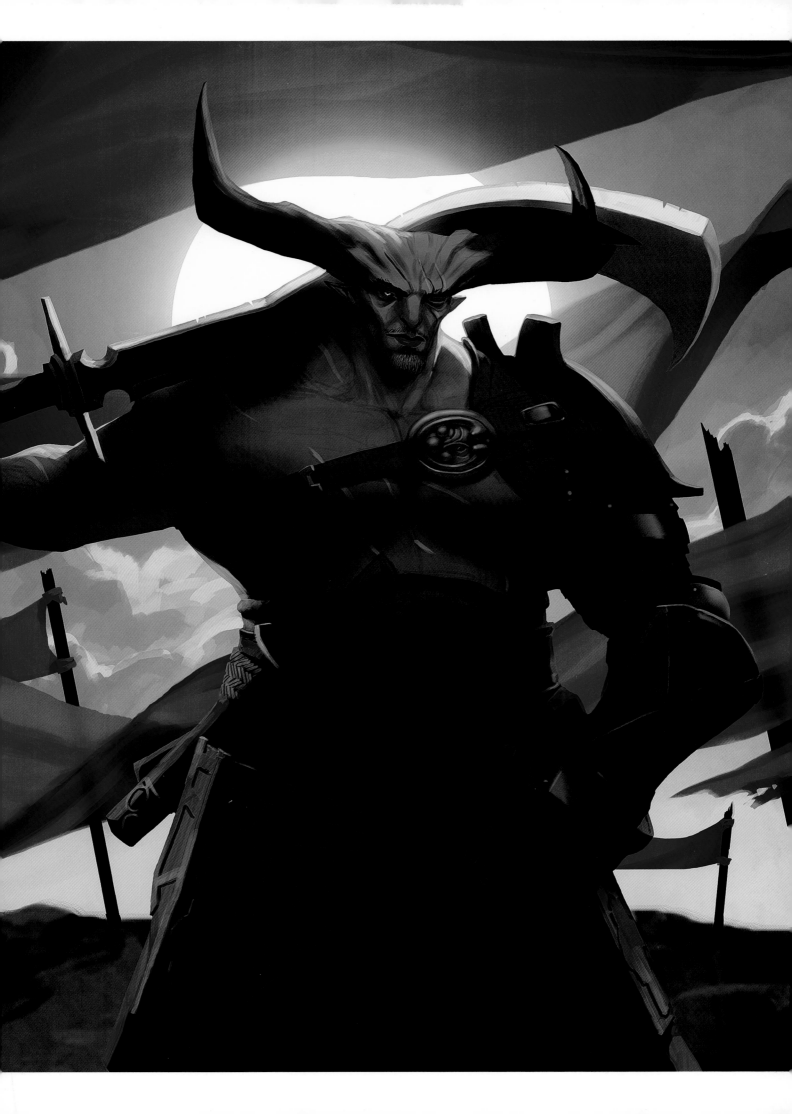